William Burrell

A Collector's Life

William Burrell

A Collector's Life

Martin Bellamy
and
Isobel MacDonald

BIRLINN

First published in 2022 by
Birlinn Ltd
West Newington House
10 Newington Road
Edinburgh
EH9 1QS

www.birlinn.co.uk

in association with Glasgow Museums

ISBN 978 1 78027 760 8

British Library Cataloguing-in-Publication Data
A catalogue record for this book is available on request from the
British Library

Typeset by Initial Typesetting Services, Edinburgh

MIX
Paper from
responsible sources
FSC
www.fsc.org FSC® C018072

Printed and bound by Clays Ltd, Elcograf S.p.A.

To Susan and Finn – MB

To my grandfather, Richard Hamilton, for inspiring me – IM

Contents

Foreword

Sir William Burrell is one of the most revered names in the Scottish art world. A name almost entirely entwined and rarely separated from the term 'collection', thanks to the gift of 6,000 artworks which he and his wife, Constance, presented to the City of Glasgow in 1944. However, the story of the Burrells is about much more than their exceptional collection, and their collection is much more than a carefully curated group of artworks. Indeed, one inspired the other, and to understand their donation requires an understanding of the people, their passions and interests, their tastes and knowledge. A product of years of research, *William Burrell: A Collector's Life* provides this vital access to the couple. From William's family history to the legacy of the gift, it delivers an all-important, in-depth and objective context for The Burrell Collection.

Our authors, Martin Bellamy and Isobel MacDonald, reveal new insights about the Burrells' business, their motivation for collecting, and the pivotal role which Constance played not only in the creation of the collection itself but in all aspects of William's life. We now know that he was not purely guided by art dealers but analysed and researched much of what he acquired. This book does not ignore the fact that the Burrells were products of the British Empire either, providing a frank take on who they were. William is also extremely present too, his direct words being frequently quoted, so that the reader has a real sense of the man behind the collection. In fact, *William Burrell: A Collector's Life* is rich in every detail, and I challenge anyone to say that they have not learnt something new from its pages.

As a Burrell myself – Sir William was my great, great-grandfather's second cousin – it's a huge privilege to have my ancestor's life so thoroughly documented. Reading the book has also revealed a connection which is both personal and professional, forged in shared experiences, shared passions and shared lives. We lived in neighbouring streets in Glasgow, visited the same museums, walked the same pavements, and he bought items from the auction house I now work for. Being a Burrell has been an asset for my professional life, and days spent at the collection which bears his name have inspired and cemented my career. It is a connection which I, like all Sir William's relatives, am extremely proud of.

This book engages and enlightens the reader, seamlessly linking the lives of the Burrells with their extraordinary collection. As a telling of their remarkable story, it will forever be an indispensable record.

Theodora Burrell
January 2022

Acknowledgements

This book would not have been possible without the support, encouragement and knowledge of the amazing curatorial team at Glasgow Museums. We thank them for their fantastic endeavours in researching Sir William Burrell and his collection over many years. In particular: Rosemary Watt, for her knowledge of The Burrell Collection; Dr Anthony Lewis for his insights into Burrell's conservatism and interest in Scottish history; Neil Johnson-Symington for his research on the staff at Hutton Castle; and Rebecca Quinton for reading through the entire manuscript and being a very useful sounding board. We would also like to thank: Hugh Murphy for checking over the shipping side of things and Roy Fenton for sharing his data on Burrell's puffers; Elizabeth Hancock for sharing her knowledge of Provand's Lordship; Fiona Cairns for simply being the best archivist; Iona Shepherd for pulling together the images; and Susan Pacitti and Anita Joseph for their subtle but brilliant editing. Special thanks are due to Vivien Hamilton for checking the manuscript and for many years of discussion and debate about Burrell and his collection, and without whom our understanding of Burrell would be very different.

Essential research was conducted at the Glasgow City Archives, Glasgow University Archives, Glasgow University Library Special Collections, Glasgow School of Art's Archives and Collections, Edinburgh University Library Special Collections, National Library of Scotland, Historic Environment Scotland, National Records of Scotland, Berwick-upon-Tweed Record Office, Tyne & Wear Archives, Victoria & Albert Museum Archive, Tate Archive, Christies London Archive, The Royal Archive and the Freer Gallery of Art

Archives. We would like to thank the many archivists and librarians for their assistance in providing information on their respective collections.

Introduction

Sir William Burrell (1861–1958) was one of the world's great art collectors. He and his wife Constance, Lady Burrell (1875–1961), created a collection numbered at over 8,000 artworks which they gave to their home city of Glasgow, Scotland, in 1944, in what has been described as 'one of the greatest gifts ever made to any city in the world'.[1]

The Burrell Collection was born out of the late Victorian industrial boom that propelled Glasgow into being the workshop of the world and the second city of the British Empire. Untold wealth was earned by an industrial elite who then sought to increase their social status by collecting art. William Burrell was born into a prosperous middle-class family of shipowners. When his father died in 1885, he and his brother George took over the business while still in their twenties, transforming it into one of the leading cargo shipping companies in Britain. William had a natural flair for business and earned himself a sizeable fortune. He had developed an interest in art as a boy and he used this wealth to steadily build his collection, quickly surpassing his local contemporaries in terms of the quantity and quality of his artworks and firmly establishing for himself an international reputation as a collector of good taste and judgement. He used his wealth and art collection to his advantage, and ultimately acquired a knighthood, a castle and a place in high society. However, this was not simply a vainglorious rise to power for its own sake. Burrell had a deep sense of public duty, serving for long periods as a local councillor and as a trustee of national institutions in England and Scotland, and wished to use his art collection for

public good. He lent large parts of it to galleries around the country so that as many people as possible could enjoy it, and, unlike most collectors, his collection was not sold or bequeathed for personal or family gain. When he donated the majority of his collection to Glasgow, with smaller parts going to Berwick-upon-Tweed and several other provincial galleries, his aim was to enhance the cultural standing of these places and to improve the lives of their citizens. At the time of his gift the collection was valued at well in excess of £1 million, and it came with an additional £450,000 in cash to build a dedicated museum for it. This was a major act of philanthropy, with very few strings attached other than stipulating where and how it was to be displayed. Burrell simply wanted people to gain as much pleasure from art as he had, and to improve their lives through a better understanding and appreciation of beauty.

Burrell proved to have an innate talent for art collecting. He understood what he was buying, and his refined taste led him to areas that other collectors dared not touch. His primary passion was for Gothic art and he built an outstanding collection of medieval and Renaissance tapestries, stained glass and furniture. His collection of Chinese bronzes and ceramics is one of the most comprehensive in the country, and his collection of French Impressionists contains numerous masterpieces by Manet, Cézanne and especially Degas, of whose work Burrell amassed the largest number of any collector in the country. And he was ahead of his time in collecting works by Dutch artists – the Maris brothers were particular favourites. As a result, parts of his collection rival those of major international art museums such as the Victoria & Albert Museum in London and the Metropolitan Museum of Art in New York. As one newspaper observed: 'It is said that there are about six thousand art collectors in Glasgow, but few can have bought more judiciously and more courageously than Sir William Burrell.'[2] His collection may seem eclectic, but what connected the different parts was his love of artistry, history and the quality of craftsmanship. He was particularly attracted by the beauty of form and colour, and admired items with strong historical connections, particularly

those associated with noble and royal families. This tied in with his Conservative political principles which, to a certain extent, guided his collecting.

These collecting passions were shared with his wife Constance, who played an active role in developing the collection. In his will Burrell was very particular in stating: 'I have had the benefit of my wife's help in many ways including financial help and have received from her the greatest assistance and most wholehearted support in forming the collection . . . it is my desire that it be distinctly understood that the entire gift is from my wife and myself and that her name shall always be associated with mine and shall receive full acknowledgement in all official literature relating to the collection'.[3] William and Constance were faithful and loving companions throughout their married lives, and operated very much in partnership in their business, collecting and philanthropic endeavours.

Unlike many collectors, Burrell knew exactly what was in his collection. He left school at fifteen but had a typically Scottish Presbyterian approach to self-education, putting in the hard work that was required to develop his knowledge. He took the time and effort to study and understand what he had, and his library contained a significant number of books on art, history and literature that were well read and annotated. He consulted leading academics on certain aspects of his collection and used respected art dealers to guide his knowledge. He revelled in understanding the full historical significance of items in his collection and it was said that 'to hear Sir William's account of the history of a particular picture, tapestry, sculpture or art object was an education'.[4]

Burrell is often compared to other major collectors such as the American newspaper magnate William Randolph Hearst, the financier J. P. Morgan and the steel and railroad baron Henry Clay Frick. Their collections were much larger and had their own strengths, but these men had wealth that far outstripped Burrell's and they often bought in bulk and rather indiscriminately. Burrell was a very different collector, far more judicious, balancing his comparatively limited wealth with his extensive knowledge of art and history to

carefully build his collection over a lifetime. He was rather disdainful of Hearst, saying that he 'paid whatever was asked whether genuine or spurious'. Later, Burrell was able to buy parts of that collection for a fraction of what Hearst paid after the American became financially embarrassed.[5]

Burrell, too, wanted to build a large and impressive collection, but not at any price. He set limits and stuck to them. If something went beyond that limit, he regretted the lost opportunity, but was quite resolute in not paying more than what he thought something was worth. He approached his art purchases as business transactions; although he let his heart select the objects, it was his head that bought them. This system worked because he rarely attended auctions himself, getting others to bid on his behalf – he built a successful network of dealers who understood and trusted his business methods, operating within the limits that he imposed. It also meant that other dealers and bidders were not alerted to Burrell's interest in certain lots. As Kenneth Clark observed: 'His stories of how he outwitted art dealers are too numerous to be repeated; but the funny thing is that they rather liked him. He was playing their game, and they knew where he stood.'[6] Although he tried to get things as cheaply as possible he always insisted that the dealers received a fair commission, and he was meticulously punctual when it came to settling his bills. The same was true in his dealings with museums. Not wanting to see them out of pocket, he always insisted on paying for the transport and packing costs when he sent things out on loan.

Although The Burrell Collection has become internationally renowned, Sir William Burrell himself has remained something of an enigma. He shunned the limelight, wanting the collection to speak for itself, leaving few clues about his personal life and hiding behind a persona of reticence. This dearth of material has allowed certain myths and fabrications to take hold which have painted him in a rather unfavourable light, compounded by the fact that most people who wrote of their personal experiences of Burrell only knew him when he was in his eighties and nineties so that their recollections of a rather tetchy old man have dominated our view of him. Newly

discovered research materials and access to resources such as digitised newspapers have allowed a much more detailed and nuanced understanding of Burrell to be revealed, especially of his earlier years.

There is no doubt that Sir William was a difficult and complex character. In many ways he was a typical west of Scotland male; he was immensely proud of his achievements but unwilling to brag about them. His actions in business and art were bold and daring, but in person he was softly spoken and shy. He was socially and politically conservative, but had an adventurous taste in modern art. And like all men who reached his position, he had a ruthless streak. He had exacting standards and expected others to meet them. This manifested itself in business when his younger brother was ousted from the family firm for not quite making the grade. In his personal life, when his daughter Marion made inappropriate romantic liaisons, he quickly intervened to call off her engagements. In dealings with museums and galleries he was extremely demanding, though always scrupulously polite. He frequently began his letters with 'Sorry to trouble you', or 'I hope I am not imposing upon your kindness'. After a particularly protracted and demanding correspondence with the director of the Tate Gallery he wrote: 'I know I am making myself a nuisance but I seem to be asking you one favour after another.'[7] He knew what he wanted and he knew how to get it.

Burrell was very much a product of the British Empire. His view of the world was based on growing up in Victorian Britain where it was considered part of the natural order of things that Britain controlled an empire and used it to advantage. His business as a shipowner was founded on Britain's dominance of maritime trade, at a time when nearly half the world's ships were British, and much of this trade was a result of the exploitation of people and resources across the empire. His view of different peoples and cultures was seen through the eyes of a Victorian industrialist art collector. For example, he revered the bronze and ceramic art from China in his collection but exploited ordinary Chinese seamen on board his ships. As with most collectors of this time, Burrell acquired a small number of objects that are today regarded as war loot or the plunder of empire. In a few

cases he knew exactly how these pieces had been acquired but, with the sensibilities of the time, this was not considered problematic, just a natural consequence of British rule. But in most cases he was completely unaware, and it is only with modern research techniques and the opening up of digital archives and collections that the true provenance of some parts of the collection has been revealed. It would be harsh to judge Burrell on this basis as in fact he was largely ethical in his approach to collecting.

The opening of The Burrell Collection museum in 1983 was the culmination of William and Constance's ambitions. It gave each citizen of Glasgow free access to his art collection in beautiful surroundings in a way that fostered enjoyment, contemplation and understanding. It immediately captured the imagination of the public, placing Glasgow firmly on the cultural map. Although it opened much later than originally anticipated, and long after the deaths of both William and Constance, its opening occurred at just the right time to play a major role in the transformation of Glasgow from a post-industrial city with a poor reputation into an internationally renowned city of culture.

After thirty years as one of Glasgow's leading attractions, the innovative museum building needed a significant upgrade to meet twenty-first-century standards of access and environmental sustainability. The Burrell Renaissance Project was born to secure the future of the building and to revitalise the displays to meet the demands and expectations of contemporary audiences. This major investment has ensured that the Burrells' wish of enriching the lives of Glasgow's citizens and visitors through 'becoming more closely acquainted with what is beautiful'[8] will continue for many generations to come.

CHAPTER 1

Early Years

The booming industrial city of Glasgow lay unusually quiet. The forges were dimmed, the looms were still and the rivet hammers silent. The factories and shipyards were closed, and the workers were enjoying their leisure. On the second day of the annual Glasgow Fair holidays of 1861 the *Glasgow Herald* gave a stark warning against visiting the 'The Shows' on Glasgow Green which were a breeding ground for thievish jackals and the light-fingered gentry. A far healthier and more economic attraction, the paper advised, was to take one of the many trains and river steamers and enjoy the pleasures of rusticating in the country.[1]

There was one family that would make it to neither the Fair nor the country, for on Tuesday 9 July Isabella Burrell gave birth to her third son, William. The Burrells were in many ways a typical middle-class Glasgow family. The father, William Burrell Senior was starting to make his name in the shipping world. His father, George, had moved to the city on canal business and as his fortunes grew he set up on his own account as a shipping agent, eventually bringing his son into the business. They lived in the north of the city close to the canal's major port in the city at Port Dundas, where they had set up business. Isabella was the daughter of Adam Guthrie, a coal agent, and Elizabeth Duncan.[2] Her parents were married and initially set up home in the Gorbals, but moved to Johnstone and then Renfrew, where Isabella was born in 1834. By 1851 they had moved to Grove Street, just around the corner from the Burrell family home on Garscube Road, in the north of Glasgow. Here the two families got to know each other, either through the business of

1

shipping coal or from living in the same neighbourhood. Isabella, like her two older sisters, was employed as a dressmaker. Her brother George had emigrated to Australia in 1852 and established himself as a shipping agent in Melbourne, and her sister Mary had gone out the following year. After her mother died in February 1855, she and her father boarded the *Glenroy*, a superior emigrant ship, and set sail for Melbourne. Whether this was intended as a permanent move or just a visit we do not know, but her father ended up staying with George, assisting him to set up the Bendigo Pottery.[3] Isabella, however, decided to return to Scotland. She departed Melbourne on the clipper ship *James Baines* in August 1856 and arrived back in Liverpool at the end of November.

It is said that Isabella and William Sr were engaged before her trip, which would have made for a very long engagement.[4] In any case, just a few weeks after her return the two married at the United Presbyterian church in Helensburgh on New Year's Eve. Quite why they decided on Helensburgh remains a mystery as neither family seems to have had any connection with the town. William Sr and Isabella initially set up home in a three-bedroomed flat in a smart new tenement building at 3 Scotia Street in the newly developing middle-class suburb of Garnethill in the north of Glasgow. Their first child, George, arrived in December 1857 and their second, Adam, was born in June 1859.

William Sr had recently joined his father in a new shipping business based on the Forth and Clyde Canal at Port Dundas. This was just one of the many new enterprises that were springing up across Glasgow as it grew into one of the world's leading commercial and industrial cities. Its population had more than trebled in the previous fifty years to around 400,000 and its trade had exploded exponentially. Customs revenue of the port of Glasgow had grown from just £3,000 in 1811 to well over £900,000 in 1861. Glasgow had long been an important cathedral and university city, but it was in the eighteenth century that Glasgow's commercial and industrial development saw a dramatic growth. Following the Act of Union in 1707 Glasgow's merchants were quick to capitalise on the opportunities

presented by the slave economy, and tobacco, cotton and sugar from America and the West Indies formed the backbone of the city's new wealth. Textile mills and small manufacturing businesses grew from this trade and soon Glasgow became a major exporter of manufactured goods. The introduction of steam shipping in 1812 had a dramatic effect. The Clyde became known as the 'cradle of steam navigation' and within a few years numerous engineering works and shipyards had grown along the banks of the river. The introduction of iron ships in the 1830s provided another spur and by the 1840s there were several specialist iron shipbuilding yards such as Tod & MacGregor at Meadowside and Robert Napier in Govan. The growth of Clyde shipbuilding was phenomenal and by 1860 the industry had become firmly established. A distinct 'Clyde form' of ships had evolved, characterised by elegance and efficiency and shipbuilders were able to boast with some confidence that 'the crack steamers on the Clyde are second to none in the world'.[5] In 1861 there were around thirty yards on the Clyde, which completed eighty-eight iron ships totalling nearly 67,000 tons, which was a ten-fold increase from the 1841 figures. What was remarkable, apart from the quality of the ships, was the sheer diversity of the output, from luxury liners and sleek clippers to armour-plated warships, dredgers and cargo steamers. *The Scotsman* observed that 'the extent to which shipbuilding on the Clyde has attained within a brief period is something unequalled in the history of any river or port in the world'.[6]

Geography played an important part in Glasgow's success. Its location on the west coast meant it was ideally placed to tap into the developing transatlantic trade. It was also blessed with abundant resources of coal and iron ore on its doorstep which provided the fuel and raw materials for industrial development. The River Clyde may have initially been long, shallow and meandering, but an extensive programme of civil engineering works straightened and deepened it so that it quickly became a major artery of international trade, bringing ships into an extensive network of quays and docks in the centre of Glasgow. But geography alone could not breed prosperity. At the heart of the city's success lay a spirit of creativity

and inventiveness that drove an innovative approach to engineering, commerce and design. From the mid-eighteenth century, with figures like James Watt and Adam Smith, the university had forged strong links with industry. A chair of engineering was established in 1840 and in the 1850s Professor Macquorn Rankine strengthened these links by founding the Institution of Engineers in Scotland, which became the principal forum for the exchange of academic and practical engineering ideas.

Alongside shipbuilding and marine engine building there grew a bewildering array of other industries. Blast furnaces, forges and foundries provided the iron and steel plates, girders, rods, pipes and rivets that supplied the numerous engineering works. These included manufacturers of steam hammers, machine tools, bridges, railway locomotives, pumps, sugar processing machinery, sewing machines, cranes and refrigerators. Textile mills produced thread, fabric and carpets using cotton and calico, silk, wool, flax and jute. Extensive chemical works across the city produced oils, acids and alkalis for cleaning, dyeing and bleaching textiles and for a host of other industries such as potteries, paper and glass making, leather tanning and rubber manufacture. Flour mills, sugar refineries, breweries and distilleries were all an important part of the city's industrial fabric. Smaller businesses made watches, musical instruments, gloves, hats, guns, furniture, fishing rods, umbrellas and artificial limbs. In fact, there was not much that was not made in Glasgow and the west of Scotland.[7] Servicing all these industries were banks, accountants, lawyers, stationers, insurance companies, stockbrokers, warehouses, wholesale and retail merchants and a vast array of commercial agents and brokers.

Behind the splendour of this economic marvel lay a terrible scar on the city. The massive influx of workers to Glasgow, largely from Ireland and the Highlands, was more than the city's housing stock could take. Unscrupulous landlords crammed so many people into cheap and unsavoury tenements that Glasgow's living conditions became among the worst in Europe. The old medieval heart of the city and the east end became a place of filth, crime and misery.

Waves of cholera and typhus eventually forced the city to act and in 1866 the City Improvement Trust was formed to begin the process of slum clearance. Massive improvements were made, but there was no getting away from the fact that Glasgow's capitalist dream was built on the exploitation of cheap labour, and the condition of the working class remained a constant stain on the city's reputation.

Glasgow had quickly developed into one of the major centres for the shipping trade. The arrival of the steamship brought many more investors into the industry seeking to cash in on their early success. George Burns established the City of Glasgow Steam Packet Company in 1830 and quickly came to dominate the shipping trade between the Clyde, Liverpool and Ireland. He later provided the finance and business know how to enable Samuel Cunard to establish his new transatlantic service, together with Robert Napier who provided the technical input to build the engines and ships for the first Cunard steamships. The close relationship with the Clyde shipbuilders saw a large number of Glasgow shipping companies established in the 1840s and 1850s. The City Line traded with China and the Far East, Patrick Henderson & Co. with New Zealand and Burma, the Anchor Line with New York and the Mediterranean, the Allan Line with Canada and the Donaldson Line with South America. The rapid increase in shipowning can be seen in the rise in the number of ships registered in the port of Glasgow. In 1811 there were just twenty-four with a total tonnage of 2,000 tons and by 1861 there were 679 ships with a tonnage of over 200,000 tons.[8] There were also numerous agents who represented shipping companies from other ports as well as shipbrokers who chartered ships and matched them with cargoes for other merchants and agents.

Amidst all this innovation and prosperity, the Burrell shipping business began to thrive and in 1862 the increasingly prosperous Burrell family moved to 30 Willowbank Street, off Woodlands Road. This was part of the westward suburban expansion of the city that enabled those with money to escape the stench of the city centre. It was here that the first Burrell girl, Elizabeth, was born in 1864. Family lore would have you believe that William Burrell

lived in hardship and grew up in almost slum-like conditions, but this is very far from the truth.[9] Both the Scotia Street and the Willowbank Street flats were newly built, and the Burrell family were the first tenants. These were elegant blonde sandstone buildings in up-and-coming middle-class districts with typical Glasgow high ceilings and spacious interiors. Willowbank Street was directly opposite the highly fashionable Park district in Glasgow's West End that was just nearing completion. The Burrells knew the property market well and so were able to pick out an appropriate home for an aspiring business family. Both Isabella and William Burrell Sr at this time owned several shop-fronted tenement buildings in Crown Street, one of the main shopping streets in the Gorbals. The rentals on these provided a considerable annual income that supplemented whatever was earned though the shipping business. It is clear that Isabella was active in the management of these properties and was very much a businesswoman in her own right.[10]

The move to Willowbank Street was only a temporary stop in the family's move west, and around 1865 they moved again, this time to a house in Auchentorlie Terrace in Bowling. This was a row of four sandstone terraced houses, two storeys high with a basement below. It had a garden running down to the railway line and a view over the harbour at Bowling. Here the Forth and Clyde Canal joined the Clyde and William Burrell Sr would have been able to see his own vessels coming and going among the busy river traffic. Henry, the youngest brother, was born here in April 1866 and the family further expanded with the arrival of Jessie in 1868, Helen in 1869, Isabella in 1872 and Mary, the youngest child, in 1874. As well as building her family, Isabella also took the opportunity to build her property portfolio, acquiring two additional houses in Bowling, including Rosemary Villa, described as having a 'good view and convenient to stations, containing 8 apartments, wash house &c. with garden'.[11]

The older boys were now growing up and the choice of school was an important one for a family on the rise. Glasgow had a number of excellent schools but, in common with many who had found new wealth in the flourishing city, the Burrell boys were sent to boarding

school. Like his two older brothers, William was sent to Abbey Park School in St Andrews. The town at this time was regarded as 'a glorious place for boys' and was renowned for its boarding schools for young gentlemen. Although Abbey Park was not the highest regarded it had a very good reputation. Boys came from all over the country including London, Dublin, Edinburgh and Aberdeen. One observer noted: 'There were all classes; I remember sons of a London organist, a Dublin physician, of army officers, dead or retired, of the greatest piano-makers in the country, and of big men in the iron and shipping industries.'[12] The school's popularity among Glasgow's industrial elite can be seen by the fact that it promoted itself in the *Glasgow and West of Scotland Educational Guide*, the essential directory for those wishing to send their children to the 'leading schools of the Western Metropolis'.[13] Among Burrell's fellow pupils were John and Beaumont Neilson, sons of Glasgow's leading ironmaster William Neilson, William Lietke, son of J. O. Lietke of Bankier, Lietke & Co., shipowners and brokers, and George Shaw, son of William Shaw of Guthrie, Shaw & Co., calico printers.

The headmaster of Abbey Park, during most of Burrell's time at the school, was Nathaniel Leask. He was said to be energetic and capable, and was no doubt much more popular with the boys than his predecessor who was described as 'a great chastiser'. According to the school's own publicity it was expressly designed by an eminent architect, making it 'unsurpassed in Scotland' as an educational establishment. Its accommodation was 'ample and commodious' with the classrooms and dormitories 'airy, roomy and cheerful'. The food was apparently plain, although there was 'an abundance of it'.[14]

Between fifty and eighty boys boarded at the school, which initially had five resident tutors and five separate masters who taught Classics, English, mathematics, arithmetic and modern languages. According to the testimonials of some of the leading academics who examined the pupils, the quality of teaching bore 'favourable comparison with any other Institution of a similar kind' and was 'equal to what may be found in the highest schools in the country'.[15] However, other reports suggest that the standard of teaching was not

quite so good as a great reliance was placed on lessons by university students supplementing their income rather than by established teachers.[16]

William began his schooling at Abbey Park in 1870 at the age of nine. In his second year he was awarded first prizes in Geography, Arithmetic and Classics and a second prize in English.[17] In 1874, at the age of twelve, he was awarded an English prize for 'accuracy in repeating the shorter Catechism'. He was also awarded a special prize for his essay on the Book of Judges. William featured in the school's art exhibition, where he was one of three boys singled out for their illuminated texts and ornamental specimens, earning praise for his 'artistic elegance of finish'.[18] The following year he repeated his success with the shorter Catechism and also received a second prize in Latin syntax.[19]

Sport played an important part in the boys' education and character building at Abbey Park. Rugby and cricket were popular and one of the Burrell brothers is mentioned in the rugby team although it is not clear which one.[20] William was awarded a prize for fencing with a single stick in 1874.[21]

It is tempting to draw parallels between William's schooling in St Andrews with its ancient university, cathedral and castle and his later interests in Gothic art and architecture. A gazetteer of the time praised its 'antiquarian and historical associations' which gave the town 'a grand aggregate of attractive character'.[22] But in reality William boarded in a new building built in 1853 on the southern outskirts of the town. Yes, the school participated in civic life to a certain extent and William would have been exposed to the beauties of the town, but to infer from his later interests that he wandered dreamily through the streets and spires cultivating his passion for the Gothic is a romantic notion too far. At best we might conclude that it piqued his interest. In any case he did not remain at school for long.

Like George, William left at the age of thirteen. There is a family tale that his introduction to the business was rather unexpected. Just before he was to return to school after the summer holidays in 1875 his father brought him into the offices one day. As William

Sr returned from attending to some business he found the young William assisting the ledger clerks with such a grasp of the work that he decided there was no point sending him back to school and so William started in the business on a clerk's wage.[23]

The business he joined had been started by his grandfather George twenty years earlier. George Burrell was born in Alnwick in 1801. According to one account his father was a barge owner and he may have begun his career in shipping working alongside him. He did not stay in Alnwick long, however, and by the 1820s he had moved to Leith, where his uncle had been living. The family tradition is that he moved to Scotland to work on the construction of the Forth and Clyde Canal, but since this opened in 1790 this is implausible. The Union Canal, however, which linked the Forth and Clyde Canal to Leith was completed in 1822. If there is any truth in the family tradition it must have been the Union Canal that drew him north. There is no evidence of how he was earning his living, but he must have been doing alright because on 6 August 1824 he married Elizabeth Hastie there. They had one daughter, Barbara, born on 9 October 1825. Elizabeth disappears from the records at this time and it is presumed that she died in childbirth. Sometime after this George Burrell moved through to Glasgow, where he married Janet Houston in 1831. By 1841 they were living on Garscube Road, which was just a short walk to the Forth and Clyde Canal at Port Dundas. In the 1851 census and the 1855 valuation roll his occupation is listed as 'clerk' and there is evidence that he was involved in working on the canal.

By 1856 George Burrell had set up on his own, establishing a business as a shipping and forwarding agent, operating from the Grangemouth and Alloa Wharf at Port Dundas.[24] He had also moved to a new house at 72 New City Road. When his son William Sr joined the business the following year it went under the name of Burrell & Son.[25] In addition to the Port Dundas office they also established an office in Grangemouth, at the eastern end of the canal, that was run by George's younger son Henry. After a short time Henry established his own canal shipping business but remained Burrell & Son's agent in Grangemouth.[26]

As a new business Burrell & Son tried a variety of different schemes before finding its place in the market. In 1858 they began advertising weekly sailings between Glasgow and Aberdeen via the Forth and Clyde Canal on the steamer *Thane*. Despite an intense advertising campaign with large adverts in all the local papers between Glasgow and Aberdeen this service did not last more than a few months. Their junior partner in Aberdeen, Hugh Fraser, was made bankrupt by the venture, but the Burrells managed to survive.[27]

They retrenched and carried on in less grand style, operating barges or lighters on the canal, shipping the likes of grain, iron and hay. This was not an easy or glamorous business and required a certain robustness of character to deal with the numerous instances of verbal abuse, violence, drunkenness and pilfering that seemed to be the stock in trade of the lightermen. There is little evidence relating to the vessels themselves. Some were wooden, some were iron, some horse-drawn and others, known as screw lighters, were steam powered. They all seem to have been able to carry about 100 tons of cargo. The earlier vessels were given heroic names such as *Vulcan*, *Hercules* and *Dauntless*, but by the 1870s they seem to have just been numbered. There is no way of determining how many barges they operated, but the numbered barges went up to at least *No. 15*. A rare announcement of a launch of one of their lighters appeared in 1868, when a wooden lighter was launched from the Firhill yard of J. & R. Swan.[28] The following year the launch of Burrell's iron screw steamer *Hercules* from Swan's Kelvindock yard at Maryhill was also reported.[29] The vessels primarily shifted cargo back and forth along the Forth and Clyde Canal and also out to Greenock where cargoes were loaded onto larger seagoing ships. The steam-powered vessels could also go as far afield as Ayr and Campbeltown.

The only evidence we have of their operation comes from newspaper reports, which largely related to accidents or court cases. Several instances of theft were reported, most of which were fairly small-scale, such as two boys, aged eleven and fourteen, who were caught red-handed stealing rags from the Port Dundas depot. An altogether more elaborate scheme was unearthed in May 1863 when

three of Burrell's employees were accused of stealing five tons of pig iron from the lighter *David* at Greenock.[30] The sheriff adjudged the scheme a deep-laid plot which was carried out 'boldly and with great cunning' and sentenced the ringleader and the lighter's master to sixty days imprisonment.[31]

The lighter trade was dangerous for those working on the vessels and there are numerous reports of accidents. Some were relatively minor, such as Alexander Cross who broke his arm while shifting a cargo of pig iron aboard the lighter *Success* in Grangemouth harbour,[32] but there were also many fatalities. Drink played a significant role in some of the incidents. Captain Felix McConnell of the lighter *Hercules*, which was in Ayr with a cargo of guano, decided to go for a 'ramble up the town'. When his crew helped him back to the vessel he fell from the gangway, hitting his head on the gunwale before plunging into the water and drowning.[33]

The vessels themselves were also subject to a fair bit of knocking about. In July 1875 Burrell's lighter *No. 15* was struck by the Dublin steamer *Duke of Leinster* off Port Glasgow and one of the crew was killed.[34] Burrell sued the steamer owners for £160 damages, but the sheriff was of the opinion that it was the lighter's fault for being in the steamer's way and the case was dismissed. This case provides a useful insight into how the lighters operated on the Clyde. Without an engine they were normally propelled by two men with poles who punted the vessel along the shallow part of the river. When the winds allowed, the lightermen sometimes erected a temporary 'sail' by attaching a tarpaulin to a pole to catch the wind. In this particular case, the temporary sail had caused the lighter to drift in an unpredictable way. The steamer was unable to judge its course accurately and caught it with its paddlebox, sending the crewman to his death.[35] Despite all these mishaps and tragedies, the canal trade remained the mainstay of Burrell & Son's operations for many years.

A successful new direction for the firm came in 1862 when they ordered a ship that would expand their business beyond the canals and firths and out into the open sea. A 'beautiful small schooner' intended for foreign and coastal trade, was built at Swan's yard at

Maryhill and, unlike Burrell's canal boats, the launch was turned into a real occasion:

> Though the day was most unfavourable, there was a large attendance of ladies and gentlemen from Glasgow to witness the launch. The vessel was turned into her watery element in beautiful style, when Mrs Burrell, the lady of the proprietor, in a most graceful manner, broke the bottle, and christened her the 'Janet Houston' of Glasgow.[36]

By August the *Janet Houston* had delivered a cargo of grain to Lancaster and then operated up and down the coasts of Britain.[37] In October 1863 it made its first overseas trip, taking a cargo of pig iron from Grangemouth to St Valery on the Normandy coast.[38] Over the next few years it traded successfully between ports on the British mainland, Ireland and the Continent. The *Janet Houston*'s captain during this time was James Cleland, who seems to have been just the sort of rough and ready character you would imagine in charge of a coastal trader. Whilst taking a cargo of iron to Hove he went to the Half-way House Inn and tendered a French penny for his glass of ale. When the landlord refused his coin he became angry, threw the beer over him followed by the glass, striking him on the temple and inflicting a wound an inch and a half long. His defence was that he had had too much to drink, which did not hold much sway with the magistrate, who promptly fined him twenty shillings.[39]

Trade must have been good for the *Janet Houston*, as in November 1863 another schooner of similar construction, but a little larger, was launched from Swan's yard.[40] The *Janet Houston* was owned outright by the Burrells, with George and William Sr each owning thirty-two of the sixty-four shares. For the new vessel, the *Jeannie Marshall*, they went into partnership with James and John Hay, fellow shipping agents at Port Dundas, with each of the parties owning sixteen shares. This allowed Burrell & Son to raise sufficient capital to invest in a new ship, while still maintaining control of its operation. It

carried out a similar pattern of trade to the *Janet Houston*, sailing to and from France and around the British coast.

With the seagoing venture proving successful, the Burrells again joined forces with James Hay, along with Captain David Miller and another investor to buy a much larger ship in 1864. The *Suffolk*, at 231 tons, was more than three times the size of the first two vessels and was a proper ocean trader. Over the next few years it settled into a regular pattern of sailing between Liverpool or Glasgow and the West Indies and Mexico, taking out general cargo and returning with timber and coffee.[41] The Burrells owned a quarter of the sixty-four shares but were clearly the principal managers of the vessel, although much of the business seems to have been conducted through agents in Liverpool.

The next major development for Burrell & Son came in 1866 when they took delivery of their first seagoing steamship. They already had experience of steam power with their screw lighters, but this was a much bigger proposition. The *Fitzwilliam* was a 300-ton iron screw steamer, and at 160 feet was the largest vessel that J. & R. Swan could build on their slip at Kelvindock. It was not a particularly large ocean trader but it was considerably larger than the *Suffolk* and showed a brave new direction for the firm. William Burrell Sr was the driving force behind this move. Rather than partnering with his father he joined with Andrew Crichton Wotherspoon, a metal broker in Glasgow. Both initially owned thirty-two shares, but Henry Burrell in Grangemouth also bought into the vessel a few years later. It began a regular trading pattern, sailing from Glasgow with general cargo to Spain and Portugal, and returning with fruit and other goods.

In order to expand the business further William Burrell Sr set up in partnership with William McLaren in 1867 to form Burrell & McLaren. They took out premises at 51 St Vincent Street and advertised themselves as 'shipbrokers and commission merchants'. They quickly set out to expand the fleet, ordering a new iron steamer from Blackwood & Gordon in Port Glasgow and acquiring the second-hand steamer *Grange*. By February 1868 they were advertising the *Fitzwilliam* and

Grange on a regular service from Glasgow to Oporto.[42] Another new steamer, *Fitzjames*, was launched in July 1868; unlike the other steamers the *Fitzjames* was designed to carry passengers as well as cargo. In September 1868 it was advertised as sailing for Civitavecchia, just north of Rome on the Italian coast, enticing prospective passengers with its 'superior accommodation'.

Burrell & McLaren quickly ordered another ship from Blackwood & Gordon that was launched as the *Fitzpatrick* in October 1869. This ship was the largest yet built for Burrell at 885 tons. This ship was actually owned by Robert Donaldson, an iron merchant in Glasgow. A similar arrangement was made with several other ships, where Glasgow iron merchants and the shipbuilder Thomas Blackwood invested in ships that were then managed by Burrell & McLaren. The new fleet of steamships and the opening of the Suez Canal in 1869 offered up new routes and they were soon advertising sailings to Singapore and Bombay. To capitalise on this new market, they ordered the large new steamer *Strathclyde* from Blackwood & Gordon. At 1,950 tons this was more than twice the size of any of their previous ships and was fitted with accommodation for thirty passengers.

In 1872 William McLaren set up on his own, leaving William Burrell Sr to manage the fleet, once again under the name of Burrell & Son. When young William Burrell joined the business in the summer of 1875 it consisted of the canal and coasting trade managed by his grandfather George Burrell and operating from Port Dundas, and an oceangoing fleet of nine steamships managed by his father with offices at 141 Buchanan Street. By this time the total number of ships on the Glasgow registry had grown to a thousand, with a total tonnage well in excess of half a million. Glasgow itself had cemented its status as the workshop of the world and was earning its reputation as the Second City of the Empire. Its population now exceeded half a million and it had just overtaken Liverpool as the largest city in Britain after London. This rapid industrialisation was a marvel of which the city was immensely proud and was described at the time as 'one of the most interesting industrial phenomena of the present or of any other age of the world's history'.[43]

The impact of Glasgow's engineering industry went far beyond the nuts and bolts of production and commerce. Alongside the factories, mills and shipyards, a vibrant cultural economy and art scene grew. Clyde shipbuilders prided themselves on the high quality of their products and this commitment to excellence played an important role in stimulating the industrial arts. Fitting out transatlantic liners was akin to recreating floating Renaissance palaces or baronial castles and everything that went into creating that artifice had to be designed and produced. As well as creating opportunities for artists and designers this stimulated the growth of companies specialising in stained glass, decorative plasterwork, architectural ironwork, furniture, carpets and textiles. As Glasgow physically expanded, the market for this type of material grew to meet the demand of the increasing numbers of tenements, townhouses and commercial premises in the city, as well as the country mansions of the industrial elite. A significant fine art market also developed with paintings being commissioned to decorate liners, company boardrooms and public buildings.

The importance of this cultural economy can be seen in the establishment of the government-sponsored School of Design in 1844. This was funded by the leading shipbuilders and manufacturers in the city as 'an excellent means of improving the art of ornamental design, and advancing the manufacturing interests of the country'.[44] Separately, Haldane's Academy of the Fine Arts was founded to improve the study of design, painting and engraving to enhance the manufacturing and mercantile interests of Glasgow.[45] These two institutions came together in 1874 as The Glasgow School of Art and Haldane Academy. From the start its primary purpose was to 'give instruction in art as applied to manufactures at fees within the reach of the artisan classes'.[46]

At the same time Glasgow's museum service was also starting to play a leading role in promoting creativity within the city and stimulating its cultural economy. Glasgow's civic collection was established in 1856 when 510 paintings were acquired from the estate of the Glasgow coachbuilder Archibald McLellan.[47] He was a prolific collector of Italian, Dutch and Flemish art, and his collection included

gems such as Botticelli's *The Annunciation* and Titian's *Christ and the Adulteress*. Along with the collection the city also purchased the suite of galleries that McLellan had been in the process of building and opened them as the Corporation Galleries.

The practice of collecting art had long been a pastime of the city's elite. The tobacco merchant John Glassford of Dougalston amassed a sizeable collection of old and new masters including works by Rubens, Canaletto and Watteau. The collection of shipbuilder Robert Napier ran to nearly 5,000 items including paintings by Tintoretto, Cranach and Rembrandt. His collection was so vast that his mansion included a purpose-built museum at its heart. These two collections were auctioned off, but as the city's art collection gained increased recognition, it became fashionable for collectors to donate their collections to the city. For example, the marine insurance broker William Euing gave thirty-six paintings in 1856 and bequeathed a further 200 in 1874.[48] Their motives for giving were a mix of status aggrandisement, civic pride and philanthropy, and most also believed in the improving power of art and its contribution to the economy as a whole. The large number of donations helped to build a collection that was 'worthy to rank with the great galleries of the world'.[49]

In 1870 Glasgow also opened the City Industrial Museum in an old mansion house in Kelvingrove Park. This was partly a shop window for the city's wares, with models and samples from Glasgow's engineering businesses, and partly a natural history and ethnography museum. Its collections increased rapidly, and by 1876 a large extension was added to the original converted mansion house. It was at this time that the visionary museum director James Paton took over the service. He came with a drive and a passion to transform the museum and gallery into a powerful force for the city's improvement, believing that investing in museums would 'raise the whole mass of the population to a higher level, and broaden and deepen the fertilising stream of industrial activity'.[50]

As well as the civic drive to improve the city's cultural landscape, the growing number of artists also began to organise themselves

16

more formally to contribute to the city's artistic scene. The Glasgow Institute of the Fine Arts was established in 1861 to put on an annual art exhibition that would rival Edinburgh's stuffy Royal Scottish Academy. Its committee was made up of professional artists and prominent businessmen, reflecting both the makers and consumers of contemporary art. From the outset the annual exhibition was a means of showing local talent and a vibrant and eclectic mix of the latest art from Britain and Europe. As well as the artists' submissions, collectors lent some of their best works and dealers exhibited exciting new works for sale. The annual exhibition became a hit with the public and was one of the highlights of Glasgow's social scene. The Glasgow Art Club also established itself as the hub for artistic exchange in the city. It was founded in 1867 initially as a forum for amateur artists, but it quickly became a popular a meeting place for both professional and amateur artists, as well as lay members, such as businessmen, who wished to hang out with the bohemian crowd. Such was the rapid flourishing of artistic endeavour in the city, that by 1880 *The Graphic* newspaper was able to report that 'the general interest shown to-day in Art in Glasgow is a hundred times greater than in any previous period of our history'.[51]

It was in this heady mix of commerce and culture that young William Burrell first dipped his toe in the art market. The story is often embellished, but at the British Antique Dealers' Association annual banquet, he gave his own account:

> Sir William Burrell told how, as a lad, some fifty-six years ago, he bought a Raeburn at a small auction for 18s. But realising that the portrait would cost at least 30s. to frame, he had it put up again, when it was knocked down to another buyer for 15s. So Sir William paid the auctioneer 3s. and left the room. As he remarked: Raeburn had hardly started to come into his own![52]

After a brief interlude staying at Clydebank House on the banks of the Clyde at Yoker, the Burrell family moved in 1879 to Elmbank, a

villa on the hill overlooking Bowling harbour. It was in his bedroom here that William Burrell's art collecting first found its expression with work by the Glasgow-based animal painter George Brown, known familiarly as 'Coo Broon'. The story goes that his father was less than impressed with his interest in art, suggesting that he would be better off investing in a cricket bat. His father had built a fierce reputation as an astute businessman and financier. Although daring in business, politically he was very much a conservative and was a member of the constituency committee of electors for Old Kilpatrick Parish that selected the Conservative parliamentary candidate.[53] He was also a staunch religious believer and on one occasion was compelled to write to the *Glasgow Herald* about doctrinal intolerance in Bowling.[54] Despite this he was reputedly lively and jovial and good with the children. It probably suits the family myth of William Burrell rising from hard beginnings to depict William Sr as a man with no artistic inclinations. In fact paintings had long been in the family. Like most successful businessmen with a villa to fill William Burrell Sr had his own fair share of decorative works, including a portrait of his grandmother left to him in his father's will. The valuation of his household contents after his own death came in at a hefty £455, so among the silver, silver plate, pictures, engravings and books there must have been some items of real value.[55] Burrell's mother was certainly very interested in art and built up her own collection of tapestries, embroidery, prints and ceramics. Andrew Hannah, who became the first Keeper of the Burrell Collection in 1944, knew William Burrell well and in his obituary noted that:

> He told me that it was from his mother that he derived interest in the arts. She fired him with an ambition not only to get to know the fundamentals of great art, but to set about acquiring many of the finest specimens procurable.[56]

His brother George and sister Mary also developed an interest and in time they also began to amass their own art collections. Although we have no idea of the nature or quality of his father's paintings, it

is clear that, far from growing up in a sterile business environment, Burrell was surrounded by art from an early age and grew up in a family that was interested in and supportive of it.

Beyond the family environment, Burrell's early interest in art was nurtured as the quality of art available in Glasgow improved considerably in the late 1870s and 1880s. As well as the annual Glasgow Institute exhibitions the galleries of established dealers such as T. & R. Annan on Sauchiehall Street and Craibe Angus & Son on Queen Street brought an increasingly diverse selection of British and European art to public attention. They were then joined by Kay and Reid on St Vincent Street. They had started out as ornamental ship carvers and gilders, but under the influence of the young Alexander Reid his father's business branched out into dealing in art as well as picture frames. Alexander Reid would later have a significant influence on taste in art in the west of Scotland, and on Burrell's collecting in particular, and it is easy to imagine Burrell, on his lunchtime visits, getting to know Reid amongst his growing stock of French and Dutch paintings.[57] Under James Paton's influence the Corporation Galleries moved away from their previous dull melancholy to become a lively and popular destination where the latest acquisitions were displayed to great effect. He also arranged a series of important loan exhibitions that brought the best examples of art into city. The highly influential Oriental art exhibition in 1881 was followed by Italian art in 1882 and French art in 1883. With Burrell's burgeoning interest it would be strange if he did not visit these exhibitions. He was certainly buying art at that time, and he recalled that he had bought Chinese bronzes 'from about the time I was 20'.[58] His taste in paintings seems to have remained more local. On 16 September 1882 he purchased a painting from the Glasgow Institute exhibition entitled *Scottish Volunteer Review* by Robert Walker Macbeth (1848–1910) for £5 5s.[59]

Meanwhile the business continued to expand. A small boatyard was established in 1875 on the banks of the Forth and Clyde Canal at Hamiltonhill which specialised in the construction of small coastal vessels known as puffers. Many of the vessels were built for Burrell

& Son's canal and coasting trade, but they also built for several other owners. The oceangoing business was also making great strides. Its success can best be seen by the voyage of the *Strathmore*, a vessel owned by James Watson & Co. in Glasgow, but managed by Burrell & Son. It left its building yard in Middlesbrough for London in June 1878, where it took on a cargo for Yokohama. Here it discharged and loaded a new cargo for Hong Kong, where it discharged again and took on a fresh cargo and 591 passengers and sailed to Singapore and Calcutta. It then made two round trips from Calcutta, one to Colombo and the other to Bombay. The next port of call was Marseille and from there it sailed to Palermo, then Malaga and Lisbon, before heading to Greenock, arriving in May 1879. During the ten-month journey it loaded and discharged seven full loads of cargo and earned around £20,000.[60] This voyage demonstrates perfectly the tramp shipping business that Burrell & Son were engaged in. They sailed from port to port, picking up cargoes as and when they could to maximise profits without having a fixed schedule. They also managed ships on behalf of other owners, taking a management fee as well as a share in the profits. When it made commercial sense, they chartered their own ships to other companies, so for example in 1879 the *Strathleven* was chartered to McIlwraith MacEacharn, a London-based shipping company that specialised in the Australian emigrant trade. They fitted out the *Strathleven* with refrigeration machinery for an experimental voyage to see if frozen meat could be shipped from Australia. When it arrived back in London its cargo of forty tons of frozen beef and mutton was declared to be in excellent condition. The success of this experiment opened up a very extensive frozen meat trade. Another example that shows the innovative and opportunistic nature of Burrell & Son is the salvage of Cleopatra's Needle in 1875. This was being towed from Alexandria to London in a specially constructed barge but when it encountered stormy weather in the Bay of Biscay it had to be abandoned. Burrell's steamer *Fitzmaurice* was nearby and managed to secure a line and towed it with some difficulty into Ferrol. William Burrell Sr demanded £5,000 for its release, but in the end he was awarded a still considerable £2,000 for its salvage.

In 1879 the business took a bold new direction. The Hungarian government had invested heavily in the Adriatic port of Fiume to open it up to seagoing trade. William Burrell Sr saw this opportunity and ordered a new fleet of ships to establish a direct route between Glasgow and Fiume. The *Hungarian* was launched in March 1879 and was followed later by the *Tisza* and the *Adria*.[61] The importance of this new route can be seen in the reception that the *Hungarian* received when it first entered Fiume in June 1879. It was greeted by the town band playing 'God Save the Queen', and the governor of Fiume hosted a banquet for eighty guests. The following day 500 people were entertained aboard the ship for an excursion around the bay, followed by another civic reception.[62] The opening of the port inspired the Hungarian government to create a national shipping line and offered a subsidy to establish a regular passage between Fiume and the major western European ports. Having already established a trade route William Burrell Sr was in an excellent position to bid for the subsidy. He joined forces with the businessman Gottfried Schenker in Vienna to create the Adria Steamship Company, which was duly awarded the contract. The two men each owned a 50 per cent share in the business, but Burrell & Son took on the management of the new company and was responsible for the operation of its ships. It was taken over by the government shortly afterwards and renamed the Adria Hungarian Sea Navigation Company, but Burrell & Son continued to manage its shipping operations.

Around this time George Burrell Sr retired to a nice West End home, leaving William Burrell Sr as the sole partner in the business. Young William Burrell was then promoted to the role of chief cashier at the age of nineteen, with responsibility for the firm's financial affairs. His father was keen that the boys specialise in different parts of the business, so George was trained in the technical aspects of ship design and shipbuilding. An indication of the growing status and ambition of the business can be seen in 1880 when William Burrell Sr and his three sons, George, Adam and William were all admitted to the Incorporation of Hammermen of Glasgow.[63] This was one of the old craft guilds in Glasgow. Many of the leading manufacturers and

businessmen were members and it was seen as a route to acceptance and success in the city's business community. In 1880 Burrell & Son also moved to prestigious new premises at 54 George Square, in the very heart of Glasgow's commercial district. The firm was fast becoming the leading tramp shipping company in Glasgow, operating at least eighteen steamships on its own account and around twenty ships for the Adria company.

The business took another turn in 1881. They had ordered two new steamships for the Adria company from the shipyard of Robert Chambers in Dumbarton. Unfortunately, Chambers became financially embarrassed and was forced to cease operations. Rather than lose the ships altogether or face a lengthy delay, William Burrell Sr decided to buy out Chambers and operate the yard on his own account, placing Adam Burrell, who had just finished his apprenticeship as an engineer, in charge of its management. The understanding was that Adam would eventually take over this part of the business as his own. The Lower Woodyard was relatively small and rudimentary, but William Burrell Sr invested heavily in new machinery including a new steam engine and boiler, several hydraulic riveters, and shearing and punching machines for shaping and preparing steel plates. When they first took over the yard Clyde shipbuilding was on a high and this level of investment demonstrated that they were serious about making a success of the yard, rather than just ensuring that their own ships were completed. They were rewarded with several new orders from a number of different owners. One of the ships built at Dumbarton, the *Rio Bueno*, was especially designed for a new branch of Burrell & Son's business known as the Clyde Line, which operated a monthly service for goods and passengers to Jamaica and other West Indian ports.

Things started to go wrong, however, at the end of 1883 when a downturn in trade prompted Burrell & Son to make a 10 per cent cut in wages. The riveters and ironworkers immediately went on strike and in time-honoured tradition the firm responded by locking the yard gates, putting nearly 500 men out of work.[64] After several weeks without pay the men were forced to return to work on the

lower wage. The following year something unusual happened in the annals of Clyde shipbuilding in that Burrell & Son unexpectedly increased the wages of its labourers – but pointedly not the riveters and ironworkers – backdating their pay to the time of the lock-out. This was unheard of in an industry that was noted for its ruthless wage policy and poor employee relations. Work remained slack but a few orders continued to keep the yard turning over until 1885 when the slump deepened and forced many yards on the Clyde to suspend operations. All but a few of the men at Burrell & Son were laid off and the yard was kept on a care and maintenance basis for a year, awaiting better times. Unfortunately, the good times never reappeared and by the end of 1886 the yard was put up for sale. No buyer was found and no further ships were ever built at the yard. For Adam Burrell the shipyard proved to be his undoing. His father believed that his management of the yard was 'injudicious and extravagant' and Adam responded to his father's interventions with hostility, conducting himself in an 'unkind and undutiful manner' towards him. As a result, he was ejected unceremoniously from the business early in 1885 and William Burrell Sr took over the running of the yard himself.[65]

By this time William Burrell Sr was in poor health with a liver complaint and he died in June 1885 at the age of fifty-three. Apart from the shipyard, the business he had built up with his father proved to be particularly profitable. William Burrell Sr's estate was valued at nearly £40,000, which in today's terms would mean he was a multimillionaire. In the terms of his will William and George were given the opportunity to buy various parts of the business. The canal business was valued at £17,000, the shipyard at £10,000 and the oceangoing fleet of ten steamers at £46,000. The goodwill of the business was offered free, which meant that they would be able to continue their agencies with the Adria Hungarian Sea Navigation Company and others uninterrupted. Adam was deliberately excluded from buying into the business and in a reflection of just how deep their animosity ran, any inheritance he received was to be £2,500 less than the other brothers. If George and William

did take on the business, they were bound to employ their younger brother Henry and offer him an equal partnership when he reached the age of twenty-four.[66] In the end the two brothers wisely declined to take on the shipyard but did acquire the canal business and the oceangoing fleet. Their mother used her extensive personal wealth to offer generous mortgages to her sons so they could purchase the business. At the ages of just twenty-eight and twenty-four George and William Burrell took over full control of Burrell & Son. William Burrell was now firmly set to become one of the leading lights of Glasgow's business and art community.

Combining Art and Industry

When George and William first took over the business of Burrell & Son, they took things rather conservatively. Shipping was suffering from one of its periodic depressions and trade remained more or less stagnant for several years in the mid 1880s. With a large debt to service from the purchase of the fleet, their first few years in charge were characterised by consolidation, with no risky new ventures or investments. Much of their time in their first few months was spent on legal pursuits as Adam contested the terms of their father's will.[1] Initial attention seems to have been paid to the canal business. Three new steam coasters were launched from the Hamiltonhill yard: *Ina McTavish*, a 'handsomely-modelled screw steamer' launched to the order of Captain McTavish of Ardrishaig; *Maid of the Mill* for G. McFarland & Co.; and *Helen* for their own use on the canal.[2] The oceangoing business carried on much as before, with two ships operating the Clyde Line service to Jamaica and around sixteen ships on the Mediterranean and Adriatic.

As the new principals of the business William and George began to take on an increasingly prominent role in the shipping business in Glasgow. Their respective roles can be seen in reports from a later court case relating to the construction of some of their ships:

> There are two partners of the pursuer's firm, William and George Burrell. The former takes charge of the commercial department of the business and is not an expert in ship-building. George Burrell, however, is a practical shipbuilder, and prepared the specifications for the vessels in question.[3]

In February 1886 they were both present at a banquet celebrating the shipping interests of Glasgow, attended by all the great luminaries of the industry.[4] Two years later William was elected as a director of the Ocean Cargo Steamers Committee of the Clyde Steamship Owners Association.[5]

An important change in the structure of the business was made in 1886 when William Burrell became one of the founding directors of the Newcastle Protection and Indemnity Association. This was a not-for-profit mutual insurance organisation that covered the liabilities inherent in managing ships. For each ship, the owner paid a certain sum per tonnage of the vessel and in return they were insured against loss and damage to the ship, its cargo and any damage it might make to any harbour infrastructure. As a director of the Association, William Burrell not only had a say in the way Burrell & Son's ships were insured, he also received a director's fee and any expenses incurred in the running of the Association.[6]

By 1888 the mortgages owing to their mother were nearly paid off and trade was picking up, so George and William were able to start making their own mark on the business. They made the bold move of ordering ten new ships from yards on the Clyde and the Tyne. They were all roughly of the same design, about 300 feet long and 2,300 gross register tons, with a single deck, large cargo holds capable of carrying around 4,000 tons of cargo, and little or no passenger accommodation. An interesting insight into William Burrell's no-nonsense attitude towards his ships can be seen in a letter to his sister Isabella in January 1890:

> We have had another launch since I last wrote you: – She was named the 'Strathdon' and is a sister ship to the 'Strathdee'. No one was present but Mr Stewart our Superintendent and the builder's wife. She broke the bottle and altogether for a 4000 tonner the ceremony could not have been of a less imposing nature. Unless those interested rush to make an occasion of it I think the quieter it is done the better.[7]

'Mr Stewart' was James Carlile Stewart who had trained with Robert Napier and was for over thirty-five years Burrell & Son's chief engineering superintendent.[8] He was responsible, along with George, for the design of Burrell & Son's ships and in time became a significant shareholder. William Burrell later attended the trial trip of the *Strathdon*, which was not a very pleasant occasion: 'It was a most miserable day and I was wretchedly sick, worse than on the way out to Australia or on the way home.'[9]

As the new ships came into service the older vessels were sold off. All of the new ships were named with the 'Strath' prefix and the two older ships that remained beyond 1889 were renamed *Strathyre* and *Strathspey*, to conform with this new house style. Within a period of two years Burrell & Son had a new fleet of standard-sized modern ships fitted with the latest machinery, including steam winches and derricks that could handle cargo in ports without extensive cranage. The papers reported that Burrell & Son now had 'an excellently-equipped fleet of useful vessels, big carriers, of moderate speed, and economical consumers'. The purpose of the ships was made very clear: 'making allowance for a small saloon for the captain and officers aft, the crew forward, and the engines, the whole of the ship is given up to cargo'.[10] In other words, these were money-making machines with few frills, fitted out to be reliable and efficient carriers of cargo that could go anywhere in the world. These ships marked a new departure for Burrell & Son's business model. They continued the Mediterranean and Adriatic trade purely as agents for the Adria Hungarian Sea Navigation Company, while the two older vessels maintained the Clyde Line service to Jamaica. The new investment was about expanding into the oceangoing tramp business. This had proved successful before but with the new fleet they were able to become world-beaters. As well as having cheap and reliable ships they also set up a system of agents around the world to arrange for cargoes to be ready and waiting whenever the Burrell ships entered port. Previously the ships' captains took on the responsibility for securing onward cargoes, which could mean several weeks laid up in port. A ship in port does not earn money,

so the use of agents maximised the profit-making potential of this new fleet.

Another change in Burrell & Son's business practice came in 1890. Having already gained a say in the way his ships were insured, William now gained influence over the way they were classified. Lloyd's Register of Shipping had held a virtual monopoly on the classification of ships since 1760. They established rules for the construction of ships and any ship that was certified as being built according to their rules was awarded a classification according to the quality of construction. This was a quality assurance system which ensured that ships were properly constructed and seaworthy according to an independent assessor that provided comfort to shipowners as well as potential shippers and charterers. The classification also determined the rates of insurance premiums that were to be paid. The better constructed a ship the less likely it was to fail, and so the lower the insurance premiums would be.

In protest at Lloyd's Register's monopoly, a group of shipowners and shipbuilders in Glasgow, including William Burrell, founded the rival British Corporation for the Survey and Registry of Shipping.[11] The British Corporation quickly established itself as a highly reputable classification organisation with its construction rules based on modern scientific practice. Burrell joined the first management committee and was able to influence the way it operated; from this time on all Burrell & Son ships were registered with the British Corporation.

On the family front, in 1883 George had married Anne Jane, the eldest daughter of Thomas McKaig, Paisley's leading brick manufacturer, and moved to a villa in Langbank, on the south bank of the River Clyde. As an indication of the way family and business interests were intertwined, Anne, her father, mother and sister were all shareholders in Burrell & Son's ships. In the summer of 1888 sister Jessie was married at the family home at Bowling to Charles Cleland who had recently inherited his father's stationery business and was also a significant shareholder in Burrell & Son ships. They moved to the Cleland family mansion at Bonville on the outskirts of

Maryhill. William, however, remained at Bowling with his mother, brother Henry and sisters Elizabeth, Isabella and Mary. Here he took an increasingly active part in local affairs. In 1886 he was elected vice-president of the Bowling Lecture Association which entertained and instructed the villagers during the winter months.[12] For a small association it was able to attract an impressive range of speakers from around Scotland, including a professor from Edinburgh University, the editor of the *Christian Reader* and other leading churchmen and educators, who lectured on subjects such as 'The Truly Great', 'National Humour' and 'The Ancient Ballad Literature of the North Country'. Burrell also enjoyed the social functions of the Dalmuir Bowling and Tennis Club, but whether he played or not we do not know.[13] He was encouraging of local education and offered prizes for domestic economy at Gavinburn School in Old Kilpatrick.[14] Not surprisingly, given his father's interests, he was a member of the Milton & Bowling section of the West Kilpatrick Conservative Association.[15]

At the end of 1888 William travelled to Australia on the P&O liner *Arcadia* with his mother and sister Elizabeth, arriving in Sydney in early February 1889.[16] There was clearly a family motive with Isabella's brother and sister still living there, but there were also strong business reasons. Two of the vessels built at the Dumbarton shipyard in 1884, the *Wellington* and the *Australia*, were for Australian owners who would have provided useful business contacts. We do not know the precise nature of the business that Burrell was undertaking, but it was most likely in relation to establishing agents for the firm. Prior to his visit, Burrell & Son ships had only occasionally visited Australia, but in the years afterwards they became a regular feature of Australian maritime trade, where they were known as the Strath Line.

William Burrell was back in Glasgow by the autumn of 1889, in time to attend the Grand Costume Ball of the Glasgow Art Club in November.[17] He appeared in the ceremonial uniform of the Austro-Hungarian vice-consul, a position he had been appointed to in 1887 in recognition of his strong business links through Gottfried Schenker and the Adria shipping company. This was a role in which

he revelled, socialising with Glasgow's elite at regular banquets and functions of the city's consular corps as well as gaining important business and political links as Burrell & Son expanded. The significance of his role can be seen in a survey of the consular corps:

> In these days of extraordinary development in travel and business the foreign consuls become more and more useful to Scotchmen going abroad and to foreigners coming to Scotland; and in mercantile matters their services are simply invaluable, being required to unravel difficulties of a great many kinds arising out of the differences in the laws, customs, and practices of this country from those obtaining in the States represented by them.[18]

As an indication of how well he carried out his duties, Burrell was promoted to full consul in December 1890.[19] Other members of the consular corps at the time included A. R. Brown, Japanese consul and founder of the Japanese NYK shipping line; Leonard Gow, Liberian vice-consul, shipowner and leading art collector; John Galloway, Paraguayan consul and director of the Henderson shipping line; and J. O. Lietke, German vice-consul, shipowner and father of one of Burrell's classmates from Abbey Park School. His brother George also joined the consular corps in 1901 as William's assistant in the Austro-Hungarian consulate, where he had the rank of *Honorarkanzler*.[20]

One of the perks of William's position was to meet Queen Victoria when she visited the Glasgow International Exhibition in 1888. This was a celebration of Glasgow's status as Second City of the Empire and was a remarkable display of the city's skills in the fields of both art and industry, with massive industrial displays alongside an extensive loan exhibition of British and European art. More importantly it was the result of James Paton's petitioning to create a new and impressive museum and gallery that would be 'adequate for the necessities and dignity of the great commercial and industrial city of Glasgow'.[21] The International Exhibition was expressly designed to

raise the funds for this new museum that was designed to elevate the city into the top rank in the world. It was therefore fitting that the Queen Empress graced it with her presence.

Among the works exhibited in the fine art sections were paintings by Jean François Millet, Adolphe Monticelli, Edgar Degas, Jacob and Matthijs Maris and James Abbot McNeill Whistler, all of whom were to become key artists in Burrell's collection. In fact, Burrell later ended up purchasing several works that had been lent to the Exhibition, including Matthijs Maris's *Butterflies* and *Montmartre* and Gustave Courbet's *Houses by a River*. Initially, however, the most influential aspect of the Exhibition was the inclusion of works by the Glasgow Boys. Responding to the display, *The Art Journal* exclaimed: '[T]here is in Scotland, notably in Glasgow, a band of young painters who have broken from the traditions of the past and boldly struck into the road that is marked with the footprints of Bastien-Lepage.'[22]

The works on display, such as James Guthrie's *To Pastures New*, illustrated a move to a more modern style of painting. Guthrie's painting celebrated the mundane subject of a young girl shepherding geese. His subject is treated in a realistic manner, with loose brushwork and a distinct lack of finish. Guthrie's work moved away from high art traditions and projected an image of rural ordinariness as promoted by French artists such as Jules Bastien-Lepage. Other Glasgow Boys represented included George Henry, E. A. Hornel and Joseph Crawhall.

Among the lenders to the Exhibition were people like James Reid, Richard Kidston and John Polson, who were all investors in Burrell & Son ships, as well as Leonard Gow who Burrell knew through shipping and consular circles. Although Burrell did not lend himself, he was certainly among influential business and art-collecting friends. As a record of Queen Victoria's visit, John Lavery was commissioned to paint the scene. The 253 attendees all sat individually for the artist to have their likeness sketched so that they could be incorporated accurately into the larger picture. Burrell can be seen in the finished painting, but unfortunately the sketch, the only known painted portrait of him, has not survived.

With an increasing burden of business and consular duties it made sense for Burrell to move closer to the heart of operations and in early 1891 the Burrell family moved from Bowling to a grand terraced townhouse at 4 Devonshire Gardens on Great Western Road. This was one of the of the most fashionable addresses in Glasgow's West End and it appears that Isabella Burrell sold off her other properties in order to finance the purchase this new home.

Elizabeth Burrell was married here on 26 March 1891 to Thomas Steward Lapraik, son of John Steward Lapraik who had extensive shipping and engineering interests in Hong Kong, including the Douglas Steamship Company and the Whampoa Dockyard.[23] Remaining in the household with Isabella were William and his two youngest sisters Isabella and Mary. Three domestic servants were employed to look after the family and lived in the building.[24]

As a sign of Burrell's increasing social status he joined the Royal Northern Yacht Club in 1891. This was one of the most prestigious yacht clubs on the Clyde, with its headquarters at Rothesay and members drawn from among Clydeside's leading industrialists. Yachting had become an enormously popular sport for the business elite and many shipbuilders and shipowners competed with each other to show off their skills on the water. Burrell did not own a yacht and seems not to have been that interested in the sport, but he certainly recognised the potential for social and professional advancement by mixing with the other members.[25]

William Burrell had continued to modestly acquire artworks while still living in Bowling. One of the artists who particularly caught his eye was Joseph Crawhall. He purchased *A White Horse* from an exhibition at the Scottish Society of Painters in Watercolour in 1886. Crawhall was one of the group of painters that emerged from Glasgow's burgeoning art scene influenced by French realist art and patronised by the growing number of industrialist art collectors. He became a particular favourite with Burrell, who continued to acquire his work over the course of his entire collecting career, amassing 140 paintings and drawings making it one of the largest collections of his work anywhere. John Lavery was another Glasgow Boy whom

Burrell began to admire, especially having sat for him for the 1888 Exhibition painting. In 1890 he purchased his *Dear Lady Disdain* from the Glasgow Institution of the Fine Arts exhibition for £50. Burrell was also interested in James Guthrie, and he bought two of his pastels from an exhibition at Dowdeswell and Dowdeswell in London in December 1890 that had been organised by Alexander Reid. He later discussed the event with Reid's son, Alexander James McNeill Reid:

> I first met your father when he had premises on the 3rd floor in a building either in West George St or St Vincent Street near Blythswood Square, when he was packing up about 30 or 40 pastels, etc. by Guthrie to be shewn in London in a place in Bond St where I saw them and where, instead of being appreciated, they caused great amusement. I heard some of the ridiculous opinions. I bought two of them, one of the Luss Road and my brother, George, bought [an]other 2.[26]

There is also evidence that Burrell bought two seventeenth-century Dutch portraits of young children in 1890 from a dealer in Holland, which provide the first evidence of his interest in earlier periods of art.[27]

The move to Devonshire Gardens, a larger house with fewer family members living in it, provided an opportunity to stretch his collecting wings. One of the first initiatives he undertook was to commission a new stained-glass window for the stairway from the up-and-coming designer George Walton, a pioneer in the development of domestic decorative glass in Glasgow. The subject, 'Gather Ye Rosebuds While Ye May', was a popular one for Arts and Crafts designers and its execution, using traditional handcrafting techniques, reflected Burrell's growing interest in medieval craftwork, as well as his support of local artists. His growing status in the art scene can be seen by the fact that he was elected as a lay member of the Glasgow Art Club in 1893. George had joined two years previously and the two brothers were now recognised as key players in the art

market. William quickly resigned his membership, however, feeling that lay members were often regarded by the artists as prey to be induced into buying their latest artworks: 'The Glasgow Art Club decided that it would be a good idea to have lay members who, when elected, were pumped full of 'art' and proved quite a gold-mine to the members and to the dealers.'[28]

Burrell was very sure of his own tastes and preferred to make his own decisions on what to purchase rather than being pressured, so this aspect of the Club would certainly not have appealed. His resignation can therefore be seen as a mark of his growing confidence in his own judgement and a lack of fear in how he might be perceived. He was definitely his own man.

Although Burrell had a strong idea of his own tastes, he was not afraid to learn, and was very much guided in his purchases by a small number of trusted artists and dealers. John Lavery took him to visit Philip Wilson Steer's studio in London around 1890, where he purchased a painting entitled *Jonquil* for £45, which was the first substantial sale that Steer made. George Burrell also bought one of Steer's works at the same time.[29] William Burrell's admiration for Lavery extended to a commission in 1894 to paint a full-length portrait of his sister, Mary Burrell, which was considered one of his early masterpieces. *The Artist* praised it as 'a magnificent work of art; its pose, lines and general treatment are superb, its paint is laid down with distinction, its texture admirable'.[30] Burrell was extremely pleased with the result and regularly lent it to exhibitions in coming years.

Burrell's relationship with Alexander Reid was also becoming increasingly fruitful. Writing about his father and Burrell's early years of association, McNeill Reid stated:

> During the next few years he bought a few more Guthries, and considerable number of Crawhalls, and some of the lesser French Barbizon Group, such as Ribot, Bonvin and Vollon, and a few pictures by the Maris brothers, & some Whistler drawings.[31]

Burrell may have purchased Degas's *Première danseuse* (*The Encore*) at the time of Reid's 1891 exhibition 'A Small Collection of Pictures by Degas and Others'. He had certainly acquired it by 1894 as it was illustrated in *The Art Journal* of 1894 and had the credit line: 'In the collection of William Burrell, Esq, Glasgow'.[32] This was probably the first time that the significance of Burrell's collection was brought to the attention of the wider art community.

Another key exhibition that Burrell lent to and also bought from was the first solo exhibition by Joseph Crawhall in 1894. This was the opening exhibition at Alexander Reid's new gallery known as the Société des Beaux Arts on St Vincent Street. The press reaction was glowing:

> Other men have doubtless influenced him, but Mr Crawhall imitates nobody. He has a language entirely his own. He loves birds and animals, especially those which are the pets and companions of man, and he paints them, more particularly the horse, with sympathy and truth.[33]

Included in the exhibition was *The Aviary, Clifton*, which Burrell had recently purchased from the dealer W. B. Paterson. It must have given him great satisfaction to see that this work was singled out by the paper for its brilliant use of colour.[34] To celebrate the opening of the exhibition, Reid held a supper party to which he invited Crawhall, Burrell and many of the Glasgow Boy artists. Burrell took great pride in being the only collector there: 'They were all there. Guthrie, Lavery, Hornel, Henry, Walker, Macaulay Stevenson, Kennedy, etc. I was the only non-artist invited – It was a very merry evening.'[35] Although Burrell mentions Henry and Hornel, they were actually still in Japan, where they were studying Japanese art. Their eighteen-month trip had been supported by Reid and in part financed by Burrell and on their return, he acquired at least one of Hornel's Japanese works, *A Silk-Shop in Japan*.[36]

As well as lending to the Crawhall exhibition, Burrell was starting to make a name for himself as a lender to other exhibitions. Steer's *Jonquil* was a particular favourite. He lent it to the New English Art

Club's 'London Impressionists' exhibition in Knightsbridge in 1890, where it was described as 'remarkably good' and the 'best figure-picture Mr Steer has painted'.[37] It then featured in the Liverpool Art Club's autumn exhibition at the Walker Art Gallery later that year and the following year it appeared in the influential 'Les XX' exhibition in Brussels, where it was hung alongside works by Van Gogh, Pissarro and Sisley.[38] In Glasgow he lent Lavery's *Dear Lady Disdain* to the East End Exhibition in 1890, which was organised by the Corporation to raise funds for the creation of a People's Palace 'for the moral and social improvement and elevation of the working classes in the East End of the city'.[39] At the Glasgow Institute exhibition in 1893 Burrell lent George Walton's design for the stained glass panel for 4 Devonshire Gardens and Steer's *Jonquil*.[40] Two years later he lent Thomas Couture's *Le Conventionnel* and Lavery's portrait of Mary Burrell. George Burrell also lent a Degas ballet scene to this exhibition.[41] In 1894 Burrell & Son lent a couple of small items – a list of early steamships and an old canal timetable – to the 'Exhibition Illustrative of Old Glasgow' organised by the Glasgow Institute of the Fine Arts.[42] This was the only time that the firm lent to any exhibition, which is unusual for a business of such growing importance. There were many opportunities to participate in industrial exhibitions, international exhibitions or exhibitions organised by the museum such as the 1880 'Naval and Marine Engineering Exhibition' or the 'Comet Centenary Exhibition' in 1912. Most other shipbuilders and shipowners profusely lent ship models, paintings and documents to celebrate their role in Glasgow's maritime development, but not Burrell & Son. The Burrells were clearly not sentimental or romantic about their history or achievements. Business was business, and ships were merely a means to make money. The Burrells were very good at business and very good at making money.

Having turned heads with their order of ten ships in 1888, Burrell & Son made another audacious move into the shipbuilding market in 1893:

Messrs. Burrell and Son, of Glasgow, have somewhat startled the ship owning community at large by what might

36

almost be termed wholesale ordering of steamers. No fewer than seven or eight vessels have been placed on the Clyde and the North-East Coast, the former district having received the lion's share of the work . . . The prices in all the above cases are reported as being exceedingly low. Messrs. Russell and Co. are to receive about £50,000 and £45,000 each respectively for the 7000 tons and 6000 tons steamers. Messrs. A. Rodger and Co. will receive £30,000 for the 5000 tons steamer, and the Tyne Iron Ship Building Company £33,000 for the 5500 ton boat, whilst it is stated that Messrs. Gray are to have £40,000 for their steamer. This is the largest order placed at once by a single firm for several years.[43]

In the end a total of fourteen ships were ordered with five different builders on the Clyde and the North East of England, taking advantage of the extreme depression in the shipbuilding market. Work in the yards was dwindling sharply and they were offering contracts at unprofitable rates simply to keep work in hand. Burrell & Son timed their entry into the market to perfection when costs were at their lowest. Freight rates were still depressed, but they were gambling on the expectation that by the time the ships were delivered the international shipping market would be on the up again. As well as the new ships, Burrell & Son also purchased another seven second-hand ships between 1893 and 1894.

Burrell & Son ran their business so that each ship operated as a separate entity, with most of its sixty-four shares owned by the partnership of Burrell & Son (i.e. George and William). Several shares were sold to Burrell family members and other businessmen, with no more than a handful of shares owned by any one person. These shares were only offered privately to friends, family and business associates and could not be traded on the open market. In this way Burrell & Son kept a very tight control over their business and ensured that any investors were hand-picked and entirely trustworthy. As senior partners William and George kept their shareholdings within the

partnership rather than personally owning shares. The Burrell & Son business was quite a family affair. Their mother, Isabella, was always a major investor, and she took out a total of thirty-two shares in fifteen of the ships. Brother Henry bought seventeen shares in twelve of the ships, sister Jessie bought one share and her husband Charles Cleland five shares in three ships. George's wife Anne bought fourteen shares in seven ships, her mother five shares in three ships, and her sister Agnes one share each in two ships. The number of female investors is truly remarkable and remained a constant feature of the business. At one stage as many as 20 per cent of its shareholders were women.[44]

In contrast to the launch of the earlier steamers, large numbers of the family attended the launches of this new set of ships:

> The ceremony of naming the 'Strathcarron' was gracefully performed by the Hon. Mrs Archd. B Orr-Ewing, Mrs Burrell, the Misses Burrell, Mr William Burrell, Mr and Mrs George Burrell, Mr and Mrs Cleland, Glasgow, Mr and Mrs Anderson Rodger, Glenpark, Port Glasgow; Mr Marshall Glasgow; Mr James H. Hutchison, Mr Peter Taylor, Mr James Stewart, superintendent to Messrs Burrell & Son.[45]

Archibald Orr-Ewing was a major shareholder in the ship, as was Anderson Rodger, the builder. Isabella Burrell, Anne Burrell, and Charles and Jessie Cleland were all also shareholders, so they were there not just to show family support, but also to look after their own business interests.

As with the earlier batch of steamers the new ships were fitted with the latest innovations for improving their operational efficiency. The *Strathcarron* was:

> fitted with all the latest appliances for the rapid loading and discharge of cargo. Her masts will be telescopic, so as to adapt her for sailing through the Manchester Ship Canal. The machinery which will be on the triple-expansion principle . . . will be of considerable power. The boilers will be

fitted with Howden's patent forced draught for economy in fuel.[46]

The ships were also fitted with extensive water ballast tanks that allowed them to sail efficiently between ports when they had no cargo to carry. Ships were particularly vulnerable when sailing in ballast due to the poor seakeeping characteristics of a lightly laden ship, so this was an important safety improvement as well.

Another new enterprise for Burrell & Son was a joint venture with Gottfried Schenker. In 1895 they established a new shipping company called the Schifffahrts-Gesellschaft Austro-Americana, or the Austro-American Line. This was intended to tap into the growing demand for cotton in Austria and to capitalise on an initiative by the Austrian government to promote the maritime trade of Trieste by establishing a cargo service between Italy and North America. Burrell & Son, Gottfried Schenker and his adopted son August Schenker-Angerer each put up a third of the initial £40,000 capital. Four second-hand ships were acquired in Britain by William Burrell and renamed the *Illiria*, *Istria*, *Tergeste* and *Betty*. These initially operated a six-week schedule sailing to Brunswick, Charleston, Wilmington and Newport News and other ports as required. Schenker also acquired railroad interests in America to secure additional infrastructure for the delivery of cargoes. As trade developed, the line also started serving New Orleans and South American ports and between 1897 and 1898 a further seven second-hand ships were acquired to meet the demand. These included one that was briefly on the books of Burrell & Son as *Kirby Hall* and then renamed *Aquileja* and another that was renamed *Gottfried Schenker*.[47] James Stewart, who had served his apprenticeship under his father James Carlile Stewart at Burrell & Son, was recruited to be the superintendent engineer for the new company at Trieste.[48]

The boatyard at Hamiltonhill was also going through something of a resurgence. Few ships had been built there since the initial flurry in 1886, but from 1892 to 1894 a total of twenty new vessels were launched for a variety of owners. None of them were for their own

use, which demonstrates how minor the canal business was now becoming in the Burrell & Son portfolio.

As well as the businesses in which Burrell & Son had operating interests, the office also acted as agents for several other shipping companies. These included: the Adria Steam Packet; the Adriatic Steam Packet; the Ancona Steam Packet; the Barbadoes Steam Packet; the Bari Steam Packet; the Catania Steam Packet; the Demerara Steam Packet; the Fiume Steam Packet; the Malta Steam Packet; the Mediterranean Steam Packet; the Messina Steam Packet; the Palermo Steam Packet; the Royal Hungarian Sea Navigation Co. 'Adria' Ltd; the Sicilian Steam Packet; the Trieste Steam Packet; the Trinidad Steam Packet; the Venice Steam Packet; and the West India Steam Packet.[49] From this list it is clear that the focus of their agency work was centred on the Mediterranean and the West Indies, reflecting their own shipping interests in those areas.

Despite these developments all was not well in the office. In accordance with their father's will William and George had employed their younger brother Henry, and when he reached the age of twenty-four in 1890 he was appointed as a partner in Burrell & Son. He was trained in the shipbroking side of the business, but it appears that he did not live up to the exacting standards of his brothers and in April 1894 he was demoted from being a full partner, with rights to a share in the profits of the business, to simply being a 'salaried partner' drawing a wage. Henry was still determined to make a go of it, but things only got worse. He had been in the habit of occasionally lunching with William Govan, who was involved in the sugar trade. One December day in 1895 the two men met each other travelling home on the train and got talking about the effect of the revolution in Cuba on the price of sugar. Govan was certain the crop would be curtailed and so push up the price of European beet sugar. With no experience of the sugar trade, Henry Burrell was reluctant to get involved, but a few months later he met Govan again, and this time was persuaded to buy in large quantities. Over the next few weeks, he entered into seven separate contracts with Stewart, Govan & Co. for the purchase of a total of 2,550 tons of German

beet sugar that was to be supplied following the harvest later in the year.

He freely admitted that he had no knowledge of the sugar trade and was relying solely on Stewart, Govan & Co. to manage the transactions for him. He was certainly not expecting to receive or trade such large quantities of sugar and was purely speculating to make a profit on the anticipated price increases over the course of the contract. Not surprisingly he quickly got cold feet and in May 1896 he informed Stewart, Govan & Co. that he was 'desirous of terminating all these sugar ventures and of selling out at once' as they had given him a great deal of mental anxiety. Part of this anxiety was no doubt because under the rules of his partnership in Burrell & Son he was not permitted to personally speculate in such ventures. As soon as William Burrell found out in June, Henry was removed: '[It] was owing to this wretched sugar transaction that I came to leave the firm ... my brother said it was impossible for me to remain.' William confirmed, 'I had insisted upon his leaving the office when I came to know about it.'[50] The finality of the situation was confirmed in the *Edinburgh Gazette*, which simply stated: 'Mr Henry Burrell, Shipowner, Glasgow, ceased, as at 10th June current, to be a Partner of Burrell & Son, Shipowners and Shipping Agents, Glasgow. The Business will be continued as formerly by the remaining Partners.'[51]

Despite this, Govan had persuaded Henry to hold on, but as soon as claims for payments started to come in, Henry found himself in such a complicated pickle that he could find no way out. Each of the contracts had slightly different terms, which he simply could not understand, and he was unwilling to make the payments that began to be demanded of him. He appears initially to have avoided the situation and Stewart, Govan & Co. tried to chase him down at his own address, the firm's office, his mother's house and the Conservative Club where he was a member. To further complicate matters two of the contracts involved London sugar brokers who now also began demanding payments. Henry had no option but to turn to his brother for help.

The whole thing was such an unholy mess that even William, with his astute business brain, had trouble understanding it. The

bottom line was that Henry had paid well over the odds and when the market failed to rise, he was significantly out of pocket. William helped his brother through the eighteen months of legal wrangling that it took to resolve the issue, with Henry in the end being forced to pay an undisclosed sum. The whole thing left Henry seriously ill and a broken man.[52] He simply did not have the commercial acuity that was required in the competitive cut and thrust of Burrell & Son's business world. The way that William and George reacted to the situation clearly demonstrates that they had the same ruthless attitude as their father when family members did not cut it in the business. Business came first, family second.

At the same time as the business was expanding, William Burrell was expanding his art collection. The increasing prosperity of Burrell & Son now enabled him to buy more high-value and high-status works, as well as increasing the sheer volume of acquisitions. There is no accurate record of what Burrell purchased at this time, but an indication of what he had can be seen in the increasing number of loans he made to exhibitions. In 1896 he lent a Jacob Maris Dutch canal scene to the Royal Scottish Society of Painters in Watercolour exhibition.[53] The following year he lent Matthijs Maris's *The Walk* and Lavery's portrait of Mary Burrell to the now Royal Glasgow Institute of the Fine Arts (RGI).[54] In 1898 he lent Whistler's *Princesse du pays de la porcelaine* and three works by Matthijs Maris to the International Society of Sculptors, Painters and Gravers' Exhibition of International Art in Knightsbridge.[55] That year Lavery's *Mary Burrell* also featured at the Royal Scottish Academy, and Maris's *The Sisters* and Théodule Ribot's *The Pedlars* (now known as *The Rosary*) were lent to the RGI; the year after that Maris's *Butterflies* was lent.[56] Burrell's interest in the work of the Maris brothers is clear and in Jacob Maris's obituary in 1899 Burrell was singled out as owning important examples of his work.[57] He later justified his interest in Matthijs Maris:

He is not everybody's painter but, nevertheless, he was a great genius. He was a dreamer and his pictures are poems

in paint, full of feeling and tenderness and it was because
I liked his work so much that I bought it.[58]

Burrell also supported the construction of the new Glasgow School of
Art building designed by Charles Rennie Mackintosh, first through
a contribution to the building fund in 1895 and then through the
loan of exhibits when the first phase was completed and opened in
1899.[59]

Alexander Reid was influential in convincing Burrell to buy works
by French artists and in the 1890s he had added to his collection
Manet's *Portrait of Victorine Meurent*, two paintings by Daumier and
at least one sculpture by Rodin. Reid also cultivated Burrell's interest
in Degas, as Reid's son later recalled in a story that says much of the
relationship between the two men:

> William Burrell told me of a visit he and my father had paid
> to a sale in Christies in the early nineties which illustrated the
> latter's flair for getting publicity. A Degas was on the easel and
> had been bid up very slowly to £320. Burrell and my father
> were standing at the back of the room when the former was
> startled to hear his neighbour call out in a loud voice 'Seven
> hundred pounds.' The entire audience turned round to see
> who this crazy lunatic was and Burrell asked my father what
> on earth he had done that for, since he would probably have
> got the picture for a bid of £350 at most. My father's reply
> was typical. 'Yes; I know I would but, when I came in here I
> was almost unknown; now everyone knows me.'[60]

Monticelli and Henry Muhrman also featured largely in Burrell's pur-
chases; however, the most influential artist that Reid sold to Burrell
at this time was Whistler. His work had been brought dramatically
to the attention of Glasgow's art scene in the 1888 International
Exhibition, which featured his *Arrangement in Grey and Black,
No. 2: Thomas Carlyle*. This excited such interest that a petition to
secure it for the city was raised by Francis Newbery, head of The

Glasgow School of Art, and many leading artists in Glasgow. James Paton and his fellow museum committee members were only too happy to oblige, and when the Town Council purchased it in 1891 it was the first painting by the artist to enter a public collection anywhere in the world. This helped to instil a passion for the artist in Glasgow in the 1890s that became known as 'Whistlermania'.

Reid met Whistler in Paris where the two became strong friends. He began to represent him and by 1893 was exhibiting his work in his Glasgow gallery. Reid bought three full length portraits from Whistler in the expectation that he would sell them on to American collectors: *Arrangement in Black: La Dame au brodequin jaune – Portrait of Lady Archibald Campbell*; *Arrangement in Black and Brown: The Fur Jacket*; and *Rose and Silver: La Princesse du pays de la porcelaine*. They were exhibited at the Pennsylvania Academy of the Fine Arts in 1892 and *The Fur Jacket* and the *Princesse* at the World's Columbian Exposition in Chicago in 1893. Despite interest from the Museum of Fine Arts in Boston, these two did not find an American buyer but were instead purchased by William Burrell. He paid around £1,000 for *The Fur Jacket*, which was about half what Reid had hoped to get. Burrell always seemed to get preferential rates from Reid, partly through his keen negotiating skills, but also because Reid saw him as an important client with whom he needed to keep on good terms.[61] Burrell later recalled, in a letter to Reid's son, that he had bought all three portraits: 'At that time your father was in constant touch with Whistler and it was then I bought from him The Fur Jacket, Brodequin Jaune and La Princesse du Pays de la Porcelaine, 3 full lengths.'[62]

He seems to have mis-remembered owning the *Brodequin jaune*, or he had it only fleetingly, as by 1895 Reid had sold it to the Philadelphia Museum of Art. He certainly owned other Whistlers though, including an oil painting, *Study for the Head of Miss Cicely H. Alexander*, a watercolour, *Amsterdam in Winter*, several pastels including *The Purple Iris* and *Morning Glories* and a number of lithographs. Burrell was extremely proud of his Whistlers and lent the *Princesse* to the RGI in 1896 and *The Fur Jacket* in 1898.

As well as the contemporary art that was increasingly coming to public attention Burrell was quietly amassing a large collection of Gothic and Renaissance artefacts such as tapestries, stained glass and furniture. As his friend, the architect Robert Lorimer, put it, he was now living in 'a regular collector's home': 'He's 36: possesses 17 Matthew Maris's – 2 Whistlers and God knows what else, and really a lot of beautiful old furniture and brass. Finest lot of these deep brass dishes I ever saw.'[63]

Burrell first met Lorimer in 1897 when visiting Earlshall, the Fife home of the collector of medieval tapestries and furniture, R. W. Mackenzie. Earlshall was Lorimer's first major contract and his sensitive restoration of the sixteenth-century castle using Arts and Crafts techniques and commissions brought him much praise. With a mutual interest in art and ancient craft techniques, Burrell and Lorimer quickly became firm friends. Burrell was in the habit of visiting the Continent two or three times a year to keep in touch with his agents and to foster new business opportunities. He used these trips to visit galleries and dealers such as Elbert van Wisselingh from whom he acquired the majority of his Maris paintings. Occasionally he took friends and family on these visits to combine pleasure with business and in September 1898 Lorimer was invited along on a trip to the Netherlands:

> The party consisted of Burrell, my Glasgow client, his mother, a fine old Trojan of 64, his two sisters and a friend of B's called Mitchell, an extremely nice young chap, 6 in all. First of all it was to be simply B and me then B wanted to take Mitchell to get him inoculated with an appreciation of things.[64]

The 'nice young chap' was Ralston Mitchell, son of James L. Mitchell, who had recently taken over his father's timber business. They travelled around the country visiting Flushing, Haarlem, Rotterdam and Amsterdam before returning via Antwerp. Lorimer accompanied Burrell on his many visits to dealers and antique shops where he

observed Burrell using his business skills to negotiate a deal, sometimes acquiring things at half what Lorimer expected to pay:

> It was very interesting going round all the shops with Burrell
> ... I didn't go in very deep – spent about £17 to £18 for
> which I think I'd have paid getting on for double over here
> or more. This was all thanks to Burrell, the man's a perfect
> nailer, A.1. taste ... To see him tackling some of these Jew
> picture dealers was a treat & in many ways I learnt a lot
> from him & I think I taught him something to[o]. There is
> one shop at Amsterdam that I think is the most delightful I
> have ever been in, & such nice people – a father & several
> daughters – nothing but Dutch stuff, but all of the finest
> – the severe really fine Dutch, not a piece of 'marquetry' in
> the place.[65]

In subsequent years Lorimer accompanied Burrell on other visits to Belgium, the Netherlands and Germany, where he learnt more about Burrell's collecting habits:

> When we arrived at our hotel the first thing that Willie
> Burrell did was to ask the hotel porter to make up a list with
> the names and addresses of *every* antique shop in the town.
> When this was completed we ordered a cab and went round
> all the dealers.[66]

Their excitement at trawling the antique shops can be seen in a letter that Burrell later wrote to Lorimer when he was on another of his Continental trips: '[O]n the homeward voyage I struck one of the finest antiquity shops in the world & will lead you to the spot – we are only beginning to learn something about this game.'[67]

Although Lorimer considered his role as something of an advisor to Burrell it is clear that the two were learning from each other. Lorimer's first impression of Burrell was that he 'really has very fine taste' and expressed wonder at how a man of business could have

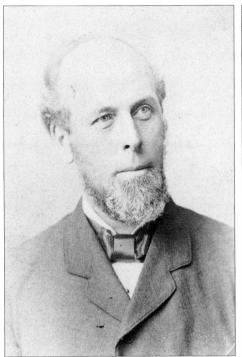

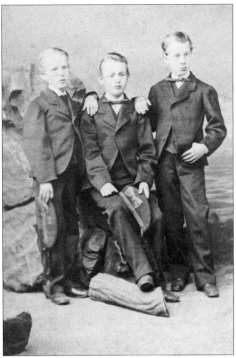

William Burrell Sr (1832–1885). Photograph by J. Weston & Son, 20A Sandgate Road, Folkestone. (All plates © CSG CIC Glasgow Museums Collection unless stated otherwise)

The young Burrell boys together. From left to right: William (1861–1959), George (1857–1927), and Adam (1859–1908). Photograph by James Bowman, 65 Jamaica Street, Glasgow.

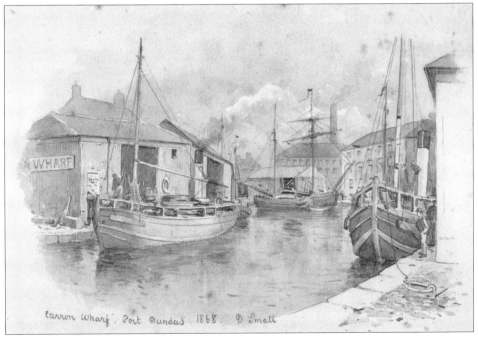

Port Dundas in 1868, when the Burrell & Son canal shipping business was in full swing. Watercolour by David Small, 1868.

William Burrell and Robert Lorimer (centre) on tour in Holland in 1898. Ralston Mitchell and Mary Burrell are on the left and Burrell's mother, Isabella, is on the right.

Portrait of George Burrell by George Henry, painted about 1899.

Constance and Marion, around 1906.

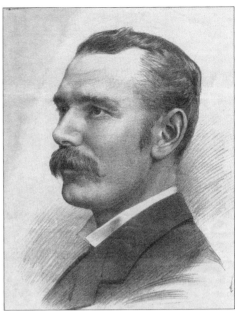

Left. Studio portrait of Constance Burrell by T. and R. Annan and Sons, Glasgow, about 1906.

Above. Portrait of William Burrell as a Glasgow Corporation councillor. From *The Bailie*, 5 November 1902.

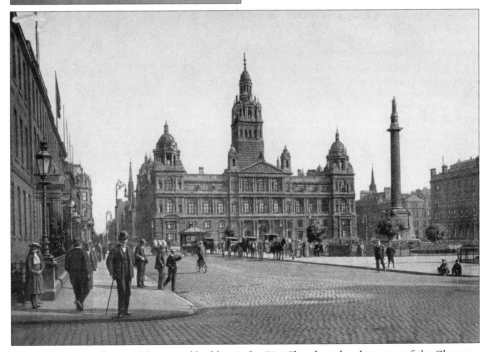

George Square in Glasgow. The central building is the City Chambers, headquarters of the Glasgow Corporation. On the left-hand side was the shipping office of William Burrell & Son.

View of the 1901 Glasgow International Exhibition. The building on the right is the newly constructed Kelvingrove Art Gallery and Museum, which was used as the Palace of Art.

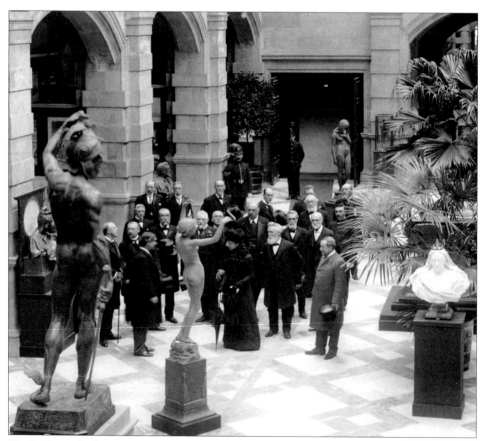

The Duchess of Fife on a private visit to the Palace of Art the day after the official opening of the Glasgow International Exhibition. William Burrell was a major lender of art and sat on the committee that developed the Royal Reception Rooms.

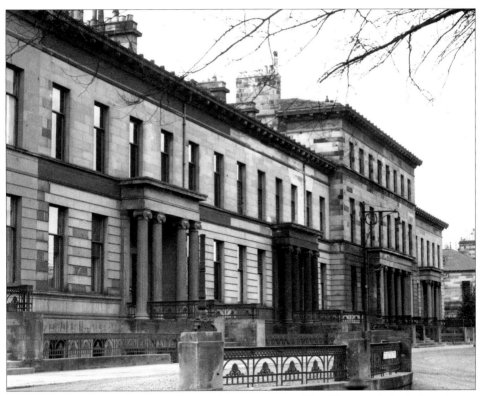

Great Western Terrace, Glasgow. William and Constance moved into No. 8 (with the dark portico) shortly after their marriage in 1901. Constance grew up two doors down in No. 10, in the three-storey section. (Newsquest, Herald & Times)

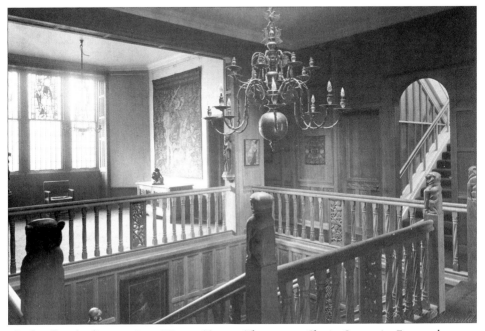

The first-floor landing at 8 Great Western Terrace. The tapestry *Charity Overcoming Envy* can be seen beside the window, with Rodin's *Fleeting Love* below. Photograph by Robert Miliken.

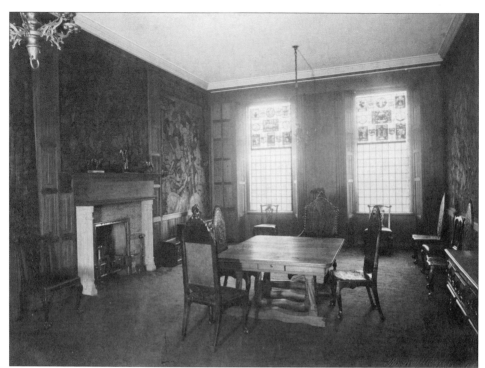

Above. The dining room at 8 Great Western Terrace, 1902. Photograph by Robert Miliken.

Right. The white drawing room at 8 Great Western Terrace, 1902. On the left can be seen the edge of Whistler's *La Princesse du pays de la porcelaine*. Photograph by Robert Miliken.

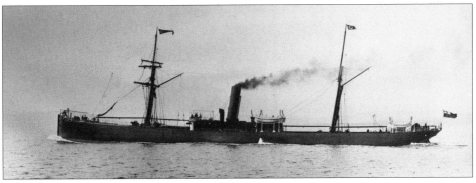

Strathavon, built in 1890 by Russell & Co., Greenock. This was one of a fleet of 10 new ships that created a modern efficient fleet for Burrell & Son.

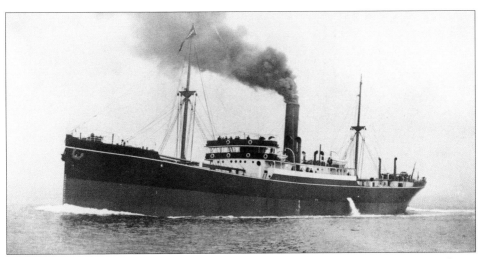

Strathesk, built in 1909 by the Greenock and Grangemouth Dockyard Co. This was one of the ships sold at vast profit in 1916 to the Commonwealth Government Line of Australia.

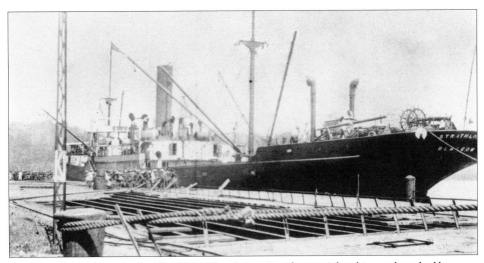

Strathlorne, built in 1909 by Archibald McMillan & Son, Dumbarton. This ship was launched by Marion Burrell and was the last ship to be sold from the Burrell & Son fleet.

Right. Studio portrait of William Burrell by T. and R. Annan and Sons, Glasgow, about 1906.

Below. Drawing of Provand's Lordship, the oldest house in Glasgow, by Andrew Allan. William Burrell was Honorary Vice President of the Provand's Lordship Society and played a major part in its operation.
(© CSG CIC Glasgow Museums and Libraries Collection: The Mitchell Library, Special Collections)

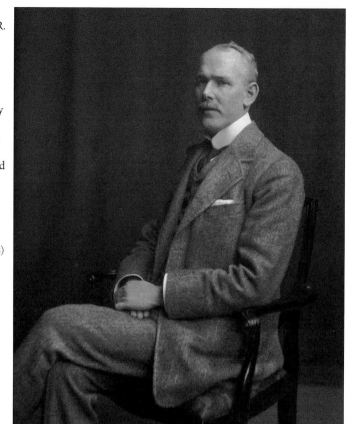

such discernment: 'God knows where he got it and his knowledge from.'[68] On the second trip, in 1899, the group went to Holland, where Lorimer wrote:

> we went over the same ground again but struck some fresh ground also – to go back to the same place two years running does one far more good than rushing off to a lot of work of a totally different type.[69]

Here Lorimer is referring to them returning to the Rijksmuseum in Amsterdam. He stated that the second trip 'really got the contents into my head'. On the third trip with the Burrell family, which took in Belgium and Germany, Lorimer wrote: 'WB is a rare guide and dead keen on the fine things both in the shops and in the museums and galleries.'[70] The fact that these trips took in museums, galleries and exhibitions as well as shops and dealers demonstrates Burrell's interest in the art historical context of his acquisitions. In 1899 Lorimer noted that they 'went straight on in the afternoon to Antwerp, where we were last year as the B's wanted to see the Vandyke exhibition'.[71] This was the tercentenary exhibition of Anthony van Dyck's birth held at the Museum voor Schone Kunsten in Antwerp. Along with his repeated visits to the Rijksmuseum, this illustrates a desire by Burrell to establish a comprehensive understanding of Dutch art history and indicates that his European visits were more than simply buying trips: they were educational.[72]

There was also a professional reason for Burrell and Lorimer's intense learning and collecting during these years. In early 1898 Lorimer wrote of Burrell: 'He's dying to get hold of an old castle, & would turn me loose in one tomorrow if I could find one.'[73] Burrell's visit to Earlshall and to Lorimer's own summer home of Kellie Castle, another restored castle, fuelled his desire to place his collection in a fitting environment and to acquire for himself a home that would reflect his growing status. Although the Burrell family can trace its roots back to Northumbrian landed gentry, Burrell was as yet a simple man of business living with his mother in a Victorian

townhouse. Acquiring a baronial home would at once gain him additional respectability, elevating his position within the aristocratic world of art collecting, as well as playing to his Conservative sensibilities of tying himself to the land.

The castle that he initially set his sights on was Newark Castle, near St Monans in Fife. The castle at that time stood in ruins, but the remnants were of a fifteenth-century structure with a late-sixteenth-century addition, including a round tower and courtyard. Newark had important royal historic associations as King Alexander III is said to have spent some of his childhood in an earlier castle on the site, which would have given it added allure for Burrell who was fascinated by ancient royalty and their possessions. Whilst at Kellie Castle, Lorimer wrote:

> Do you remember an old ruin hanging right over the sea near St Monans called Newark Castle. Burrell has been wanting it for years but I've always dissuaded him, but when he was staying here we went down to see it & I came to see that it could be made a place of so I roughly measured it up & made sketch plans . . . & after doing this & seeing that it was feasible.[74]

Lorimer's provisional plans for the restoration included servants' quarters and a wine cellar on the ground floor, a smoking room, dining room and drawing room on the first floor and the six bedrooms, dressing rooms and bathrooms on the second floor. From his sketches of the exterior, it is clear that Lorimer planned to renovate the ruin in an appropriate Baronial style. Burrell's desire was not to *restore* Newark, but rather to renovate the ruin as a home fit to live in, in the style later termed as a 'castle of comfort'.[75] Unfortunately for Burrell, however, the owner of Newark Castle did not wish to sell and so his dreams had to be put on hold for the time being.[76]

Things were not going so smoothly in the contemporary world of shipping either. Burrell & Son became embroiled in a number of court cases that took up large amounts of time and resources. In

1893 the *Strathdon* had been travelling through the Suez Canal when it went on fire and part of the cargo of sugar was destroyed. The ship needed repairs and by the time it reached New York it was very much delayed and short of cargo. The owner of the sugar sued for loss of earnings and over many years the case was deliberated in the New York courts until it was finally resolved in 1900. In October 1894, the *Strathord*, on a voyage to Australia, came across the *Buteshire* in distress and towed it to safety in Mauritius. This resulted in two separate court cases. The first related to the salvage claim against the owners of the *Buteshire* which went from the Court of Session in Edinburgh to the Admiralty Court in London in 1895. The second action was by the charterers of the *Strathord* against Burrell & Son for breach of contract and loss of earnings resulting from the delay in the ship reaching Australia. This case went through the High Court in London in 1896 and the Court of Appeal in 1897. Smaller actions were also taken out, such as the widow of a stevedore who died aboard the *Strathavon* suing for compensation in 1896.[77]

The case that took the greatest time was an action by Burrell & Son against the shipbuilder Russell & Co. Burrell had contracted with Russell & Co. for the construction of four ships in 1893. When they came into service, they were found to have a greater draught than contracted, which meant that they were prevented from entering a number of ports that they had been designed to use. The reason for this was that the vessels were constructed with cambered keels meaning that the bow and the stern sat lower in the water than the centre of the ship. Because the keel was not flat it also meant that when the ships entered drydock, they could incur damage and additional expense. Burrell & Son also argued that the fineness coefficient of the hulls was greater than contracted which hampered the speed and operational efficiency of the ships. They therefore sued for breach of contract and loss of earnings resulting from the faulty design. This started in the Court of Session in 1897 and was finally resolved in the House of Lords in 1900 after eleven days of argument. The business was also involved in a case of fraud in Germany. A well-known fraudster, Albert Wilhelm Zellekens, among a string of deceptions,

had impersonated 'Lord Burrell' in a Stuttgart hotel and got the Burrell & Son office to wire £200 to the hotel. William had at the time been in Vienna, so it was not implausible that he could have gone to Stuttgart as well. In the end Zellekens was caught and at his trial it emerged that he had also been defrauding Schenker.[78]

In all these cases Burrell & Son ultimately came out victorious. The firm had been no stranger to the courts over the years, but this was an extraordinarily large number of complex cases all happening concurrently. This not only kept their lawyers and insurers busy but inevitably distracted the firm from the core business of making money.

Whether this was a factor in their decision to sell off all their ships between 1898 and 1900 we do not know, but for some reason Burrell & Son decided to get out of shipowning entirely at this time. They sold their first ship in October 1898 and in little over a year they had sold their entire fleet of twenty-five vessels. Robert Lorimer offered an insight into William Burrell's business practice at this time:

> his scheme is really the nimblest I've ever struck. He sells his fleet when there is a periodical boom on, then puts his money into 3 per c stock & 'lies back' until things are abso-lutely in the gutter – soup kitchen times – everyone starving for a job. He then goes in like a roaring lion, orders a dozen large steamers in a week gets them built at rock bottom price less than ½ what they'd have cost him last year – then by the time they're delivered to him things have begun to improve a little bit & here he is ready with a tip top fleet of brand new steamers & owing to the cheap rate he's had them built at, ready to carry cheaper than anybody! Sounds like a game any one could play at but none of them have the pluck to do it.[79]

This clearly has an element of truth to it, but the full story was rather more complex. Shipping had been struggling through a prolonged depression during the 1890s and Lorimer was right in

terms of Burrell profiting from new steamers. *The Economist* in 1891 reported, 'The rates now ruling leave a heavy loss in working for all but cheaply-bought new steamers.'[80] This demonstrates that Burrell & Son were right in their strategy of ordering large numbers of new ships in 1888 and 1893. These earned Burrell & Son slightly above-average profits, which also shows expert management in a period of depression. The market began to turn at the end of the 1890s, but the prices realised for the sale of the ships were not spectacular, achieving not much more than the purchase price. Taking depreciation into account this gave a return on investment of about 3 per cent, which was respectable, but certainly not a killing. In fact, it could be argued that if they had waited another year or so the prices would have risen substantially due to the increase in demand for tonnage at the start of the Boer War. Burrell never disclosed his thinking about this, but the reason for selling was most likely not to maximise profits but a strategic decision to alter the management structure of the business.[81]

By the end of 1899 William Burrell, at the age of thirty-eight, had made a name for himself in the business and art worlds and had secured a small fortune. Without a castle to renovate or a fleet of ships to manage it was now time to turn his energies in a different direction.

CHAPTER 3

Collector and Conservative

With the fleet sold off and the office ticking along nicely, William Burrell had time to pursue other interests, and in October 1899 agreed to stand as the Conservative candidate for the Exchange ward in the Glasgow Corporation elections. The family's affiliation to the Conservative party was long-standing. His father had been a 'keen Conservative' and was active in the conservative association in Bowling. [1] His uncle, Henry Burrell, had long served as a Conservative councillor in Grangemouth Town Council and was chairman of the local Conservative Association. His brother-in-law Charles Cleland, also a staunch Conservative and Unionist, was convenor of the Maryhill Conservative Association and was elected to Glasgow Corporation in 1891 at the age of twenty-four.

William Burrell and his brothers were active members of Glasgow's Conservative Club, and from their city-centre office they could attend business and political meetings with ease. When a new building for the club on Bothwell Street was opened in November 1894 William Burrell was among the guests at the celebratory rally at which the principal speaker was the English Member of Parliament Sir Edward Clarke. [2] The Conservative party had recently reinvented itself and Clarke emphasised the importance of Conservative clubs in galvanising support among the new industrial and commercial businesses. New Conservatives, he said, were people who patriotically combined their private and public lives to represent this new party in the best light. The old Tory party had represented the landed interest, but the new Conservative party could now represent urban businesses. This was a message with great appeal in Glasgow and the

Conservative Club quickly grew to more than a thousand members. In terms of Glasgow's population, it was a tiny elite, but it was one that Burrell supported. With such strong family connections to the party, it was only natural then that he might wish to get involved more formally in politics.

Burrell's decision to stand for election as a councillor had been a last-minute one. The sitting councillor, Robert Murdoch, had initially been selected, but he died suddenly shortly before the election. At a pre-election speech at the Merchants House on 1 November 1899 Burrell explained that 'he had not intended to come forward, and it was not until he had been very much pressed that he had consented to do so'.[3] Whether he offloaded the fleet as a deliberate precursor to taking up a political career, as he later claimed, is doubtful, but it certainly proved fortuitous. As one commentator put it:

> Mr Burrell has long been ambitious to devote a portion of his time to the public service, and he now finds himself in that happy position – a position attained by few gentlemen of his own age and business standing – of being able to devote the time necessary to make a reputation for himself in the public service.[4]

The same person gave an insight into the appeal that Burrell had for the electorate, stating that he was 'a man of wide experience in business, of great public spirit; and it would be safe to say that few men outside the Town Council take greater interest in, or have a better knowledge of, city affairs'. Despite his strong political leanings, it is clear that it was his business ethics that really earned him the nomination and that he had 'seen too much in life to be a narrow party man in politics'.

At his hustings event at the Merchants House, William Burrell set forth his platform for election. His primary concern was to take the finances of the Corporation under control. He wanted to cut back on the 'crotchets and fads' such as the municipalisation of milk and bread and the manufacture of policemen's helmets. He opposed

anything that would increase the tax burden on the city's ratepayers and any legislation that would impose, in his view, unnecessary and oppressive restrictions on the building of business premises. This was very much a business-first approach, and the polar opposite of the principles of improving the physical and spiritual wellbeing of all its inhabitants for which Glasgow had become famous. The Corporation had pioneered what became known as municipal socialism, taking into public ownership all those services that were required to keep its citizens safe, healthy and productive.[5] Glasgow was the first British city to build a council-owned public water supply in 1859. It established a municipal hospital in 1866, took over the gas supply in 1869 and opened the first of a series of municipal baths and public washhouses in 1878. It expanded the number of public parks, created museums and galleries, and took control of the electricity supply, the tram system, the police service, and the telephone exchange. This expansion saw Glasgow create the largest civic administration in the UK outside London. It was hailed as a world leader in municipal endeavour and was visited by delegations from across Europe and America.

Burrell's stance was music to the ears of the business elite who were the electors in the Exchange ward. The ward took its name from the Royal Exchange that was the commercial heart of Glasgow's business activity. Within its boundaries were some of the city's most prominent commercial addresses: George Square, the City Chambers, the Bank of Scotland and the Customs House. Burrell easily won the election and on 8 November 1899 he was duly elected as a Conservative Party councillor. An anonymous author in the *Glasgow Herald* celebrated this success:

> William Burrell is decidedly the most welcome of all new members of the Corporation. He brings to the service of the city proved business ability and that large grasp of affairs which the majority perhaps only hope to acquire by sitting at the Council board.[6]

Burrell's reputation as a successful businessman with vast mercantile experience was clearly recognised as something that would be of great benefit to the Corporation. The move from business to politics was therefore logical and it was only a short walk across George Square from the office of Burrell & Son to the grand City Chambers that was to be the focus of his activity over the next few years.

During his five years as a councillor, Burrell sat on twenty-two committees. These included general committees on libraries, gas supply, electricity and telephone services, as well as more special-ised committees on subjects such as the proposed friendly society, the proposed fire insurance department, and the appointment of a new Town Clerk. Unsurprisingly, he tended to sit on the finan-cial sub-committees of the majority of these groups. Finance was something that Burrell understood; within Burrell & Son he was in charge of commercial operations, and as an art collector he was con-stantly striving for the best deal.

In Burrell's pre-election rhetoric he railed against the Free Libraries Act and he followed this opposition through to his time on the Corporation. His argument was centred around the increase of taxation on the occupants of business premises and 'struggling shopkeepers'.[7] Burrell believed that these people would receive no benefit from the Act, which gave authority to town councils to establish public libraries through a tax of one penny in the pound of the assessed rental valuation.[8] The passing of the Act was reliant on a vote in its favour from the ratepayers.[9] Three such votes were held in Glasgow, all of which returned majority votes against the Act. For example, in April 1888 only 13,500 out of the 89,000 people eligi-ble to vote were in favour and 52,300 did not vote at all.[10] Burrell did not believe that libraries were an essential service for those who would bear the burden of their cost.

In December 1899, a meeting on the topic of public libraries was held. One of the members, Bailie D. M. Stevenson, argued in support of the Act and pressed for the enforcement of the Libraries of the Glasgow Corporation Act of that year.[11] This Act gave the Corporation the ability to raise taxes, build and acquire property,

or borrow money as a means to establish a public library service in the city.[12] Burrell was present at this meeting and his opposition to Stevenson was clear. His primary concern was that he did not believe the Corporation had the right to force ratepayers to pay for something that they expressed little interest in. He argued, 'The wishes of the ratepayers had been taken on the subject on three occasions, and by a consistently increasing majority they had shown that they did not want libraries.'[13] Those in favour of the Act argued that libraries were beneficial in improving the citizens' minds, regardless of the cost, but others, like the ex-Lord Provost, Sir David Richmond, stood with Burrell in opposition. Burrell's worries were directly linked to the increase of rates which had been occurring in the city. According to Burrell's calculations, there had been an increase of 20 per cent between 1890 and 1899. He argued that if this was to continue, by 1904 the excess taxation of the city would rise to £200,000 per year.[14] These staggering figures were deemed 'wild and visionary' by the City Treasurer but, although taxation did not rise quite as high as Burrell had predicted, it is clear that he was worried about the unnecessary tax burden which he felt would damage the city's financial position.

Burrell's stance against the Act highlights his belief in the freedom of the individual. By referencing the three votes, Burrell showed his determination to listen to the ratepayers' opinion. In the December meeting, Treasurer Murray compared Glasgow's status on public libraries to other cities. He discussed the Boston Public Library, which had 700,000 volumes and provisions that its citizens could use for free. He also noted Edinburgh, Manchester and Liverpool as cities which had public library facilities.[15] Murray was worried about the status of Glasgow in comparison with these other cities at a time when it was fiercely proud of its status as Second City of the Empire. Establishing public libraries was seen by some in the Corporation as an opportunity to raise its cultural capital to the same level as its industrial prestige. Burrell was not against enhancing Glasgow's cultural prestige. He just did not want to do it at the ratepayers' expense.

By opposing the Free Libraries Act, Burrell publicly aligned himself with Conservative principles. Indeed, he was active in both local and national Conservative circles at this time. In the minutes of the Glasgow Conservative Association, Burrell is listed as General Vice President from the general meeting held in January 1900.[16] Burrell appears as a member in the Association's minutes until at least the early 1940s, although he only held the role of General Vice President until around 1920. In the Association's first annual report from 1870 its mission was clearly established: '[T]o educate the public mind as to what conservatism really is, and by a clear account of what it does, show that it sincerely labours for the public good with a prudent zeal.'[17] Lord Salisbury was prime minister in 1900 and the Association acted in service to his government in Glasgow; it 'desired to express continued and unwavering confidence in Her Majesty's Ministers, and record its appreciation of their able and efficient administration of the affairs of the Empire'.[18] Burrell was also involved in Conservative circles in London as a member of the Constitutional Club. This gentlemen's club was off Trafalgar Square, and held close associations with the Conservative Party. Burrell's political beliefs explain his opinions on how best to financially manage Glasgow and his concern for the city's growing municipalisation. By opposing the Free Libraries Act, Burrell put his belief in the right to private property, individual freedom and reduced taxation for the ratepayers into action. Despite his opposition, the Act was passed in 1900 and, unsurprisingly, the following year Burrell's name did not appear on the committee's list of members.

What did take up much of Burrell's time was his role on the organising committee of the upcoming 1901 Glasgow International Exhibition.[19] As well as showing off the city's industrial prowess and its links with the Empire, the Exhibition was designed to launch the newly built Kelvingrove Art Gallery and Museum, which, for the purposes of the Exhibition, was termed the Palace of Art. In October 1898 Burrell wrote to James Paton, superintendent of the Corporation Galleries, in response to Paton's request that he be involved in the Exhibition: 'I shall be glad to do what I can

in connection with the sub-committees of the Fine Art Section although my time is much taken up. I am a good deal from home.'[20] Burrell's reference to being 'a good deal from home' was linked to the fact that he had not given up his business duties altogether and still made regular trips to the Continent. In spite of his initial hesitancy, Burrell did indeed get involved and he was able to perfectly combine his role as a Corporation Councillor with his status as one of the city's leading art collectors.

Burrell threw himself into the role and used the opportunity to show off his own collection. He had been twenty-seven years old when the city presented its first International Exhibition in 1888 and his collection was still in its infancy. Now he was forty and in possession of an exemplary art collection that could hold its own alongside the other great collectors in the country. He loaned over 220 objects to the fine art sections in the Palace of Art, making him the single largest lender of art objects.

The 'Fine Art, Art Objects and Scottish History' display in the Palace of Art was divided into seven sections: oil paintings of the nineteenth century; nineteenth-century watercolour paintings, pastels and miniatures; sculpture and architecture; works in black and white; photography; art objects; Scottish archaeology and history. Burrell loaned work to all but the photography and Scottish archaeology and history sections. He also sat on three of the seven sub-committees – watercolours, black and white (i.e. prints), and art objects – and was the sub-convenor for the Royal Reception Rooms. Other local collectors were also involved in the Exhibition. Sir Thomas Gibson-Carmichael loaned seventy-two objects to the art objects section. Sir John Stirling Maxwell of Pollok was on the art objects' sub-committee with Burrell and loaned one picture and twenty-three objects. William Allen Coats loaned fourteen works to the foreign oil paintings section, including pieces by Monticelli, Millet and Corot. Arthur Kay, who was on the sub-committee for oil painting, loaned fourteen works on paper. Set among these well-known established Scottish collectors, it is clear that by 1901 Burrell's collection was very much their equal. However, it was the

generosity of Burrell's loans, paired with his work on the various sub-committees, that singled him out amongst his contemporaries. In James Paton's report on the fine art sections of the Exhibition, Burrell's contributions received special mention in the oil painting, watercolour, black and white, and art objects sections.[21] In his review of the sculpture section, although no specific collectors were referenced, Paton acknowledged the work of Auguste Rodin and Charles van der Stappen as two of the Exhibition's examples of 'eminent continental . . . sculptors'. Burrell loaned works by both of these artists: *La Glaneuse, Maternity* and *Un Vieux* by Van der Stappen, and *Fleeting Love* (referred to in the catalogue as *Maternal Love*) by Rodin.

The *Edinburgh Evening News* for 24 April 1901 reported on how artists from the new Glasgow School, such as E. A. Walton and James Guthrie, helped the lay members of the art committee to hang the pictures.[22] Burrell lent three British oil paintings, five British watercolours, five foreign watercolours, thirteen foreign oil paintings and twelve black-and-white works. These included Lavery's painting of his sister Mary, three paintings by Joseph Crawhall: *The Cockatoo, The Pigeon* and *The Black Cock*; two works by Whistler: *The Fur Jacket* and *La Princesse du pays de la porcelaine*; seven works by the British cartoonist Phil May; eight works by Jacob and Matthijs Maris; one work by Manet; and two by Monticelli. The purpose of the fine art sections was to illustrate the progress of art during the nineteenth century and many of these were artists who were popular in Glasgow and regularly hung at the Art Institute's exhibitions.

In contrast, the Royal Reception Rooms were decorated in a much more conservative style with old master paintings, antique furniture and stained glass. It was in these rooms that the royal guests, the Duchess and Duke of Fife, were to be entertained at the formal opening of the Exhibition. The catalogue of paintings from the rooms described them as 'being gathered together at the eleventh hour, being the outcome of a strong desire on the part of a few to show pictures other than those of the nineteenth century'.[23] As Burrell was a sub-convenor for the rooms, we can assume that he

was one of these few. The East Room included furniture and stained glass lent by Burrell. The West Room included Burrell's *Portrait of Infanta Maria Theresa*, at the time attributed to Velasquez. The choice of a Spanish seventeenth-century portrait is interesting in the context of Glasgow Conservatives. Sir John Stirling Maxwell's father, Sir William Stirling Maxwell, 9th Baronet, had formed the largest and most comprehensive collection of sixteenth- and seventeenth-century Spanish works in Britain, numbering 130 paintings.[24] Sir John was on the hanging committee as well as being a member of the royal reception party and perhaps, through his loan, Burrell was highlighting his affinity with the Stirling Maxwell family both in their taste in art and in their politics.

As well as paintings, Burrell loaned a significant number of objects to the Exhibition. Indeed, roughly two-thirds of his loans were decorative art objects. These included Gothic tapestries, Persian carpets, brass wares, medieval stained glass, furniture and glass. His family also loaned works; brother George loaned *The Black Rabbit* by Crawhall and *Oysters and Still Life* by Bonvin, showing a similarity in the brothers' taste. George also lent furniture and Swiss sixteenth-century stained glass to the Royal Reception Rooms. His sister Mary loaned stained glass, displayed in a case with Burrell's own examples. A 'Miss Burrell' also had a case in the same gallery entitled 'Miscellaneous Collection of Objects of Art', however the catalogue does not make it clear which of the Burrell sisters this was referring to. His mother, Isabella, loaned a Spanish fifteenth-century coffer and three Southern Netherlandish tapestries dated to around 1500 – *The Months: January*, *The Months: April* and *The Months: September*.

For Burrell this was the first major loan exhibition of his collection and he wanted to make an impact. Including work from his family in such an international public setting allowed Burrell to present himself as coming from a family with a strong collecting pedigree rather than simply being yet another businessman collector. The number and quality of the pieces he exhibited, along with the very public work that he put into the organisation and running of the

Exhibition, ensured that Burrell considerably enhanced his status. To see the *North British Daily Mail* report that 'Baron Rothschild, the Duke of Argyll, Lord Kinnoull, the Earl of Mansfield, Councillor William Burrell, Mr James Cowan, the Duke of Portland, and others have given of their best' would surely have stoked his pride.[25] He had long been recognised as a successful businessman and now his name was nestling among the great noble art collectors.

Burrell was also involved in the Austrian section of the Exhibition.[26] He went to Vienna in January 1900 on consular duty, and it is likely that the Exhibition formed part of his business there.[27] The Austrian section in the Industrial Hall included Royal Vienna Porcelain, Bohemian glass and a variety of industrial goods, while in the Palace of Art there was a selection of porcelain, bronzes, ivories, furniture, clocks and other decorative items on loan from the Viennese porcelain artist and art collector Franz Dörfl. This collection was sold off at the end of the Exhibition by Lyon & Turnbull, but it is not known if Burrell made any purchases.[28] Burrell was also part of the organising committee of the International Engineering Congress that was held alongside the Exhibition in September 1901.[29] The 1901 Exhibition therefore combined his key interests and duties as a shipowner, local councillor, Austro-Hungarian consul and art collector, and further boosted his professional and social status.

Apart from his role in the 1901 Exhibition, Burrell did not have any formal remit over the city's museums as a councillor. However, this did not stop him from getting involved. He would occasionally contact the head of museums, James Paton, with suggestions for exhibitions and potential acquisitions. In the year following the 1901 Exhibition, one of the major lenders put his collection up for auction and Burrell wrote to Paton emphasising the importance of the sale:

> As you are aware Sir Thos. Gibson Carmichael's treasures require unfortunately to be sold. I know the collection well and to my mind it is without exception the finest private collection in Scotland. I understand that . . . everything is

to be sold without any reserve and I think that it is a <u>great</u> opportunity for the council to acquire beautiful works of art at very moderate prices which will be far below what they cost.[30]

On the same day he wrote to Bailie Shearer, chairman of the Corporation's museum committee, 'I hope that your committee may see its way to have works of art inspected by me or the two of the number with a view to making some purchases. There certainly has not been as great an opportunity for many years.'[31] The sale included 'early ivories, bronzes, enamels, ecclesiastical and other silver work, terra-cotta' as well as 'old Chinese porcelain and French decorative furniture of the eighteenth century; and a few fine old Italian pictures'.[32]

Burrell himself visited the preview of the sale on 10 May with Robert Lorimer. Lorimer noted that he and the collector 'had a most interesting time going round the things . . . Then he had asked two old blokes who were up from the Glasgow Corporation to make purchases to dine'.[33] Evidently Paton and Shearer had taken Burrell's advice on board.

In the same month that the 1901 Exhibition opened, Burrell proposed to Constance Mary Lockhart Mitchell. She was the sister of Ralston Mitchell who had accompanied Burrell on his European trips. Ralston and Mary Burrell had got to know each other on one of these trips and he proposed to her on a balcony at Heidelberg Castle. They were married at Hillhead Parish Church in January 1901. As the two families socialised the young Constance, described as 'a fine-looking girl, charming, dignified and elegant', caught the eye of William and in June 1901 they announced their engagement.[34] They were married at the Westbourne United Free Church on 19 September 1901, with Robert Lorimer as best man. William was forty and Constance was just twenty-five, but this was very much a marriage of financial equals. Constance was the daughter of the leading merchant and shipowner James Lockhart Mitchell. He had been a partner in Edmiston & Mitchell, the foremost timber merchants in

Glasgow and had numerous directorships in iron, coal and insurance companies, as well as being vice-president of the Glasgow Chamber of Commerce. When he died in 1893, he left a massive net estate of £130,530, which was divided amongst his six children. Constance was therefore a woman of very considerable independent means before her match with William Burrell. She also shared William's love of art. Although her father was not a major collector, he showed a keen interest in art. He attended the opening of the Italian Art Loan Exhibition at the Corporation Galleries in 1882 and owned a number of paintings and engravings.[35] Constance grew up in a house where art was appreciated and later started collecting in her own right.

Two months after Burrell's proposal he purchased a house in Glasgow's West End for the couple to live in. Their new home at 8 Great Western Terrace was only two doors down from Constance's family home, at number 10, and just along the street from Burrell's mother at Devonshire Gardens. The exterior of 8 Great Western Terrace was neoclassical in style, designed around 1860 by Alexander 'Greek' Thomson. Originally the interior of the house was decorated in Greco-Egyptian style, but this was not to Burrell's taste and so he asked Robert Lorimer to completely redesign it.[36] He wanted Lorimer to create a more baronial feel that would better complement his collection. If he could not own a castle, he could at least make his townhouse feel like one. Given their shared experiences of hunting for antiques on the Continent, it is not surprising that the schemes designed by Lorimer paid homage to Northern Europe. In 1901 Lorimer wrote to his close friend and colleague Robin Dods regarding his commission,

> I'm going to alter it for him, 'chip away the ginger bread' as he expresses it, also the plush mantelpieces etc etc rather a nice job . . . He wants it very simple as he has such lovely 'contents' – I want to do a simple black and white floor in the hall with oak walls, balustrade, etc and give him a white drawing room in which to hang his Whistlers etc . . .[37]

Photographs of the interiors of the townhouse show that Lorimer followed Burrell's call for simplicity. In the main entrance to the home the walls were covered in a Gothic-style linenfold oak panelling: a simple style of relief carving that imitates the folds in linen. This panelling was designed by Lorimer and carved by W. & A. Clow in Edinburgh. In the centre of the picture of the hallway there is a decorative mantelpiece, which was adapted from a late-medieval Valencian predella, the platform on which an altar is placed in a church.[38] Three statuettes were placed on top of the mantel: an emaciated depiction of Christ on the left, a Madonna and Child in the centre and St George on the right. On either side of the mantelpiece are two paintings, on the left we see Lucas Cranach the Elder's *Venus and Cupid, the Honey Thief*. Unfortunately, the painting to the right of the mantelpiece is unidentifiable. However, it is likely to have been an old master to match the Cranach picture. This photograph gives a sense of how Burrell wanted the interiors to complement his objects. The plain oak-panelled background suited his growing late-Gothic collection.

Another photograph shows the main staircase. The wooden stairwell is decorated with newel posts topped with carved heraldic animals and balusters intermittently decorated with Arts and Crafts-style foliage. The beasts depicted on the posts are lions, monkeys, an elephant and a hound. At the bottom of the stairs two lions are depicted in front profile, seated and collared. On the left-hand side of the first landing is a seated monkey, with nuts placed between its legs. Opposite this is another monkey holding pineapples in its arms. Above these two humorous monkeys are two further depictions of monkeys, this time both of a mother with a baby clinging to her chest. The inclusion of the maternal apes could be a reference to Burrell's marriage to Constance and the couple's desire to build a family.

Lorimer was a recognised Arts and Crafts architect-designer, and so his choice of decoration would have followed the movement's call for imagery to hold some symbolic intention and to reference historical and natural motifs.[39] Within the language of heraldry

animals hold specific meaning. Considering those on the stairwell, the lion is defined as 'The noblest of all wild beasts, which is made to be the emblem of strength and valour'; and the monkey (or ape), 'An animal well known for its sagacity'.[40] Placed together, the lion and monkey tell a story of their patron's nobility and wisdom. This stairwell, which would have been seen by anyone who visited their home, projected a narrative within which Burrell wanted himself and his family to be placed through the use of traditional, recognisable historical imagery.

According to Lorimer's correspondence with Dods, Burrell was not always happy with the townhouse's interiors. In January 1902 the architect wrote to his friend,

> [I] have at last got him to enthuse a bit over his house – seeing his Gothic tapestries hung up in his dining room was what did it. His dining room is now to be tapestry all round. The 3 Gothic hunting scenes he had in the Glasgow exhibition just fill one side and he's going to have a tear round the continent in the spring to try & find some more.[41]

These were the tapestries that had been loaned under his mother's name to the 1901 Exhibition. The dining room itself was furnished simply: a Gothic-style table designed by Lorimer placed in the middle of the room was accompanied by chairs and a low seventeenth-century dresser. This type of interior scheme was fashionable at the time and the photographs of 8 Great Western Terrace were published in *The British Home of Today* in 1904, highlighting the currency of the scheme.[42]

The dining room also held examples of modern European sculpture: Constantin Meunier's *Le Marteleur* (*The Hammersmith*) and van der Stappen's *La Glaneuse* (*The Gleaner*) can be made out in the photographs. A photograph of the first-floor landing shows Rodin's *Fleeting Love* placed under a sixteenth-century tapestry entitled *Charity Overcoming Envy*. This pairing of nineteenth-century bronze sculpture with Gothic tapestries was somewhat unusual and suggests

a desire of Burrell's to juxtapose modern and medieval works of art as a means of highlighting the depth of his collection and his refined taste.

In the dining room we see Burrell following a thoughtful interior decorative scheme where his carefully placed objects suited their context. Just as the heraldic animals on the newel posts of the stairwell held symbolic meaning, the tapestries and sculptures chosen for the dining room also reflected Burrell's identity. The secular scenes of the tapestries, showing the processes of hunting, gathering and feasting, paired with bronze sculptures of workers, reflected the function of the dining room.

The Arts and Crafts movement was inspired by historical objects as well as traditional materials or methods of manufacture.[43] It was an interest in things from the past, as well as traditional manufacturing methods and materials, that drove the movement. As a collector of historical works of art ranging from painting to furniture, tapestry, glass, lace, porcelain, sculpture and much more, Burrell followed the movement's philosophies by championing the craftsmanship of the past. We can see his interest in the thinkers of the Arts and Crafts movement through his personal library.[44] He owned books by Thomas Carlyle, John Ruskin and Sir Walter Scott: all central figures in the movement. Scott's novels promoted interest in medieval literature and history, Ruskin's *Stones of Venice* (1851–53) especially inspired a taste in the Gothic style, and Carlyle's *Past and Present* (1843) emphasised the moral importance of work. *Stones of Venice* has not survived in Burrell's library, however, the presence of four other works by Ruskin suggest Burrell's interest in his writing. His library holds fifteen works by Carlyle, including *Past and Present*, and eighty-two works by Scott, the largest number of works by one author, illustrating his admiration for Scott's medievalism.

Throughout the house, varying types of craftsmanship were on display, including examples of tapestry weaving, woodwork in sculpture, stained glass and bronze casting. This love of craftsmanship can also be seen in the furniture that Burrell commissioned Lorimer to design for the house. By now Constance was pregnant and so Burrell

commissioned Lorimer to create an appropriate cradle. In another letter to Dods, Lorimer referred to the cradle,

> I sent you a scribble yesterday – containing 2 letters from Willie Burrell which I thought would amuse you – isn't he a record breaker? Think of going into the question of a cradle with such thoroughness – 2 or three months before the kid is due! Last Sunday was wet – so I stayed home & drew the whole thing out full size. Have put a hound on the top of the pillar at the foot & the pelican in her piety on the one at the top, won't that rather lift the bun? Brushed out with wire brushes and fumed – its own mother won't know it from a piece of 'French Gothic late 15th century'.[45]

As with the newel posts on the staircase, Lorimer used heraldic creatures in his design for the cradle. Along with the pelican were winged angels kneeling in prayer. Lorimer used similar imagery in a proposed sketch for Burrell's double bed: lions were accompanied by crowned angels playing musical instruments and a swan. The decorative elements of the bed, cradle and stairwell all correspond in subject, style and medium creating continuity throughout the house and illustrating Burrell and Lorimer's consideration for all elements of the interior schemes for the townhouse. The design scheme was so important that a modern contrivance such as a telephone had to be hidden from sight by a curtain.[46]

One room that stands out in contrast to the others is the white drawing room that Lorimer referred to in his letter. The photograph shows a fireplace topped with three Chinese painted porcelain vases. To the left of the fireplace the side of Whistler's *La Princesse du pays de la porcelaine* can be seen. It can be assumed that *The Fur Jacket*, which Burrell had in his collection at this time, was also hung in this room. Both were full-length portraits of women and they had been hung together at the 1893 World Columbian Exposition in Chicago and the 1901 Glasgow International Exhibition. Although apparently out of place, the white drawing room still adheres to the

established Arts and Crafts principle of simplicity in interior deco-
ration, where plain white walls should only be interrupted by what
was functional or beautiful.[47] The Whistler paintings would have
looked out of place displayed on oak-panelled walls. By setting them
against plain white walls their beauty as objects was highlighted.[48]

In the newly decorated family home, Constance gave birth to a
daughter, Marion, on 6 August 1902. Despite William engaging
the best medical care through Professor Murdoch Cameron of the
Royal Maternity Hospital, it was not an easy birth and Constance
suffered terribly as a result. She endured great physical pain and
developed what we now call postnatal depression. A couple of years
later Constance had to have an operation on her kidney and again
had a long and difficult convalescence. As a result, Constance was to
suffer physical and mental ill health for the rest of her life. Although
the physical side of their marriage was now over, William remained
devoted to his wife and provided her with the best possible care.[49]

When the house was nearing completion, like all good collectors,
William Burrell decided to have something of a clear-out. He put
up thirty-nine paintings for sale at Christie's in London. The first lot
in May 1902 included works by Daumier, Manet and Whistler, as
well as Steer's *Jonquil*. The second sale in June 1902 included works
by Degas, Millet, Hornel and Lavery. Quite why he decided to sell
is not clear. He later stated that he 'had to sell' but if the intention
was to raise funds it was not entirely successful.[50] Not everything
sold and the prices raised were not that high; the best was a Daumier
which went for 300 guineas. Later that year he also sold off his share
in the Austro-American Line which would certainly suggest that he
was trying to raise capital. He had more success the following year
when he sold Whistler's *La Princesse du pays de la porcelaine* to the
Detroit industrialist Charles Lang Freer for £5,000.[51]

Burrell continued to lend paintings during this time. At the London
Corporation Art Gallery annual loan exhibitions he lent a Chardin
still life in 1902 and three works by Matthijs Maris in 1903.[52] Two
of these Maris works, *Butterflies* and *Montmartre* returned to London
the following year for the Whitechapel Art Gallery's exhibition of

Dutch art.[53] Whistler's *The Fur Jacket* was particularly well travelled, appearing in Edinburgh in the Royal Scottish Academy show of 1903, the Copley Society's exhibition in Boston, Massachusetts in 1904, and the International Society of Sculptors, Painters and Gravers' Whistler memorial exhibition in London in 1905.[54]

Meanwhile, Burrell's work in the Corporation continued apace. A portrait appeared of him in the gossipy Glasgow periodical *The Bailie* in November 1902 which painted a rather glowing picture:

> Though Mr Burrell has only completed three years of Municipal service, he has already made his mark in the Council Chamber. On the discussion of many important questions he has shown ability and critical power of the highest order, and in all his utterances he gives his colleagues matter for pause and reflection, especially in regard to questions which deal more or less directly with Municipal Finance.[55]

Such was his tenacity in defending the ratepayer's interests when it came to setting the Corporation budget that his interjections were known as 'Mr Burrell's annual wail'.[56] He may have been a fierce and dogged defender of fiscal responsibility, but he was well liked and respected. He was described as having a 'bright and agreeable disposition' that made him 'the most delightful of companions'.[57] In 1903 his devotion was rewarded by being appointed as a city bailie, which gave him additional civic duties and the responsibility of acting as a magistrate.[58]

One of the areas that he was keen to progress was the housing crisis and in 1904 he became the convenor of the sub-committee on 'Uninhabitable Houses, Areas and Back Lands, and Underground Dwellings', which was charged with overseeing Glasgow's slum clearance.[59] The fact that Burrell's parents had owned tenement buildings in Crown Street in the Gorbals, an area that was noted for its slums, may have influenced his thinking on this issue. Burrell's dedication to alleviating the city's slum crisis was noted in his lifetime; in his obituary in the *Glasgow Herald* the then Lord

Provost, Andrew Hood, recalled that Burrell had claimed that 'he had become so much impressed by the necessity of doing something about Glasgow's serious housing problem that he decided to sell all his ships'.[60] This is something of an over-simplification, but clearly demonstrates how important the issue was for him.

Two years before Burrell's election, the Public Health (Scotland) Act was passed which provided legislation to control the construction of houses. At the first meeting of the Uninhabitable Houses sub-committee in November 1904, the committee members laid down their purpose. This mission was 'in all respects to execute the provisions of Sections 74, 75 and 76 inclusive' of the 1897 Act.[61] These three sections stated that the letting of a room without at least one external side completely above street level was illegal.[62] Such rooms found being let after 1894 were penalised, with fines amounting to up to twenty shillings per day for the first offence. For any further offences the sub-committee was granted the power to recommend the closure of the premises.[63]

The sub-committee was also responsible for the enforcement of Section 30 of the Housing of the Working Classes Act of 1890. This referred to houses which were deemed unfit for human habitation because of overcrowding, sanitary or structural factors. The sub-committee was given the right to recommend the closure or demolition of such houses. In the year that Burrell became sub-convenor of the committee, the uninhabitable status of 121 houses was assessed and the letting of seven underground dwellings was prohibited.[64]

Burrell was only on the sub-committee for a year and he left the Corporation completely in 1906. Shortly afterwards, invited by Dr A. K. Chalmers, the Medical Officer of Health for Glasgow, Burrell gave a paper to the Glasgow Civic Society on the subject of 'Back Lands in relation to the Housing Problem'. Burrell's paper outlined his personal opinions and worries on the subject of the Glasgow slums.[65] He covered three areas: clearing away the slums, the effect on health, and corporate housing. In the first he spoke critically on the origins of the slums, deploring the Dean of Guild Court for only concerning itself with ensuring that the front tenement blocks

were built in line, ignoring the mass of overcrowded buildings that lay behind them. He then described the part that the Back Lands Committee played in the clearing of the most affected areas of Glasgow. Burrell went on to applaud the work of Dr Chalmers who ensured that dispossessed people were given better homes. Whilst the cost of these were around £1 more per year, Burrell stated that 'in nineteen out of twenty cases that simply means £1 less to spend on drink', an opinion that the audience shared.

Burrell went on to discuss the slums' effect on the health of Glasgow's poorest classes, relaying the progress that had been made since the formation of the Back Lands Committee in 1901. He cited that between 1901 and 1905, 211 properties, including 2,000 apartments, had been taken down or agreed to be demolished. The death rate of Glasgow in the same period had fallen from 21.1 to 17.5 per 1,000 people. In conclusion, Burrell described his views relating to the issues which surrounded new housing. When asked whether a solution for the problem was to build houses for the poor, he replied,

> The houses owned by the Corporation of Glasgow . . . were to the extent of three-fourths tenanted by well-to-do trades-men, tramway servants, policemen, small shopkeepers, etc., while the remaining fourth were occupied, not by the 'poorest classes' but by the 'respectable poor'. They began with the best intentions – to cure the evil which existed in the slums – but they finished by building houses for quite another class.

Burrell's closing statement showed his frustrations with the way that the Corporation was dealing with the housing problem. Rather than building new houses, he believed that the council 'should clean up the town so that it would be impossible for any man, woman, or child to live in a house that was not fit for human habitation'. Only then could the problem be solved with 'business-like methods' which would 'involve the ratepayers in neither expenditure nor taxation'. Clearly, in matters of social improvement, his Conservatism was strongly rooted.

In 1904 Burrell took on another public duty as a governor of Glasgow School of Art. He became one of fifteen members of the School Committee, chaired by the Glasgow architect William Forrest Salmon.[66] On the committee was fellow shipowner Robert S. Allan, whose brother Claud was married to Constance's sister Ada, showing just how closely Glasgow's worlds of commerce, family and public service were intertwined.[67] From the minutes of the committee, it appears that Burrell was not in attendance at many meetings and two years later his name is not listed as a governor in the annual reports.[68] However, in 1906 he reappears in The Glasgow School of Art records, this time on the committee for the completion of the Mackintosh School of Art building.[69] Other members of the committee included: Sir Frances Powell, the first president of the Royal Scottish Water-Colour Society; Thomas McArly, the president of the Glasgow Chamber of Commerce; and Hugh Reid of the North British Locomotive Company and a major art collector. Although Burrell's name is listed initially, he did not stay on the committee until the building's completion in 1909. While not the most active member, his position on these committees demonstrates his growing status and his support for the ideals of the school in developing art and craft skills in the city.

In March 1905 Burrell had another clear-out of his collection. This time he used the local dealer Robert McTear who advertised a sale of the 'property of William Burrell Esq' which included 'antique furniture, bric-a-brac, art brass work, German cut glass, oriental carpets; also, two etchings by Whistler, and several original drawings by Phil May'. The advert made a point of stating that these had been 'removed from stores for convenience of sale', suggesting that this was excess stock that was not part of the design scheme at 8 Great Western Terrace.[70] A French walnut escritoire was sold for £150, a carved Italian bedstead went for £90 and some Persian carpets for £30 each, but most lots went for between £10 and £24.[71] The fact that he was selling off considerable parts of his collection did not mean that he had stopped collecting. He had acquired some significant pieces from the Gibson-Carmichael sale including Cranach's

Venus and Cupid, which had featured in the Royal Reception Rooms of the 1901 International Exhibition, and a Southern Netherlandish tapestry depicting *Charity Overcoming Envy*. He also purchased some Dutch seventeenth-century paintings from Alexander Reid including the *Interior of the Oude Kerk, Delft* by Van Vliet. One of the more striking works he acquired during this period was a portrait of his mother commissioned from George Henry. Burrell was an exacting client and rejected Henry's first attempt, only to declare, once it had been destroyed, that it was better than the second version. The result however is very distinguished, with tones of Velázquez and Whistler. It is a fitting homage to his mother who was such a major influence on his business and collecting careers.

At the council election in November 1905 Burrell was returned unopposed. His three-year term as bailie had come to an end but he was swiftly appointed as a Justice of the Peace so he was able to continue his magistrate's duties.[72] However in January 1906 he tendered his resignation, stating that he had 'returned to business and would not be able to devote the time to the Town Council which it required'. The Lord Provost accepted his resignation with very deep regret: 'Bailie Burrell had given them six years most arduous and effective service, especially on the Health and Backlands Committees, and his retiral would be a distinct loss to sanitary progress in the city'.[73] Despite the high praise, Burrell had found committee work on the Corporation deeply frustrating. In business he was used to being in command. He was ruthless and able to make quick decisions which saw swift results. The world of politics moved at a much slower pace and required patience and negotiation to overcome opposition. It also didn't pay. Local councillors did not earn a salary, instead it was seen as an honour to represent your ward. Burrell had shown his devotion to his native city for a little over five years, but he was used to making money and having his own way. It was time to get back to what he was good at. As Provost Hood recalled, Burrell 'became so disappointed over his inability to realise his ambition that, in his own words, he "bought back his ships and became a millionaire shipowner again"'.[74]

CHAPTER 4

Shipping Magnate

Although the Burrell & Son fleet had been sold off in 1899, the office in George Square still remained active. Some parts of the operation were wound down such as the West Indies service which stopped at the end of 1900, and the share in the Austro-American Line was sold off in 1902. The canal business was also run down around this time. The canal office at Port Dundas had closed in the 1890s and the business was transferred to William Jacks, an iron merchant who transported iron along the canal. The number of vessels built at the Hamiltonhill boatyard dwindled to only one or two a year and the last launch took place in April 1903. Their business as brokers and shipping agents carried on as before, however, and they kept on many of the agencies for the Mediterranean shipping companies. They also continued to be managers of the Austro-Hungarian service, with steamers regularly sailing between Glasgow and Fiume. In addition, William Burrell became an agent for the Veritas Austro-Ungarico ship classification society in 1900. This was similar to Lloyd's Register and the British Corporation, and the agency was 'for the purpose of inspecting, visiting and classifying vessels of any kind, whether under construction, floating, under repair or under reconstruction'. This meant that not only did Burrell have consular responsibility for any Austro-Hungarian ships being built or repaired on the Clyde, but he would now also profit from overseeing and approving any work.[1]

Following the end of the Boer War in 1902 there was a general slump in shipping. During the war, shipowners rushed to take advantage of the high freight rates by ordering new ships, but once

the war was over freight rates fell, the demand for shipping fell and there were simply too many ships for post-war levels of trade. The shipping industry remained depressed for several years and by August 1904 *The Economist* was reporting that three-quarters of the world's ships were 'utterly unremunerative' and large numbers of ships were laid up around Britain's ports. With too many unprofitable ships already on the market, the shipbuilding industry fell into another of its periodic slumps. As *The Economist* reported, 'the prospects for winter in the shipbuilding districts are at present very gloomy'.[2]

This was music to William Burrell's ears and the temptation of making a bargain proved too much. In the autumn of 1904, he began making preparations for an audacious return to shipowning. James C. Stewart, the chief engineering superintendent, was tasked with coming up with a standard design that would be used for a new fleet, while Burrell got to work planning a new structure for the way the business would manage its ships. At the beginning of January he placed orders for ten ships with lower Clyde ship-builders; six with the Grangemouth and Greenock Dockyard, two with William Hamilton, and one each with Anderson Rodger and Robert Duncan. A few weeks later ten individual steamship companies were registered. The capital for each was £23,000 divided into £100 shares. The subscribers for all ten companies were William and George Burrell, their wives Constance and Anne Jane, and three long-standing Burrell investors: Andrew Muir, a muslin manufacturer in Bridgeton; William Clarke, a retired iron merchant; and R. D. Mitchell, a chartered accountant. As *Lloyd's List* explained, 'the object of the company is in each case to acquire a steamship now in course of construction and intended to be called by the name of the company'.[3] The number of shareholders in each company was limited to fifty and the shares were not offered for public sale. Instead, they were distributed among friends, business associates and family members so that very tight control could be maintained by the Burrell & Son partnership (i.e. William and George), which in each case was the majority shareholder and acted as the manager for all the business conducted by the company.

Shares were taken up by some of the leading industrialists of the day such as structural engineer Sir William Arrol, steel maker and shipbuilder William Beardmore, decorative ironfounder Walter Macfarlane, and carpet manufacturer James Templeton. Other investors included the scientist Lord Kelvin; Sir Archibald Ernest Orr Ewing, son of Conservative MP Sir Archibald Orr Ewing who had earlier been an investor in Burrell ships; and August Schenker-Angerer, Burrell's former partner in the Austro-American Line. Female investors remained an important feature of the Burrell & Son business, so for example the Strathairly Steamship Company had thirteen different female shareholders, including Constance, Anne Jane and Isabella Burrell. As before, family members formed an important group of investors across all of the ships built during this period. Isabella had the highest number of shares at 102, Anne Jane had fifty and Constance forty-seven. Ralston Mitchell had seventy-five shares and Mary Mitchell had eight. Constance and Ralston's brother, Robert Douglas Miller Mitchell, also had twenty-six shares. George's mother-in-law, Helen McKaig, had six shares and his daughter Gwladys and son Gordon had one share each. Gwladys's future father-in-law Bryce Knox also had ten shares. It was quite a family affair.

The ships were all of the same standard design that was described as 'a fine example of the modern cargo carrier'. They were 370 feet long, had two decks and a gross tonnage of 4,400 tons. They were fitted with triple expansion engines of 350 horsepower and 'furnished with all the latest and most approved appliances for the quick handling of cargo', including nine steam winches, and double derricks at each cargo hatch.[4] They also had double bottoms that meant that they could easily be trimmed with water ballast to get the best sailing characteristics. 'Excellent accommodation' was provided for the officers and engineers amidships below the bridge, but the crew accommodation in the forecastle was intended for Chinese seamen, for whom the regulations allowed a smaller size and poorer standard than for British crews. All this was designed to carry 7,100 tons of cargo at a speed of 10 knots as efficiently as possible.

Even before the first ship was launched rumours started to spread about another large order from Burrell & Son later that same year. The impact of this is summed up perfectly by *Lloyd's List*:

> As to orders for new vessels it is very difficult to know what to make of those announced to-day. Messrs William Burrell and Son, Glasgow, who already have ten vessels building, are credited with other six large cargo steamers. One of these is to be built by Messrs A. Rodger and Co., Port Glasgow; another by Messrs R. Duncan and Co., Port Glasgow; and four by Messrs Wm. Hamilton and Co., Port Glasgow. These are given as 'currently reported on 'Change',[5] and while they may all represent real work, it is difficult to believe that one firm, especially one which at present has no boats whatever, should build, practically at the same time, 16 cargo steamers. If this is the case it shows that Messrs Burrell, at any rate, believe that there will soon be either a great deal of work for cargo steamers or a good market for them.[6]

If even *Lloyd's List*, the world's leading specialist shipping newspaper, found this news hard to believe, then it is easy to imagine the consternation across the rest of the industry. In fact, the order was for ten more vessels, all more or less identical to the first batch. Two were ordered from Napier & Miller at Old Kilpatrick and the rest were shared out among the first set of builders. The contract price for all of them was around £40,000, which was at the absolute limit of profitability for the yards, and in fact some ended up making a loss. For example, Robert Duncan made a loss of over £2,000 on each of the contracts for *Strathairly* and *Strathdee*.[7] Not that that would have troubled Burrell. Business was business and the primary aim was to make as much money as possible.

This was more than emphasised at the launch of the first steamer, which, unlike some previous Burrell launches, was a grand affair. The *Strathearn* was launched from the Grangemouth and Greenock Dockyard on 19 October 1905. Among the 'large and representative

company' that attended the launch were Lord and Lady Kelvin, Professor Henry Dyer, the Provost of Greenock, members of the Burrell family, representatives of the builders, several shareholders and sundry other guests. Lady Kelvin launched the vessel and afterwards the guests adjourned to the drawing office for cake, wine and speeches. William Millar, head of the shipyard, proposed success to the *Strathearn* and 'hoped that she would prove everything that the shareholders could desire, especially in the way of dividend earning'.[8] He then went on to make a rather pointed remark: 'They knew that shipowners like shipbuilders had often a hard struggle to make both ends meet and he congratulated the Messrs Burrell in having placed their contracts at a time when prices had reached a low level.' Bailie Burrell, as he was then, replied promising that 'his firm would do everything in their power to make the *Strathearn* as successful as possible'. Lord Kelvin then weighed in, complaining that unfair legislation and burdensome safety measures had put British ships at a disadvantage. He hoped the (Liberal) government would see sense and legislate to put British private ships in a better position. This would have been a welcome message for Burrell. There was nothing about the beauty of the ship or the majesty of the sea, just profit.

Another two ships were ordered in February 1906, this time from the Middlesbrough shipyard of Craggs and Sons, bringing the total number of ships ordered in just over a year to twenty-two. Other shipping companies quickly followed Burrell's lead in ordering new tonnage, which inevitably led to further overcapacity, depressed freight rates and another slump in shipbuilding. Typically, Burrell & Son used this as an opportunity to expand further. When the Clyde shipyards were again struggling for work and laying off workers in the summer of 1908, Burrell placed orders for another eight ships: four going to the Grangemouth and Greenock Dockyard, two to William Hamilton, and two going to the Dumbarton shipbuilder Archibald McMillan. Finally, in 1911, four more ships were ordered from the Grangemouth and Greenock Dockyard. Two entered the Burrell fleet to bring the number of ships up to thirty-two. The

remaining two were sold on the stocks to the Romanian government for an inflated price of £60,000 each.[9]

This was extraordinary. Normally shipowners would order one or two ships at a time, perhaps half a dozen at most. This buying spree rapidly propelled Burrell & Son into being one of the largest tramp shipping companies in the UK. This was only possible because Burrell had the capital reserves for the initial investment, as well as the confidence of the business community to secure additional investors. It was a bold and risky move, but William Burrell's business strategy of creating individual limited liability companies for each ship minimised the risk. The structure of these companies also ensured that Burrell & Son's profits were maximised. As managing directors, they received a commission on every ship that was purchased and were paid an annual management fee. If any ship was sold, they received a broker's fee and if any company was wound up, they acted as liquidators and received an additional fee for this service. At every turn they stood to benefit, quite apart from any profits of actual trading.

The design of the ships also enabled Burrell & Son to be incredibly efficient in its operations. Every ship was more or less identical, which meant initial savings in terms of design and build costs. They used modern reliable technology that meant the ships were efficient to run and required fewer crew. It also meant that it was easier to manage the ships if they each had the same number of crew, the same cargo-carrying capacity and the same speed. Planning wage bills and maintenance was simplified, and overseas agents didn't need to worry about which ship might match a cargo as they were all the same. Using Chinese crews also saved about a quarter on wages compared to British crews.[10] Having an entire fleet of identical ships was almost unheard of in other shipping companies and provided Burrell & Son with a distinct competitive edge.

As the ships were launched, they were immediately put to work. These were again tramp steamers and sought profit wherever the opportunity arose. When the San Francisco earthquake hit in April 1906 there was a desperate need for building materials so four of the newly launched ships were quickly loaded with steel and cement

and despatched to the disaster zone. There was no set pattern to the trade, so, for example, cargoes might include sugar from Java to Greenock, grain from Australia to Hamburg or nitrate from Chile to the east coast of America. Ships were also frequently chartered to other shipping companies, particularly in America, where there was not a strong merchant shipbuilding industry. Many of the ships carried goods to Australia, where it was noted, 'They are purely and simply cargo carriers, and have traded to the Commonwealth chiefly under charter to other steamship lines.'[11]

The search for efficiency unfortunately did not lead to happy ships. In 1908 ten of the Chinese crew of the *Strathyre* jumped overboard into New York harbour rather than suffer another voyage. Two of the men drowned as their pigtails had been tied together. At the inquest, the coroner declared that he had never heard of such brutal inhumanity as that meted out by Captain Donald Gunn to his Chinese crew.[12] Many other Chinese crew members regularly jumped ship, although in less dramatic fashion. While the Chinese seamen lost their lives or livelihoods, Burrell received an insurance pay-out for each of the men who deserted.[13] Two years later Captain Gunn also disappeared over the side in an apparent suicide.[14] Another ship that had its troubles was the *Strathspey*:

> Of her complement of thirty-eight officers and men only eight are whites, the remainder being Chinese, Arabs and Lascars. Off Port Natal a Chinese stoker was killed by falling into the hold, and for three days afterwards the steamer merely drifted, the other stokers refusing to work on the ground that the ghost of the dead man was prowling about the stokehold.
>
> In the Canton River one of the Chinese coolies working the cargo was knocked on the head by a heavy chain and instantly killed.
>
> Off Malta the chief engineer, James McMurray, jumped overboard, and nothing was seen of him again, although a prolonged search was made.[15]

These are perhaps extreme examples, but they are symptomatic of the harsh and brutal life aboard British tramp steamers in the early years of the twentieth century. Burrell & Son ships were really no better and no worse than the majority of ships where life was cheap, and profit was the driving force.

While Burrell & Son was focused on the modern and efficient, William Burrell's private interests were of a decidedly more ancient character. In 1902 he joined the Glasgow Archaeology Society, an organisation whose object was 'the encouragement of the study of archaeology generally, and more particularly in Glasgow and the West of Scotland'.[16] The Society held a series of evening lectures and an annual excursion for members. By 1909 Burrell had also joined the Provand's Lordship Literary Society, recently set up with the aim of preserving Glasgow's oldest house and fitting it out as a museum of old Glasgow history. This was to become a major focus of his attention in later years. He also joined the Philosophical Society of Glasgow in 1900 which offered an eclectic mix of lectures on science, art and history.[17] Membership of all these societies demonstrates Burrell's strong and continued interest in Scottish history. Members were drawn from Glasgow's academic, political and business elites, and as well as enjoying the subject matter Burrell would have benefited from business and social contacts that all helped to cement his status and reputation within the city.

With so much of his attention taken up by the new business venture it is no surprise that his collecting took something of a back seat at this time. Despite huge pressure to keep Whistler's *The Fur Jacket* in the UK, Burrell decided to sell it in 1909. The world's press reported excitedly that he had sold it for £10,000 to the Worcester Art Museum in Massachusetts. In reality he sold it via a gallery and received 'only' around £6,300.[18]

In 1911 Burrell started to record most of his purchases in small soft-backed exercise jotters.[19] In them he noted the date of purchase, who he had bought the items from, the price he paid, a short description, sometimes with a small sketch, the date of delivery, plus any additional notes that he considered helpful.[20] We do not know if and

how he kept track of earlier purchases but it would seem that he had decided he now needed to be more meticulous with his collection. This may be because the shipping office was taking up most of his time and he needed an easy way to keep tabs on things. He was a man of business who liked a ledger, after all. However, it does seem that he was now viewing the collection as an entity in its own right, that needed to be administered in a much more businesslike way, rather than as a set of individual pieces. The purchase books gave it a structure and an identity that would suggest he was moving away from simply collecting for pleasure to collecting with some future higher purpose in mind.[21]

The early purchase books show that the primary focus of his collecting activity was now Chinese bronzes and ceramics. From the photographs of 8 Great Western Terrace we can see that by 1904 he had at least three Kangxi period (1654–1772) Chinese painted porcelain vases – one rouleau vase and two ginger jars. We also know that he bought £65 worth of goods from the Chinese art dealer John Sparks in July 1910, although we don't know what these were.[22] From 1911 we can get a far better indication of what he was buying. The first entries in the purchase book were ten Chinese ceramics purchased from E. Erison & Co. in London, including two Kangxi frogs, three Song vases and three Han figures. This set the trend for what was to become the largest part of his collection. Rather than collect just the fashionable Kangxi wares that other collectors favoured, Burrell was interested in a far wider range of periods, particularly earlier periods. This type of material was only just starting to come onto the market as graves were being uncovered in China as a result of railway building and industrial expansion. Burrell bought from dealers such as S. M. Franck & Co., who imported direct from China. He was therefore able to acquire material that was previously unknown to Western audiences. Some of the practices that were employed would not be viewed as ethical today, for example the purchase book entry for a 'rare bronze ritual wine vessel' purchased from T. J. Larkin carefully notes that it was 'from the looting of the Summer Palace, Pekin, 1901'.[23] However, at the time this was seen

as legitimate business and just part and parcel of British imperial dominance over other cultures.

Burrell was one of only a small number of collectors and museums who acquired this type of material. His interest may have been stimulated by the 1910 Burlington Fine Arts Club exhibition in London of early Chinese pottery and porcelain. The growing Chinese collection of fellow shipowner and Glasgow Archaeology Society member Leonard Gow would certainly have been an influence, and Burrell later acquired some of Gow's pieces when they came up for auction. Whatever the initial inspiration, Burrell set about educating himself thoroughly on the subject and the numerous books on Chinese art in his library are all carefully annotated.

Between 1911 and 1914 Burrell bought almost exclusively Chinese pottery and bronze. The only other things he purchased were two pieces of lace and a couple of Persian items. The volume of acquisitions, however, was not great, around thirty or forty pieces a year, and in 1914 be bought just eight objects. It was not until 1915 that he started buying paintings again, when he bought five works from the sale of old masters from the collection of the London stockbroker Charles T. D. Crews at Christie's, including *Peasant Children* attributed to Le Nain and a fifteenth-century painting of *Ecce Homo*.

In his personal life things were not as comfortable as he might have wished. Constance remained poorly and needed regular care. William cherished his wife and took his caring responsibilities seriously and in 1911 he took her to the famous Bohemian spa resort of Karlsbad for a rest cure. Karlsbad had no doubt been recommended by George who stayed there the year before with Anne Jane, and it may have had an added interest for William as this is where Jacob Maris died.[24] William and Constance then took to spending the summer months away from the city. In 1912 they took up summer residence at Carriden House, a seventeenth-century mansion overlooking the Forth near Bo'ness.[25] Marion was, by all accounts, growing into a demanding and independent-spirited only child. William was at once a strict and indulgent father. He enthused her with historical tales and she learned to love the collection. Family outings included

Saturday trips in the new Daimler to the Trossachs countryside and Marion also accompanied her parents on trips abroad. However, on a day-to-day basis she was cared for and educated at home, initially by a French governess and then by a German one, whom she hated. At the age of eleven she went to Laurel Bank School, which was just around the corner from their house, but the transition was not easy and she remained something of a difficult child. She was eventually shipped off to Heathfield boarding school for girls near Ascot. [26]

In February 1912 Burrell's mother Isabella died. She had been a massive influence on his life and he keenly felt her loss. This would have been compounded by the behaviour of his younger brother Henry. After being ousted from the family firm Henry had tried to make his own way as a ship designer and shipowner. He took out several patents for improvements in ships and in 1910 established the Straightback Steamship Company which operated a vessel built to his new design. Unfortunately, the *Ben Earn* was wrecked off the coast of Canada before it could really prove its worth and the whole venture collapsed.

Henry still lived with his mother rent-free at 4 Devonshire Gardens, but he was a prickly character who exhibited some extreme forms of behaviour and was not easy to get along with. His conduct towards his mother 'vexed her very much' and in the end she found it hard to live in the same house as him 'because he nagged and worried her so'.[27] When she moved away for the sake of her health Henry stayed on and took responsibility for running the household. He still expected her to foot the bills, but he did hand over one share in the Straightback Steamship Company as security. After she died, he was given permission to stay on until such time as the house was to be sold. However, when the time came, he refused to move out, claiming that he had tenancy rights since he had 'paid' his mother the £100 face value of the share certificate. His brothers William and George were trustees of the estate and took out an action at the Sheriff Court in Glasgow to evict him so that the property and furnishings could be sold. The sheriff deemed that there was no contract that allowed him to stay and so he should be evicted. Henry

appealed this decision at the Court of Session in October 1913 but failed to overturn the verdict.[28]

When pushed during the court case, the Burrell & Son lawyer and family friend revealed: 'He is peculiar; in fact, he had a severe brain affection when he was a child and he never recovered from it.'[29] He suffered from poor mental health throughout his life, and it appears that he had become unstable at this time. He behaved in a hostile manner and 'in a state of excitement' to the lawyers. He secretly removed the 'For Sale' sign and obstructed the auctioneer from gaining access into the property. When he was eventually locked out, he promptly broke in again through a skylight with the help of a couple of 'fighting men'. When he did finally leave, he helped himself to copious amounts of silverware, a tapestry and various other items, which William and George had to recover through the courts. Henry then took out what appears to be a vindictive legal action against his brothers.

Each of Isabella Burrell's children had been left £2,500 in her will, but due to the depressed state of the economy at that time her assets did not cover the full amount and an interim payment of £1,250 was made. Both William and George's wives had purchased some of their mother-in-law's shares in several Burrell & Son shipping companies as part of the winding up of the estate. Henry complained that they had received preferential prices for them, which devalued the estate and thereby compromised his legacy. He took out a case against his bothers, initially at Glasgow Sheriff Court and then on appeal at the Court of Session. The final judgment in early 1915 was that the shares were indeed purchased legally and at the same price as other purchasers. Henry was then faced with legal costs of over £340.[30] He appealed this decision and again it went all the way to the Court of Session before the appeal was turned down in May 1916 and a further £105 added to the costs. The words of the defence lawyer ring all too true: '[T]he vexatious tactics by which Mr Henry Burrell is delaying ejection and keeping back the realization of his estate will not benefit him.'[31] Henry would have been far better off leaving graciously and getting what he could from the legacy. He seems to

have harboured a deep-seated resentment that he did not receive his rightful patrimony by being excluded from the family business back in 1896, evidenced by the vindictive legal action against his brothers. This would have hurt William deeply, but despite all this he still retained an affection for Henry and offered him an annuity of £250 to make up the perceived shortfall in his inheritance.

As political tensions escalated across Europe, Burrell started to make preparations for potential hostilities. In 1913 he established, along with the other directors of the Newcastle Protection and Indemnity Association, another mutual insurance company called the Newcastle War Risks Indemnity Association Ltd, which had the sole purpose of insuring ships against loss or damage caused by the 'consequences of hostilities, or warlike operations, whether before or after declaration of war'.[32] This was a clause that was specifically excluded from other insurance policies and so special provision had to be made if owners wanted to protect their assets during wartime.

Despite the obvious war clouds, William Burrell was promoted to the highest consular rank of consul-general of the Austro-Hungarian empire in February 1914.[33] He was also appointed dean of the Consular Corps in Glasgow and was presented to King George V and Queen Mary and joined them for dinner when they visited Glasgow in July 1914.[34]

A few days after war was declared in August, Burrell established another company called the Strath Steamships Mutual Insurance Association Ltd. This provided additional insurance for Burrell & Son ships and their cargoes as well as protection against any losses incurred on policies with other insurance organisations. Membership of the association was limited to the individual steamship companies with a Strath prefix and the company subscribers consisted of William Burrell, James C. Stewart and five clerks from the Burrell & Son office. George was not included because he had been staying in Karlsbad with his wife and daughter when the war started in Europe at the end of July 1914.[35] However, as with all their companies, George and William were to be the sole managers.

The benefit of all this additional insurance was felt immediately after war was declared. *Strathlyon* had been at Luleå in Sweden and was unable to leave the Baltic so the War Risks Association paid out a detention claim of £1,980. *Strathyre* was berthed at Emden and was interned by the German authorities. The ship was declared a total loss and Burrell received the full insurance value of £39,000. At the end of August, the *Strathroy* was captured by the German cruiser *Karlsruhe* off the coast of Brazil and then scuttled. Again, the full value of £39,000 was paid out.[36] Although Burrell had contributed through his mutual associations, the insurance pay-outs for these ships were more or less free money as at the start of the war the government had underwritten all war risk policies to the tune of 80 per cent.

At the start of the war George's three sons all enlisted for military service, Gordon and Thomas joined the Highland Light Infantry, while William signed up to serve as a lieutenant in the Royal Naval Volunteer Reserve. William Burrell Junior was being groomed to ultimately become a partner in the business, but in November 1914 tragedy struck. He had been carrying out despatches in a small motorboat on Loch Ewe in the Scottish Highlands when it capsized, drowning him and two other crew members.[37]

Unlike many of their contemporaries in the Glasgow shipping world, neither George nor William Burrell took on any official duties during the war. Shipowner Joseph Maclay was appointed Minister of Shipping, William Weir became Director of Munitions in Scotland, and shipbuilder William Lithgow was Director of Merchant Shipbuilding. Others served on local committees and played a significant part in the war effort.

Burrell never seemed to revel in his position as a leading ship-owner. Ships, for him, were simply economic units and a way of making money. He was happy enough to attend industry dinners and social engagements, but in contrast to other leading shipowners and industrialists he was never a committee or board member of the Clyde Shipowners' Association, the Clyde Navigation Trust, the Shipping Federation, or any other industry body. He was a member

of the Glasgow Chamber of Commerce but not an office bearer.[38] As a shipping magnate he had great financial and commercial power, but he did not seek to extend that into industrial policy or public duty.

It appears that Burrell's primary interest in World War I was to make money. The war created a massive demand for shipping as large numbers of merchant ships were required to support government efforts in supplying the military effort. Nearly a quarter of all oceangoing ships were requisitioned in the first few months. No Burrell & Son ships were requisitioned to begin with, but some were chartered to the British, French and other governments at lucrative rates to be used as colliers and supply vessels. Typical of the kind of work they were engaged in can be seen with the *Strathdee*:

> In 1915 she was engaged in conveying a cargo of wheat from Bahia Blanca, Argentine, for the Belgium Relief Committee at Rotterdam. In 1916 she was chartered by the then Russian Government, and made a trip to Archangel with coal. On her return to England she was commandeered by the British Government and sailed with a cargo of coal for Alexandria, proceeding thence with war material to Salonika.[39]

Those ships not on government contracts were free to trade and make as much profit as they could. With shipping scarce and freight rates high there was a lot of money to be made. In fact profits were made on such a prodigious scale that public opinion began to turn angrily against the profiteering. The newspapers were full of headlines such as 'The Shipowner's Good Time', 'Joys of the Shipowner' or 'The Shipowner's Harvest'. The *Dundee Courier* noted, 'Shipowners and ship brokers are having the time of their lives. Freights to and from foreign ports have risen to an unprecedented height, and dividends of shipping companies have risen above the wildest dreams of avarice.'[40]

The socialist newspaper *Justice* meanwhile talked of the 'plundering shipowners' being sharks who were 'making themselves rich at the expense of widows and fatherless children, whose erstwhile breadwinners have given their lives for the nation's safety'.[41] The reported scale

of profits is borne out by Burrell & Son's dividends to shareholders in 1915, which amounted to nearly half a million pounds.

On the back of these profits, Burrell bought himself a castle, of which more in the next chapter, and one evening he was entertaining fellow shipowner and art collector James Caird when a young Norwegian shipowner dropped by. They talked business and the Norwegian outlined his plans to sell off his shipyard and ships while prices were high and buy cheap ships when there was a glut once the war was over. He was nervous about what these two 'wise and wily Scots' might think of him, but he needn't have worried:

> Caird now looked at Burrell. Burrell looked at Caird. Then both turned to me and said in chorus, 'The boy's a genius. I told you so.' We all roared with laughter. Both men stood up and clapped me on the shoulders. Even the rather remote Burrell became animated to such an extent that I thought he was going to dance a jig. 'One of us. Truly one of us,' he repeated. 'Truly a soul mate, and one who can think. Oh, Caird, what a rare treat.' They realised that I needed an explanation, for their behaviour had passed the point where it could be regarded as rational. 'You must be thinking of us as two middle-aged mad men,' Caird said. 'But the truth of the matter is that your plans exactly mirror our own. Friend William here has just finalised arrangements to sell his fleet, his entire fleet of thirty ships and all that goes with it. He has had enough. Fed up to the back teeth with the worry of it. So am I for that matter. Moving along the same road but haven't got as far yet as friend William. Take time and guts to do these things, as you will find out, young friend. But you are on the right lines. Exactly the right lines.'[42]

The government had reacted to the shipowners scandal by imposing an excess profits duty of 50 per cent in 1915 and also planned additional regulations and statutory controls to tighten its control of shipping.[43] For a free-market Conservative like Burrell this was a

threat and he sought to maximise his profits by selling his ships at vastly exaggerated prices. To begin with he sold them individually to Scandinavian and American owners, for example the *Strathmore* was sold to W. Wilhelmsen of Tønsberg, Norway, in March 1915 for £65,650. By 1916 ship prices had become even more inflated and in March 1916 he sold six steamers to the London-based Rome Steam Shipping Company for an undisclosed sum, but reputed to be around £135,000 each.[44]

The next sale was altogether more controversial. The UK government had restricted the trade in which British ships could operate, which meant that long-distance trade with Australia was severely curtailed. This in turn meant that the Australian economy was severely affected, with large quantities of wool and grain lying rotting on the wharves for lack of transport. The Australian prime minister W. H. Hughes travelled to the UK to negotiate the transport of Australian goods with the government. When they refused to entertain his plan, Hughes decided to take matters into his own hands, and set about buying his own fleet to create a new government-controlled shipping line. He knew that this would meet fierce opposition from the UK government and the British shipowners' lobby and so this operation was done in great secrecy.[45]

As part of his state visit Hughes travelled to Glasgow at the end of April. Here he gave a lecture on 'Empire trade after the war' attended by Glasgow's leading commercial and industrial figures. With Burrell's long-standing interests in the Australian trade, it is hard to imagine that he was not present. At any rate, Hughes' shipping agent was certainly well aware of Burrell and when the deal was announced that he had secured fifteen ships for the Australian government, ten of them were from Burrell & Son. For the Australians this made sense as Burrell's ships had already proved their ability and were an obvious target for negotiation: 'The steamers of the "Strath" Line are well known in Sydney, and most of them have figured at various times in the Australian trade.'[46] It also made a great deal of sense for Burrell as he was already committed to getting rid of his fleet. With the negotiations happening in secret, and Hughes willing to

pay whatever it took to secure the deal, Burrell was only too happy to exploit the situation and reap the extraordinary proceeds. Each ship was bought for £141,000, which was over £100,000 more than what he had paid for the ships nearly ten years before.

The deal was met with fierce opposition from British shipowners who operated as a closed shop or cartel. They did not want this new government-subsidised shipping line stealing their trade and disrupting their carefully managed business arrangements. One leading shipowner even threated to confiscate the ships. British politicians were equally opposed to the move as it significantly reduced Britain's shipping capacity in a time of crisis and threatened the security of wartime supplies. All of the ships were chartered to the British government at the time and moves were made to either cancel the deal or obstruct it by requisitioning the ships into Admiralty service. In the end a deal was struck between the British and Australian prime ministers that Hughes was allowed to keep his ships on the assurance that he would not buy any more. Burrell's ships therefore made up the nucleus of the newly formed Commonwealth Government Line of Australia.[47]

The prices paid by the Australian government were extremely high, but not as eye-wateringly exorbitant as the £170,000 paid by the Anglo-American Oil Company for *Strathfillan*.[48] This was more than a 400 per cent return on a ten-year-old vessel that in normal times would have been worth little more than its scrap value. Between 1915 and 1916 Burrell & Son sold twenty of their ships. This rapid reduction was noticed by the shipping world and many speculated as to their motivation: 'The fact that Messrs. Burrell and Sons of Glasgow have disposed of more of their tonnage appears to indicate that they must be tired of the business of shipowning.'[49] By the end of 1916 the Burrell bonanza was over. As well as the vessels that had been sold, five were sunk by enemy action. The fleet had been reduced to just two vessels, the *Strathearn* and *Strathlorne*, and along with all other British merchant ships these were taken under government control in 1917. When they were returned in 1919 *Strathearn* was immediately sold to a Glasgow owner, leaving just *Strathlorne* as the sole ship owned by Burrell & Son.

The total revenue on the sale of ships was in excess of £2.5 million and combined with the excess profits from running the ships, meant that it was a very good war for William Burrell. The level of income was so inflated that in 1920 both William and George were challenged by the Inland Revenue for the non-payment of over £200,000 in super-tax. The Burrells fought their case all the way to the Court of Appeal, which eventually found in their favour, judging that when each of the individual shipping companies was liquidated, the assets that were distributed to shareholders were considered as capital and not income and could not be taxed as such. With some deft accounting by William, the Burrells had saved themselves a fortune. As the economic historian of Burrell & Son noted: 'Obviously, a working knowledge of tax laws and proper timing of decisions could reap financial benefits.'[50]

The one recorded way that William Burrell aided the war effort was to lend works of art. In 1916, The Glasgow School of Art held an 'Exhibition of Ancient and Modern Embroidery and Needlework' to raise money for the Scottish Branch of the Red Cross Society and other war charities. In 1917 he also lent some items to an exhibition of antique furniture, tapestries and 'allied domestic arts' that Robert Lorimer had organised in Edinburgh for the aid of Edenhall Hostel in Kelso, for limbless sailors and soldiers.[51] Constance was also listed among the lenders of lace to the exhibition.[52]

The School of Art exhibition was particularly influential. The director, Francis Newbery, expressed the educational purpose of the exhibition by stating that it was 'to be organised to give opportunity to the students, craftsmen and collectors to study the work that past Ages have left us'.[53] It was mainly British objects that were exhibited, but an international section was also included. Loans came from the Victoria & Albert Museum, the Edinburgh Museum, Morris and Co. of London, and a number of private collectors.[54] Burrell was one of the principal private owners, loaning a total of twenty-nine examples to the exhibition.[55] Burrell's brother George and sister Mary also loaned works, and Robert Lorimer was listed as both a lender and organiser of the exhibition. In the minutes for the exhibition

committee it was noted, 'That permission be asked, in certain cases, for students of the School to copy exhibits.'[56] Burrell's exhibits were one of these 'certain cases'. On 16 February he wrote to the secretary of the art school confirming, 'I have Mr Newbery's letter of 15th inst. And am quite willing to agree to the request he makes.'[57] Burrell's involvement in this exhibition, and his willingness to allow students to copy items from his collection, connects him directly to individuals, institutions and firms that promoted the Arts and Crafts movement's call to copy from historical sources and reinvigorate the spirit of craftsmanship.[57] This was reflected in the way in which he refitted the interiors of his neoclassical townhouse at Great Western Terrace to complement his Gothic artefacts. Only months before the Art School's exhibition Burrell had purchased a castle, finally fulfilling his desire to live in a setting which was appropriate for his collection.

CHAPTER 5

Knight and Trustee

The end of World War I heralded a buyer's market in the art world as prices of fine and decorative arts were in decline and the whole world moved towards recession. This is the period when we see a direct connection between Burrell's business mind and his collecting mind. The massive profits he had made from his shipping business during the war not only funded the purchase of a castle, but also enabled him to dramatically expand his art collection. As when buying ships, Burrell took advantage of the stagnated market, continuing to purchase at a time when his money could go further. He had finally secured a castle, purchasing Hutton Castle, near Berwick-upon-Tweed, in September 1915. Compared to the few hundred pounds he was spending before 1916, now he was spending many thousands of pounds a year and acquiring hundreds of objects. In 1917, for example, he spent over £15,000 on 185 items. The focus of his collecting also changed dramatically. As well as the Chinese bronzes and ceramics of previous years, he was now buying large quantities of domestic objects such as furniture, glass and wood carvings that could be used to furnish his new home.[1]

With the purchase of Hutton, there was a definite change in the way that Burrell developed his collection. He now envisaged it as forming two distinct groups. On the one hand he collected things to be used in his new castle home. This included all things late Gothic and early Renaissance, such as tapestries, stained glass, furniture, and arms and armour. On the other hand, he developed a collection that was more intended to be loaned out to museums and galleries for public display. This allowed him to continue purchasing in areas

in which he had a long-standing interest, but which were not in keeping with the interiors he envisaged for Hutton.[2] As well as the Chinese collection, this included British and European paintings and drawings, which he returned to collecting in a big way in the 1920s.

Hutton Castle consisted of a late-fifteenth- or early-sixteenth-century medieval tower, which had been enlarged in the late sixteenth century by the addition of a large L-shaped extension to the west of the keep. Overlooking the River Whiteadder, it had acted as a Border fortress. The surrounding estate, which extended to 4,618 acres and included seven farms, had belonged to the 3rd Lord Tweedmouth, Dudley Churchill Marjoribanks and had been in the hands of the family for some time. Lord Tweedmouth's father had represented Berwickshire in the House of Commons and held high offices of state. The *Berwickshire News* reported, 'the association between the Marjoribanks family and Berwickshire has been a long and pleasant one, and the partial severance of it is much regretted'.[3]

The castle was put up for sale at the Royal Hotel on Princes Street in Edinburgh in September 1915. The sale notice made remarks on the quality of the soil, position of the estate, distance to banks, postal facilities, school and churches as well as a notice of the historical associations of the castle. The historical description began,

> In the Plantagenet period when England and Scotland were frequently at War, it is recorded that Edward I encamped his Army at Hutton and the day following took possession of the town of Berwick.
>
> There are still many relics at Hutton, which date back to the thirteenth and fourteenth centuries. Many old iron cannon balls, at least four inches in diameter, have been discovered in the trees in front of the Hall. The oldest part of the building is the square tower or keep which dates back to 1200, having a projecting circular tower, a stone stairway and a huge fire-place.[4]

The sale notice also listed noted past owners of the castle, including William, Earl of Douglas; George Ker of Samuelston; Colonel Robert Johnston; Sir John Marjoribanks, Provost of Edinburgh in 1813; and Sir Dudley Coutts Marjoribanks who became the first Baron Tweedmouth of Edington.

The history of Hutton, and specifically its royal connections, appealed greatly to Burrell. Objects with royal connections were a particular focus for his collection and his joy at being able to match a thirteenth-century English stained-glass panel of Beatrix de Valkenburg from his collection to a specific location in the castle is evident:

> He [Edward I] slept in the Tower bedroom and as it was the only bedroom in the 'Keeps' you may be sure that his cousin Richard Plantagenet – Beatrix de Valkenburg's stepson – slept in the same room . . . Her little panel is today only a few feet away from the bedroom in which her stepson no doubt slept.[5]

Burrell had been keen to purchase a castle since the 1890s, not just as a suitable setting for his growing collection of Gothic objects, but as a way of demonstrating his new-found status and his Conservative credentials.[6] He had long admired the grandeur of industrialists such as Sir William Arrol and Hugh Reid who had extensive country estates. Both were significant art collectors, and both were major shareholders in Burrell & Son ships. To truly be their equal Burrell needed not just to pay them dividends, but to acquire his own country estate and be seen to live a comparable life. Hutton provided that opportunity.

Burrell was able to capitalise on Lord Tweedmouth's financial insecurity and the depressed state of the property market to secure Hutton for just £23,000. He may have got the estate at a knock-down price, but the timing of the purchase was a powerful statement. The Liberal government of 1906 had introduced the 'People's Budget' which increased taxation of land and income to fund social welfare.

At the start of World War I income tax and inheritance tax were steeply increased. This level of taxation threatened the established Conservative values of owning property on a large scale and destabilised the old certainties of inheritance. As a result, many aristocratic estates and art collections were sold off; Hutton was just one of a long string of estates which the landed gentry could no longer afford to retain. Burrell was therefore not just buying an estate, he was bucking the trend and demonstrating to the world that he had truly made it. He was putting Conservative values into action and establishing himself as a man rooted in history and property ownership.

Hutton was not only an outward demonstration of wealth and status, but Burrell's attempt to invent a new tradition for himself that implied a strong continuity with the past.[7] However, he didn't just want to live in a stale and preserved history, he wanted to live in a comfortable version of it. His purchase of Hutton followed a drive to own old castles and renovate them into homes fit to live in, to create what were termed 'castles of comfort'.[8] For Burrell that past was a Gothic one, and Hutton gave him the opportunity to create a domestic ensemble that celebrated his love for the craftsmanship and style of the late-medieval and early-Renaissance periods.

According to the local press, Burrell planned on 'making extensive renovation of the fabric, and the operations are likely to extend over a considerable period'.[9] The length of the operations proved to be very true, as it was to take seventeen more years before he, Constance and Marion could fully move into Hutton. Burrell sought guidance from Robert Lorimer from the outset. In October 1915 Lorimer made a survey of the castle and in 1916 drew plans of the existing structure, unhelpfully concluding that Hutton was not a suitable residence for the Burrell family. He initially drew up plans for a new three-storey house on the site of the castle, detailing where Burrell could hang his tapestries and paintings, however, this idea was strongly rejected.[10] Some of what Burrell desired was revealed in correspondence with Lorimer. Burrell and Constance told Lorimer that they wanted to double spaces to make the castle seem bigger. They thought that Lorimer's idea of a new entrance hall was 'splendid and that it

would be very good if the door could be at the end so that in entry one would have the whole length of the hall before him'.[11] A long, wide, hall would accommodate selected objects from the collection to impress visitors coming in through the front door. The couple also suggested that the new drawing room could lead from the hall and requested that Lorimer recycle elements from Great Western Terrace. This included the fireplace which was to go into the castle's new entrance hall, and linenfold panelling for its dining room.[12]

Letters full of sketched and written ideas and instructions flowed to Lorimer as they specified what they did and did not want. Lorimer collected estimates for the work. However, by May 1916, Burrell had changed his mind on the extent of the renovations. He wrote to Lorimer on the change of plan:

> as I informed you I am quite happy with the exterior of Hutton as it stands and am not prepared to remove any part of it. All I thought of doing was what I indicated in my letters of 7th instant but since writing them I have decided to do only the undernoted, leaving the rest for consideration after the war is over.[13]

He then listed ten alterations that he wanted, including the thinning of some walls, the removal of some chimneys, fireplaces and other features, and turning the beer cellar and larder opposite the kitchen into a butler's pantry.

Burrell had indicated that he wanted to get into the house as early as possible, but by the end of July the work had still not materialised. Burrell wrote to Lorimer from his office at 54 George Square to request that there was now a 'revised arrangement' to 'alter as little as possible' and with 'as little expense as possible'.[14] He included a sketch of his own plans showing what he and Constance wanted. Burrell's change of mind undoubtedly put a strain not only on the project, but also on his relationship with the architect. The tone of the correspondence between Burrell and Lorimer became increasingly tense as their friendship of over twenty years began to fracture.

Burrell objected to Lorimer's resentment of his sketches and baulked at the proposed £40,000 that Lorimer had quoted for altering Hutton. In August Burrell wrote again to Lorimer that the couple were 'most anxious' that any addition should not be higher than the old tower. It was, in their opinion, a real attraction and nothing should injure its appearance.[15]

Despite Burrell's requests for minimal renovations, Lorimer had other ideas for the castle. In November 1916 he wrote to Burrell, particularly concerned by the fact that the upper floors could only be accessed 'by two extremely narrow corkscrew stairs – the one in the old Tower being about as bad and difficult a one as I have ever seen'. He drew on his forty years' experience of living in Kellie Castle:

> At Kellie there are four corkscrew stairs three of them fairly easy and one unusually wide. Where everyone is 'merry and bright' these stairs answer well enough, but when any one is not too strong or suffering from lumbago or rheumatism or some such ailment, these stairs are a difficulty. I cannot picture to you the agony of trying to get my mother up and down the Turret stair to her bedroom the last year or two at Kellie.[16]

This letter shows the close nature of the men's relationship, but it also suggests why their friendship was to come to an end. Lorimer's continued references to Kellie enforced a competition between the two friends' individual status. By 1917 Lorimer's standing as an architect in Scotland was significant, both as a renovator of historic houses and as the designer of the exuberantly Gothic Thistle Chapel at St Giles Cathedral in Edinburgh, for which he earned a knighthood in 1911.[17] When Burrell and Lorimer had first met, Lorimer's success as an architect was still growing. Under Burrell's employment the two men developed their interests together and learned from one another. By 1917 both men had matured into their roles as collector and architect respectively. Perhaps the collector felt overshadowed by Lorimer's successes. On Lorimer's part, his knighthood might also

have brought with it a sense that he knew better than Burrell. His disparaging remarks about what Burrell wanted for Hutton compared to what he achieved at Kellie might indicate as much.[18]

By August 1917, Burrell's tone was marked with a distinct change,

> I have your letter of 3rd instant in which you write 'owing to the fact that no one can teach you anything about your own business you assume you are equally conversant with everything else'.
>
> I think this remark is surely unnecessary. What I have done is to decline your £40,000 proposals of which up till now I have received three although I made it clear from the beginning that I was quite pleased with the exterior of the house and was not prepared to remove any part of the exterior – that all I wanted was to remove some of the partitions etc in order to get more space inside and larger rooms and – provided the expense was not too much – to build some servants rooms at the east end of the house. But because I tell you what accommodation I wish and suggest how it might be got surely the remark you make is quite unnecessary.
>
> I note you have prepared another plan and I wired asking you to send it through – I hope it does not embody more than I wish.[19]

Lorimer's suggestions had gone far beyond Burrell's desired internal renovations, and he had drawn up a number of plans for a new wing to be added to the castle. In September 1917 Burrell angrily wrote to Lorimer,

> As you know I only agreed to allow the wing to be built on your distinct assurance that it could be carried out comfortably at £3000 or a little over. Had I known that it would have cost more I would never have allowed the work to go on.[20]

In October 1917 Burrell and Lorimer's friendship of over two dec-ades came to an end. Burrell's patience was broken. He dismissed Lorimer for 'tearing out the guts of the house', making the old house 'unworkable', and for proposing such a high cost.[21] Burrell wrote to Lorimer, 'The result is so unsatisfactory and annoying that I shall not require further professional assistance from you.'[22] In response, Lorimer defended his professional conduct, commenting that the budget was always unrealistic for the type of work he was asked to do, and stressed that he understood 'your stuff and the architectural setting it requires'.[23] Although the letters only indicated a break of their professional association, their personal friendship was also at an end.

With the fleet nearly all sold off in 1916 Burrell no longer needed to be as close to the office, and with the privations of wartime Glasgow taking their toll on Constance's health, they decided to move away from the city. Hutton was not ready to move into so they initially checked into the Marine Hotel in Troon, where they stayed for the majority of the summer of 1916. The following year they rented Kilduff House near Haddington in East Lothian, an eighteenth-century house with Victorian modifications, close enough to railway links for easy access to Hutton, Glasgow and London. In 1919 the Burrells took on a five-year lease of Rozelle House in Ayrshire, set within thirty-seven hectares of woodland. This was relatively close to Burrell's sister Mary, Ralston and their growing family at Perceton House in Irvine. The final house that the Burrells rented saw the family return to East Lothian in 1924, this time to Broxmouth House, just east of Dunbar. This would remain their home until the summer of 1927, when they finally moved into Hutton Castle.

After Burrell's rift with Lorimer, no renovations took place on Hutton Castle until the close of World War I, when Burrell employed a pupil of Lorimer's, Reginald Fairlie, to undertake inter-nal and external renovations to the castle's west block. Given the fallout, Fairlie might seem to be a surprising choice. However, due to the competitive nature between Burrell and Lorimer it is possible that Burrell's choice was deliberate. But the appointment was to be

short-lived, and the architect was dismissed following a legal dispute about the quality of workmanship by the contractor.[24]

In July 1925 Burrell purchased an English Gothic chimneypiece and various other items intended for the fitting out of Hutton from Frank Surgey, a London-based antique dealer and designer. Surgey had recently set himself up in business following a successful career with an interior decorator in which he had worked on Buckingham Palace and the influential New York collector Henry Clay Frick's house. Surgey's new business, Acton Surgey Ltd, was focused on the renovation of old houses and the supply of antique furniture and fittings. Burrell and Surgey hit it off immediately and soon Surgey was engaged to take on the remaining work at Hutton. Reflecting on the renovation of Hutton Castle in later years, Burrell wrote,

> When I bought Hutton Castle I employed Sir Robert Lorimer to do a part of the building, the servants wing, & on his own he submitted a plan for the main building which was so poor that it was not worth consideration. The 1914–18 war took place & everything was closed down but some time after I employed Reginald Fairlie. But he made several serious blunders & to strengthen up the building I found a Mr Frank Surgey who was immeasurably [more] capable than either of the men. I can't tell you how clever & helpful he was – He takes the deepest interest in the house and knows the collection more intimately than anyone else.[25]

The key thing for Burrell was Surgey's strong interest and understanding of the historical nature of Hutton and the importance of the collection to the realisation of the whole scheme. Lorimer had claimed to know Burrell's 'stuff' but tried to impose his own views on how it should be treated in the interior designs. The relationship with Surgey was far more collaborative and the two men were totally in tune with making the castle and the collection work harmoniously together. They worked together for seven years to fully realise the

scheme and the final bill came to a staggering £57,000. The interiors had cost more than twice what Burrell had paid for the entire estate.

Throughout the process the two men retained a deep respect and affection for each other. When Surgey later took up the role of president of the British Antique Dealers' Association, Burrell was present for his inaugural speech. Surgey not only complimented Burrell and demonstrated his knowledge of the castle and the collection, but also alluded, in the nicest possible way, to Burrell's tendency to make quick judgements on people who did not do as he pleased:

> After complimenting Sir William Burrell on both his prowess as a collector and on his services to national institutions, the speaker humorously alluded to a possible revival of the high justice at Sir William's border castle. 'If I am to be executed in the romantic atmosphere of Hutton Castle,' added Mr. Surgey, 'I beg Sir William to have the deed performed with the mighty two-handed sword in front of the well-known tapestry, Justice overcoming Envy.'[26]

Hutton Castle had rooms over four floors. On the ground floor of the main block was an entrance corridor, the main hall and bathrooms. On the first floor was the drawing room and the dining room. The second and third floors of the castle contained bedrooms, bathrooms, and smaller drawing rooms and boudoirs. Photographs and inventories of the castle taken in 1948 give an idea of the type of objects that were displayed in the Burrells's domestic sphere. Public rooms such as the main drawing room held fine tapestries, examples of late-sixteenth- and early-seventeenth-century English oak furniture, early-eighteenth-century cane and upholstered chairs and settees, medieval sculpture and a large Gothic stone chimneypiece.[27] The oak floors were covered in rich carpets and the windows fitted with stained glass. Most of the rooms of the castle followed this style closely.

Included in Burrell's summary accounts for the renovation are lists of doors, chandeliers, radiator cases and pelmets that Burrell

had either bought through Acton Surgey or that they had adapted for Hutton. Surgey's business partner, Murray Adams-Acton, wrote *Domestic Architecture and Old Furniture* shortly after Hutton had been completed and the text demonstrates the firm's approach to the decoration of houses. The chapter on the use of historical furniture in domestic spaces closely reflects the interior schemes at Hutton Castle.[28] Adams-Acton mentions Burrell by name and includes a photograph of a 'fine and till now unrecorded example' of an exceedingly rare Gothic side table from Hutton. As with 8 Great Western Terrace, Burrell was not only following fashionable taste, but being seen to follow it.

The way that the collection was arranged at Hutton Castle was highly stage managed. The Gothic aesthetic was the overriding factor. William and Constance did not try to fit in extra works just because they liked them; it was the overall ensemble that mattered. An indication of this can be seen with Rodin's *The Call to Arms*, which was displayed at Hutton. Burrell was initially concerned that it did not fit in: 'I feel it is hardly taking its place with my Gothic things' but decided to keep it because 'my wife wishes to keep it here in the meantime'. The Burrells did, however, decide to remove four other modern bronzes because 'we feel they don't go well with our Gothic things'. This indicates that not only was the aesthetic very carefully curated, but that it was a joint effort by William and Constance.[29]

This influenced the number and type of paintings at Hutton, where there were only a few carefully chosen old master portraits to complement the interior design. In Burrell's own bedroom was a sixteenth-century portrait of Henry VII by an unknown artist and two Dutch pictures. Other paintings included a portrait of William Cecil, Lord Burghley and several seventeenth-century Dutch works found in one of the servants' passageways. As well as these original paintings there were also several copies and prints of old masters.[30] This reinforces the idea that he wanted his interiors to be consistent, with the paintings on the walls complementing the late-medieval and early-Renaissance decorative arts and furnishings. Only a small

number of modern paintings were found in the castle and these were mainly in Marion's bedroom and sitting room, where she had several works by Crawhall and a Whistler lithograph. Lavery's *Dear Lady Disdain* also hung in one of the servants' passageways.

This begs the question as to where the rest of Burrell's collection was located. He kept on 8 Great Western Terrace as his Glasgow address, but it was now increasingly being used as a store for excess artworks. Rather than simply lending a few items as part of temporary exhibitions as he had regularly done in the past, he now started to lend the collection en masse on a more long-term basis. Over a number of years Burrell had lent his collection of Chinese bronzes and pottery to Kelvingrove Art Gallery and Museum, Glasgow. This was supplemented around 1918 with over a hundred paintings, pastels and drawings, including several works by Ribot, the Maris brothers and Crawhall, as well as Degas's *Ballet Dancer*, Cranach's *Stag Hunt* and Whistler's *Mother and Child*. These were displayed in a dedicated gallery and for the first time the public could see, as a distinct entity, 'the Burrell Collection'. As *The Scotsman* explained:

> for some years his collection of Chinese bronzes and Oriental pottery have been a feature in the museum section of the Kelvingrove Gallery. It was not, however, until about two years ago that the public had an opportunity of seeing his pictures, when these, or at least the most important, appeared on loan in the Glasgow Gallery.[31]

The collection did not stay long in Glasgow, however, as in 1919 Burrell instructed the museum to remove the paintings and arrange for them to be shipped across to the National Gallery of Scotland in Edinburgh. Glasgow had been Burrell's home and Kelvingrove had been the location for the first major public exposure of his collection in 1901, but Edinburgh was the capital and that brought greater status and exposure. When his collection was displayed *The Scotsman* responded by describing him as the 'keenest and most discerning collector in Scotland'.[32] The paper went on to enthuse:

Mr Burrell's pictures form an exceedingly interesting special collection, not only because most famous painters not represented in the permanent collection may be seen there, but from the exceptional quality of most pictures and drawings in it.

The loan consisted of fifty-seven oil paintings, thirty-three watercolours, fifteen pastels and eleven prints and drawings. The gallery reported that it had been 'much enhanced' by the loan which was 'representative chiefly of the French and Dutch Schools'.[33] The modern European paintings included works such as Maris's *Butterflies*, Degas's *Girl Looking Through Opera Glasses*, and 'one of those charming single-figure subjects by Corot' which was his *La jeune fille à la boucle d'oreille* (*The Young Girl with the Earring*). A number of British works were included as well and the eleven watercolours by Crawhall were described as 'one of the great attractions of the collection'.[34]

As well as modern paintings, Burrell also loaned old master works including Lucas Cranach the Elder's painting *Venus and Cupid, the Honey Thief* that had previously hung in the hallway at Great Western Terrace. The *Still Life* by Chardin that he had loaned the London Corporation Art Gallery twenty years earlier was also included. Commenting on the selection, *The Scotsman* reported,

> Nearly all the pictures are pitched in a low key, have colourations which incline to richly modulated tones or low, mysterious concords, rather than to full pitched consonant harmonies, and, as regards subject, are suggestive in a purely pictorial, a remotely fanciful, or a subtly decorative way, rather than directly representative, imaginative, or dramatic. To some extent, the unusually high proportion of still-lives may have to do with this impression, as it certainly witnesses to the owner's delight in fine painting for its own sake.[35]

The paper also noted that 'accomplished craftsmanship' was one of the most noticeable characteristics of the collection. This reception

would have greatly pleased Burrell, not just because of the publicity, but because it accurately got to the heart of his collecting rationale. As a result of its success, Burrell added to the loan again in 1921 with some additional watercolours by Matthijs Maris and Crawhall as well as some other works. The following year he added Millet's austere *Winter, The Plain of Chailly* and Degas's *Red Ballet Skirts*, which drew particular praise.[36]

The wholesale loan of his collection ultimately earned Burrell a place on the board of trustees of the National Galleries of Scotland in February 1923,[37] where he was among people who shared his principles. The chairman was Sir John Ritchie Findlay, proprietor of *The Scotsman*, which had been so complimentary about his collection, and fellow trustees included his old friend Sir John Stirling Maxwell and fellow tramp shipowner Sir William Raeburn.[38] The purpose of the board was to approve new acquisitions for the National Gallery of Scotland and the Scottish National Portrait Gallery. The board also dealt with additions to the buildings, and salaries and appointments of new staff. This was Burrell's first public appointment based purely on his artistic credentials, not as a city councillor or as a captain of industry, and it significantly reinforced his status as a connoisseur and collector of the first rank.

Burrell remained a trustee for twenty-three years and was closely involved in the running of the National Galleries and the growth of its collections. Stanley Cursiter, who joined the curatorial staff of the National Galleries in the same year that Burrell was appointed, later becoming director, recalled that, 'It was mainly on questions of costs and expenses that he was difficult. If a picture came up he would never accept it at the price offered, always he wanted the Board to bargain or haggle for a lower price.'[39] Burrell was not going to change the habit of a lifetime, even for the national collection.

The loan of paintings may have got him a seat on the board, but before he had taken up his seat for the first time, he had decided to withdraw his collection and pack it off to London. Edinburgh may have been the capital of Scotland, but London was the metropolis and the centre of the British art world. He had made

his intention known from February 1924 when the papers reported
that:

> The private art collection of Mr William Burrell, the mil-
> lionaire Scottish shipowner, is likely to be shown in London
> shortly. Mr Burrell has not yet come to a definite decision,
> but it is expected that should he decide to let the public see
> the pictures they will be hung at the Tate Gallery.[40]

The Tate Gallery had been created in 1897 as a subsidiary of the
National Gallery specialising in British art. In 1917 it was recon-
stituted with its own board of trustees and, although its remit
was expanded to cover international modern and contemporary
art, it was still officially known as the National Gallery of British
Art (Millbank). It had been extended over the years, but Burrell
was concerned that there was no gallery space big enough for his
collection to be seen in its entirety and he was extremely reluc-
tant to see the collection divided throughout the building. The
idea of 'The Burrell Collection' as a distinct entity was clearly
very important to him. In the end the Tate agreed that ultimately
his collection would be placed in a new extension that was then
under construction:

> The Trustees have accepted the loan of Mr William Burrell's
> collection which has been on loan for some years at the
> National Gallery, Edinburgh, with a view to increasing the
> interest in the collection of Modern Foreign Art, which will
> shortly be housed in the new Gallery now being built on the
> vacant site behind the Gallery at Millbank.[41]

One observer noted,

> I am told that it was partly with the idea of stimulating
> public interest in this addition to the gallery that the offer of
> the Burrell collection was accepted, and the decision taken

to incur the very considerable expense attached to the reception of these 'loans'.[42]

The collection that went to the Tate consisted of 153 paintings, which now included Courbet's large and popular *Charity of a Beggar at Ornans*, which Burrell had bought the previous year, as well as Rodin's iconic sculpture of *The Thinker*, another recent purchase.[43] The exhibition was received favourably, with *The Times* admiring the collection and picking out Boudin's *Empress Eugenie* and Degas's *Edmond Duranty* for special praise.[44] In the Director's Report from April of that year, Charles Aitken, the director of the gallery, thanked Burrell for his loans in light of the high number of visitors that the pictures had attracted since the opening of the exhibition.[45] This may have been helped by the reduction in the entrance fee from a shilling to sixpence shortly before the exhibition opened, but it was undoubtedly popular:

> I went to the Tate Gallery to see the Burrell collection of French impressionist paintings which has just been placed there. This should not be missed by any visitor to London who likes pictures, for it is a better selection of the works of Degas, Boudin, and Manet than we have ever been able to see before.[46]

This was no overstatement, as the major London institutions simply did not have this type of work in their collections. A major article on the collection featured in the very first edition of the influential *Apollo* art journal in January 1925, in which several of the works were illustrated.[47] Incidentally, the same issue also included Murray Adams-Acton's article on 'Domestic Architecture and Decoration', which no doubt had some influence on Burrell's appointment of Acton Surgey later that year to complete the refurbishment of Hutton Castle. The only negative impression came from the acerbic critic Walter Sickert, who wrote, 'The French Impressionists have in this collection somewhat the air of an afterthought.' He was particularly

scathing about Monticelli, whose paintings were 'jewelled mud-pies of fancy', and Courbet who was an 'execrable draughtsman'. These were among Burrell's favourite artists and the criticism would have hurt. He never bought another Courbet. Sickert did, however, concede that 'Mr Burrell's collection holds one of the great Millets of the world'.[48]

There seems to have been some expectation that Burrell's collection would end up permanently at the Tate Gallery. One newspaper referred to the loan as a 'loan' in inverted commas, while another said that his loan should be seen in the same context of 'patriotic munificence' that had influenced previous donations.[49] In the end, though, it was not patriotic, but municipal munificence that won the day.

In June 1925 it was announced that Burrell had donated forty-eight oil and watercolour paintings and thirty prints and drawings to the city of Glasgow to be featured in the Art Galleries of Kelvingrove. The collection was estimated to be worth around £30,000 and was largely made up of modern French and Dutch paintings.[50] The three French works that were picked out for special mention were Courbet's *Beggar at Ornans*, Degas's *Red Ballet Skirts* and Lucien Simon's 'large and brilliant' painting of three Breton women attending the races. There were also two works by Millet including *Going to Work*, Corot's *La Forêt*, two sketches by Boudin, and paintings by Ribot, Bonvin and Daumier. There were a number of British works as well in the gift including Guthrie's *Luss Road* and Lavery's portrait of Burrell's sister, *Miss Mary Burrell*. Three watercolours by Crawhall were also particularly well received.

The *Glasgow Herald* hailed it as a 'princely gift' and declared that 'the collection which he has now munificently presented to his city is world-famous, a monument of artistic taste and enterprise'.[51] In the same article, the director of Kelvingrove Art Gallery and Museum, T. C. F. Brotchie, recognised the deep links between art and industry that characterised Glasgow's museum collection, stating that 'the splendour of his generosity to the city of his labours' earned him a place on the roll of honour of those citizens 'whose gracious

munificence has done so much to advance the ideals of art culture, and thereby to sweeten somewhat the heavy and oft-times deadening atmosphere of industrialism'. He went on to describe the way in which the collection had come permanently to Glasgow:

> The pictures have been chosen with rare discrimination, a factor acknowledged gladly, alike by artist and connoisseur. They are tolerably familiar to the art-loving public of Glasgow, who will recall their exhibition at Kelvingrove some six years ago. At that period their superb quality aroused keen attention not only in our city but amongst art lovers throughout the United Kingdom. After remaining for some time in Glasgow the collection was loaned and exhibited in the National Galleries, Edinburgh. Its exhibition in the Scottish Capital still further stimulated interest in its splendour and variety, and it was subsequently transferred to London, where for a considerable period it formed the chief attraction of the spacious and beautiful Tate Gallery. There have been some few changes in the collection since its stay in Glasgow, but broadly speaking it is the same, and I venture to assert that it comes into the possession of the city in unimpaired magnificence, and in itself constituting one of the greatest art gifts amongst the many to which our Art Galleries have fallen heir.[52]

The Bailie carried another feature on Burrell, thanking him for the generosity of the gift and praising the high intrinsic merit of the collection. It suggested that the city should express its gratitude for this priceless gift by offering him the freedom of the city.[53]

Quite why Burrell decided to donate this large group of paintings to Glasgow at this time is not known. He was certainly aware of the long tradition of industrialists making a name for themselves through donating their collections to Kelvingrove, although these tended to be bequests after the donor's death rather than gifts. If storage was an issue, he could have easily sold parts of the collection, as he had

done in the past. Despite having moved away, he retained a strong allegiance to Glasgow, and he may have wished to give something back to the city that earned him his fortune. Burrell had a characteristic Scottish Presbyterian reserve but also a large streak of vanity and he would have revelled in being included on that Kelvingrove roll of honour that put him alongside the likes of coachbuilder Archibald McLellan, whose collection founded Glasgow's museum service, locomotive builder Sir James Reid and whisky baron Adam Teacher. All made their money in Glasgow and bequeathed their collections to improve the cultural lives of Glasgow's citizens. As well as establishing his fame as a connoisseur and collector, Burrell was now also fêted as a cultural philanthropist.

The gift of paintings to Kelvingrove joined Burrell's significant loan of Chinese art. The Chinese collection was never intended to feature at Hutton, and it seems that Kelvingrove was always considered the principal display space for it. He made continual additions to it and in the months before his gift he added 'a pair of Kanghi vases, decorated in colours, figures, and landscape, figure of a Chinese god in green, &c'.[54] A later Annual Report recorded that Kelvingrove had twenty-one display cases holding 338 examples of Chinese earthenware, stoneware and porcelain out of a total of 357 pieces of 'Chinese pottery' that was listed as being in Burrell's collection at that time.[55]

Many other parts of Burrell's collection remained on long-term loan to other institutions. Although the Glasgow gift had reduced the number of paintings, the Tate Gallery still retained over 150 pictures on display and in store,[56] and the National Gallery of Scotland also continued to receive loans of paintings and the occasional donation.[57] Burrell lent the Victoria & Albert Museum five panels of sixteenth-century French glass in 1920 and added to this loan over the years with tapestries and furniture. In 1924 he wrote to Eric Maclagan, the director of the museum, asking whether the museum would accept a loan of an Elizabethan table that was currently on loan to the Burlington Fine Arts Club. The reason behind this request was because Hutton 'cannot be ready for a couple of

years'.[58] This suggests that Burrell would rather the table displayed in London than put into storage during the final years of renovations.

Burrell also continued to lend works to temporary exhibitions; for example in 1925 he lent Courbet's *Woman with a Parasol* to an exhibition of fifty years of French art at the Musée des Arts Décoratifs in Paris.[59] In Scotland he lent Reynolds' *Portrait of a Boy* to the Smith Art Gallery in Stirling in 1922, a number of Crawhalls to the inaugural exhibition of Kirkcaldy Museum and Art Gallery in 1925, and a Degas, Manet and Daumier to the Royal Scottish Academy in 1927.[60] That year Burrell exhibited a group of ten late-fifteenth-century Gothic tapestries from the Southern Netherlands at the dealer Frank Partridge's galleries in London. A few of the panels had been lent to the 1901 Glasgow International Exhibition and later hung in the dining room at 8 Great Western Terrace.[61] *The Times* praised the group, which included *The Months: January, September* and *April,* and *Scenes of Wine-Making: Vinters, a Wine-Press,* writing, 'Outside a museum we are not likely to have another such opportunity to study the art of tapestry in its most characteristic phase'.[62] As with the table that was offered, Burrell was giving the public a chance to see his collection before it was installed at Hutton: 'Pending the completion of Hutton Castle, Berwickshire, where the panels are destined to hang, this art lover has lent them for exhibition at the Partridge Galleries'.[63]

The tapestries were ultimately hung together in the main drawing room of the castle. Cecil Tattersall, the textile historian and curator at the Victoria & Albert Museum, noted in July 1927 that they would soon adorn Hutton Castle, where 'a large gallery has been built to accommodate them. Seen, as they will be, in conjunction with fine early examples of stained glass, wooden furniture and Persian carpets, they will provide a noble *ensemble*.'[64] Tattersall celebrated the choice of objects to accompany the tapestries, highlighting that Burrell had the knowledge and taste to know what setting was suitable for these objects.[65] A 'noble' ensemble was exactly what Burrell was trying to achieve.

The high proportion of the collection that was out on loan was not just a convenient ruse to find homes for the collection while

Hutton was being prepared. There was a definite purpose behind the loans. This was partly a benevolent wish for the public to enrich their lives by engaging with his collection, but there was also a more self-centred aspect as well. Offering high-profile loans meant that he was continually praised in the newspapers for his refined taste and his generosity. As a result of the higher profile, significant parts of the collection also started to be published in major art journals where the quality of his collection was universally praised. With an astute strategy redolent of his business dealings, Burrell was able to create a narrative that placed him as one of the country's leading collectors.

Whilst the renovations were being done to Hutton, the Burrell family took advantage of the ability to travel, taking a number of trips both to the Continent and further afield. In 1920 Marion was sent to a finishing school in Paris and during her Easter holiday Burrell and Constance joined her in France and they took a holiday to Cannes.[66] A few months later Burrell and Constance were back in France, this time in Paris, to celebrate the end of Marion's schooling. This appears to have been a moment of congeniality within the Burrell family. Unfortunately, it would not last for long. The following year, back in Ayrshire, Marion met Captain Leslie Watson. He came from a well-regarded Lanarkshire family, had attended Rugby then Sandhurst, and had fought in the war with the 7th Dragoon Guards. He cut a dashing figure and Marion was immediately taken by him. However, he had no title to inherit and so Burrell did not think he was good enough for his daughter and broke off their liaison. Marion was heartbroken by her father's actions and removed herself from the circle of friends she had made in Ayrshire.

As a means of consoling his daughter Burrell began to teach Marion more about his collection. He is said to have instructed Marion to begin her own collection of Chinese porcelain, noting, 'You should gradually get a specimen of each so that they would be a guide to you and you would have a bird's eye view of the whole field and roughly know where you were when a price was offered either by a shop or at auction.'[67] When you consider the comprehensive nature of Burrell's own Chinese collection, this is clearly an approach that

he had practised himself. Although Marion was keen to learn, such diversions could not distract her enough to forget Captain Watson. Eventually, Burrell and Constance decided that getting away from Scotland would help. So, in 1922 the family embarked on a trip to India on the P&O steamship *Naldera*. They went on the invitation of Lord Inchcape, a senior colonial administrator and chairman of P&O who lived at Glenapp Castle in Ballantrae, Ayrshire. Although their businesses could not have been more different, Burrell and Inchcape mixed in the same shipping circles and the two families socialised in Ayrshire. Inchcape was on his way to India to chair the Indian Retrenchment Committee, which was tasked with bringing colonial expenditure to heel, but the Burrells were simply there for pleasure. They arrived at Bombay (Mumbai) on 8 November and over the following months they made an extensive tour of the subcontinent, visiting Rajasthan, Jaipur, Delhi, Calcutta (Kolkata), Rangoon (Yangon), Madras (Chennai), and Colombo, from where the family sailed back home on the P&O liner *Morea*.[68] The trip was extensive and filled with many new experiences. Even if Watson was not a completely distant memory to Marion, she was ready for a fresh start when she returned to Ayrshire in the spring of 1923 with her mother and father.

Meanwhile the health of Burrell's brother Henry had begun to deteriorate. He had spent the years after the war in lingering legal disputes, desperately trying to recoup some financial compensation from his failed shipping enterprise. In the end he was rebuked by Scotland's leading judge for his incompetence in presenting his case and for wasting everyone's time in pursuing an action that was baseless. The reckless pursuit of justice seems to have taken over his life and he came away from the process thoroughly defeated, broke, and in a poor state of mental health. This had a serious effect on his physical health as well and in early 1924 he contracted pulmonary tuberculosis. As the disease developed, he was moved to Nordrach-on-Dee Sanatorium, in Banchory in the north-east of Scotland. This was a specialist private clinic for the open-air treatment of lung diseases and William Burrell, despite their earlier falling out, footed the

bill for his younger brother who hardly had the wherewithal for this kind of exclusive treatment. Henry Burrell died at the sanatorium on 15 July 1924.[69] William acted as his executor and in contrast to the vast riches that his brothers enjoyed, Henry had less than £400 to his name.

At the outbreak of World War I William Burrell's role as consul-general for Austria-Hungary came to an abrupt end. However, in May 1924 he once again took on consular duties when he was appointed as the consul for Hungary in Glasgow.[70] In the upheaval after the war Hungary and Austria were reconstituted as separate kingdoms and in 1925 George Burrell was appointed consul for Austria. Burrell's trading relationships with the region had evaporated as a result of the war and so these appointments were less about furthering business ambitions, as the earlier Austro-Hungarian appointments had been, and more altruistic or symbolic in nature. Whatever the motivation behind taking on this new consular position, it was a role that William served with pride and distinction.

With the rest of his life in very good order, Burrell considered that it was time to make a suitable match for Marion. Not long after their return from India, the Burrells dined with Florence Lady Garvagh, an old Danish aristocrat who was a major influential figure in London society and a friend of Queen Mary. Lady Garvagh took Marion under her wing and started referring to her as her god-daughter. In January 1924 the *Daily Mirror* gossip columnist announced that 'Lady Garvagh has Miss Marion Burrell staying with her, who is, I am told, to be an interesting figure among this season's debutantes.'[71] The London season was an opportunity for the offspring of the nobility and gentry to find suitable spouses in what was known as the 'marriage mart'. Marion seems to have stayed with Lady Garvagh in London for much of the year. As well as being presented at Court, she attended exhibition openings, visited the royal enclosure at Ascot and was a guest at many society dinners. In June, William and Constance were in London where they joined Lady Garvagh in hosting a dance for Marion in the opulent surroundings of Chesham House, the old Imperial Russian embassy in

Belgravia.[72] By the end of the season no suitable suitor had emerged and Lady Garvagh travelled to Scotland to join the Burrells on a shooting party in the Highlands. By December Marion was back in London with Lady Garvagh where they attended the opening of Parliament.[73]

Marion seemed to spend much of her time in London with Lady Garvagh and in preparation for the 1925 season, a portrait of Marion appeared in the pages of *The Gentlewoman*, a weekly high society paper with links to the Court.[74] This time Burrell spared no expense in his matchmaking exercise for his daughter. Marion was fitted with a fine new wardrobe of dresses from the best London design-ers and as the base of operations he rented 40 Grosvenor Square, a townhouse in the centre of Mayfair and the former residence of the Earls of Strathmore. To fit out the house in appropriate style Burrell had fifty-nine paintings, including Manets, Daumiers and Crawhalls, temporarily transferred there from the Tate Gallery.[75] While Marion and Lady Garvagh stayed in Grosvenor Square, William and Constance oversaw proceedings from the comfort of Claridge's Hotel. The summer was filled with dances, trips to Ascot and the rowing at Henley. A ball was organised at Grosvenor Square attended by a fine array of princes, dukes and other nobles, and younger members of the consular fraternity. Marion was also formally presented to the Queen at Buckingham Palace.[76] Marion had the time of her life, but again no engagement was forthcoming. Once the London season was over, the young debutante returned with her family to Scotland where the hunting season and all of its festivities were just beginning.

There was no London season in 1926 due to the General Strike, and Lady Garvagh died that year. In her obituary her relationship with Marion was particularly noted: 'For the past two or three sea-sons she took out Miss Burrell, who is a very good-looking young girl . . . Miss Burrell was very devoted to her god-mother and will miss her very much.'[77] The following year Burrell tried the whole thing again. Another lady chaperone was engaged, and another Mayfair mansion was hired. This time they rented Norfolk House

in St James's Square.[78] This had been the town house of the Duke of Norfolk since 1722 and was perfectly positioned for Burrell to attend sales at Christie's, just round the corner on King Street, and to keep an eye on his tapestries that were currently on loan to Frank Partridge's gallery. It was also only a short distance from his London club, the Constitutional Club on Northumberland Avenue.[79] Again no expense was spared, with the budget this time stretching to a ball for 1,200 guests. Alas the investment yet again failed to pay dividends and the season ended with Marion still lacking a marriage proposal. While the season was in full swing it was announced in the King's birthday honours that Burrell was to be knighted for his 'public and political work and services to art in Scotland'.[80] So, on 22 June 1927, the Burrells found themselves back at Buckingham Palace, only this time it was William's turn for royal recognition, receiving his knighthood from King George V himself.[81]

Three months after this happy occasion, Burrell's life was altered by the sudden death of his brother and business partner George. George's youngest daughter Isobel had married Charles Louis MacKean, partner in the Howden Brothers shipping company in Larne, in 1917. In 1922 he became High Sheriff of the County of Antrim and was a major figure in Ulster business and Unionist politics. In September 1927 George was visiting his daughter and son-in-law, and enjoying a fishing holiday in Antrim, when he died suddenly of a heart attack. A good indication of the success of the Burrell & Son business can be seen in his estate, which was valued at £263,000.

George's death signalled a gradual slowing down of the family business, which had already taken on a different character after World War I. Given Burrell & Son's previous practice it would be reasonable to assume that they intended to re-enter shipowning at the end of the war when they could exploit the expected slump to buy cheap ships. However, instead of a slump there was a shipbuild-ing boom as wartime losses were replaced. The state also continued to maintain a strong control over shipping for several years after the war, which limited the commercial freedom of shipowners. This was

not the type of market that would have been attractive to Burrell. The brief post-war boom was then followed by a severe and lasting depression in world trade where British shipowners struggled in the face of growing international competition. By the time trading conditions offered potential in the mid 1920s the impetus for Burrell & Son to re-enter the market had gone. Both George and William were getting on in years and there was no obvious successor to carry on the dynasty. George's son, William Burrell Jr, would have been the natural heir but his death in the war created a void. His other sons, Gordon and Thomas, were not business-minded and preferred sporting and country pursuits.

Despite getting rid of the rest of its ships, Burrell & Son continued to operate the *Strathlorne* throughout the 1920s. By now it was getting rather old and inefficient. It regularly suffered from coal fires in its bunkers and needed frequent repairs. This was very different to previous ventures by Burrell & Son that were based on having large numbers of modern efficient ships. Quite why the ship was kept on is a mystery. The business had certainly not been shy in the past of operating without ships. Perhaps there was finally an element of emotion creeping into Burrell's business decisions; *Strathlorne* was the only one of Burrell's ships to be launched by his daughter Marion and there may have been some lingering sentimental attachment. The ship still managed to trade at a profit and provided a steady return for the business. It was primarily chartered to other shipping companies. In April 1926 it was on its third six-month time charter to the London-based Bank Line, sailing from Taiwan to Auckland, then across the Pacific and through the Panama Canal to Norfolk Virginia then on through the Kiel Canal to Helsingborg in Sweden. The ship was then chartered for another seven months. During this thirteen-month period the *Strathlorne* made a loss of £2,150 for the Bank Line, whereas Burrell & Son earned over £18,000 in monthly hire fees and brokerage commissions. It certainly made sense for them to charter out the vessel rather than try and operate it themselves.[82] To rub salt into the wounds, there was a dispute during this charter over an unauthorised shipment of rice and the courts

found the Bank Line liable and ordered them to pay Burrell & Son £25,000.

The *Strathlorne* was disposed of in 1930 to Greek owners. When the final accounting was done, given that the Strath Mutual Insurance Association was also wound up at the same time, William Burrell earned £3,000 in liquidator fees plus around £16,000 in share returns. Constance would have received £1,250 for her three shares. Even if there was an element of sentimentality in keeping the ship on for so long, the end result was still cold hard profit.

As well as managing the *Strathlorne* Burrell & Son continued to operate as agents and brokers. George Burrell's obituary in 1927 indicates that he was 'engaged in the South American trade'. This is borne out by adverts that show that Burrell & Son were agents for the Royal Holland Lloyd shipping line which ran a service from Southampton to Las Palmas, Brazil and the River Plate.[83] William Burrell had been semi-retired for years and when George died in 1927 the office was managed by the senior shipping clerk John B. Bodie, who had worked with Burrell & Son for many years. The business, however, was now being run on a much reduced basis. As well as having shares in his own companies, Burrell also earned dividends from his shareholdings in other businesses. Details are scarce but he was certainly a shareholder in the North British and Mercantile Insurance Company and the London and African Mining Trust.[84] Unusually for a shipowner, Burrell does not seem to have taken on any directorships outside his own businesses. It was common practice for leading industrialists to become directors of associated companies such as mining, steel and insurance, but this was not something that Burrell did, preferring, seemingly, to keep his business interests closer to home.

With his brother gone and a change in the pace of business life, Burrell's focus became more set on building up his collection and undertaking his public duties. In the same month as George's death, Burrell was appointed as a trustee of the National Gallery of British Art at Millbank. When the Tate board was first set up there had been some conflict between the National Gallery appointees and the

artists, so when the first tranche of trustees came to the end of their tenure the gallery wished to include some additional independent trustees who could bring a steadying hand to proceedings. The choice fell on two staunch supporters of the gallery in William Burrell and the artificial silk manufacturer Samuel Courtauld, who had recently donated a £50,000 fund to purchase modern French paintings.[85] Burrell's existing relationship with Millbank, his work as a trustee of the National Galleries of Scotland in Edinburgh, as well as his knighthood, all played a hand in this appointment. Unfortunately, one of his first tasks as a trustee was to deal with the consequences of a major flood that reportedly damaged a large number of prints and watercolours 'beyond recovery'.[86] These included eighty-eight of Burrell's, including works by Whistler, Degas and Crawhall, which were salvaged by the quick attention of a specialist restorer.[87] After this initial excitement, board life settled down to a more routine agenda of business and acquisition decisions.

By the end of 1927 Sir William Burrell had achieved his dream. He was now installed in his own castle, surrounded by a collection that was recognised as among the best in the country. He had been awarded a knighthood, had the prestige of serving as a consul once more, and sat on the board of two major national art galleries. He was acknowledged as a man of rare distinction, whose wealth, taste and generosity had placed him in the higher echelons of society. It was now time to enjoy that dream.

CHAPTER 6

Living as a Laird

Hutton Castle enabled Sir William Burrell to establish himself in the mould that he had always desired. Although the building was not ready to move into until the late summer of 1927, Burrell took to calling himself William Burrell of Hutton as soon as the purchase was made public in 1916. While most of the castle remained a building site the Burrells would stay there intermittently to establish their presence. By 1917 new kitchens were installed and some bedrooms and other parts had been made habitable. Both William and Constance threw themselves into the community life of the county, attending flower shows, sports days and church fêtes. They were particularly active in the small hillside village of Chirnside, close to Hutton Castle. In 1917, Burrell became a Justice of the Peace for Berwickshire, by 1919 he was vice-president of the Chirnside Athletic Sports Club, and he later became vice-president of the Paxton and Hutton Amateur Horticultural Society, vice-president of the Chirnside Quoiting Club and patron of the Chirnside charity bazaar.[1]

As soon as Hutton was ready to move into permanently, the Burrells needed a suitable staff to run the castle and its grounds. It is thought that the castle itself had a staff of around ten people including Peter Clark the butler and a team consisting of a cook, a head housemaid, a liveried footman, and several domestic servants including Lexie Lesenger and Mary Renwick. There was also a chauffeur and maintenance man, a head gardener and a small team of gardeners plus a gamekeeper. From 1935 Sir William also employed a secretary, Ethel Todd Shiel, who gave an interesting account of working for him:

Sir William Burrell would dictate letters to me, which were handwritten by me, as he disliked the noise of typewriters. He would sit next to me, and usually we worked in the library of Hutton Castle, although sometimes if he was troubled by bronchitis, particularly in the winter, we would work in his bedroom. Sometimes also we would work in the Billiard Room if he had bought new items for his Collection, as these were usually brought to the Billiard Room for the purposes of listing. I would make lists of the new items as they arrived, and Peter the butler would then pack these if they were to be sent to galleries for exhibition.[2]

In common with everything in his life, Burrell expected high standards from his staff, which occasionally led to friction and even dismissal, but on the whole he treated them well and he built a core of loyal staff. Unlike in similar establishments, the servants had hot and cold running water in their quarters, though electricity was rationed, being shut off at 10 p.m. Electricity came from a generator on the estate and it is understandable that Burrell was concerned about its use, but he was perhaps a bit stricter than absolutely necessary. The staff supported Burrell in establishing himself as the lord of the manor and in running the estate in a way befitting the expectations of the more established landed gentry.[3]

As with his ships, Burrell divided the management of the separate parts of his estate into individual private limited companies. The Hutton Estate Company Ltd was the largest, with a capital of £16,100. The Blackburn Estate Company had a capital of £8,100 and the Whiterig Estate Company £6,100. Constance was appointed chairman of the three companies and William Burrell was the majority shareholder. The registered office for all three companies was the Burrell shipping office at 54 George Square and the company secretary was John B. Bodie, the senior clerk at Burrell & Son. He was very much Burrell's right-hand man and took on the additional responsibility of managing the business affairs of the estates such as finding tenants for the farms and other properties, and recruiting

staff. Bodie also managed the insurance of the collection and took care of Burrell's affairs in Glasgow. He held a key to 8 Great Western Terrace and frequently liaised with Kelvingrove on Burrell's behalf about loans and transfers of his collection.

Constance quickly stepped into her role as Lady Burrell and was soon involved in a variety of local initiatives and charitable causes. Her interest in social and medical affairs can be seen in her membership of the Berwickshire Committee of the National Society for the Prevention of Cruelty to Children and she later became vice-president of the Chirnside and District Nursing Association.[4] This was a local branch of the British Nurses Association, which united nurses who sought professional registration. She assisted the fundraising efforts of the association through, for example, manning a stall at a bazaar.[5] Constance and Marion also ran a cake and candy stall at the grand fête held at Lennel House, Coldstream, in aid of the Scottish Children's League of Pity, which was affiliated with the Scottish Society for the Prevention of Cruelty to Children.[6] She later became chair of the local Red Cross Society.[7]

In November 1928 the national newspapers reported on Constance's gift of £10,000 to purchase one gramme or fifteen grains of radium for the Glasgow Royal Cancer Hospital. *The Scotsman* recorded, 'The radium . . . will be available for the benefit of the whole community, as a portion of the gramme is to be set aside to furnish emanation (radon) for outside cases.'[8] This initiative came through the persuasion of Sir George Beatson, head of the hospital and one of the country's leading oncologists. Her remarkable gift enabled the establishment of the Glasgow and West of Scotland Radium Institute in 1930, now known as the Beatson Cancer Research Institute.[9]

This gift highlights the fact the Constance remained financially independent and managed her own affairs. She also paid for the building of a new parish church hall in Hutton.[10] At the opening ceremony in 1931 William Burrell made the gift on Constance's behalf, stating that handing over the hall to the parish was 'a great pleasure to his wife, and she hoped that the hall would prove not

only useful, but a joy to themselves and all their neighbours'. The Rev. D. S. Leslie, chairman of the hall, responded to the gift by saying that it was one of the happiest moments of his life to receive 'the most generous gift of such a beautiful hall'. The hall was decorated with 'replicas of famous pictures by outstanding artists' which were gifted by Sir William.[11] In recognition for her gift, Constance was presented with a book on farms and gardens with a dedicatory inscription. She made a brief speech of thanks, noting that she would 'treasure it as a souvenir of the occasion'. Every year thereafter Constance hosted a Christmas party in the hall for the parishioners, with lively entertainment, refreshments and presents for the children.[12] She has sometimes been presented as rather cold and mean-spirited, and there is no doubt that her ongoing health issues affected her personality, but these acts of generosity demonstrate a different side of her character. She and William supported each other but Constance was very much her own woman who took her public duties seriously.

One of the events that William Burrell had a particular affection for was the annual show of the Chirnside Poultry, Pigeons, Rabbits and Cage Birds Society. He became patron of the show when it was held for the first time since World War I in 1927 and continued in this role for many years.[13] Burrell's interest in farming matters can also be seen in his involvement with the Paxton Agricultural Show, where he donated two Sir William Burrell Cups, one for the best-bred horse and one for the best animal in the Aberdeen Angus section.[14] These farming competitions may have brought Burrell's Crawhall collection to mind. The artist's depictions of bulls, chickens, cows, ducks, goats, farm horses and hunting, which Burrell continued to collect, were suddenly more realistic to their owner than ever. Crawhall's work had always been one of Burrell's greatest passions and remains one of the most popular parts of the collection. They were constantly being sent on loan and wherever they appeared they were singled out for praise. Crawhall died in 1913 so the only way to acquire more work was through dealers and other collectors. The other main collector of Crawhall was Paisley thread manufacturer

William Allen Coats. Following his death in 1926 Burrell bought three works that had been in his collection.[15] Eight years later he bought a further eleven works through Reid & Lefevre, following a sale of Coats' collection at Christie's in London.[16] Burrell bought many Crawhalls through Alexander Reid, who, according to Burrell, 'looked upon Crawhall as a genius, which he was'.[17] Burrell and Reid had shared a love of modern European art and Reid's death in 1928 would have come as sad news to the collector.

As the new laird of Hutton Castle, Burrell took a great interest in local affairs and in November 1928 was elected unopposed to Berwickshire County Council as the member for the Hutton ward.[18] Local politics were pursued in a far more gentlemanly way in Berwickshire and were less politically adversarial than Glasgow, which seems to have suited Burrell far better. He certainly stayed on the council far longer, not giving up his seat until 1945 at the age of eighty-four. During all of this time the council was led by the Earl of Home and was overwhelmingly Conservative. Berwickshire was very different to the urban industrialism of Glasgow but despite its rural charm it was not without its problems. From the County Hall in Duns, Burrell pursued similar issues to those that he dealt with in Glasgow: poor housing, sanitation, policing and financial management. Housing and fresh water supplies were particular concerns in Chirnside. In 1929 some houses in the area were described as 'hovels' by the Sanitary Inspector because of their 'deplorable conditions'.[19] A proposal was made to replace them, and the tenants, at the time living in one-roomed homes, would be given the option to live in three-roomed homes. It was confirmed that two blocks of four of these homes should be built immediately, with the hope that they would be finished by September of that year. Burrell asked for the rents to be as low as possible so that people could afford to live there.

Burrell was sometimes reported as being a generous laird. The local newspaper reported his seasonal gift of a turkey to each household on his estate.[20] However, in due course, Burrell railed against the costs of being a laird. In October 1931 he supported the move to cancel the Rural Housing Scheme which had been in place for

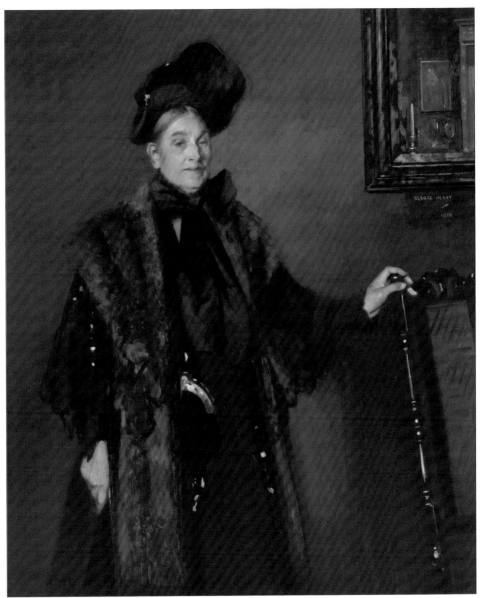

Portrait of Isabella Burrell by George Henry, 1903, oil on canvas. William Burrell's mother played a prominent role in the shipping business of Burrell & Son and was a major influence on his art collecting.

Portrait of Miss Mary Burrell by John Lavery, 1894, oil on canvas. William Burrell commissioned Lavery to paint this portrait of his sister, and it remained one of his favourite paintings. He donated it to Kelvingrove in 1925.

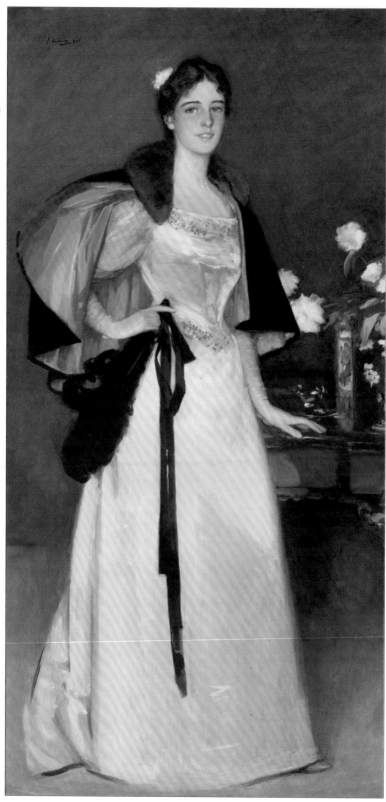

State Visit of Her Majesty, Queen Victoria to the Glasgow International Exhibition, 1888 by John Lavery, 1890, oil on canvas. William Burrell is amongst the guests shown in the audience.

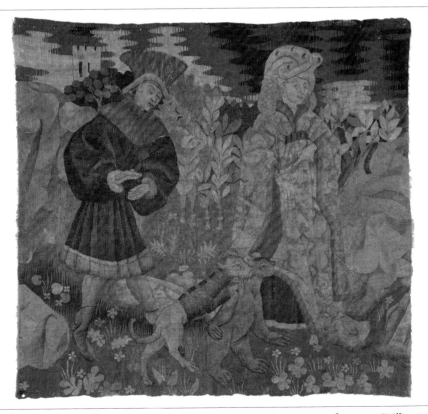

Bear Hunt, Southern Netherlands, around 1435–45, wool and silver tapestry fragment. William Burrell purchased this for £2,200 in 1936 from the dealer M. & R. Stora in Paris.

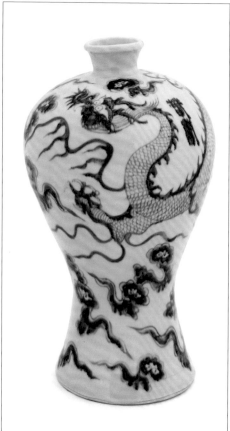

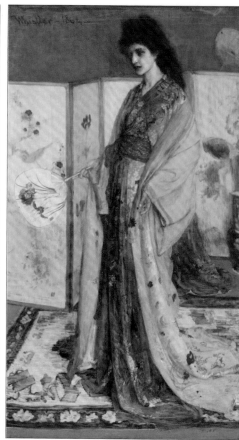

Above. Chinese ceramics form one of the most important parts of The Burrell Collection. This Ming Dynasty piece, known as the Meiping Vase, dating from 1368–1398, is one of the rarest and most important items.

Above right. La Princesse du pays de la porcelaine by James McNeill Whistler, 1865, oil on canvas. William Burrell bought this from the dealer Alex Reid in 1895 and sold it to the Detroit industrialist Charles Lang Freer in 1903 for £5,000. (From the collections of the Freer Gallery of Art and Arthur M. Sackler Gallery)

Right. Burrell had a great interest in Islamic art. This lustre-painted ceramic tile, dating from AD 1261, once decorated the walls of the burial chamber in a Muslim saint's shrine – the Imamzada Yahya.

Still Life by Jean-Baptiste-Siméon Chardin, late 18th/19th century, oil on canvas. Burrell purchased this in 1936 from the Munich-based dealer Julius Böhler who, unknown to Burrell, had acquired it from the forced sale of the Jewish art gallery A.S. Drey.

Burrell bought this Swiss early 16th-century tapestry, *The Visitation*, from John Hunt in 1938. We now know that it was forcibly sold in Berlin in 1937 and the Jewish owners did not receive the proceeds of the sale. Reparation was made to the Budge estate in October 2015.

Portrait of Edmond Duranty by Edgar Degas, 1879, gouache with pastel enlivenment on linen. Burrell collected more works by Degas than any other collector in Britain. This is one of the most important pieces.

The Aviary – Clifton by Joseph Crawhall, 1888, painting (watercolour and gouache). Crawhall was one of Burrell's favourite artists. He acquired this work in 1892 and regularly lent it to exhibitions.

This bedhead was made for the marriage of Henry VIII and Anne of Cleeves in 1539. Burrell was passionate about collecting material with royal connections.

This hawking set, dating from about 1600–1620, is said to have belonged to King James VI & I. Burrell regularly lent it to exhibitions, including the 1938 Empire Exhibition in Glasgow.

'Beatrix de Valkenburg', stained glass panel, English, 13th century. Burrell was excited to acquire this piece because he believed that Beatrix de Valkenburg's stepson had slept at Hutton Castle.

Russian Dancers by Edgar Degas, about 1899, charcoal and pastel on tracing paper. Burrell donated this sketch to the town of Berwick-upon-Tweed in 1948, causing friction with the director of Kelvingrove, T.J. Honeyman, who wished to keep it in Glasgow. (Museums Northumberland, Berwick-upon-Tweed Museum & Art Gallery)

Dear Lady Disdain by John Lavery, 1890, oil on canvas. This is one of Burrell's early purchases. He gave it to the town of Berwick-upon-Tweed in 1948. (Museums Northumberland, Berwick-upon-Tweed Museum & Art Gallery)

Butterflies by Matthjis Maris, 1874, oil on canvas. Maris was one of Burrell's favourite artists. This is one of his most popular works and Burrell regularly lent it to exhibitions.

five years and had seen 800 houses reconditioned through grants from the council and the Treasury, as well as through rates paid by the landlords.[21] Burrell raised concerns about the amount that proprietors were paying for the scheme. Three years later Burrell raised further concerns about paying for new farm cottages on his estate, stating that he had a small estate where rents were £800 or £1,000 of which he only received 1.5 per cent after paying his rates. He agreed with fellow councillor Colonel Algernon R. Trotter who, although sympathetic with the work done to improve the housing of the rural population, did not think that this was the time for the burden of the improvements to fall on the proprietors.[22] The costs of paying for them increased through even higher property and water rates, as well as the engineering and inspection fees incurred for laying new water pipes. Although this motion was ultimately dropped, it illustrates Burrell's frustrations with his financial duties as a landowner. He may have supported lower rents for tenants of homes not on his estate, but the improvement of rural housing seems to have become a more sensitive question when they fell within the confines of his own property.

As both laird and celebrated art collector, Burrell loaned parts of his collection to local exhibitions and events. In 1928, he sent works to an exhibition of arts and crafts at the neighbouring Manderston House in Duns, organised by The Hon. Lady Miller to raise funds for the Berwick branch of the Royal National Lifeboat Institution. Burrell's works were exhibited in the antiques section, and the local press reported that they were 'a most interesting feature, and one over which one felt disposed to linger a long time'.[23] The Scottish Women's Rural Institute were also the recipients of selected Burrell items for displays. This was an organisation that both Constance and Marion were heavily involved with. Firstly, in 1931, silver, samplers and embroidery were lent to Hawick Town Hall for the Roxburghshire Rural Institute. The *Southern Reporter* noted the 'very interesting and valuable antique pieces', including some 'very rare and beautiful examples of early samplers, exquisitely worked on linen' lent by Burrell.[24] A larger loan of tapestries followed in 1934

for the Scottish Women's Rural Institute's national exhibition at the Royal Scottish Academy in Edinburgh. *The Scotsman* reported that the exhibition was 'one of the most representative and comprehensive collections of the work of the needle ever gathered together'.[25] Burrell loaned a significant number of pieces to the exhibition, including the sixteenth-century Luttrell table carpet.[26] Interestingly, Lady Lorimer also loaned the fifteenth-century Burgundian tapestry *Avril* to the exhibition.[27] This tapestry had hung in Lorimer's home in Edinburgh in the early 1900s when the architect had been employed in fitting out the interiors of 8 Great Western Terrace. It was a tapestry that Burrell would have known well and recognised. Whether the two men crossed paths at the exhibition is not known; however, the respective loans would have been a stark reminder of a friendship now lost. Exhibitions and loans such as these endorsed Burrell's position as laird of Hutton Castle, and his place within the established social hierarchy.

The Burrell family also got into the spirit of country life in the form of hunting, shooting and fishing. Running through the Hutton estate was the Whiteadder, a fine trout and salmon river to which Burrell retained the fishing rights. His brother George had been an avid angler, but whether Sir William enjoyed fishing quite as much we do not know. He certainly grew to love grouse shooting, which was an interest he started to develop when staying at Broxmouth Park in the mid 1920s. The theme of hunting was especially pertinent to Burrell's endorsements of established country life and social order. Between 1926 and 1937 Burrell rented the grouse moor at Mayshiel in the Lammermuir Hills from Major Alexander Houstoun.[28] The local press regularly recorded his parties' returns in the sports pages. In August 1930 the *Berwickshire News and General Advertiser* reported that Burrell's shooting party shot over 500 brace of grouse, seventeen hares, nine snipe, one duck and one rabbit.[29] Over eight days in August 1934 they bagged a record 1,728 brace of grouse.[30]

Hunting was a means by which Burrell could demonstrate his informal political power as a laird. Grouse shooting was not just about killing birds, it was about being seen to be part of the country

elite and entertaining influential guests. It was considered a noble sport and having a grouse moor was one of the prime signifiers of wealth and status, just like an art collection. One of Burrell's guests was Sir Michael Malcolm, 10th Baronet, who was featured on the front cover of *The Sphere* magazine on 19 August 1933 in action at Mayshiel. The magazine noted that Malcolm was 'seen in the butts of Sir William Burrell's shoot at Mayshiel in the Lammermuir Hills, Berwickshire'.[31] It then went on to note the importance of the technique of the butts, describing it as 'the perfect combination of shooter and loader that often bags the extra bird'. *The Sphere* was a weekly newspaper covering news stories from across the UK and the British Empire. Two years later the Burrell shoot appeared in *The Scotsman*'s feature on the Glorious Twelfth (12 August, the first day of the grouse shooting season) with another photograph of Sir Michael Malcolm at Mayshiel. Alongside were pictures of the Earl of Lauderdale, the Marquess of Tweeddale and the Earl of Mansfield. Also included was George Burrell's son Tom, who by now had established himself as a Perthshire estate owner.[32] Here we see Burrell's soft politics at play. His shoots were not only reported locally but nationally. Burrell and his extended family were seen to be on a par with the high nobility of Scotland.

This field sports aspect of Burrell's life is also reflected in his collection. He had several tapestries depicting hunting scenes, a Cranach painting of *The Stag Hunt*, eighteenth-century glass engraved with huntsmen, and various pieces of seventeenth-century hunting equipment. In 1934 he acquired an elaborately embroidered falconry set that is said to have belonged to James VI and I, which has become an iconic part of the Burrell Collection.

Another sport of kings that Burrell was associated with was sailing. He had joined the Royal Clyde Yacht Club in the 1890s, but with his move east he spent little time on the Clyde. Instead, he switched allegiances in 1921 to the even more prestigious Royal Thames Yacht Club in London. This was one of the oldest and most exclusive yacht clubs in the country, counting royalty and nobility among its members. He does not seem to have taken much interest

in yachting itself, but the Knightsbridge clubhouse and the social connections were clearly an attraction. It was this club that he listed in his *Who's Who* entry.[33]

Marion enjoyed going on the grouse shooting expeditions, and she equally enjoyed the lively social scene associated with them. There were parties, hunt balls and dinners that formed the basis of the autumn season of the county. She had firmly established herself on the Borders social scene and had become something of a local celebrity, mixing with all the best families. In January 1927 she attended the annual North Northumberland Hunt ball at Berwick.[34] A few years later she was a bridesmaid to Elizabeth Anne, the only daughter of Major and Mrs Reginald Hunter Blair of Broomhouse, near Duns. The local paper reported that the bridesmaids, of whom there were six, wore 'dresses of green chiffon, with sashes of twisted chiffon, flame and green, and carried sheaves of apricot-coloured roses'.[35] Marion was one of the train-bearers along with the bride's cousin. In the same year Marion and her parents attended the wedding of Lady Susan Alice Egerton, fourth daughter of the Earl and Countess of Ellesmere, of Mertoun, St Boswells. The *Berwickshire News* reported that it was a society wedding of 'extraordinary interest to people in Berwick, Norham, and indeed all the borders'.[36] The following year Marion attended another society wedding, this time in London, of 'two prominent Berwickshire families'.[37] A few years later, in January 1937, she was listed as having given a set of Pyrex dishes to Miss Jeanetta Scott, cousin of the Duchess of Gloucester and the daughter of Lord George and Lady Elizabeth Scott, upon her marriage to Captain James Stirling-Home-Drummond-Moray of the 2nd Scots Guards.[38] Marion's social calendar was busy, and there can be little doubt that such social events kept the Burrell family's interests and name in the media.

The driving force behind Marion's entrance into society had been to secure her a suitable husband. Three London seasons had failed to find a match and the prospect of a noble alliance seemed to be slipping away from the Burrells. This was an age when girls married young and Marion was now into her later twenties. Finally, in early

May 1929, the *Berwickshire News and General Advertiser* reported on her engagement to the Hon. John Roby Benson, the only son of Lord and Lady Charnwood.[39] Marion's suitor was the heir to a peerage and a baronial home in Buckinghamshire, and this would have held great appeal for Sir William. However, it turned out to be too good to be true and two months later *The Scotsman* reported that Lord Charnwood had broken off the engagement.[40] Marion is said to have really been the one to break the engagement, confessing later to her god-daughter, 'I suppose I didn't love him enough.'[41]

Three years after this the paper reported another engagement, this time to John Patrick Douglas Balfour, a journalist in London whose father, Lord Kinross, was the second Baron and had been the sheriff of Dumfries and Galloway since 1927. The paper reported that Marion was 'a very beautiful girl . . . popular in Scottish and English society', adding that she had, at one time, been engaged to Hon. John Roby Benson but the engagement was broken off.[42] Less than a month after the news of this engagement *The Scotsman* reported that it too had been called off.[43] This time it had been her father who had broken the engagement. Hearing whisperings of the gambling debts accrued by Balfour, Burrell felt uneasy. After looking further into his future son-in-law Burrell heard further rumours of Balfour's homosexuality, a fact that came as an 'ugly shock' to Burrell.[44] In the 1930s the mere mentioning of homosexuality in the presence of ladies was unheard of, and so, without advance warning to his daughter, Burrell publicly announced the end of their engagement. Marion is said to have learned the news herself through the newspaper announcement.[45] Shortly after this she vowed never to marry. Unsurprisingly, her relationship with her father would never be the same. The project to get Marion a suitable marriage had backfired spectacularly. Sir William's aim had been to form a strategic alliance with a noble family and cement the Burrell name among the elite of the country. Instead the failure was yet again publicly paraded in the nation's press. The combination of Marion's wilful nature and Sir William's overbearing control had doomed the whole process.[46] In an attempt to recover, William and Constance left Hutton in

December 1931 for a trip to London and then an extended stay at the Savoy Hotel in Bournemouth. Sadly the south coast climate did not live up to expectations: 'My wife is making steady progress I am glad to say but the weather is wet and foggy and does not allow her to make as much progress as she would otherwise do.' [47] They eventually returned to Hutton in July 1932 after eight months away. Marion stayed behind at Hutton where she got stuck into creating shell pictures for the Scottish Women's Rural Institute and deputising for her father in his local commitments such as opening the sale of work at Hutton Church Hall.[48]

Even if his attempts to secure a suitable husband for Marion had failed, Burrell could still put his energy into Hutton and his collection which was now receiving the royal seal of approval. In September 1930 Queen Mary visited Hutton Castle.[49] She was an avid art collector in her own right, and was already aware of the richness of Burrell's collection having visited the exhibition of tapestries at Frank Partridge's galleries in London in 1927.[50] She was on a three-day stay at Carberry and visited Lord Lothian's Newbattle Abbey and Dalkeith in the morning and then, as she noted in her diary,

> Early luncheon & at 2 to Hutton Castle near Berwick on Tweed (50 – miles) via Dunbar. Met by Sir William & L[ad]y Burrell who showed us all his treasures, tapestries, carpets, Jacobean furniture & fine old glass in the windows – a real museum & most interesting.[51]

The Queen's reference to Hutton as 'a real museum' would have greatly appealed to Burrell as it highlighted the status of his collection, now suitably housed in a country estate.

Whether as a result of his falling out with Marion and the failure to secure a line of succession, Burrell had decided in the early 1930s that he was going to leave his collection to the nation. With this in mind he welcomed another important guest to Hutton Castle in 1931, Harold Clifford Smith, a furniture historian and curator of furniture at the Victoria & Albert Museum (V&A) in London who

had written the first two volumes of the 1930 *Catalogue of English Furniture & Woodwork* for the museum.[52] In his account he wrote,

> I had heard various reports concerning the tapestries, carpets, needlework, stained glass, sculpture, armour, furniture, and other works of art which Sir William Burrell had for many years been gathering together; but what I saw far exceeded my expectations.
>
> Some of the stained glass and a number of the tapestries are already known to the Museum; but I found not only quantities of these objects, but a great deal of English Gothic and Tudor oak furniture of the highest quality and import-ance – comprising Gothic cupboards, chairs, panelling, and carvings, Elizabethan 'refectory' tables, buffets and side-boards, and elaborately carved bedsteads and armchairs.[53]

At this time Burrell was in discussion with the museum about the possibility of gifting part of his collection and Clifford Smith's trip to Hutton was to assess the collection's quality. Clearly he was impressed by the range and class of objects found at Hutton. As with that of Queen Mary, Clifford Smith's visit acted to enhance Burrell's status as a collector. His collection now had the seal of approval from both royalty and the foremost museum of decorative art in the country.

Perhaps in light of his decision to leave the collection to the nation, in the 1930s Burrell began to lend more of it to museums, galleries and other institutions around the country. Between 1930 and 1939 he loaned seventy-five tapestries to seventeen different locations. The first of these loans was to the Victoria & Albert Museum in London in 1930, which received *The Meeting and Marriage of Jacob and Rachel* and *Bathsheba Leading Solomon to David's Mule*. Perth Art Gallery and Museum received five English seventeenth-century tapestries in 1936. The Ashmolean Museum, Bowes Museum, Fitzwilliam Museum, Ipswich Museum, Leicester Museum, Laing Art Gallery, Luton Public Museum and Torre Abbey Art Gallery in Torquay also all received tapestries from Burrell. In addition,

loans could be found in five cathedrals across England: Chichester, Durham, Ely, Salisbury and Winchester.

Other parts of the collection went out on loan too, either for short-term exhibitions or for longer-term displays. In 1930 he transferred a further 100 pictures to the Tate Gallery; these had remained in store in Glasgow as there was no room for them at Hutton. Burrell was concerned that they were 'in a more or less dirty state as they have been stored so long'. He paid for the gallery's picture restorer to clean them so that they could be displayed and enjoyed by the public.[54] He followed this up in 1933 when he declared, 'My house is now finished. I have hung up as many pictures as it will carry and have about 7 or 8 over', which he offered to the gallery.[55] A few days later he wrote saying that he had sent off nine paintings and drawings. His obvious concern for his collection being cared for and appreciated can be seen when he concluded: 'Many thanks again for your kindness in taking them on loan from me. It is a great relief to me. I hope you may like them.'[56]

In 1932 he lent a newly purchased portrait of William Pitt the Younger by Dupont Gainsborough along with a portrait of William, Duke of Gloucester, to an exhibition at the Museum of London.[57] This was to garner support for the preservation of Pitt's Bowling Green House in Putney, then threatened with demolition.[58] A few years later he also lent the museum a large pewter plate with the head of Charles II and a set of Restoration chairs.[59] These loans reflect Burrell's strong support for the monarchy and Conservatism.

Other loans were less overtly political, more just a celebration of the quality and breadth of the collection. In 1935 he lent three Matthijs Maris paintings to a Maris brothers retrospective exhibition at the Gemeentemuseum in The Hague, for which Burrell was a member of the honorary committee.[60] The exhibition also included Jacob Maris's *Amsterdam*, which Burrell had donated to Kelvingrove in 1925. In 1936 he lent a Crawhall to the Fitzwilliam Museum in Cambridge, the *Souvenir of Dordrecht* by Jacob Maris to Dundee Museum and Art Galleries, Bellini's *Virgin and Child* and the fifteenth-century *Judgement of Paris* to the National Gallery.[61]

The following year Degas's *Jockeys in the Rain*, which he had just purchased from Leonard Gow, was sent to the National Gallery to join some of his other French nineteenth-century paintings which had been transferred temporarily from the Tate Gallery.

In 1937 a large collection of around 250 pieces of Elizabethan and Restoration silver and Chinese porcelain went on loan to the Royal Scottish Museum (now the National Museum of Scotland) in Edinburgh and this was later supplemented with thirty pieces of lace.[62] Dundee also received a considerable number of pictures. In 1937 and 1938 he regularly sent them paintings, including a Manet, a Cézanne, a Degas and Whistler's *Nocturne*. These were later joined by fifty pieces of Chinese blue-and-white porcelain.[63] Other items that were sent out in 1938 included a large selection of textiles, furniture and sculptures to Luton Public Museum, French seventeenth-century paintings to Bristol Museum and Art Gallery and some fine alabaster carvings to the Burlington Fine Arts Club in London.[64]

Most of the lending was done very much on Burrell's terms. The fame of the collection led to a constant stream of requests for loans to exhibitions, but Burrell was becoming increasingly frustrated with them. In 1937 he wrote that 'as you know I am tired lending'.[65] He was approached about lending two Crawhalls to the art section of the Empire Exhibition to be held in Glasgow in 1938 but declined, saying that 'I find an exhibition is no place for water colours'.[66] He did lend the James VI and I falconry set to the exhibition, but this was for the historical embroidery section of the Women's Pavilion.[67]

While all this was going on Burrell did not neglect Kelvingrove and he continued to regularly deposit significant numbers of Chinese objects there.[68] He was particularly concerned that his collection was seen in isolation from other exhibits in order to retain its own identity. After Burrell had made a fuss, the director of the museum James Eggleton wrote to him in rather grovelling fashion:

> We have now completed the rearrangement by which your
> loans to the museum are shown in cases unmixed with pieces

from any other sources. I trust that the adjustments will be thoroughly to your satisfaction, as I would like you to realise how much we appreciate having the Collections and also how much effort we have put into their adequate display.[69]

A new branch museum was established in Glasgow in 1936 when Aikenhead House in King's Park, on the south east of the city, was converted into a museum of history ranging from the time of Mary, Queen of Scots to Queen Victoria. Burrell was asked to contribute some items of furniture to complement the embroidery, paintings and other curios, which he was more than happy to do. He initially sent through a selection of seventeen pieces from Hutton including tables, chairs, cabinets and a couple of grandfather clocks. It is clear that the choice of exhibits was entirely Burrell's, as he then advised the director, 'I am also sending from my house in Glasgow 17 pieces of furniture . . . I think these things should complete furnishing the museum, and I hope you will like the pieces.'

The lack of input to the selection did not bother Eggleton, who was more than happy to receive the gift: 'The furniture, besides adding several items of outstanding intrinsic quality, gives a very fine finish to the whole exhibition.'[70]

Other parts of the extensive furniture collection also found new homes at this time. Temple Newsam House, a Tudor-Jacobean country house on the outskirts of Leeds, had been taken over by Leeds Corporation and was being refurbished to restore its original character. Burrell lent 'a large collection of oak and walnut furniture of the Jacobean and Restoration periods'. The loan included twenty-four exquisitely carved tall-backed chairs from the Charles II period, a James VI and I table and a magnificent Flemish sixteenth-century oak chest. With the installation of this collection Temple Newsam was said to have been 'furnished as splendidly as it ever was in the past'.[71] A collection of French and English oak furniture was also sent to Aston Hall in Birmingham. This was a large Jacobean country house that was run as a museum by the local authority. Burrell's loan was enough to fill four rooms and enabled some parts

of the building that had been closed to reopen to the public. The chapel was installed with six Gothic French church stalls and a massive fifteen-century refectory table. Other items included three large bedsteads and various cupboards, chests and tables.[72] An early-sixteenth-century English oak cupboard from Norfolk was also lent to the Tower of London in 1939.[73]

With so much of the collection dispersed it could really be considered as a distributed national collection that was awaiting its final home. Burrell was very discerning about where his collection went, and always wanted the character of the museum or gallery to complement the nature of his collection so that the public could see it in the best possible light. Very occasionally he also let the public into Hutton; for example, in August 1939 he opened up Hutton Castle for one day in aid of the Queen's Nursing Institute, which provided a district nursing service in Berwickshire.[74]

Having made the decision that he would ultimately donate the collection, and without the limitations of space at Hutton as a consideration, Burrell began to rapidly expand the collection. Burrell's intent to gift the collection was publicly known from at least 1933 when Frank Surgey announced to the British Antique Dealers Association, 'It was a source of satisfaction to know that his treasured acquisitions would never leave the country.'[75] The scale and scope of the collection changed in the 1930s as he was no longer collecting items to fit out his castle, but to create a comprehensive collection in its own right. Paintings and Chinese ceramics remained core elements, but tapestries and stained glass began to take greater prominence. Between 1933 and 1939 he spent £235,000 on roughly 630 objects. In 1936 alone he spent £79,280, the highest annual total by quite some margin during his entire collecting career.[76] Many of the objects that he bought went more or less immediately on loan to galleries around the country.

Throughout his career as a collector Burrell used around 350 individual dealers. The catholic nature of his collection meant that he had contact with dealers of wide-ranging specialisms, from glassware to Chinese porcelain, embroidery, painting, lace, furniture, arms,

armour and more. Some of these dealers Burrell only ever purchased one object from, others he returned to, buying hundreds of pieces for his growing collection. The high number of dealers used suggests that Burrell was a collector who knew his own mind. He was not reliant on individuals to shape his taste, rather it was he who sought out dealers who had the objects that he desired.

Burrell trusted a small core of dealers who were established specialists in their field. These included Frank Partridge, dealer in medieval and Renaissance antiques and Chinese art, and Robert Lauder the furniture specialist. Burrell was confident in his taste but was less certain of his knowledge and the dealers with whom he was closest shared their expertise with him, helping to bolster his own confidence. He believed that dealers were more trustworthy than academics as they invested their knowledge in commercial ventures that had consequences: 'My experience is that a good dealer is more accurate as a rule than a Professor and that is because the dealer, if he makes a mistake has to pay, but the Professor has not and is less accurate.'[77]

Burrell was particularly concerned with authenticity and with the art and antiques market awash with fakes, forgeries, copies and optimistically attributed works, he was rightly wary. As with all big collections there are a number of pieces that turned out not to be what they originally purported to be. When Burrell discovered these he would return them to the dealers, sell them on, or have them removed from display. For example, when he visited Kelvingrove with Frank Partridge he discovered some fakes:

> Mr Partridge confirmed that the three black jars are modern and as I do not wish to show anything which is not 'period' I shall feel greatly obliged if you will kindly give instructions to have these three pieces very carefully packed and sent by the 4 o'clock train from Queen Street on Friday to Berwick on Tweed.[78]

Burrell later asked Partridge to sell off some of his Chinese collection, but Partridge declined as they would harm his reputation if he

were to list them.[79] On at least one occasion Burrell took a vendor to court for misrepresentation. In 1928 he bought what he thought was a fifteenth-century reredos, or altar screen, from the London dealer Edmund Harding. He later discovered that much of it was modern forgery, rendering the piece of little value. The Court of Session agreed, and the case was found against the dealer's widow and executrix.[80]

Burrell built a particularly strong relationship with Wilfred Drake, a dealer in medieval glass. Drake not only supplied large amounts of glass to Burrell but acted as one of his principal advisors. His knowledge of heraldry and the history of medieval stained glass was extensive. Burrell often wrote to him requesting information about the heraldic motifs found on his panels as well as the historical context of the pieces. He even commissioned Drake to prepare a catalogue of the glass at Hutton Castle in 1933. Burrell was genuinely interested in the history of the pieces in his collection, not just to satisfy his own thirst for knowledge, but to provide him with the confidence to speak about his collection to others: '[S]ooner or later someone is sure to ask. I feel very stupid when I am not able to tell them.'[81] Under his tutelage Burrell built up such an incredible knowledge that Drake went so far as to call him 'a connoisseur of Gothic glass'.[82]

Burrell also developed a close working relationship with John Hunt, a dealer of late-medieval and Renaissance art, who became Burrell's main dealer for this material from 1933. More than a quarter of all the pieces that Burrell bought in this period came through Hunt, including tapestries, furniture and religious objects, candlesticks and stained-glass panels. Burrell first met Hunt in 1932, when he was working as a buyer for Acton Surgey.[83] Two years later Hunt established his own business in St James's, London, where he worked with his wife Gertrude until they moved to Ireland in 1940. Hunt and Gertrude were successful collectors in their own right and their collection of 2,000 works of art and artefacts can be seen at the Hunt Museum in Limerick.

Like Drake, Hunt played an important pedagogical role as a dealer. Burrell had the utmost respect for him and the two built

a close personal and professional relationship. His confidence in collecting was nurtured by this relationship and Hunt provided a platform from which Burrell could improve his collection in size and quality. Unlike some of the sparse entries in the purchase books for other dealers, many of the works that came from Hunt had long and detailed descriptions of their significance. A good example is one of the lengthiest entries of any object that Burrell listed, spanning five pages of text. This was for an oak bedhead possibly commemorating the marriage of Henry VIII and Anne of Cleves in 1539 that he purchased from Hunt in November 1938.[84] The entry begins with a detailed physical description of the object:

> The head of a bed, of oak. This is formed of three panels, flanked by supporting figures and separated by columns. The dexter panel bears the royal motto: 'Dieu et mon Droit' on a shaped reserve surrounded by Renaissance scrolls of gold and blue.

He then began to incorporate an historical analysis of the bedhead,

> This is a highly important piece of furniture . . . It is known that Holbein was designing furniture for his royal master at this period and the design of the capitals to the columns can be matched on some of his existing drawings from silver cups etc. as also can be the gold decoration on the surrounds to the inscription. These floriated Renaissance designs occur almost line for line in several of his drawings. There also exists a design for a Jewel of intertwined initials H and A on the bed back that it leaves very little doubt that Holbein himself was responsible for the design of this.[85]

Through his analysis Burrell connected the bedhead's date and style to the work of Hans Holbein the Younger, court painter to Henry VIII. This is what interested Burrell, an object's place in history, as well as its value as an example of the type of artistry that it

represented. In his entry Burrell compared the bedhead to similar pieces in other collections: 'It can only be compared in quality with the stalls at King's College Cambridge.'[86] Burrell was determined to confirm the importance of his own acquisitions, and with this comment he placed his new purchase firmly beside a well-known public collection and institution. This is one of the pieces that Burrell lent to Aston Hall in 1939 and indicates that he felt that its significance meant that it should be on public display rather than keeping it in his own private domain at Hutton.

An important issue to be considered with purchases bought during these years is that many pieces came onto the market as a result of forced auction sales of works belonging to Jewish collectors by the Nazis. Some collections were seized directly, and many were sold as a result of the increasing persecution and unfair taxation of Jewish people in Germany and German-controlled territories. Some art and antiques dealers were complicit in this trade, but many others were also caught up unwittingly.

John Hunt was accused and later exonerated of active collusion with the Nazis, but some of the items that passed through his hands during this period were unprovenanced and have subsequently been proved to have come from forced sales.[87] Most collectors at the time were more interested in the historical significance of their purchases rather than their immediate provenance. As Andrew Hannah stated: 'Sir William, very naturally, concentrates on the things themselves, but does not always have the same concern for antecedents.'[88] There are no records or correspondence that might explain where Hunt acquired the objects that Burrell purchased. When Hannah tried to find out the provenance of one piece, Gertrude Hunt replied: 'I am afraid I have at the moment no details about the previous history of the piece. It was for some years in the private collection of a dealer here, but he has given me no information as to where he got it.'[89] This was common practice for dealers and auctioneers at the time as this type of information could be commercially sensitive and many sellers wished to remain anonymous. Not only did collectors like Burrell not know who had previously owned items, but quite often

the dealers were unaware as well. So while the volume of artworks from forced sales increased during the 1930s, it was by no means clear to purchasers what their origin was.

Not all the objects Burrell acquired from Hunt have questionable or tainted provenance, but this was certainly the case with one of them. Burrell bought the Swiss early sixteenth-century tapestry, *The Visitation*, for £315 from Hunt on 8 August 1938.[90] How the piece came to be in Hunt's possession is not known. Burrell's purchase book entry is the only known documentary evidence of the transaction and it does not list any provenance. However, we now know how the tapestry came to be sold. Emma Ranette Budge was a Jewish art collector from Hamburg, who lived in the United States with her husband in the late nineteenth and early twentieth centuries. Although Budge had advised that her collection was not to be sold in Germany, following her death in 1937 her executors sent her collection to Berlin for auction. Two sales of her work were held at the Aryanised Jewish auction house of Paul Graupe in September 1937. The money generated from these went to an account in M. M. Warburg & Co., a bank that had formerly been Jewish but was now controlled by Nazi supporters. Budge's heirs did not have access to this account, and they never received any proceeds from the sales. This case was considered by the UK government's Spoliation Advisory Panel in 2014, which concluded that these two sales were forced and, as such, Burrell's acquisition of the tapestry was the result of a forced sale.[91] Glasgow City Council agreed to make an *ex gratia* payment to Budge's estate that reflected the current market value of the tapestry. In consideration of this payment Budge's estate released any claim over the tapestry and it was agreed that, when exhibited, a notice would be displayed recording the circumstances of its acquisition.

Another object in Burrell's collection also came from a forced sale at Graupe's auction house. This was a still life by Chardin that Burrell purchased in 1936 from the Munich-based dealer Julius Böhler. Burrell had bought several items from him in 1930 and, knowing what he was interested in, Böhler wrote offering him the

painting. Burrell purchased it, sight unseen, on the strength of its auction catalogue entry which Böhler had enclosed, and the fact that it had been published in a catalogue raisonné a few years previously. Burrell knew that the sale was of the stock of A. S. Drey, a Jewish-owned gallery in Munich.[92] What he almost certainly did not know was that Böhler was now in the pay of the Nazis and that the sale was forced. Burrell only saw an extract from the auction catalogue showing the Chardin as lot number six. He would have had no idea that the sale was of Drey's entire stock consisting of over 500 lots. Burrell knew the firm, having purchased material from them in 1930, and would have been appalled if he had known the full circumstances of the sale.[93]

Following the establishment of the Spoliation Advisory Panel in 2000, Glasgow Museums' curatorial team identified this painting as potentially problematic and listed it on the official spoliation website, along with other works whose provenance had gaps in the 1930s. As a result, the lawyer for the heirs of A. S. Drey contacted the museums service and, after additional research confirmed its provenance, the case was taken to the Spoliation Advisory Panel. The panel agreed in 2004 that the painting had been subject to a forced sale and that it should be restituted to its rightful owners.[94] The heirs accepted an *ex gratia* payment of £10,000 from Glasgow City Council and the painting remains in the collection.

Research by the current curatorial team has indicated that there are other works in Burrell's collection that may have been acquired as a result of forced sales. However, Burrell was not alone. The quantity of material on the market meant that anyone collecting this type of art in the 1930s could easily have ended up acquiring looted goods unwittingly or without fully understanding the issue.

Although Burrell may not have known the full provenance of every item he purchased, when he did know he was keen to do the right thing. When he was offered a piece of stained glass from Glasgow Cathedral in 1929, he was very excited about the discovery, but rather than snatching it up for his own collection he stated: 'Personally I think it should be in the Glasgow Cathedral. It is a

document and should be in its proper place.'[95] This kind of ethical approach would have also guided any purchases he made in the 1930s and he would have been horrified if he knew the full story of how some of his purchases had come to auction.

A collector who shared Burrell's passion for the historical significance of objects, and in particular medieval objects, was the American newspaper magnate William Randolph Hearst. Unlike Burrell, the American collector was happy to pay inflated prices for the pieces that he acquired, something that no doubt had an impact on the Hearst Corporation coming to the brink of insolvency in 1937.[96] The following year large parts of Hearst's commercial empire were sold off and St Donats, his medieval castle in Wales, was put on the market. Hearst had bought the castle in 1925 and spent the next thirteen years restoring it and fitting it out with a fine collection of art and antiques. When the castle was put up for sale Christie's was called in to sort the contents for auction. The collections were to be 'gradually broken up, some to be kept by him, others to be sold'.[97]

Burrell seized on this opportunity and over the years acquired a substantial part of Hearst's collection, including important stained glass such as the fifteenth-century windows from the Carmelite church at Boppard am Rhein, large pieces of architectural stonework and English silverware. He paid relatively large sums for some of the purchases, but nothing like what Hearst had paid for them. Among the more important pieces from Hearst were a series of six tapestries. In July 1938 he purchased a mid-fifteenth-century tapestry from the Southern Netherlands entitled *The Annunciation and the Nativity*. This had come into Hearst's collection in 1925 when he paid an astounding $160,000 for this and another two pieces. Burrell bought the same piece for £8,000 through Hunt. A few weeks later he purchased two fifteenth-century German tapestries: *Hunt of the Unicorn* and *Hawking and Hunting* for £750 through Frank Partridge. These two secular hangings depicted hunting scenes which evoked the pursuits of courtly life in the later Middle Ages. At the same time he also bought a pair of mid-sixteenth-century *mille-fleurs* ground tapestries from the Southern Netherlands: *Ibex*

and Unicorn and *Wyvern and Griffin*. The pair, which had at one time been owned by the Count and Countess of Kermaingant in Paris, were purchased for £2,500. A year later, at another Christie's sale of Hearst's property, Burrell purchased a late-fifteenth-century tapestry depicting *Peasants Preparing to Hunt Rabbits with Ferrets* for £2,200.[98]

Although the main areas of focus for his collection at this time were England, Europe and China, Burrell still maintained a very strong interest in Scottish history. He was elected a Fellow of the Society of Antiquaries of Scotland in December 1928.[99] This is an old and prestigious society charged with researching, publishing and displaying the material history of Scotland. As well as purchasing Scottish items for his collection, Burrell's interest in Scottish history manifested itself through the Provand's Lordship Society. This was an organisation that was formed to preserve one of the oldest buildings in Glasgow, known as Provand's Lordship, which was built as part of St Nicholas's Hospital in 1471. Burrell had been a member of the society since 1909 but does not seem to have been that active in its early years. For example, he was not involved in the exhibition of medieval items in 1907 that was intended as a fundraiser for the building and he is not mentioned in relation to any of the annual displays or events. However, in the 1920s he started to become much more involved. He lent tapestries and 'Chippendale' chairs to the exhibition of medieval art held in the McLellan Galleries in 1924 which was organised by the Provand's Lordship Society.[100] This exhibition seems to have stimulated his interest in Scottish furniture and he started to purchase examples for his own collection as well as pieces to be displayed in Provand's Lordship alongside the loans from other collectors.[101] Then, in 1927, he donated £5,000 to be used as an endowment and 'to acquire a portion of the furniture at present on loan, and also from time to time other articles of historic value'.[102] This included the furniture, tapestries and stained glass that he had already loaned. The chairman of the Society later said that the generosity of Sir William in 'bearing the expense of furnishing and equipping the house with the beautiful furniture it contained'

had ensured that Provand's Lordship 'took its place among the most historic memorials in Scotland'.[103] Burrell also became more intimately involved in the running of the Provand's Lordship Society, becoming an honorary vice-president and a trustee alongside Sir John Stirling Maxwell and Arthur Kay. As with his other trusteeships, his main areas of interest were the acquisition of items for the collection and the financial management of the Society, advising on investments and insurance matters.[104] When the office of honorary president became vacant in 1929 he encouraged the Earl of Home, the leader of Berwickshire County Council and a Fellow of the Society of Antiquaries of Scotland, to take up the position.[105] Burrell was clearly among friends who shared his passions and, as ever, his politics, collecting and arts administration were all closely intertwined.

In November 1931, following Queen Mary's visit to Hutton Castle, both the Queen and Burrell lent embroidery dating from 1580 to 1750 to an exhibition put on at the art dealer Robert Lauder's galleries on Sauchiehall Street, Glasgow, to help raise funds for the Society. The Queen lent some Jacobean curtains which she had purchased for Holyrood House, and Burrell lent some tapestries and embroidery. The Duchess of Montrose, who opened the exhibition, noted the high level of skill in the pieces exhibited and stressed the many hours of work put into the art by women.[106] Two months later Provand's Lordship welcomed its first royal visitor since Mary, Queen of Scots visited in 1567, when Prince George paid a brief visit during an official tour of Glasgow.[107]

The royal patronage of the exhibition and the building itself undoubtedly played a part in increasing the Society's membership. The president, Sir John Samuel, reported at the 1931 annual meeting that 122 new members had joined. He boasted that 'the addition of so many new members had enabled the club to qualify for the generous additional gift of £1,000 which Sir William Burrell promised'.[108] As with striking a business deal, Burrell had given the Society a target to meet with an incentive for success, and he remained active in its management through the 1930s and 1940s.

The 1936 annual report paid particular tribute to him, noting that his 'generous donations have provided the bulk of the magnificent collection of furniture, tapestries, needlework and stained glass which now make the Old House probably the most attractive place of its kind in the country'.[109]

By now Sir William was getting on in years. He celebrated his seventieth birthday in 1931 and was still leading a busy and hectic lifestyle with all his commitments as a laird and trustee and his efforts to build the collection into a national treasure. Gradually some of these commitments began to reduce. Having taken something of a backseat in his role as Hungarian consul for a couple of years he finally retired in 1932. The Hungarian population in Scotland was not large and his duties were not onerous – the most notable thing he had to do was to welcome the composer Béla Bartók to Glasgow in 1932 – but it was no doubt a welcome relief to be able to stand down.[110] He was honoured by His Serene Highness the Regent of the Kingdom of Hungary with the Hungarian Order of Merit, Second Class 'in recognition of the very valuable services he rendered in protecting Hungarian interests in Glasgow'.[111] In November 1934 his seven-year tenure as trustee of the Tate Gallery came to an end. He had taken his duties seriously and was a regular attender at its board meetings so the end of this appointment would have provided some more free time for Burrell. In 1934 Burrell was elected to the council of the National Trust for Scotland.[112] This had been established in 1931 by Sir John Stirling Maxwell to preserve and safeguard places of historic interest and natural beauty. Council members served for only one term and Burrell was elected after the first councillors stood down. With his strong interest in history and as a fellow trustee of Provand's Lordship, Burrell was a natural choice for Stirling Maxwell to approach. However, he does not seem to have been as active on the council of the National Trust for Scotland as he was for other organisations and the only records of him in the minutes are apologies for absence. He stood down on rotation in 1938.

For relaxation William and Constance had regularly visited Europe, often combining business and collecting with holidays. France and

Austria were particular favourites and they also spent time on the south coast of England when Burrell was on trips to London. One of the reasons was that Constance's health was still a major concern and she was now suffering from phlebitis, an inflammation of the veins. Burrell's correspondence regularly mentions Constance's illness and the need to take rest cures in the sun. For example, in July 1931 they stayed at the Royal Hotel Evian in Haute-Savoie and Burrell wrote that 'my wife has been taking the cure here and I am glad to say she is feeling much better'.[113] In 1932 Constance underwent a series of operations which took a long time to recover from.[114]

By the mid 1930s it was time for the two of them to start taking some serious time away from their other commitments. They therefore began to make regular trips to Jamaica, where they enjoyed the pleasant climate and the relaxed way of life. Burrell explained that 'warm weather is my wife's best friend and cold her worst', so they would typically travel out in December or January and return in March or April.[115] As with all distinguished visitors to the island, their arrival was celebrated in the press and their earlier business connection through the Clyde Line made their trips to Jamaica of particular note:

Sir William Burrell, Kt, and Lady Burrell arrived in the ship to pay Jamaica their third annual visit. They were met on arrival by Mr Bourke of the Royal Mail Lines Ltd. Like his father, Sir William was a big shipowner of Great Britain. Some fifty years ago his father operated the Burrell Steamship Line which in those days traded between England and Jamaica. He is a Trustee of the National Gallery of Scotland, and a Trustee of the National Gallery of British Art, London. Sir William and Lady Burrell brought a little message for the Press. This is our third visit to Jamaica, and we have come out to get our annual sunning. As usual, we are going to Mandeville where we hope to enjoy good weather, and a happy time said Sir William. And Lady Burrell nodded her approval.[116]

Unlike the trips to Europe, which were combined with visits to galleries and dealers, the holidays in the West Indies were purely for sun and relaxation. The frequency of visits increased as the years went on. In 1937 they returned from a two-month stay in April and then they embarked again at the beginning of November and stayed for another four months. Burrell wrote to the director of the museum in Glasgow from the Newleigh Hotel in Mandeville, 'I am here with my wife to spend the winter in the sunshine as, after all she has passed through, she cannot stand the winter in Scotland.'[117] With all of these trips the Burrells travelled first class, but in separate cabins: 'I have always got to have a separate cabin on a ship or a room in a hotel because, you see, I snore!'[118]

During these years Burrell had little active involvement in the business of Burrell & Son and it was eventually wound up in 1939. In its latter years the office was run by John B. Bodie, the senior shipping clerk, who also managed the Hutton estates. In 1929 the firm had moved from its George Square offices to more modest premises at 124 St Vincent Street. As the Burrell business dwindled Bodie set up his own company as an insurance broker and the two businesses ran in parallel from the same office. Bodie had taken on the role of acting Hungarian consul for a number of years and when Burrell retired from his consular duties in 1932 Bodie was appointed as his successor. In February 1939 Bodie became a director in a new rubber linoleum factory in Arbroath and it was most likely this venture, rather than the onset of World War II, that prompted the final demise of Burrell & Son.[119]

CHAPTER 7

Giving Away the Collection

The outbreak of World War II had little immediate impact on Sir William Burrell. Unlike some stately homes Hutton Castle was not requisitioned for war use, but in common with most owners of country estates, Burrell struggled to maintain a full complement of staff. James Guthrie, his chauffeur, joined the RAF and served with distinction, being mentioned in despatches.[1] His secretary Ethel Todd Shiel was called up to serve in the Aeronautical Inspection Department of the Air Ministry. She was replaced by Janet Feenie, a university student, who took the job on a temporary basis. Lexie Lesenger, the Burrells' maid, left in 1942 to work for the Navy, Army and Air Force Institutes (NAAFI).[2] Other staff also joined the war effort and adverts soon began to appear in the newspapers for a chauffeur, gardeners and assistant gardeners, with the adverts specifically stating that applicants must be exempt from call up. It was not just the war that made it difficult to get staff. Life on a country estate was not as attractive anymore, as Burrell later complained, 'no maid wishes to go to a house nowadays unless it is within a stone throw of a cinema'.[3] Marion also left Hutton to join the Voluntary Aid Detachment and worked as a nurse at Peel Hospital near Selkirk.[4]

In the run up to the war, Burrell wrote extensively to all the places where his collection was on loan to ensure that adequate arrangements were in place to protect his artworks against enemy action. Most museums assured him that his collection was well cared for and placed in secure storage in the museum or else shipped out to safer country locations.[5] Some items were returned to Hutton, where preparations were made against air raids:

After the start of the Second World War, we were busy pack-
ing up the contents of Hutton Castle and the carpets and
the tapestries were put away. Sir William Burrell was fearful
of the risk of bombing by German aircraft and he received
warnings from Berwick whenever any aircraft were in the
vicinity. Many of the smaller items at Hutton were put in
special crates which were made for him. I would then write
a list of the contents which were then labelled on each crate.
The crates were stored in the garages of Hutton Castle. The
library and dining room however remained fully furnished,
but many of the other rooms were stripped of their contents.[6]

He was right to be prepared, as Hutton was on the German flight-
path to Clydeside and the occasional stray bomb came close, as he
reported to Wilfred Drake: 'A German dropped bombs nearby yes-
terday evening and shook the house.'[7]

On Berwickshire County Council, Burrell was a vociferous advo-
cate of collecting salvage for the war effort and led efforts in his ward
of Hutton to collect scrap paper and iron.[8] As a former shipowner he
would have known only too well the benefits of reducing the need
to import materials by sea in wartime: 'we are losing far too many
vessels but we shall pull through somehow'.[9] By encouraging the
county to be more rigorous in collecting scrap and removing railings
he was playing a leading part in securing vital raw materials and
safeguarding lives at sea. However, when it came to the removal of
the railings at Hutton he felt aggrieved for years afterwards:

> I still feel too sore over the treatment I received from
> Edinburgh. I begged them not to break down my ornamen-
> tal railings but they insisted and having done so they offered
> me a total sum of £3 in compensation, while the lowest
> offer for replacing them is £640 leaving a loss of £637.[10]

Apart from the expense, what particularly annoyed him was that the
railings were not actually used and just lay in a scrapyard for years.

As a consequence, he refused to allow the loan of any of his collection to Edinburgh as a way of nursing his grudge. He confirmed many times that he was 'not willing to lend <u>anything</u> of <u>any kind</u> to <u>Edinburgh</u> . . . I have been very badly treated and I resent it'.[11]

On a more positive note, he regularly donated to local war effort fundraising appeals, giving £100 for the war fund of the Scottish Red Cross, £100 for the Clydeside Air Raid Distress Fund, and even a pound for the King's Own Scottish Borderer's football fund, which provided footballs for the regiment.[12] Officers from the regimental barracks in Berwick were also periodically invited out to Hutton.

Burrell's wartime input was significant, but not necessarily onerous. He wrote to Wilfred Drake:

> I am now, as you know, in my 81st year and, beyond collecting waste metal and other potential in the Parish consisting of 300 people, and attending to the War Weapons Week, I have not much to do so am going over all my things and getting them, when required, put into better order.[13]

What he was mainly doing was preparing to achieve his ambition of securing a long-term home for his collection. He began with a number of small donations. When he was making the wartime arrangements for his collection he offered some items that had been on loan as gifts. Ipswich Museum was presented with some 'oriental bronze figures' and porcelain objects, and the Torre Abbey Art Gallery in Torquay was given twenty-four 'valuable ornaments'.[14] In November 1940 Burrell decided to dispose of twenty-one paintings that were on loan to Kelvingrove. He wrote to the new director T. J. Honeyman, 'I think of giving them and should like to know if you can suggest some small gallery or galleries which might care to have them.' Honeyman indicated that he would like to retain two for Kelvingrove, a Grosvenor Thomas landscape and Robert Noble's *Rouen*, to which Burrell agreed. For the rest, Burrell was happy for Honeyman to distribute as he saw fit and so he invited six galleries around Scotland to view the paintings and make their

selection. The McLean Museum in Greenock selected four works; *Still Life* by Vincelet, *The Farmyard* by Hervier, a copy of Raphael's *Madonna of the Goldfinch*, and a Muhrman pastel.[15] Kirkcaldy Museum and Art Gallery received a Matthijs Maris landscape, an oil painting and a pastel by Muhrman. Perth Art Gallery and Museum received *Sheepfold* by Hervier, a still life with lobster by de Heem and a pastel by Muhrman. Aberdeen Art Gallery received a Dutch flower piece, a still life with fish by Alexander Adriaenssen and a pastel by Muhrman.[16] Dundee Museum and Art Galleries received two Muhrmans, a Ribot and a still life by Charles Woolford, and Paisley Museum and Art Galleries received two Muhrmans.[17]

Some of these museums received addition gifts in subsequent years. In 1941 Burrell gave nine domestic objects to the McLean Museum, including a pair of seventeenth-century brass altar candlesticks and a nineteenth-century pewter dish.[18] To Perth he donated another thirty-one objects, including twelve swords, three works on paper and a Chinese silk brocade wall hanging.[19] Dundee also received six Kangxi plates.[20] In 1942 when Burrell decided to get rid of another three paintings, Kelvingrove accepted *Portrait of a Mother and Child* attributed to Moroni, Paisley was given Teniers' *Tavern Scene*, and the Dick Institute in Kilmarnock received a Pickenoy, *Portrait of a Woman*.[21] None of these items were necessarily of the highest quality and although the gifts were generous, he later referred to these paintings as 'faults of my youthful collecting'. He was actively filtering out some of the lesser pieces to strengthen the main collection, as he later confessed: 'I am anxious to leave as few "blots" in the collection as possible'.[22]

These gifts may also have been motivated by a desire to ensure that some parts of his collection remained in Scotland as his thoughts on the ultimate destination of his collection were initially focused on London. Even though he had donated a large number of paintings to Glasgow in 1925 and kept a large part of his collection on loan to Kelvingrove, he was less sure about donating it in its entirety. He felt that London, not Glasgow, was the centre of the art world and that his collection would receive a larger and more appreciative audience

there.[23] When he loaned a number of tapestries to the Victoria & Albert Museum in the 1930s he wrote, 'I don't wish if I can avoid it to send them to the Museum in Glasgow as, if I once did so, I should not feel justified in ever taking them away again – I should much prefer that they should not be separated but all in London.'[24]

The V&A was therefore his first option when it came to finding a home for the collection. After the initial loan in 1930 Burrell had offered a number of individual tapestries over the following years, but these were initially turned down by the museum. Although loans had been of great importance to the V&A since its opening, by the 1930s there was much less space available, leading to offers regularly being declined.[25] When Burrell intimated that the tapestries might become part of a larger gift, however, they were accepted.[26] A pattern of initial resistance to Burrell's loans and then ultimate acceptance continued on an annual basis until 1935, with some of his tapestry purchases being sent directly to the museum.[27] Burrell's loans were interlaced with hints that he desired the tapestries to remain in the V&A's collection after his death. The director, Sir Eric Maclagan, commented on this in 1932: 'I understand Sir William Burrell is prepared to pay for frames for these tapestries if they are accepted as loans and I believe on his visit he dropped some sort of hint that once here they are not likely to go away again.'[28]

However, the museum was concerned about the appropriateness of taking on such a large collection. In his 1931 report on Hutton Castle's holdings, Harold Clifford Smith suggested that the V&A were interested only in select pieces such as a Queen Anne walnut bureau-book cabinet, which he noted was 'a piece of outstanding importance'.[29] He went on to comment that Burrell had bought the piece from Frank Partridge a few years before and that Burrell 'offered to pay the cost of its packing and carriage if the Museum would care to have it on loan for an indefinite period; and he suggested that if accepted, it would be likely to remain at the Museum after his death'.[30] However, the museum was not interested in all of the pieces at Hutton. Clifford Smith reported the chairs 'being all of the same pattern would scarcely be suitable for the Museum,

considering the limited space available for loans'.[31] It is clear that the V&A were not interested in acquiring such a large collection. In May 1931 Maclagan questioned Burrell's proposed gift: 'I suppose some general reference should be made to this proposed bequest, although it is difficult to estimate how much of such a large Collection is ultimately acceptable.'[32]

Maclagan visited Burrell at Hutton Castle in the summer of 1935 to discuss the potential gift and by November Burrell's thoughts had coalesced into a definite plan. He proposed that the collection be housed in London in an entirely new museum with its own staff and director, all funded by the government.[33] Clearly, given Maclagan's concerns about the collection, this was never going to succeed. Burrell viewed his core collection of medieval and Renaissance antiques as a single, distinctive, entity and decided that if the museum was only interested in taking a few choice items then it was going to get nothing.

The paintings were never a consideration for the V&A. Instead, the strong contender was the Tate Gallery, to which Burrell had been lending paintings since 1924. By 1940 the Tate had 290 paintings on loan as well as twenty-five drawings and eight bronze sculptures.[34] Burrell's paintings were displayed in various galleries throughout the Tate, and in the late 1930s the director, John Rothenstein, approved decoration works for a separate room to house the 'Burrell Loan Collection', suggesting the importance of the collection to the Tate and a desire, if not an expectation, that the collection might come its way on a permanent basis.[35] While Burrell's thinking in the 1930s was that he would leave his collection of historical furniture, medieval tapestry, stained glass and other domestic objects to the V&A in South Kensington and at least some of his modern picture collection to Millbank, by the early 1940s he was settled on the idea that the entire collection should be kept together as whole.[36] An idea of his aspirations can be seen from the recollections of his secretary Ethel Todd Shiel:

I obtained the distinct impression that his Collection was intended for a site in London, and indeed, I recollect Sir William advising me that he had identified a site in the

Strand, which he thought might be suitable. He would often talk about his Collection, and in particular, would compare it to the Wallace Collection. He regarded his own Collection as something which was intended to have an even greater impact than the Wallace.[37]

By 1942 Burrell was growing more anxious about what he was going to do with his collection. He wrote to Frank Partridge in April detailing his plan to leave his collection to the nation with the idea that it would be a separate government institution. He understood that it was an inopportune moment to be discussing this with the government, but he was worried about his age and wanted to find a resolution before it was too late. As well as the collection he also offered to bequeath Hutton Castle as a holiday resort for government ministers. This would have provided a Scottish Borders equivalent of Chequers, a stately home in Buckinghamshire, that had been donated to the government as a country retreat for serving prime ministers. Partridge took Burrell's proposal to the government and it was seriously considered. The Treasury and the Inland Revenue investigated the financial implications while the directors of the National Gallery, the Tate Gallery and the Victoria & Albert Museum were consulted in relation to its quality. Although concerns were raised about the finances and the quality of parts of the collection, the government offered to negotiate with Burrell on the proposal, but in the end nothing came of it.[38]

Burrell therefore turned his attention to the London County Council. It was a great supporter of the arts and had run the London Corporation Art Gallery at Guildhall, where he had lent paintings in the past, so it seemed to be the logical next step if he wanted his collection to find a home in London.

In November 1942 he wrote to Sir Kenneth Clark, the director of the National Gallery, that 'on account of my age, I am anxious to have the matter settled while I am still here'.[39] Clark joined the board of trustees at the Tate Gallery in January 1934 when he was appointed director of the National Gallery, just under a year before

Burrell's term of office was due to terminate.[40] Clark was a rising star of the art world and had earned a reputation for his academic credentials and his ability to make things happen. He deeply admired Burrell's collection and respected him as a collector, noting that he was 'not simply an amasser; he was an aesthete', but he was less enamoured with Burrell as a person. Clark was born into wealth and was educated at Winchester College and Oxford University. He rather looked down on Burrell and after his death was particularly catty about his parsimony. However, Clark was an operator and to Burrell's face was nothing less than professional. Despite an age difference of over forty years, Burrell admired and trusted him, and this led to some important loans to the National Gallery during the 1930s. With Clark being so influential, it is no surprise that Burrell would turn to him for help in trying to establish a prestigious home for the collection in London.

Clark acted as Burrell's intermediary and by the end of November London County Council had decided that it was minded to accept the offer and sought the Treasury's advice on the financial aspects of accepting such a gift.[41] Meanwhile, Burrell wrote to Clark enclosing a memorandum of terms for his gift to London County Council: 'I am offering 100% of the Collection, 100% of the residue of my estate and I think you will agree that it is impossible for me to give more.'[42] Nine terms and conditions were listed in the memorandum. It offered Burrell's total collection, apart from the picture *Grief* by Matthijs Maris which he proposed to bequeath to the Rijksmuseum in Amsterdam,[43] the Spode dinner service by Copeland and Garrett, the needlework settee which had belonged to Disraeli, and all modern items of furniture and glass which he did not consider suitable for the collection. It stipulated how the collection would be assembled and displayed: firstly that the collection be 'housed together in a suitable building . . . entirely separated and detached from any other building', and secondly that it be 'shewn as it would be if in a private house . . . so as to insure that the building has as little of the semblance of a Museum as possible'. It confirmed that it was the duty of the recipient of the gift to ensure the care and upkeep

of the collection as well as the insurance of the items within it; that the recipient was not entitled to sell, donate or exchange any item within the Burrell Collection; and that only items from his collection were to be exhibited within the building. Finally, it stated that the collection should be no further than twenty-five miles from Charing Cross and on the north side of the River Thames.[44]

In the end, Burrell's efforts to establish a site in London were not successful. Although London County Council's initial response had been positive, difficulties were soon found with regard to the cost of maintenance of the collection.[45] The council was not willing to offer any more than £10,000 per year from the rates towards its upkeep.[46] They were also keen for Burrell to hand over the collection and the majority of his fortune within his lifetime, so as to avoid death duties.[47] Burrell was not willing to make such a condition.[48] In the end, Clark suggested that it was the council's fear of being 'associated with the arts in the public mind' that turned them away from the collector's offer.[49] On 22 December 1943 Clark confirmed to Burrell with feelings of 'disappointment and regret' that the collector's 'marvellous offer [was] turned down in this way'.[50]

Only a matter of days later Burrell brought his offer to Dr T. J. Honeyman, the director of Kelvingrove Art Gallery and Museum. Honeyman was a surgeon by training but abandoned medicine for art dealing in 1929 when McNeill Reid, Alexander Reid's son, invited him to become a partner in Reid & Lefevre in London.[51] Burrell had come to know and respect Honeyman through this connection and was happy to provide a reference in support of his application to the Glasgow Corporation. When he was appointed director of Glasgow's art galleries and museums in June 1939 Burrell had someone he could trust in charge. They were strong personal friends and when Burrell was seeking to distribute the paintings on loan to Glasgow in 1940 he decided that one of the paintings would be a personal gift to Honeyman: 'I should be glad if you will accept for yourself from me the little picture "Peaches" by Leslie Hunter. I know how much you appreciate his work. I should like it to go to someone to whom it would give pleasure.'[52]

Honeyman replied:

> In the first place, let me express my very warm thanks for your further generous gesture in giving me the little Hunter picture. I do like it immensely and it is, in its way, a little gem. I am beginning to feel embarrassed by your kindness and it looks as if the Director of the Glasgow Art Galleries will have to make a corner in his own home marked, 'The Sir William Burrell Collection'. This leads me to say that my wife and I would be greatly honoured if you could spare some time when you are next in Glasgow to see us in our new home and inspect my very mixed collection.[53]

Honeyman also sent a copy of his book on Leslie Hunter to Burrell as 'a small token of how deeply I appreciate your kindness'. The two had a deep admiration and respect for each other, both personally and professionally. Honeyman knew Burrell's collection intimately from his days as a dealer and as custodian of the loan collection at Kelvingrove, and had discussed with Burrell the possibility that it might come permanently to Glasgow. In November 1942 Burrell wrote to Kenneth Clark, 'Confidentially and only for yourself Glasgow is very anxious to have the collection and will feel very sore if I pass them.'[54]

Even so, when Burrell finally made his decision, it still came as a shock to Honeyman:

> One December evening in 1943 he got me on the telephone . . . When he told me that Lady Burrell and he had finally determined to present the entire collection to the City of Glasgow plus the sum of £450,000 to provide a gallery for its display . . . I was too excited to be coherent.[55]

Burrell's earlier anxieties about leaving his collection to Glasgow had clearly been allayed by the appointment of Honeyman, who he regarded as the key to the success of the collection's future. Honeyman

was a man after Burrell's own heart; he was forthright and determined, knew his own mind, and did not suffer fools gladly. This independent spirit often resulted in spats with the council hierarchy, and in May 1946 he threatened to resign. Hearing rumours of Honeyman's sudden departure, Burrell wrote to the Glasgow Corporation,

> I read with the greatest regret that Dr. Honeyman may cease to be the Director of the Glasgow Art Galleries. I have known him for many years and his great knowledge of art was one of the principal factors which decided my wife and myself to offer our Collection to Glasgow. I have always looked forward to his putting the Collection in order. He has already done so to a considerable extent but a great deal has still to be done and I feel that if he leaves the service of the Corporation, it will be nothing short of a misfortune. I sincerely hope that any difficulties will be overcome and that we shall have the benefit of his knowledge and advice for years to come.[56]

Whether or not this had any effect is unknown, but in the end Honeyman withdrew his resignation. Burrell's letter confirms the extent to which he admired Honeyman, and the pivotal role that he played in Burrell's decision to gift his collection to Glasgow. The significance of Honeyman in the deal was widely recognised. Lewis Clapperton, a Glaswegian collector of British pewter and glass, wrote to Honeyman regarding the withdrawal of his resignation, noting, 'In view . . . of the Burrell gift your departure would have been nothing short of a calamity.'[57]

The gift was of great importance to Glasgow and the city expressed its appreciation by conferring upon Burrell the Freedom of the City in May 1944. This was an accolade that *The Bailie* had originally suggested back in 1925 following his initial gift of paintings. The award ceremony was a grand affair, held in the Banqueting Hall of the City Chambers on 26 May 1944. The burgess ticket confirming the award stated that the freedom was conferred

in recognition of Sir William's public service to the city as a member of the Corporation for seven years and as a magistrate, of his generous support of benevolent and religious institutions in the city and of the lofty civic spirit manifested by the gift of his unique and most valuable collection of pictures, tapestries, stained glass, and other works of art for the enjoyment and benefit of the citizens of Glasgow.[58]

The Lord Provost James Welsh gave a speech in which he praised Burrell's service as a councillor. He also thanked Constance for her gift of £10,000 to the Glasgow Cancer Hospital 'to combat that dread disease'.[59] He stated that the collection was 'the finest in Europe' and that the gift had made Glasgow's claim to have the best municipally owned art collection in the world 'completely unassailable'. He concluded by referring to the gift as their 'crowning act of generosity'.[60] In response, Burrell said that 'he greatly appreciated the honour because he felt that in honouring him they were also honouring his wife, as the collection came from both of them'.[61]

The memorandum of agreement between William and Constance and the Corporation of Glasgow was signed in April 1944. It listed thirteen conditions, ranging from the name of the collection to the specifics of what was and was not included in the gift, and where the new building was to be located. The first condition read,

> The Collection shall be known as 'The Burrell Collection' and shall be so described for all purposes: and it is to be clearly understood and known that the bequest and gift of the Collection is from the Donors jointly and that their names shall always be associated in respect of it.

Both in his speech at the City Chambers and in the legally binding agreement Burrell recognised the part that Constance had played in the creation and ultimate donation of their collection. This condition also outlined the intrinsic intention behind the gift of preserving it as a distinct collection with its own identity.[62] Despite contending

that 'the collection, not the collector, is the important thing', this was not to be some anonymous gift.[63] Instead, he made sure that both his and Constance's name would forever be associated with the collection.

Burrell also had clear intentions with regard to the collection's contents and display. The eighth condition of the agreement stated that the collection was to be housed by Glasgow Corporation 'in a suitable distinct and separated building' that was to be 'within four miles of Killearn, Stirlingshire, and not less than sixteen miles from Glasgow Royal Exchange'.[64] He also stipulated that the collection be 'shewn as it would be if in a private house . . . so as to insure that the building has as little of the semblance of a Museum as possible'.[65] Examples of how this domestic display might be manifested in the new museum were given. For example, he suggested that windows be constructed around the building for the display of his medie-val stained-glass panels, rather than exhibiting them together in a gallery.[66] He also called for oak panelling, fireplaces, carved stone, lintels etc., to be removed from Hutton Castle to become part of the new building.[67] Initially, Burrell had intended for up to eight public and private rooms to be reproduced in the gallery space. The reproduction of these rooms was central to the gift and the condi-tion was repeated in his will where Burrell noted that the new rooms should 'retain [the] artistic value and feeling' of their original coun-terparts.[68] The importance of Hutton Castle to Burrell is clear. It allowed him to create an aesthetic within his home that reflected his taste and identity as a collector. The call for rooms from his castle to be reproduced in the new building was Burrell's call for this specific aesthetic to be carried over into the museum.

In 1944 Burrell's collection comprised of around 6,000 objects. A significant number of these were at Hutton Castle, but many were housed in thirty-six separate locations across the country. Although some material had been returned as part of the wartime contingen-cies, there were still large numbers of loans kept in various museums and galleries. In Scotland he had material in Perth Museum and Art Gallery, Dundee Museum and Art Galleries and the Royal Scottish Museum in Edinburgh. In England objects were in twenty separate

museums and galleries including the National Gallery, the V&A, the Tate Gallery, the Laing Art Gallery in Newcastle, the Bowes Museum in County Durham, the Fitzwilliam Museum in Cambridge, and the Ashmolean Museum in Oxford. There were also objects in Winchester, Chichester, Durham and Ely cathedrals as well as in dealers stores and homes, including those of Frank Partridge, John Hunt and Wilfred Drake.

In January 1944, having learned of Burrell's gift to Glasgow, the director of the Tate Gallery, John Rothenstein wrote asking whether Burrell's generous and 'most important loan' to the gallery would continue. [69] Rothenstein noted that many works included within the Burrell Loan Collection had become popular favourites, such as: *La Répétition* and *Edmond Duranty* by Degas, *La Dame au parasol* by Courbet and *La Jetée à Trouville* by Boudin. The gallery was eager to retain some of the paintings which 'constituted a very vital part of the collection of nineteenth century art'.

Burrell responded the following month, saying 'I had great difficulty in knowing how to arrange matters but in the end I decided not to split up the collection as I felt that would largely take the interest out of it so that all the pictures are included.'[70] Burrell's response suggests that his desire to bring his collection together in its entirety was a relatively recent decision, and one which had ramifications for the wide variety of institutions which had benefited from his generous loans over many years.

The matter of recalling loans from all these locations was a great effort and one largely overseen by Burrell himself. The years immediately after the gift and the end of the war saw a great flurry of letters from Burrell to the Corporation. Honeyman and his staff received letters almost daily, and sometimes more than one a day, as Burrell went through the process of identifying the items in the collection and arranging for their safe transport, storage and insurance. Vans were sent to Hutton Castle on a regular basis and paintings, sculptures, textiles and ceramics were despatched on trucks and trains from around the country to Kelvingrove. One of his main issues was that the collection was being kept safe and properly maintained.

Tapestries were a particular concern, with a large volume of correspondence relating to the manufacture of wooden rollers on which to store them. In the end Burrell felt that it was safer for some of the larger tapestries to be sent back out on loan:

> As you know tapestries, carpets, needlework, require much more attention than things like bronzes, glass and porcelain. I always regard it as a <u>very great</u> favour on the part of the Cathedrals and Museums when they agreed to take the tapestries on loan and now that they know they cannot possess them the favour, if they will agree, is greater than ever. I therefore hope the committee will not hesitate to agree to send back the tapestries to Ely Cathedral, Campion Hall Oxford, Chichester Cathedral and the Fitzwilliam Museum Cambridge to which they were lent before the war took place – it means expense of course but one cannot have a collection of such a nature without some expense and the cathedrals cannot be expected to pay as they are never blessed with funds. What are a few pounds of expense when you consider that the tapestries are each worth £10,000 to £15,000 and that to hang them up means greater safety.[71]

It is notable that these locations are all outside the big cities. For the tapestries in the V&A he was keen that they be returned as early as possible due to the risk of air pollution. Despite his earlier intention to gift the collection to London he maintained, 'I lent them to the Victoria & Albert only because I couldn't find suitable places in the country.'[72] Burrell recognised that the Gothic tapestries were extremely rare and fragile and that they were particularly vulnerable if exposed to the black smoke of industrial and domestic fires. He feared that 'the damage would be incalculable'; they were 'irreplaceable and must be kept in their present beautiful condition'.[73] He was equally concerned about moth damage and regularly wrote regarding the use of naphthalene balls and taking care to gently beat the tapestries regularly to dislodge any moths or eggs. His fury when

Leicester Museum informed him that some of his Islamic rugs had been damaged is palpable: 'The rugs which have been motheaten are <u>ruined</u>. If repaired the repairs will shew to such an extent in 20 years or less that the rugs will <u>not be worth anything</u>.'[74]

Other parts of the collection he was less concerned about. While arranging for the return of material, he decided to donate some items which he did not wish to be included in the main collection. He stated, 'The items I gave to Leicester I didn't consider were quite good enough for the "Burrell Collection".'[75] The Bowes Museum at Barnard Castle was also given several items in 1944.[76] Of the fifty-one objects that Burrell had loaned to the museum since 1934, the Corporation took forty-three. The final eight articles, six embroidery panels, one floral tapestry and one embroidered seat, Burrell offered as a gift. The Laing Art Gallery also benefited from the gift of a Hornel painting.

The collection in Glasgow also needed to be tidied up: 'There are in Kelvingrove altogether 91 items which are not good enough for the "Collection", which require to be eliminated.'[77] He explained that 'they are youthful mistakes which I have hung on to too long'. He also occasionally spotted duds that needed to be excised: 'I find that a "Chinese Pot" 7⅞" high is modern. I shall therefore feel obliged if you will kindly cancel it from the "Burrell Collection".'[78] He suggested that items of lesser quality could be retained in the general museum collection and displayed in one of the branch museums, but only if they were authentic: 'It is all right to send a genuine but inferior article to a Sub Museum but all wrong to send a fraud.'[79] In that way King's Park Museum gained some furniture, the People's Palace some views of Glasgow and other material may have ended up in Tollcross or Springburn.

Although it took several years for everything to arrive in Glasgow, the 1944 gift saw the collection being brought together for the first time in its history. To celebrate, a modest exhibition of the main highlights was held in Kelvingrove in 1946. At the opening, the principal of Glasgow University, and Burrell's fellow Provand's Lordship trustee, Sir Hector Hetherington, stated that the 'magnificent assembly

of objects' was 'among the greatest gifts ever made to any city in the world'. He went on to enthuse:

> Measured in terms of money, the Burrell Collection was the greatest gift ever made to Glasgow. The city had, however, received a gift not of money only, but of a rarer thing – the fruits of a catholic, critical, and cultivated taste. To assemble such a remarkable collection even in a long life-time called for the command of great means, but called also for a deep concern with objects of beauty and interest, for patient and careful study, care, affection, courage and decision.[80]

He concluded saying that Burrell's gift was an example of what Aristotle regarded as 'the crown of civic virtue'. The convenor of the Art Gallery Committee then expressed a desire for the collection to be used to gladden and enrich the lives of Glasgow's citizens by the 'beauty and excellent workmanship of their art treasures'. The wording was precise; these were no longer the possessions of a wealthy individual, but the property of each and every one of Glasgow's citizens.

Later that year Glasgow expressed its gratitude once again by awarding Burrell the St Mungo Prize, a prize given every three years to 'the person who has done most during the preceding three years for the good of the city by making it more beautiful, healthier or more honoured'.[81] Burrell was the third recipient of the £1,000 prize, succeeding Honeyman who had received the award in 1943 for his work as director of Glasgow Art Galleries. In a typical act of generosity Sir William donated the prize money to the West of Scotland branch of the Indigent Gentlewomen's Society.

In March 1947 a selection of seventy-three paintings from the collection began a tour of Scotland under the auspices of the Arts Council of Great Britain. There had been a huge public interest in the gift and this was a way of letting people across the country get a taste of what the collection held. The exhibition started in Dundee and then over the next couple of years it toured to various venues, from established galleries to public halls, in St Andrews, Perth, Aberdeen,

Kirkcaldy, Arbroath, Airdrie, Cupar, Kilmarnock and Stirling. The success was such that in subsequent years two further exhibitions were put together with the Arts Council, with one touring Scotland and the other going round England.

The assimilation of such a large collection into Glasgow was a major logistical exercise and required a great deal of effort from the museum staff. Storage of the collection became a major headache as the sheer volume of material simply could not fit in Kelvingrove or the museum service's other stores. When Aikenhead House in King's Park was returned from military use it was immediately taken up as the principal destination for the bulk of the collection, but large numbers of objects were also distributed across other venues in the city.

In September 1947 the art curator Andrew Hannah was appointed to the new position of Keeper of the Burrell Collection, and he immediately set about cataloguing and classifying the collection. He quickly established a rapport with Burrell and kept up a lively correspondence as he tried to get his head around everything in the collection. Burrell helped as much as he could, but after yet another request for information he replied to Hannah, 'Now Mr Hannah, I am an old man and get <u>very</u> easily tired . . . so please work out the details as well as you can. I know how difficult it must be and wish I were younger, stronger and could be more helpful.'[82] This was a rare admission of vulnerability from Burrell and indicates just how much he trusted Hannah. One of Hannah's first duties was to liaise with Burrell on the planning of a major exhibition at the McLellan Galleries with around 1,200 exhibits covering the full range of the collection, including tapestries, paintings, ceramics, stained glass and furniture. This opened in June 1949 to great critical and public acclaim, and was the first time that anyone, including Burrell himself, had seen the full splendour of the collection in one place. *The Scotsman* hailed it as a 'truly exhilarating exhibition' but warned that visitors would be wise not to try and cope with it all at once, but purchase season tickets and visit the different parts in turn.[83] The more populist *Glasgow Herald* described it as 'rich as a pre-war plumcake'.[84] Visitors from all over the world came to marvel at the display and,

despite Honeyman complaining of a lack of local interest, 60,000 paying visitors attended the exhibition over its three-month run.

An opportunity to see another part of Burrell's collection also opened in Berwick-upon-Tweed in 1949. Burrell had a great affection for the town – it was his local big town and the centre for much of his social activities; 'he was very well known in the town by local inhabitants, and was often seen in the town with Lady Burrell'.[85] He was a great supporter of cultural institutions such as the Berwick Amateur Operatic Society and the small Berwick Museum, to which he had given a collection of 140 pieces of 'old pewter, brass and glass ornaments' in 1940.[86] In 1946 he was invited to open a local art exhibition in the museum and ended up buying two of the works to present to the town to encourage the development of a new art gallery.[87] The following year Berwick asked to host the Arts Council touring display of the Burrell Collection, but after inspecting the gallery space the Arts Council refused on the grounds that it was not of sufficient standard. Burrell was pleased that they were being so careful, and this spurred him to try and improve the situation.[88] A few weeks later the Berwick and District Society of Arts was formed with the intention of establishing an art centre in the town. Burrell was appointed its honorary president and he donated a pastel by Muhrman by way of encouragement.[89] By the spring of 1948 the town had secured the space for an art gallery at the top of the museum and to celebrate Burrell donated a further three works.[90] A month later the local newspaper announced that Sir William and Lady Burrell would 'provide for the town a complete art gallery, some 30 pictures to be hung in the Museum Buildings'.[91] As with the bigger Burrell Collection, this was to contain only his gift:

> Sir William Burrell proposed that only pictures presented by Lady Burrell and himself, with a possible exception of that entitled 'Berwick Harbour', should be hung in the present Art Gallery and that the thirty or so pictures required to fill the wall space would be presented by Lady Burrell and himself.[92]

Over the next few months Burrell assembled a collection of paintings for Berwick, but when the opening date approached he found that he did not have quite enough and so wrote to Andrew Hannah in Glasgow: 'I find the room, which is large, requires 42 pictures altogether. I have bought for it 29 leaving me 13 short and these I should like to get from the Burrell Collection.' He listed the thirteen paintings he wanted to transfer along with his reasoning. He was careful to choose works which had duplicates or which he felt were of lesser quality. Of the Le Nain he said 'as you know, you have the same picture painted twice and I should like one of them'; for the Fantin-Latour he said 'you have 3 pictures – all peaches on a plate'; for the three Jacob Maris paintings he stated that 'you have many more important examples'; the Daubigny he reckoned was 'not up to much, but it is the ships I require'; the Degas was 'one of the least important'; and Philip Angel's *Oysters* he described as 'a picture I really like and which I know you don't'. Burrell went on to request, 'If Dr Honeyman and you can let me have them it will enable me to stand up in town and will not in any way injure the Burrell Collection.'[93] He had earlier requested a Crawhall as well, but in the meantime had found a suitable replacement, so it was no longer needed.

Honeyman did object to losing the Daubigny and the Degas, but Burrell stood firm. He had done his calculations and knew exactly what he wanted: 'I spent a great deal of time arranging – on paper – the walls of the Berwick room and as you know if one size is altered the whole line is "thrown out".' Given the scale of Burrell's generosity, Honeyman, and the Glasgow Corporation, had little option but to accede to the request and a few days later Andrew Hannah had them loaded on a van and delivered to Hutton.[94]

After Burrell had paid for the alterations to accommodate the gallery it was opened to the public in May 1949. The mayor of Berwick-upon-Tweed noted the significance of the gift to the town:

in these pictures, we have the finest art gallery on the whole of the east coast route between London and Edinburgh.

That may sound a rather sweeping claim to make but, I believe it will be found fact, and that is how I personally regard the value of this great gift.[95]

Sir William said it had given his wife and himself great pleasure to bring the pictures together, but it gave them greater pleasure to offer them to the ancient and honourable town of Berwick. They hoped they would prove a source of interest and pleasure to the citizens of Berwick for many years to come.[96] In the end he donated a total of forty-nine paintings to Berwick, including modern European paintings and old master works, which represented the character of his larger picture collection.[97] Alongside the paintings Burrell also donated a sizeable collection of Japanese and Chinese ceramics, medieval sculpture, Venetian glassware, and German pewter, which was displayed in the museum. The scale and quality of the donations was highly significant and through this second Burrell Collection the cultural profile of Berwick-upon-Tweed was raised immeasurably. The creation of the art gallery also allowed the next Arts Council touring exhibition of the Burrell Collection to be displayed there in 1950, giving Berwick's residents another opportunity to enjoy the riches of their local celebrity art collector.

Throughout his collecting career, Burrell had a clear mind as to what he wanted to collect and how those pieces were to be experienced. This did not change when the gift was made to Glasgow. Indeed, it could be argued that the idea of the collection's identity only grew in importance. He wrote a steady stream of letters regarding what should and shouldn't be included in the Burrell Collection, as well as regular letters that began, 'My wife and I should like to make the following additions to the Burrell Collection'. There then followed perhaps a painting or two or a whole list of Chinese ceramics or stained glass. Between 1944 and 1957 Burrell added over 2,000 objects to the collection.[98] He initially bought items from his own purse, but following the Finance Act of 1949, which increased the term after which gifts would attract death duty from three to five years, no longer felt able to do this. He was becoming worried

about his advanced age and the effect that this 'monstrous taxation' would have on the Corporation and his collection.[99] Instead it was agreed that he could use the interest on his cash gift of £450,000 set aside for housing the collection, and this sparked a flurry of additional purchases. The Corporation allowed him to use his own judgement on what additions were to be made and he insisted that he would only purchase items that he would have bought if using his own money. He was very particular about this arrangement and when Hannah sent a receipt for a purchase saying 'received from Sir William and Lady Burrell' he was told in no uncertain terms to use the wording 'received from Sir William Burrell the following items purchased by him on behalf of the Corporation'.[100]

Burrell began this phase of his collecting by extending his Chinese ceramic collection, purchasing earlier pieces including important Neolithic period wares from the renowned collection of Neilage Brown, a Glasgow-born Far East merchant and former chairman of the Hong Kong and Shanghai Banking Corporation.[101] In 1946 Burrell began to acquire examples of Persian pottery. He had previously only bought a handful of examples, but over the next thirteen years he added 180 pieces. In 1947 he began to purchase Persian metalwork, a field he had not before entered into, adding twelve examples to the collection by 1957. In the same year he bought thirty-four examples of Turkish pottery, having only bought one before this date, in 1919. In his final years, Burrell also returned to purchasing pictures. Rembrandt's *Self-Portrait* was bought for £13,125 in 1946 from the sale of Viscount Rothermere's collection and two years later he acquired the *Portrait of a Gentleman* by Frans Hals for £14,500. These two works account for some of the most expensive purchases he ever made.[102]

One new area that he ventured into was antiquities from ancient civilisations. Before 1945 Burrell had collected only a few isolated examples, but this now became a major focus of his collecting activity, and he acquired many Sumerian, Assyrian, Egyptian, Greek and Ancient Persian objects. This was an area that he did not have the same grounding in as say medieval furniture or stained glass, and nor

did he have a strong relationship with a reputable dealer to guide him. It was almost as if he felt that now he had an established and respected collection in a museum it ought to have representative examples from this earlier period. Some important pieces were acquired, but on the whole this remains the weakest part of the collection. As the *Burlington Magazine* rather snobbishly explained:

> Unfortunately, one is conscious, in some parts of this section, of a certain falling off from the very high standard set by the rest of the collection. This is particularly noticeable among the Greek works, the most striking of which, the bronze youth formerly in Lord Tredegar's collection, here catalogued as 'style of Ply Keitos' (sic) is very far from being a satisfactory example of the best achievements of classical sculpture, while the best of the vases hardly rise above the level of respectable mediocrity: Admittedly, first-rate classical works are not now easily obtained, but if this were the highest level attainable it might have been better not to have extended the collection in this direction.[103]

The quality of other parts of the collection was considerably enhanced through the input of respected scholars who were invited to view the collection. Burrell was particularly keen for the collection to be published in scholarly journals and over the years he had supported a number of academics in their research. One of the most important was Dr Betty Kurth, a medieval art historian and specialist in tapestries who worked for the Warburg Institute at the University of London. She had been studying Burrell's tapestries since the 1930s and had published a several articles on the collection. In 1944 she wrote to Burrell:

> I am going to ask a favour of you. I have read in the papers about your marvellous gift to the Glasgow Corporation. It occurred to me that it would be a wonderful work to write a catalogue of your tapestries with reproductions of all of

them and thorough descriptions and explanations. It should be a monument for your connoisseurship and knowledge.[104]

Burrell passed Kurth's request on to Honeyman, who managed to gain Corporation approval to award her a £400 contract to complete the catalogue in eighteen months.[105] Burrell was delighted and wrote to Honeyman:

> I . . . am very pleased that you approve of getting Dr Kurth to catalogue the tapestries as . . . no one else could do it. No one else can give you anything like the accurate explanations & information about each tapestry. She has been engaged on the subject all her life and her knowledge is marvellous. It will be the finest tapestry catalogue in any Museum.[106]

With this success Burrell then approached Honeyman about a similar project for the stained glass:

> As I told you Mr Wilfred Drake made a catalogue of all the stained glass. It is really not a catalogue but an inventory and I think it would be well worth while getting him to make a catalogue . . . He can do all that it would turn the bare inventory into a catalogue like Dr Kurth's & make it so much more interesting & informative. And Mr Drake is the greatest connoisseur of glass living.[107]

He also suggested that Murray Adams-Acton would be an ideal candidate to write a catalogue of the furniture. Unfortunately, none of these catalogues was to see the light of day. Sadly, Kurth was killed in an accident before her catalogue could be completed and it was not until 2017 that a definitive catalogue was published.[108] The idea for catalogues of the stained glass and furniture never got off the ground but it is clear that Burrell's intent was for as much of the collection as possible to be researched and published by the most eminent authorities.

Another opportunity arose in 1947 when W. Perceval Yetts, Professor of Chinese Art and Archaeology at the School of Oriental and African Studies, University of London, wrote to Burrell asking for details of the Chinese bronzes in his collection to inform a book he was writing on the subject. The two had got to know each other several years earlier and Burrell was keen to have his professional opinion on the collection that had now been transferred to Glasgow. As he explained to Andrew Hannah, 'Professor Yetts is a most prominent man and his book I should think will become one of the standard works on Chinese bronzes.'[109] Burrell and Hannah arranged for Yetts to visit Glasgow in October 1948 where he reviewed as much of the collection as could be unpacked. He was highly impressed with what he saw, and only a small number of pieces were deemed of lesser quality and removed from the collection. Following the visit, Burrell and Yetts corresponded regularly, and Burrell ensured that any further details relating to the collection were passed on to Hannah to include in the museum records.

As the collection's status and reputation grew, an increasing number of requests for loans came in from institutions around the world. Despite having been happy to lend overseas before, Burrell became increasingly concerned about his loans travelling by sea. In 1953 a planned exhibition of Crawhalls in Belfast had to be cancelled after Burrell found out. He wrote, 'I am most anxious that nothing should go overseas and it was for that reason that I specially made the stipulation I did.' It was not the sea passage itself that was the concern, but the way crates were handled by carters and dockers: 'I have seen the boxes at the place of delivery thrown about like bricks.'[110] Judging by the number of insurance claims for Burrell items damaged in transit to Kelvingrove he was quite right to be concerned.

The relationship between Burrell and Honeyman had been deteriorating over the years and the issue of overseas loans was the thing that irrevocably fractured it. The two were powerful characters with strong opinions and inevitably their opinions did not always align. The first sign of friction had come in 1946 when Honeyman suggested that several Matthijs Maris paintings had gone 'right

"off"' and that they were 'hopeless'. This was a dangerous tactic with one of Burrell's favourite artists. He replied with a seven-page diatribe explaining that these poems in paint were precisely how the artist intended them to look and that the only thing wrong was Honeyman's opinion of them.[111] Honeyman's resistance to parting with paintings for Berwick had also severely irked Burrell, but when he received a letter from McNeill Reid saying that he had seen two of his Gericault paintings at an exhibition in Winterthur in Switzerland he was incensed.[112] The two had taken to using Andrew Hannah as an intermediary in their correspondence and when Hannah confirmed that Honeyman had agreed to the loan without consulting either Burrell, Hannah or the appropriate committee, Burrell responded: 'The fact that the committee was not meeting at the time nor the fact that Dr Honeyman happens to know the Winterthur Gallery has nothing whatever to do with the matter.' With obvious rage he wrote, 'I am very much surprised that the agreement should have been so broken. Had I known in time it would not have been allowed. It mustn't occur again and I am glad to see from your letter that it won't.'[113] This episode strengthened Burrell's relationship with Hannah over Honeyman, and when Honeyman resigned again the following year after another tussle with the Corporation there were no impassioned pleas for his retention from Burrell.

In the 1950s Burrell made some important acquisitions that were directly linked to the future building for his collection. Between 1952 and 1954 Burrell purchased several architectural elements from the Hearst Collection. William Randolph Hearst had died in 1951 and his National Magazine Company was charged with disposing of his assets, engaging Murray Adams-Acton as its agent. Through their long-standing relationship, Burrell was able to secure significant parts of the collection at bargain prices. As Andrew Hannah indicated, 'You are able to give Sir William what he dearly loves – a reasonably modest price.'[114] In 1952 Burrell acquired an elaborately carved fifteenth-century ceiling from Bridgwater in Somerset. In 1953 he acquired four medieval stone doorways and the following year he purchased seven French late-Gothic doorways

and windows, and two fourteenth-century Flemish and German windows, which he envisaged becoming features within the fabric of the future museum building. He was particularly keen to acquire the Hornby Portal, a sixteenth-century doorway from Hornby Castle in Lancashire, which after a long search Adams-Acton was able to find:

> I was with Sir William this morning and I think I was the first to congratulate him as it was nine o'clock and he was still in his pyjamas in his bedroom and we discussed many subjects at considerable length; and I think that no birthday present he may receive today will give him so much joy than the knowledge that we have found the Hornby Castle portal![115]

Burrell's vision for where and how his collection was to be displayed was one of the most difficult and exacting conditions of his deed of gift. He fully recognised that what he was asking for was not easy to achieve, but he was resolute in defending his position. When the gift was signed over in 1944:

> He knew, he said, that there had been some disappointment on that point. In the past century many collections had been given to cities in this country but generally these collections had consisted of pictures, or, if not pictures, of such works of art as could be housed in a city area. But in this instance the collection included tapestries, carpets, and needlework, which if housed in an industrial city would quickly deterio-rate. The condition was made to preserve the property, and he hoped that that would be appreciated by the citizens.[116]

Finding a suitable site for the collection was not easy.[117] Even before the agreement had been signed, the city had started making investigations about potential sites, which included the Dalnair estate near Drymen, Stirlingshire, and Killearn House, which was at the time being used as a museum store. In the late 1940s at least eight different sites were thought of as possibilities and Sir William

would occasionally come through to inspect potential properties, but none was quite right. One of the options being considered was Old Ballikinrain House, near Balfron, Stirlingshire, but Burrell was none too impressed: 'The house would be no good for housing any part of the Collection but it would be useful for housing the staff or for tea rooms, etc. All that is required really is ground and a <u>copious supply of water</u>.' The word copious was underlined twice. What he was particularly concerned with was the risk of fire and the need to have enough water to fight it effectively. He then went on to say, 'I have had a plan drawn up for the Museum and hope to submit to you soon.'[118]

These plans had been drawn up by Frank Surgey who 'after a <u>great</u> deal of thought and care' over a period of two years had come up with a neoclassical design with a formal H-shaped layout. The paintings were to be displayed on the top floor where they could be top-lit, while the tapestries and carpets would be protected from the light on the ground floor. Burrell explained the reasoning behind the concept:

> I told him I should like the Museum to have the contents shown to look as little like the usual Museum as possible, eg. to have the contents of the bedroom beds etc shown in bedrooms instead of all the beds being clubbed together and to have the stained glass shown so that the windows with their vistas would show it to the best advantage instead of all the stained glass being shown as in the Victoria & Albert in the Glass Department – all huddled together.

He went on to say that 'personally I think the plan is <u>exceedingly</u> good' and that he felt 'it would be a wonderful building and <u>most suitable</u>'. It is clear, that despite wishing the museum to contain period room settings he did not see the Burrell Collection fitting into an existing building, but one which was purpose built. He understood that with post-war reconstruction under way it was not the right time to be building 'as prices are about 4 times what they

ought to be' but he was particularly keen that the matter was settled rather than 'leaving it to be competed for after my death and a monstrosity produced'.[119]

The plans were taken seriously by the Corporation and Surgey's design was developed over the following months into a meaningful proposition for Ballikinrain. Surgey wrote, 'Sir William and I, after having had time to consider the project, feel it has very great possibilities'.[120] Despite this positivity the Corporation was unable to secure the estate and the search for a suitable site continued.

The next serious contender was the Mugdock Castle estate, near Milngavie to the north of Glasgow. This had been the home of Archibald McLellan, whose bequest in 1855 had created Glasgow's civic art collection but was then in the hands of the department store tycoon Sir Hugh Fraser. As this was far closer than the stipulated sixteen miles, Burrell was initially reluctant, but after he surveyed the site with Andrew Hannah in March 1951 he was convinced and asked Surgey to dust down his plans. The proposal sailed through the appropriate Corporation committee but negotiations with Fraser eventually fell through and so it was back to the drawing board.

The Dougalston estate, also near Milngavie, was the next possibility, offered as a donation to the Corporation by Therese Grabowsky Connell, widow of a Glaswegian shipbuilder. As with Mugdock, it had historic connections with art collecting, having been the country estate of tobacco merchant, shipowner and one of Glasgow's major art collectors John Glassford.[121] Burrell was not initially satisfied with the site, but he was eventually convinced. In October 1951 Mrs Connell presented the house and its 370-acre estate to the Corporation of Glasgow with the conditions that the Burrell Collection would be constructed there and that she would retain a life interest in the property. In preparation for this new site Burrell commissioned Murray Adams-Acton to draw up a set of plans. Writing to Andrew Hannah in July 1954, Adams-Acton noted:

> Sir William is most anxious for me to set out a few sketches
> for the arrangement of an architectural court and I shall do

this when time permits as it will please him. I shall work on the assumption that portals such as that at Hornby, which includes a door, could be placed against a wall, as it would convey the idea that it actually led somewhere; but the Gothic façade and the Chateau Thierry arch should be open & used as such i.e. part of the fabric. I also think that the large Gothic windows could be put into service if facing an internal courtyard. We seemed to be in agreement upon this, but Sir William is uncertain about it. There's time enough![122]

Adams-Acton drew up a set of preliminary sketches that showed neoclassical elements. The layout was centralised with an inner courtyard and galleries coming off this central space. The plans showed two floors and detailed the placement of individual objects. On the ground floor the fifteenth-century Bridgwater ceiling and the sixteenth-century oak panelling from the Neptune Inn in Ipswich were to be displayed in the same room; there was to be a room with linenfold panelling on the walls that displayed early furniture and tapestries, and a room he named the 'Elizabethan room'. On the first floor, Burrell's pictures were to be displayed in two rectangular galleries on either side of the internal courtyard. Within the galleries were to be balconies that would allow the visitor to look down into the courtyard below. As per Burrell's stipulations, rooms from Hutton were included in the plans: bedrooms as well as the Drawing Room appeared on the ground floor.

Accompanying the plans, Adams-Acton made drawings showing the potential placement of the architectural features from the Hearst Collection. The sketches showed the doorways and windows, complemented by tapestries and sculpture from Burrell's collection. These were not specific proposals for construction, but an exercise in showing how these features could be 'assembled harmoniously' in a building. Despite the care and attention that Adams-Acton gave the scheme, Burrell never responded directly.

I'm properly fed up with Sir William. He asked me to plan an architectural court and arrange the various features he had recently bought. I told him from the start that it would be a sheer waste of time to plan such a place without considering in some way a building of which it was part.

I sent him some plans which, after a time, he acknowledged but without <u>one single</u> comment about them! I worked for some time on them and – dammit – one either likes a scheme – or an idea – or one doesn't! . . . Sir William's only remarks concerned payment, a factor which I never thought about, as I was only out to be of help with advice. I shall ask him to send my plans back and I shall burn them![123]

When Hannah mentioned this on the phone to Burrell, he was told that not only did he think highly of Adams-Acton's draughtsmanship, but that he was very favourably impressed with these particular drawings. Hannah, ever the diplomat, tried to smooth things over with Adams-Acton, explaining, 'You must just look upon it as being due to his extreme age, and no doubt his economy in effort because he writes far too many letters to far too many people.'[124] This was a heartfelt message and indicates both how active Burrell remained in his later years and how difficult it was to work with him and keep him onside.

Whatever the situation with the plans, large parts of the collection were shifted into storage at Dougalston House in preparation for when post-war building restrictions were finally lifted and by the end of 1954 real progress was made in terms of selecting the precise site for the museum. Then in March 1955 the bombshell dropped that the National Coal Board was investigating the possibility of sinking a mine shaft close to the site. This seriously spooked Burrell and all plans for Dougalston were immediately abandoned. Instead, he wanted to try again at Mugdock, declaring, 'The site at Mugdock is particularly fine. It would be the best site of any museum in Britain and I hope it will be adopted.'[125] Unfortunately nothing further came of this and the Burrell Collection remained homeless.

By now Sir William was becoming increasingly frail. He was well into his nineties, his eyesight was failing, and he was frequently confined to bed with various ailments. 'My wife and I have both had a very bad time but are now well or as well as the weather will allow.'[126]

Hannah reported in March 1956, 'I saw Sir William about 10 days ago, and am afraid that he is having rather a rough time at home ... While he is still mentally alert his eyes are giving him considerable trouble, and he has aged rather a lot just recently.'[127]

Burrell's mind, however, was as sharp as ever and he kept up his relentless correspondence with the staff at Kelvingrove. As Hannah rather candidly explained, he had a tendency to ask for 'long lists of detailed information which are guaranteed to cost the maximum of effort from someone else'.[128] Following the departure of Honeyman, Hannah was promoted to depute director in 1955, partly on Burrell's recommendation, and William Wells was appointed as the new Keeper of the Burrell Collection. Wells was very much welcomed by Burrell; he had studied art history at the Courtauld Institute and had written about Burrell's furniture loan in his guidebook to Temple Newsam House in Leeds when he was curator there.[129]

Topics in Burrell's letters included the correct type of acid-free tissue to use when storing lace, his prohibition on lending pastels due to the risk of damage, the purchase of new additions and arrangements for their packing and insurance, new research on parts of the collection and help with cataloguing. Burrell retained a remarkable memory about when he bought certain items, how much he paid for them and what condition they were in. His eye for detail remained undiminished and he always kept the museum staff on their toes. For example, he kept very close tabs on all the comings and goings from Hutton: '[W]hen you were here two days ago you took away nine pieces and left a receipt for one fewer than your van got. How was this?'[130]

Burrell and Constance now lived in only a small part of Hutton Castle and the staff reduced to a cook/housekeeper, a chauffeur and gardeners. More and more of the contents of Hutton were sent over to Glasgow for safekeeping as he was becoming increasingly worried about the risk of fire:

The County Fire Service is of no use in the event of a fire taking place – it arrives from the other end of the County after the fire is out and everything has been destroyed so that much of what is here must be removed to a place where there is a first class fire brigade and it would be no answer, especially after a warning had been given, to tell the Public who, as you know are the owners, that a large and most valuable part of the Collection had been lost and the Collection in consequence largely ruined through not being removed from a place of danger to a place of safety while there was still time.[131]

Burrell was quite right to be concerned as in January 1958 a fire broke out on the top floor of Hutton Castle. The staff had an afternoon off, and so Sir William and Constance were left to fight the fire on their own. They threw buckets of water from the bathroom onto the flames and laid down strips of wet cloth on the floorboards. By the time the fire tenders from Duns, Eyemouth and Berwick arrived they had managed to contain the fire and it was quickly extinguished. Thankfully only one room was damaged, but it shows how vulnerable an old property full of antique furnishings could be.[132] Theft was also a major concern for Burrell, and he put in place considerable security measures. This did not stop one wily burglar from trying his hand, although he probably ended up regretting his efforts as Burrell brought his grouse shooting skills to bear:

Sir William got out of bed when he believed he heard someone outside. He fired a shotgun from his bedroom window and then called in the Police. It was confirmed later that there had been an attempt at a break-in, but the intruder had been scared off by the shots.[133]

Burrell made his last purchase, consisting of five pieces of Persian pottery, in June 1957. During the course of 1956 Burrell's handwriting became increasingly shaky, and finally Constance and Alex

Braid, the chauffeur, took over the task. From this late correspondence it is clear that his mind was still very much active, but his body was now failing him. William Burrell died of heart failure brought on by pneumonia at Hutton Castle on 29 March 1958 at the age of ninety-six.[134] He was buried in a simple ceremony at the family plot in Largs cemetery overlooking the Firth of Clyde.

A few days after Burrell's death, Stanley Cursiter, the director of the National Galleries of Scotland between 1930 and 1948, wrote to Honeyman, 'We won't see his like again – he was the last of the Collectors – modern conditions are all against such things happening again.'[135] Cursiter saw Burrell's death as marking the end of a generation of collectors who devoted their lives and fortunes to art collecting. His death was mourned in the local and national press. The *Glasgow Herald* reported that thanks to Burrell's generosity Glasgow could now 'claim to have the best municipally owned art collection in the world'.[136]

The Lord Provost, Andrew Hood, was quoted as saying, 'Sir William was among the men who would be remembered for their outstanding generosity so far as Glasgow was concerned.' Hood ended his tribute to Burrell with reference to the search of a suitable site for the building:

I would hope that as a tribute to his memory and in appreciation of what he has done for the city we will take steps in the corporation to find a suitable home for the collection at the earliest possible date so that it can be opened in the very near future as a tribute to his memory.

CHAPTER 8

Legacy

Sir William Burrell's estate was valued at £759,535.[1] Given that he had already donated a collection valued at over £1 million and £450,000 in cash to Glasgow, this was a very remarkable sum indeed. To put this into context, of his contemporary industrialist collectors, Sir Hugh Reid left a little under £250,000; Leonard Gow, £145,000; and Arthur Kay just £12,000. Even after tax and other liabilities were taken care of it was still a substantial fortune, and to manage it Burrell left a long and detailed will.[2] He first made provision for a trust to be established, consisting initially of Constance, two members of his Glasgow firm of lawyers Bannatyne, Kirkwood, France & Co., and a chartered accountant. This trust was designed to administer his estate and to oversee the conditions set out in his will. Over the years the Burrell Trustees have carried out sterling work and oversee the management of the collection to this day.

In terms of the distribution of the estate, he first made provision for his cousin Clare Lapraik, daughter of his sister Elizabeth, who was to receive an annuity of £200. Next, Constance was to be allowed to stay at Hutton for as long as she wished, with an annuity of £2,000. Marion was not included in the will as he had already made 'ample provision by Marriage Contract or otherwise for my daughter Marion and her issue'; the implication being that she would receive nothing unless she married. Given Marion's past romantic history, this could be seen as either an incentive or a punishment. Either way, she never did marry.

Following Constance's death, Hutton Castle was to be offered free of charge to be used as a holiday residence for the directors of,

in the first place, a group of insurance companies. If they did not want it, it was to be offered, in turn, to a number of banks, Lloyds Underwriting Association, London Stock Exchange, the burgh of Berwick-upon-Tweed, and finally the National Trust for Scotland. If none of these parties were interested, then it was to be sold. In the end the Hutton estate was sold to a local landowner, but the castle remained unoccupied for the rest of the twentieth century. All of the remaining art and antiques at Hutton were to be transferred to Glasgow, either as part of the official Burrell Collection or for the collections more generally. The remainder of the estate, which included shares in the gold mining company the London and African Mining Trust Limited, was to be sold off to create a fund for the purchase of new additions to the collection:

> I direct my Trustees to hold the whole residue and remainder of my means and estate in perpetuity and to apply the whole free income thereof in the purchase of works of art . . . (it being my wish that a very decided preference be given to works of art of the Gothic period of the highest standard) and to deliver these works of art when purchased to the Corporation of the City of Glasgow to form additions to 'The Burrell Collection'.

Even before Burrell's death, steps had been taken to wind up the estate. Constance, as chair of the three management companies, the Hutton Estate Company, the Whiterig Estate Company and the Blackburn Estate Company, began the process of voluntary liquidation in December 1957 and the companies were then officially wound up in June 1959.[3] The Burrell Trustees in the meantime took on responsibility for the running of the Hutton estate and Constance continued to live there on her own. She was looked after by Alex Braid and his wife, the last remaining staff at Hutton, who lived in the chauffeur's cottage. Latterly a lady companion, Helen Fischer, moved into the castle to keep Constance company.

The Burrell Trustees took an active role in the management of the

collection and although the lawyer John C. Logan was appointed as the chairman, it is clear that they deferred to Constance on most matters. The first point of business to be considered was a request from Andrew Hannah to lend a painting to the Rijksmuseum in Amsterdam. Sir William had turned down an earlier request from them and now Glasgow was keen to test the waters with the trustees to see if his prohibition on lending overseas still stood. In the end Lady Burrell and the trustees stood firm and refused to consent to the request.[4] The next item of business was a request to purchase two sixteenth-century tapestries that were up for auction at Sotheby's. The trustees agreed and once the sale had gone through reminded Hannah that tapestries should not be displayed in Glasgow due to the level of pollution, as per Sir William's previous instructions. If Hannah thought that it was going to be easier to manage the Burrell Collection with Sir William gone, he was quickly disabused of the idea. The trustees were clearly going to be upholding the terms of the spirit of the gift as rigorously as Burrell himself. They were equally eagle-eyed about reports in the press and when it transpired that Hannah had purchased a small tapestry for the Burrell Collection without consultation he was severely admonished:

> I must draw your attention to the fact that the only persons who have any right to make any additions to the Collection are Sir William Burrell's Trustees, Lady Burrell and Miss Marion Burrell. The Corporation have no right whatsoever to purchase any additions . . . I shall be pleased to have your assurance that such action will not take place in future.[5]

A contrite Hannah apologised and never made the mistake again.

The one area where Hannah was able to overturn Burrell's wishes was the loan of the collection to Edinburgh. In December, the Royal Scottish Museum enquired whether it would be possible to stage an exhibition of the 'Treasures of the Burrell Collection' in the summer of 1959. After consulting with Lady Burrell, the trustees were able to agree to the proposal. The exhibition featured medieval and

Renaissance wood carvings, stained glass, pottery, embroidery and tapestries and proved to be exceedingly popular, with over 125,000 visitors during its four-month run from June to October. It was timed to coincide with the Edinburgh Festival when there was an influx of international visitors to the city. The following year the trustees also approved the loan of the bust of Lilian Shelley to the Edinburgh Festival Society for a memorial exhibition on Jacob Epstein.

Constance had played an active role in building the collection all her married life and in the years after Sir William's death, she continued to keep an eye on auction catalogues for potential additions. She suggested the purchase of a Corot and a Degas pastel, but in the end they were not taken forward by the museum. Her devotion to Sir William and the collection remained undiminished but, after years of declining health, she died of heart failure on 15 August 1961 at Hutton Castle, aged eighty-five. She was described on her death certificate as a property owner and her estate was valued at £42,542.[6] Lady Burrell had been a successful woman with significant business interests and their marriage had been a partnership of equals, both personally and financially. She was extremely generous with her time and money to nursing and welfare charities, and with her donations of Hutton church hall and £10,000 to the Glasgow cancer hospital she should be regarded as a philanthropist in her own right.

Prolonged ill health had compromised Constance socially but, as Sir William indicated, she was an integral part of the Burrell collecting endeavour. She had a particular fondness for lace and other textiles and acquired several items on her own account. Constance was also very knowledgeable about art and antiquities and used her expert judgement to assess the suitability of items proposed for purchase by the museum, rejecting some items on the grounds of quality, date, or their appeal to her and Sir William's taste. As a tribute to her husband, she wanted to acquire some suitably ancient stained glass to be installed in the crypt of Glasgow Cathedral, but she died before she was able to realise this wish. It would have been an entirely fitting tribute and indicates just how closely she understood Burrell and his devotion to medieval art.

Like Sir William, Constance's mind remained sharp to the last, even though she suffered greatly from phlebitis and arthritis. Despite complaining 'I have an eye which gives me trouble and am not allowed to write much', she maintained a steady correspondence that indicates that she took her responsibilities as a Burrell Trustee seriously and her letters were always professional and courteous.[7]

Despite her illness, Constance took what small pleasures she could in her final years: 'Although she was handicapped, Lady Burrell, who was 84, found great pleasure in being driven around the beautiful countryside near her home.'[8] Her relationship with her difficult and rebellious daughter remained strained to the last, but she was hardly the monster that she has sometimes been portrayed as. A rare glimpse of the Burrells' private life and Constance's tenderness can be seen in a remark at the end of a letter to the Dutch dealer Willem van Meurs, where William says, 'My wife was <u>very</u> pleased to hear that you had kissed the twins for her. She is passionately fond of children.'[9]

Marion had left Hutton Castle in 1950 and initially found work as a matron in a school in Sussex. She then embarked on a two-year adventure in Australia and New Zealand before returning to Scotland in 1955. Always fascinated by her father's collection, Marion became a regular visitor to Kelvingrove. When she moved into a flat in Edinburgh in 1960 she was given a housewarming present of a framed print of a painting from the collection by William Wells. The following year she opened an exhibition of the Burrell Collection at the Smith Art Gallery in Stirling. Like her mother, she was greatly interested in what the museum in Glasgow was doing with the collection and visited every time there was a new display. Marion suggested ideas for future exhibitions and raised concerns about the conservation of some of the material. She was also keenly interested in progress on finding a permanent home for the collection: 'I do hope the Corporation will take decisive steps immediately.'[10]

The Corporation had indeed taken some steps in trying to renegotiate with Sir Hugh Fraser about the use of Mugdock, but they were hardly decisive, and the collection still remained homeless. The situation was starting to become embarrassing, and a great deal of

criticism began to appear in the press. In its 1963 *Survey of Provincial Museums and Galleries*, the government's Standing Commission on Museums and Galleries criticised the Corporation's failure to find a suitable building, writing, 'Nothing could be more obviously contrary to Sir William's intentions than the present deplorable situation.'[11] The chairman followed this up with a piece in the *Daily Express* in which he called it 'a national scandal' and noted, 'this magnificent collection . . . has been languishing in packing cases for the past 20 years without anyone having the backbone to do anything about it'.[12] He was not entirely accurate but the sentiment was clear.

For years the Corporation had worked with Sir William to try and find a suitable site that met his exacting requirements. It was clear that Burrell would have been happy to relax the conditions in the deed of gift if the right property became available: 'I am of course quite willing to alter the clause about distance.'[13] This is borne out by Burrell's enthusiasm for both Dougalston and Mugdock, but contractual issues and the difficulty of the Corporation managing an estate outside its own area of jurisdiction proved insurmountable. The ideal solution finally arrived with the offer of Pollok House and its estate to the city. This was the ancestral home of the Stirling Maxwells and had been in the family for over 700 years. The estate was on the south side of Glasgow, only three miles from the city centre, however, its 360-acre parkland made it an ideal rural setting that was within the spirit of Sir William's ambitions for his museum. It was particularly appropriate that it had been the home of Sir John Stirling Maxwell, who was one of Burrell's great supporters. Their lives had intersected at many points and they had shared a deep love and interest in art and history. The two men had worked together on the same committee for the 1901 International Exhibition; for many years they both served on the board of trustees of the National Galleries of Scotland, the National Trust for Scotland and Provand's Lordship; and they were fellow members of the Glasgow Conservative Association and the Society of Antiquaries. They had different but complementary art collections, sometimes lending to the same exhibitions.

Sir John Stirling Maxwell had been instrumental in the foundation of the National Trust for Scotland and was keen that the people of Glasgow should be able to use his estate. After his death in 1956 his daughter was eager to secure an appropriate future for it and in 1962 offered Pollok House and the Pollok estate to the National Trust for Scotland. This sparked the Lord Provost of Glasgow Peter Meldrum to enquire whether this might provide a suitable location for the Burrell Collection. The various parties involved gathered at the park in December 1963 to survey the potential site. Anne Maxwell Macdonald and the National Trust were both in favour and with some surprise and relief the Burrell Trustees were also convinced. A modern Burrell Collection museum with its Gothic tapestries and nineteenth-century European art, combined with the eighteenth-century Pollok House and the Stirling Maxwell collection of Spanish art, both set in glorious parkland, would make a unique visitor attraction.

Despite this initial optimism it proved impossible for the National Trust for Scotland to take on the financial commitment of the estate and protracted discussions with the Corporation ensued. Delay followed delay until finally Richard Buchanan, a Glasgow MP and former city councillor, brought a debate to the House of Commons to try and push things forward:

> I implore my ex-colleagues of Glasgow Corporation to take their courage in both hands. Glasgow has always played her part in stimulating and encouraging the arts. In this respect a responsibility has been placed on them, and I ask them to stop this delicate, dithering, dickering diplomacy. Delay simply plays into the hands of the Philistines in their midst. If the opportunity is lost here, it may never recur. I ask my former colleagues of Glasgow Corporation to 'go it alone' if need be. They can do this sort of thing better than most.[14]

The Under-Secretary of State for Scotland, Bruce Millan, responded with the offer of government financial support if a solution could be found and finally, in 1967, an agreement was made whereby

Burrell purchased Hutton Castle near Berwick-upon-Tweed in 1915. This photograph, taken about 1948, shows the modifications he made to it.

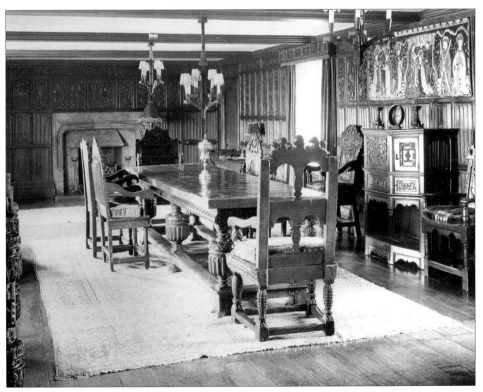

The dining room at Hutton Castle, showing how William and Constance lived with their collection. Photograph by Fiona Ritchie, about 1948.

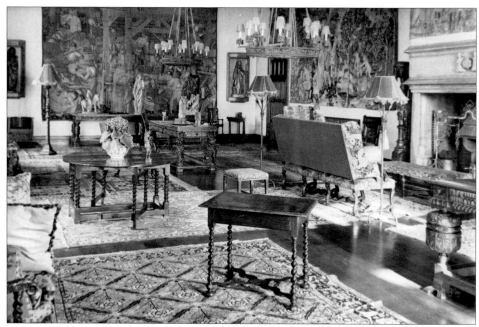

The drawing room at Hutton Castle. Photograph by Fiona Ritchie, about 1948.

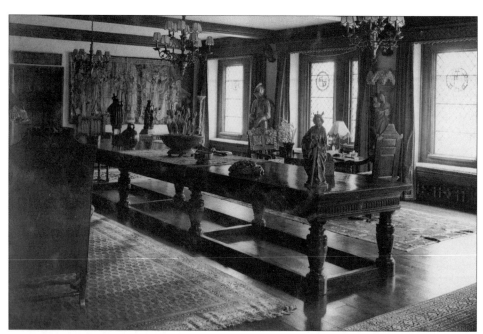

The hall at Hutton Castle. Photograph by Fiona Ritchie, about 1948.

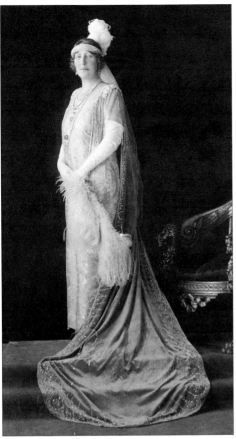

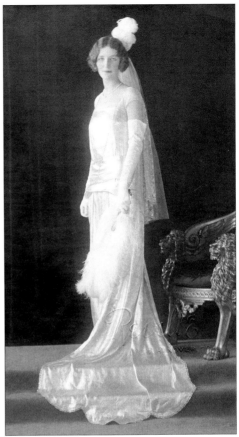

Studio portrait of Lady Burrell in court dress designed by the exclusive London firm of Reville. Constance wore this during Marion's debutante season in 1925.

Studio portrait of Marion Burrell in court dress designed by Reville in 1925 for her presentation to the Queen. (© S.M.O. Stephen)

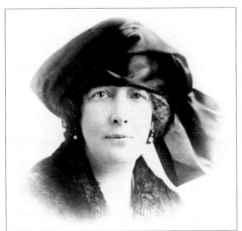

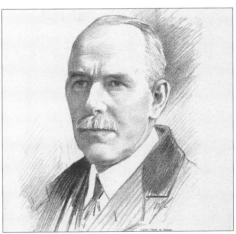

Constance Burrell in a rather nice hat. She was an avid collector of textiles and played a significant role in the development of The Burrell Collection.

Sketch of William Burrell from *The Bailie*, 17 June 1925. The magazine ran a feature on him after his gift of paintings to Kelvingrove in 1925. (© CSG CIC Glasgow Museums and Libraries Collection: The Mitchell Library, Special Collections)

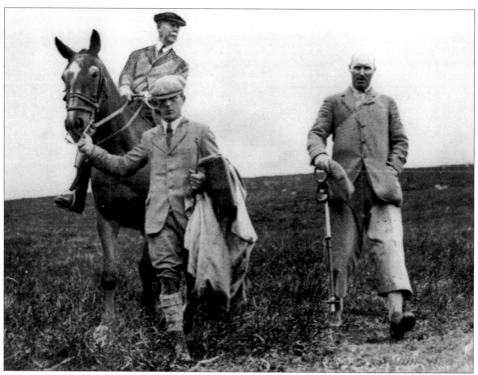

William Burrell with Lord Digby at Burrell's grouse shooting estate at Mayshiel in the Scottish Borders, 12 August 1936.

Sir William and Lady Burrell walking in the grounds of Hutton Castle around 1955.

Constance Burrell at home in Hutton Castle in the late 1950s or early 1960s. By this time the majority of the collection had been transferred to Glasgow. On the wall is a copy of Rembrandt's *Hendrickje at an Open Door*.

Sir William signing the visitor's book in the City Chambers after receiving the Freedom of the City of Glasgow in 1944. Constance is on the left and Lord Provost James Welsh is on the right.

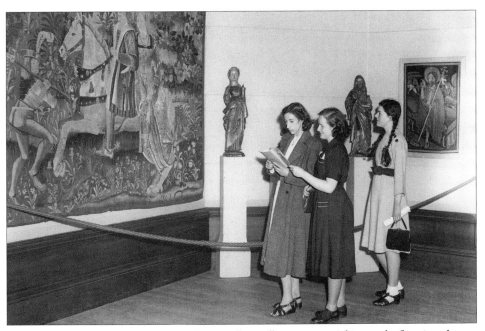

Exhibition of The Burrell Collection at the McLellan Galleries in 1949. This was the first time that anyone, including Burrell himself, had seen the full splendour of the collection in one place.

William and Constance Burrell with Frank Surgey at Hutton Castle in January 1954.

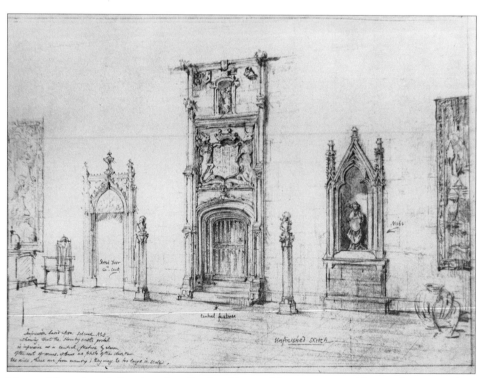

Murray Adams-Acton's drawing of medieval architectural features acquired from William Randolph Hearst for a prospective Burrell museum in 1954.

Sir William Burrell being presented with the St Mungo Prize by Lord Provost Sir Hector McNeill in 1946.

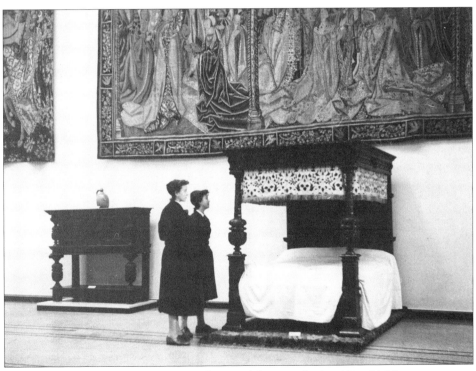

Visitors enjoy the *Treasures of The Burrell Collection* exhibition at the Royal Scottish Museum, Edinburgh, in 1959.

The Warwick Vase was acquired by the Burrell Trustees in 1978 specifically to create a central feature in the new Burrell Collection building.

The Burrell Collection under construction in December 1980. The building took five years to complete.

Silvia (previously Marion) Burrell meeting the Queen at the opening of The Burrell Collection on 21 October 1983.

Anne Maxwell Macdonald gifted Pollok House and its estate to the city of Glasgow, with the Picnic Field identified as the site for the future museum. The government duly stepped in with an offer of £250,000, which, on top of Burrell's initial gift, now worth around £750,000, gave the Corporation a quarter of the amount estimated to erect the new building.

Three years later an architectural competition was launched to identify a suitable architect for the museum. The competition pack went into great detail about the history of the collection and Burrell's taste. It noted that Sir William's chief interest as a collector was the later Middle Ages and the Renaissance with the tapestries and stained glass the highlights of the collection. It then went on to discuss the architectural fragments acquired in 1954 from the Hearst Collection which were intended to 'provide a reference for the tapestries, stained glass, sculpture and metalwork of these periods'. Subsequent sections detailed the rest of the collection including the furniture, paintings, Persian carpets, Chinese pottery and ancient antiquities.[15]

The competition brief put the collection firmly at the centre of the project and to enhance this a special exhibition of representative objects was held at Kelvingrove Art Gallery and Museum in September 1970, where competitors could purchase illustrated books and catalogues on various parts of the collection. The idea was for the competitors to understand the collection as much as possible so that the buildings proposed were sympathetic to the objects housed within. The competition pack also laid out Burrell's main conditions: that no other collection should be housed within the building; that the three rooms that were collected in their entirety from Hutton Castle should be recreated within the museum; and that the collection should 'so far as possible, be shown as it would if in a private house'. It was made clear in the brief that whilst the competitors were to comply with the conditions, they were at liberty to design 'a fine modern building' which would make the most out of both the collection and the site. The brief also went into detail about what percentages of the collection should be displayed or made available for study in the reserve collection. The amount of

planning put into the brief was exceptional and it took two years to produce. Burrell's conditions were exacting and it is clear that the Corporation wished to achieve them as much as humanly possible.

A panel of assessors was appointed, consisting of four architects and representatives of the Corporation, the Burrell Trustees, the Stirling Maxwell family, and the National Trust for Scotland. In total, 242 entries were received and six were short-listed for a second stage of the competition. In March 1972 Barry Gasson, John Meunier and Brit Andresen, all tutors at Cambridge University's School of Architecture, were announced as the winners. A few months later Barry Gasson wrote to Trevor Walden, Director of Museums in Glasgow, suggesting visits to museums in Milan, Berlin and Lisbon that he thought would provide comparable examples for the new museum.[16] This was an internationally significant collection and it deserved an internationally significant museum to house it.

Inevitably, as the project progressed the costs increased, and this again put the museum in jeopardy. The Corporation had no option but to approach the government for additional support. As a way of demonstrating just how important the collection was, Walden arranged for a major exhibition of 'Treasures from the Burrell Collection' at the Hayward Gallery in London in 1975. The exhibition was curated by William Wells and designed by Barry Gasson and Brit Andresen. Although large parts of the collection had previously been displayed at the Tate Gallery and the V&A, this was the first time that a London audience could see the full breadth and scale of the collection in one place. It was very well received, and the smart catalogue, containing a plea for government assistance, was handed out to all those with influence. It was a very clever piece of advocacy and ended up with Bruce Millan, by now Secretary of State for Scotland, promising that the government would meet 50 per cent of the estimated £9.6 million cost in recognition of the fact that the Burrell Collection was not just important for Glasgow but a national treasure that would benefit the country as a whole.

With the funding finally secured it was possible to proceed with construction work, and on 3 May 1978 Marion Burrell, who had

recently changed her name to Silvia, signalled a bulldozer to cut the first sod. In her speech she praised a small band of people who had kept faith in the project after a long and frustrating thirty-four years of uncertainty.[17] Over the next five years the complex and beautiful building emerged.

The building was influenced by Scandinavian design and the understated exterior harmonised effortlessly with its woodland surroundings. Unlike the concrete brutalism of some of the competition entries, it was constructed using the local traditional building materials of red sandstone, glass and wood. The high quality of materials and finishes was a nod to both the Gothic artisans represented in the collection and the craftsmanship of Clydeside engineers.

The architects created a clever way of using the orientation of the building to bring in as much natural light as possible while still protecting the vulnerable parts of the collection. The visitor emerged through the entranceway into a central top-lit courtyard planted with trees. This provided a gathering space for visitors and created the feeling of an exterior space onto which the three Hutton Castle rooms faced. These three rooms, the dining room, drawing room and hall, were recreated as closely as possible to the original and ensured that the museum had at is heart the domestic aesthetic that was so important to Burrell's view of his collection. One addition to the collection that made a dramatic impact was the Warwick Vase. This massive vase weighing nine tons was originally sited in the garden of Hadrian's villa at Tivoli, near Rome, but removed in the eighteenth century to be restored and placed in the grounds of Warwick Castle. It was put up for sale in 1978 and purchased by the Metropolitan Museum of Art in New York. However, an export ban was placed on it and the Burrell Trustees stepped in to save it for the nation. It created an ideal focus for the central courtyard, where the wild fig trees created the feeling of an Italian palazzo and hinted at its original location.

The Hornby arch was also placed in the courtyard and provided a dramatic portal into the full richness of the collection. The integration of the building, its rural setting, and the collection was central

to the architects' thinking, and the way in which the objects were sensitively built into the structure ensured that the museum became a part of the collection rather than simply being a space in which Burrell's objects were housed. The architects not only considered the needs of the collection, but were also very conscious of the way visitors might engage with it, as Gasson explained:

> After passing through the arch, the visitor embarks on a 'walk in the woods'. The first view takes in the ride to the west seen through the two Gothic tracery windows. From then on the main route leads the visitor through a series of large open spaces containing a selection of art objects from antiquity, from Turkey, Persia, India and China, and from Europe. Further investigation of the Collection would lead the visitor away from the main route, through a sequence of different spaces, to the long tapestry gallery at the heart of the building. It is anticipated that the collection of tapestries and the woodland scene will be complementary, and that the exploration of the Collection will link them. The main route then returns down the east side of the building, through the picture gallery into the corner overlooking the restaurant and views to the park. Leading off the gallery are rooms for 16th, 17th and 18th century arrangements of the Collection. Silverware, glassware, ceramics and metalwork are displayed along the south of the building. The south wall is glazed, and against this bright light is shown the extensive collection of religious and armorial stained glass.[18]

The museum was finally opened on 21 October 1983 by Queen Elizabeth. For the first time the public could view William and Constance's gift that had, for the most part, lain in storage for the past thirty-nine years. In her speech the Queen stated: 'Glaswegians can be proud, not only of Sir William Burrell and his astute and unflagging pursuit of excellence, but also of the way in which they have responded to his generosity. He himself could not have

visualised a finer setting for the museum than Pollok Park.' She then went on to comment on the long wait to achieve the museum: 'Difficulties which would have daunted people of lesser mettle have been overcome, and the collection is now permanently housed in a building worthy of it.'[19]

Burrell's daughter, Silvia, attended the opening ceremony and a few days later she wrote to Lord Muirshiel, chairman of the Burrell Trustees, 'What a gift from the gods, the day was so beautiful – Everyone's spirits were affected by it; and what a glorious welcome for the Queen . . . It is hard to be grateful enough for all those who went to make the day such a success.'[20]

Indeed, Muirshiel received a number of letters praising the collection. A letter from the Civic Trust in London the following month read, 'How very happy you must be about Burrell. Did ever a new building of this kind receive such rapturous applause?'[21] Both the popular press and the specialist architectural journals praised the museum, hailing it as the 'final triumph of a truly remarkable venture'.[22] What impressed the critics most was the way the collection was so harmoniously integrated into the building. Many remarked, as the Queen did, that Burrell himself would have been pleased with the result. Typical of the comments was that of the *Financial Times*, which concluded: 'The aesthetic thrills do not come from the architectural language of the building – but from the collection itself and that is how it should be. Sir William would have approved.'[23]

Burrell would have baulked at the final cost of the building, but the end result certainly resonates with his feelings that the museum should be 'as simple as possible': 'To put up an extravagant building is quite opposed to what we have stipulated. What it needs is fine contents.'[24]

The public reaction was equally positive, with more than a million visitors passing through its doors in the first year. The Burrell Collection quickly established itself as one of Glasgow's most-loved buildings and one of the jewels in its cultural landscape.

It is hard to overestimate the importance of the Burrell Collection in Glasgow's cultural renaissance. Glasgow had suffered terribly with

the collapse of its industrial economy in the 1960s and 1970s. The economic heart of the city had been ripped out and it was a city in search of a new identity. Its international image was one of dirt, squalor, social unrest, drunkenness and violence. In the months leading up to the opening Glasgow adopted a new marketing slogan, 'Glasgow's Miles Better', with Mr Happy as the new face of Glasgow. The Queen alluded to this in her opening speech saying that visitors would flock to Pollok Park from all over the world 'to see for themselves the warm smile of Glasgow's face'.

The international headlines show the impact of the Burrell Collection. The *New York Times* ran with 'Glasgow's Treasures Belie its Gritty Image'; the *Globe and Mail* had 'It isn't Grim Glasgow Anymore'; and the *Wall Street Journal* said 'Glasgow Cleans Up Its Act – With Art'. Most of these articles began with how bad Glasgow was: 'The view of Glasgow is sufficiently clear: Red Clydeside and razor gangs; a good town gone wrong'; 'Glasgow is thought of as a rough, plainspoken, uncultivated and memorably dirty place. Few people will go there who can avoid it'.[25] The Burrell Collection was the catalyst to change the image of Glasgow from grim despair to beauty and hope.

Glasgow's investment in the Burrell Collection was not simply a way of complying with an old man's peculiar wishes, it was investing in a new identity and a new economic focus for itself. Culture was to be the new industry, but it was not some strange and alien imposition. Glasgow's cultural credentials stretched back centuries and it was the industrialist collectors, the leaders of the now-dying industries of engineering, shipbuilding and shipping, who had provided the building blocks on which to build this new economy.

The Burrell offered a glimpse of what the future could be, and the city grasped the opportunity with both hands. Major investments in a conference centre and an international concert hall swiftly followed. A garden festival grew from the old docks on the Clyde in 1988 to show how industrial dereliction could be transformed into an oasis of pleasure. The accolade of European Capital of Culture followed in 1990 and now Glasgow is regularly cited by the likes of *Lonely Planet* and *Time Out* as one of the top ten cities in the world.

Glasgow is an exemplar in the use of art to transform a post-industrial city in crisis into a vibrant modern city of culture. Although often called the Bilbao Effect, after the Basque city used the Guggenheim Museum as a talisman for its urban redevelopment, Glasgow did it first and it was The Burrell Collection that provided the model and the inspiration for Bilbao.[26] Glasgow is still a city with great social problems, but without Burrell's gift it is unlikely that it could have achieved quite the same level of transformation. With Burrell's interest in slum clearance and urban renewal it seems a fitting legacy.

While Burrell's legacy on the fabric of his home city is assured, his reputation as a person and as a collector requires some reassessment. He is often characterised as a penny-pinching 'millionaire magpie' who indiscriminately picked up bargains. He earned this nickname following a BBC television documentary of that title which first aired in 1976.[27] In it he was called a 'Victorian Howard Hughes' and is portrayed as a compulsive collector who was driven by the desire for a bargain. Kenneth Clark did not hold back his contempt, calling him 'an obsessive collector and bona fide miser' and saying, 'He's the only man I've ever known who was like a miser in Balzac.' This is a reference to the French novelist's *Eugénie Grandet* in which the lead character's tyrannical father is so obsessed with money and status that he destroys his relationship with his daughter. That approach pervaded the whole documentary. Kenneth Clark continued the character assassination in a personal reminiscence the following year in which he again alluded to Balzac and detailed further examples of Burrell's meanness. He also snidely explained that 'we became friends – if that word be applicable to a man so singularly devoid of human feelings'.[28] He admired Burrell as a collector, but clearly despised him as a person. As there was no counterpoint, this became the dominant narrative. Typical of this new idea of The Burrell Collection was that it was a 'weird mixture of oriental, French and medieval art . . . stored in a secret warehouse'.[29] The magpie metaphor grew from the fact that the collection at that time remained in storage so a picture emerged of Burrell as a hoarder, rather than the enthusiastic lender that he had been during his lifetime.

The millionaire magpie metaphor was challenged by Richard Marks, Keeper of the Burrell Collection following William Wells' retirement, and author of the only other biography of Burrell. He gives Burrell much greater credit for the way in which he collected, but still claims that 'it is not difficult to pick holes in Burrell's collecting'.[30] References to his lack of academic learning, a constant focus on prices, and some rather condescending comparisons with other major collectors still painted Burrell in a rather negative light. One reviewer picked up on this, observing, 'The biographer tries hard to provide us with the human touch, but the evidence is thin,' and concluding, 'He does not seem to have been an altogether likeable person.'[31]

However, even Burrell's harshest critics agreed that he had impeccable taste. He had a gifted eye and a strong sense of aesthetics. Dealers, critics, museum directors and academics all regarded him as a connoisseur who had the knowledge and judgement to spot and appreciate good art. As William Wells noted: 'It is characteristic of every part of this collection that only the best was good enough for this great connoisseur. When collecting pictures of the nineteenth-century French school, he selected not only the greatest masters but also the finest procurable examples of their work.'[32]

Kenneth Clark picked up on Burrell's special sensitivity to art objects: 'He had a strong plastic sense, and would pick up an enamelled pyx with the hands of a sculptor.'[33] He also stressed that Burrell was 'not an amasser' and Honeyman emphasised that 'there was nothing casual or haphazard in Sir William's collecting'.[34] Instead Burrell carefully built a collection, focusing on a few discrete areas that were based on his own personal interests and taste, rather than being dictated by fashion. He may have taken advice from dealers but any decisions on acquisitions were very much his own, and he was assured enough not to be swayed by what others might think. As Andrew Hannah stated, 'He is accustomed to trust his own judgement and flair in these matters, and to let the critics talk.'[35]

William Wells also noted:

> Who, but a person of great taste, would have bought the delightful little Bonvin, *Still Life with Pears*, which was, without doubt, one of the highlights of the exhibition. Bonvin is not one of the great names in nineteenth century painting and, but for such discriminating collectors as Sir William, might have remained completely obscured under the shadow of his great colleague Ribot.[36]

The way Burrell crafted his collection can be seen in how he planned his purchases. Of one auction he noted: 'There are many wonderful items in the Sale but fortunately we have examples of them already and I think it better to fill the "gaps" than bid for even better specimens of what we already have.'[37] There was nothing indiscriminate about this and he was equally careful about thinning out the collection to make it stronger:

> My experience is . . . that a collection is more improved by eliminating articles not up to the standard than by adding many fine things. Until the articles not worthy are eliminated there are always so many 'blots' in the collection that does more harm to it than the addition of more fine things helps.[38]

For Mark Fisher, former Minister for the Arts, what was most impressive was Burrell's love of objects: 'He loved every aspect of collecting: the choosing, the assessment, the comparison, the valuation, the competition, the bargaining, the decision and the ownership.'[39] Fisher's evaluation of Burrell gets to the core of his significance. In 1900 Burrell exclaimed to Lorimer 'we are only beginning to learn something about this game' and it is clear that his passion was based as much on the 'game' of collecting as it was on the objects that he acquired through playing it.[40] The pleasure that he gained from the act of collecting shone through, from his delight at acquiring the *Beatrix de Valkenburg* glass panel to connect with Hutton Castle's

history, to the thrill of securing items he had kept an eye on for years, right through to his obvious satisfaction in the last days of his collecting when he discovered that an Assyrian fragment that he thought was worthless turned out to be 'most interesting' and worth adding to the collection. His passion for collecting never dimmed and the collecting drive that drew him as a boy to buy paintings was still there in his mid nineties when he was scrutinising Sotheby's catalogues on his sick bed, barely able to see.

The issue of the prices Burrell paid is an important one. He was a true mercantile collector whose ability to navigate the art market was learnt from his background in the tramp shipping industry. This meant that he took risks on the market when others might not, especially in the depressed interwar years; it also meant that he was savvy with his money. After purchasing the fifteenth-century Romanesque portal from the Hearst Collection in 1953 Burrell wrote to Andrew Hannah:

> It cost Hearst £4,500 and was then sent to America. Later it was brought to St Donat's so that it has crossed the Atlantic twice and what between packing, freight, insurance etc etc it must have cost Hearst around £5,000. I bought it for £500.[41]

One of the barriers to understanding Burrell is that he was an intensely private individual who was, according to William Wells, 'reserved in temperament'.[42] He never gave much away about his thoughts, feelings or motivations for collecting and it is hard to penetrate the guard that he put around himself. He never wrote anything other than business letters. There is no memoir, diary or even a preface to an exhibition catalogue. He did not want to share his private life with the public and he resisted all calls for a portrait in either pen or paint.[43] The idea that it was the collection and not the collector that was the important thing seems to have been his guiding principle. Following the 1944 gift, Honeyman, with a background in marketing and publicity, wanted to make a big splash, but Burrell had other ideas: 'With regard to publicity my

wife and I should prefer if there could be none at all . . . no-one can say anything about my youth except myself.'[44] Two years later he received a letter from the editor of the *Scottish Field* asking him to write about his experiences in bringing the collection together. He declined and wrote to Honeyman: 'If anyone approaches you at any time with such a suggestion I beg that you kindly let them know it is quite impossible. For any experiences to appear in print would be repugnant to me.'[45]

Burrell also shunned the limelight when it came to exhibition openings, not even attending the opening ceremony for the first major exhibition of his collection in 1946. He preferred to slip in quietly without fuss when there was no public around. It was only with people he knew and trusted that he was prepared to open up. Honeyman stated that 'the occasional reminiscence with which he illuminated conversation was often delightfully amusing and always historically important' and Kenneth Clark observed that 'he loved to tell stories with what is known as a pawky sense of humour, and very funny they were'.[46]

Burrell never explicitly explained the motivation behind his numerous gifts and loans to museums. The deed of gift made no mention of the uses to which the collection should be put, just the mechanics of its transfer and display. However, he made it clear that in donating his collection to Glasgow Corporation he was passing ownership to each citizen of Glasgow for their enjoyment. He believed in the power of art to make people's lives better and wanted everyone to have access to great art. Burrell had a strong sense of civic duty; his was not the liberal social engineering, or municipal socialism, that had been behind the development of Glasgow's museums, but an investment in social capital that offered people a chance to improve themselves in the finest traditions of conservative philanthropy.

Only in smaller and more intimate gatherings close to home did Burrell reveal his thoughts on art. At the opening of an exhibition in Berwick he bemoaned the lack of beauty in the modern world: 'In these days of rush and utility and of mass production, everything in

the way of art received little or no attention.'[47] He returned to the theme of beauty the following year when he opened an exhibition in the small Berwickshire town of Duns:

> We cannot have too many exhibitions . . . for the greater the number, the greater are our opportunities of becoming more closely acquainted with what is beautiful. There are in this world today many things which could be made more beautiful than they are, at little or no extra cost, if only more attention was paid to what is artistic when they are designed.[48]

A further glimpse of why he was so interested in art was revealed in his speech at the opening of the new Berwick Art Gallery in 1947:

> Art, to his mind, was the most fascinating, most delightful, and at the same time most educative hobby anyone could take up. It not only taught one to know that art was beautiful, but it helped one in many other directions. It brushed up one's geography and improved history like nothing else could, because the history of a country and the art of a country were very closely interwoven. It was difficult to speak of one without bringing in the other.[49]

This neatly sums up Burrell's passion for collecting, but perhaps the most revealing insight comes when he quoted Charles Kingsley in saying 'Beauty is God's own handwriting'.[50] This is not simply Burrell being a good God-fearing Presbyterian, but a reference to his belief in the transformative power of art. The full quote from Kingsley is as follows:

> Picture-galleries should be the workman's paradise, and garden of pleasure, to which he goes to refresh his eyes and heart with beautiful shapes and sweet colouring, when they are wearied with dull bricks and mortar, and the ugly

colourless things which fill the workshop and the factory
. . . Those who live in towns should carefully remember this,
for their own sakes, for their wives' sakes, for their children's
sakes. Never lose an opportunity of seeing anything beauti-
ful. Beauty is God's hand-writing—a way-side sacrament.[51]

Kingsley goes on to say that art galleries should be 'the townsman's
paradise of refreshment' and to describe how a street boy or labourer
would become 'handsomer and nobler on the spot' if they had an
opportunity to engage with beautiful pictures. It was this sentiment
that Burrell was evoking when he more prosaically hoped that his
paintings 'would prove a source of interest and pleasure to the citi-
zens of Berwick for many years to come'.[52]

It would be unfair to suggest that Burrell was motivated purely by
altruism as he was also strongly motivated by pride and status. He
wanted to be the best collector, and he wanted to be recognised as the
best collector. This can be seen early on when he took such obvious
pride in being the only collector invited to the Glasgow Boys party in
1894. It is also evident from the way that he acquired the best exam-
ples from other collections when they came up for sale, especially if
he was able to secure them for less than what the original collector
had paid. It was not just about improving his collection but being
seen to be a better collector than they were. The same craving for
status can be seen in the way he acquired Hutton Castle and shaped
his lifestyle to match those of more established wealth. Becoming a
trustee of prestigious national bodies and gaining a knighthood were
public affirmations of his status. He wore these accolades with great
pride while still maintaining a persona of understated reserve. He
embodied a very Scottish mix of humility and vanity.

Despite shunning personal publicity, every loan that he made was
identified as his and Constance's and he always wanted their collec-
tion presented separately from the rest of any museum or gallery's
other works. By 1920 the 'Burrell Collection' had become a recog-
nised entity that the public could identify. At the National Gallery
of Scotland his loan was displayed on a separate floor and at the

Tate Gallery a room was refurbished specifically to accommodate the 'Burrell Loan Collection'. This approach is confirmed in his deed of gift in which the very first clause states: 'The Collection shall be known as "The Burrell Collection" and shall be so described for all purposes'. Although he shunned the physical limelight, he always wanted to see any press clippings that featured his collection and to know how many people were visiting exhibitions featuring his artworks. He also took great satisfaction in seeing items from his collection published in specialist art magazines and academic journals. It is clear that he craved the adulation of both the general public and the professional art community, even if he hid behind a very private exterior.

The opening of the Burrell Collection in 1983 was the final act in Burrell's curation of his collection and his life. In a way, the museum was his last and most expensive purchase, even if his initial gift only paid for a fraction of the final cost. Although it opened twenty-five years after his death, he left such specific instructions about how the collection should be housed and displayed that it still embodied the essence of his personality and his passion. It was the objects that he wanted to be remembered by, and his life was only reflected through this constructed narrative of the collection and its setting.

Burrell's most immediate presence in the museum was found in the recreations of the rooms that he had spent years developing at Hutton. In these, Burrell can be seen as an artist who used the museum as his medium.[53] In this sense, these rooms are almost a self-portrait. They embodied the collecting drive that began with the attempt to buy Newark Castle and led to the construction of a medieval aesthetic within the neoclassical exterior of 8 Great Western Terrace, and culminated in the very detailed and precise curation of a Gothic interior at Hutton Castle that took more than a quarter of a century to complete.[54] Their recreation in the museum showcased his love of late-medieval and Renaissance works of art and preserved his wish to see his collection in a domestic setting with its own personality, rather than in an arid taxonomic museum display.[55]

The Burrell Collection is one of only a few museums in the world that preserve a single individual's entire collection as a whole.[56] As

well as allowing visitors the pleasure of seeing the internationally significant and beautiful artworks it offers the opportunity to look into the mind and soul of one of the most important collectors of the twentieth century. Like all collections of this nature the out-standingly beautiful and significant objects sit alongside items of lesser pedigree and those with difficult and troubled histories that reflect the times in which they were created and collected. But they are all part of the same story, and that story is of a young shipowner with a rare eye for beauty who used his incredible business skills to create a fortune and build, in partnership with his wife, one of the greatest art collections ever assembled. And then he gave it away for everyone to enjoy.

Notes

All material from Sir Robert Lorimer's Papers is reproduced by kind permission of Edinburgh University Special Collections

Introduction

1 Quote from Sir Hector Hetherington, Principal of Glasgow University at the opening of the first exhibition of the Burrell Collection in 1946, *Glasgow Herald*, 18 May 1946.
2 *Dumfries and Galloway Standard*, 26 January 1944.
3 'Extract Registered Trust Disposition and Settlement and Codicils of the late Sir William Burrell', National Records of Scotland, 'Records of Wills, no. 14', SC60/47/15, 453–4.
4 T. J. Honeyman, *Art and Audacity* (London, 1971), 140.
5 Glasgow Museums Archive, 52.56.216, Burrell to Drake, 3 March 1939.
6 Kenneth Clark, 'Sir William Burrell – A Personal Reminiscence', *The Scottish Review*, 2:6 (Spring 1977), 15–16.
7 Tate Archive, TG 4/8/3/4, Burrell to Manson, 10 May 1935.
8 *Berwickshire News and General Advertiser*, 24 June 1947.

Chapter 1: Early Years

1 *Glasgow Herald*, 9 July 1861.
2 All genealogical information comes from ancestry.com, findmypast.com and scotlandspeople.gov.uk. Additional data also comes from britishnewspaperarchive.co.uk.
3 *Bendigo Advertiser*, 20 April 1874.

4 S. M. O. Stephen, *Collector's Daughter: The Untold Burrell Story* (Glasgow, 2015), 26.

5 J. G. Lawrie, 'On the Form of Ships', *Transaction of the Institution of Engineers in Scotland*, 3 (1860), 76–8; John Ferguson, 'On River Steamers', *Proceedings of the Scottish Shipbuilders' Association*, 1 (1861), 55.

6 *The Scotsman*, 31 March 1863.

7 British Association for the Advancement of Science, *Some of the Leading Industries of Glasgow and the Clyde Valley* (Glasgow, 1876); *Glasgow Post Office Directory*, 1861.

8 W. West Watson, *Report Upon the Vital, Social and Economic Statistics of Glasgow for 1871* (Glasgow, 1872)

9 Stephen, *Collector's Daughter*, 12–13.

10 *Glasgow Herald*, 29 June 1861; Valuation Rolls VR010200341-/62, GLASGOW BURGH, 62–3.

11 Valuation Rolls VR009600031-/445, DUNBARTON COUNTY, 445–6; *Glasgow Herald*, 25 January 1884.

12 *Dundee Courier*, 12 August 1938.

13 *Glasgow and West of Scotland Educational Guide* (Glasgow, 1871), 63.

14 *The Scotsman*, 3 August 1872.

15 *Glasgow and West of Scotland Educational Guide*, 63.

16 *Westwood's Parochial Directory for the Counties of Fife and Kinross* (Oxford, 1862).

17 *Fife Herald*, 3 August 1871.

18 *Fife Herald*, 23 July 1874.

19 *Fife Herald*, 22 July 1875.

20 *Fife Herald*, 26 November 1874.

21 *Fife Herald*, 19 March 1874.

22 *The Imperial Gazetteer of Scotland* (London and Edinburgh, 1868), I, 45.

23 Richard Marks, *Burrell: Portrait of a Collector* (Glasgow, 1983), 42.

24 *Glasgow Post Office Directory*, 1856–57.

25 *Glasgow Post Office Directory*, 1857–58.

26 *Falkirk Herald*, 7 May 1868.

27 *Aberdeen Press and Journal*, 23 February 1859.

28 *Glasgow Herald*, 21 December 1868.

29 *Glasgow Herald*, 14 April 1869.

30 *Glasgow Herald*, 21 May 1863.

31 *Glasgow Morning Journal*, 23 June 1863.

32 *Falkirk Herald*, 13 July 1872.

33 *Ardrossan and Saltcoats Herald*, 9 April 1870.

34 *Glasgow Herald*, 19 November 1875.

35 *North British Daily Mail*, 24 June 1876.

36 *Glasgow Herald*, 7 June 1862.

37 *Lancaster Gazette*, 30 August 1862.

38 *The Scotsman*, 15 October 1863.

39 *Brighton Gazette*, 15 June 1865.

40 *Glasgow Herald*, 11 November 1863.

41 *Lloyd's List*, 18 February 1865.

42 *Glasgow Herald*, 3 February 1868.

43 *Some of the Leading Industries of Glasgow and the Clyde Valley* (Glasgow, 1876), 142.

44 *Glasgow Citizen*, 15 June 1844.

45 *Glasgow Herald*, 24 April 1866.

46 *The British Architect*, 11 February 1876.

47 McLellan had intended this to be a bequest but was insolvent when he died. The city therefore had to pay £15,000 to acquire the collection.

48 Martin Bellamy, 'Art and Industry: The role of the maritime industries in Glasgow's cultural revolution', in D. J. Starkey and H. Murphy (eds), *Beyond Shipping and Shipbuilding* (Hull, 2007).

49 James Hunter Dickson and James Paton, *The Present Position of the Museum and Art Galleries of Glasgow* (Glasgow, 1885).

50 *Dundee Evening Telegraph*, 12 November 1879.

51 *The Graphic*, 5 June 1880.

52 *The Connoisseur*, August 1933, 72.

53 *North British Daily Mail*, 31 March 1880.

54 *Glasgow Herald*, 2 May 1869.

55 Will of William Burrell, 1885 (Wills and Testaments Reference SC65/34/29, Dumbarton Sheriff Court); Will of George Burrell, 1881 (Wills and Testaments Reference SC36/48/96, Glasgow Sheriff Court Inventories).

56 *The Scotsman*, 31 March 1958.

57 Frances Fowle, *Van Gogh's Twin: The Scottish Art Dealer Alexander Reid, 1854–1928* (Edinburgh, 2010).

58 Glasgow Museums Archive, GMA.2013.1.2.4.252, Burrell to Hannah, 13 October 1948.

59 Glasgow City Archives, TD1981/1/1/5/1, 3, 'Autumn 1882-Spring 1892 Sales Book', Royal Glasgow Institute of Fine Arts.
60 *Glasgow Herald*, 19 May 1879.
61 *Glasgow Evening Post*, 10 March 1879.
62 *Shipping and Mercantile Gazette*, 3 June 1879.
63 H. Lumsden and P. Henderson Aitken, *History of the Hammermen of Glasgow* (Paisley, 1912), 340.
64 *Glasgow Evening Post*, 6 December 1883.
65 *Glasgow Herald*, 17 June 1886.
66 Will of William Burrell, 1885 (Wills and Testaments Reference SC65/34/29, Dumbarton Sheriff Court).

Chapter 2: Combining Art and Industry

1 *North British Daily Mail*, 17 July 1886; *Lennox Herald*, 24 July 1886.
2 *North British Daily Mail*, 28 April 1886; *North British Daily Mail*, 25 December 1886.
3 *Glasgow Herald*, 1 November 1897.
4 *North British Daily Mail*, 4 February 1886.
5 *Glasgow Evening Post*, 11 January 1888.
6 Martin Fryer, *A Newcastle Century: One Hundred Years of the Newcastle P&I Association* (Newcastle, 1987), 31–5.
7 Richard Marks, *Burrell: Portrait of a Collector* (Glasgow, 1983), 47–8.
8 *Marine Engineer and Naval Architect*, 40 (1918), 126.
9 Marks, *Portrait of a Collector*, 48.
10 *The Sydney Morning Herald*, 21 August 1891.
11 *The British Corporation Register of Shipping and Aircraft, 1890–1947. An illustrated record of 50 years' progress* (Glasgow, 1947).
12 *Lennox Herald*, 28 August 1886.
13 *Lennox Herald*, 25 December 1886.
14 *Lennox Herald*, 6 July 1889.
15 *Lennox Herald*, 25 January 1890.
16 Public Record Office Victoria, Unassisted passenger lists (1852–1923), Record Series Number (VPRS): 947
17 *Glasgow Herald*, 30 November 1889.
18 James Nicol, *Vital, Social and Economic Statistics of Glasgow, 1885-1891* (Glasgow, 1891), 328.
19 Glasgow Museums Archive, no ref. no., Certificate of appointment.

20 *Jahrbuch des k.u.k. auswärtigen Dienstes*, (Vienna, 1901).

21 James Hunter Dickson and James Paton, *The Present Position of the Museum and Art Galleries of Glasgow* (Glasgow, 1885).

22 *The Art Journal*, 1888, 276.

23 *Glasgow Herald*, 28 March 1891.

24 National Records of Scotland, 1891 census record for William Burrell, 1891/646-3/46, 53–4.

25 The authors are indebted to the honorary archivist of the Royal Northern and Clyde Yacht Club for details of Burrell's membership.

26 National Library of Scotland, Acc. 6925/II N – Burrell, A. J. McNeill Reid Papers, Letter from Burrell to A. J. McNeill Reid, 14 January 1946.

27 Marks, *Portrait of a Collector*, 65–6.

28 National Library of Scotland, Acc. 6925/II A, A. J. McNeill Reid Papers, 'Life of Alex Reid'.

29 D. S. MacColl, *Life, Work and Setting of Philip Wilson Steer* (London, 1945), 46.

30 *The Artist*, April 1897, 164.

31 National Library of Scotland, Acc. 6925/II N – Burrell, A. J. McNeill Reid Papers.

32 *The Art Journal*, 1894, 205.

33 *Glasgow Herald*, 12 April 1894.

34 *Glasgow Herald*, 12 April 1894.

35 National Library of Scotland, Acc. 6925/II N – Burrell, A. J. McNeill Reid Papers.

36 Frances Fowle, 'Alexander Reid in Context: Collecting and dealing in Scotland in the late 19th and early 20th centuries', unpublished PhD thesis (Edinburgh University, 1993). 113.

37 *Pall Mall Gazette*, 29 March 1890.

38 *Liverpool Mercury*, 12 September and 5 November 1890; Bruce Laughton, *Philip Wilson Steer, 1860–1942* (Oxford, 1971), 49.

39 *Glasgow Herald*, 22 and 24 December 1890.

40 *Glasgow Herald*, 3 February 1893.

41 *Dundee Advertiser*, 2 February 1895.

42 Glasgow Institute of the Fine Arts, *Old Glasgow Exhibition Catalogue 1894* (Glasgow, 1894), 216.

43 *The Age*, 24 July 1893.

44 R. A. Cage, *A Tramp Shipping Dynasty: Burrell & Son of Glasgow*

(1850–1939): A History of Ownership, Finance and Profit (Westport, CT and London, 1997), 16–17.

45 *Glasgow Herald*, 8 May 1894.

46 *Glasgow Herald*, 8 May 1894.

47 Herbert Matis and Dieter Stiefel, *The Schenker Dynasty: The History of International Freight Forwarding from 1872 to 1931* (Vienna, 1995).

48 *The Shipbuilder and Marine Engine-builder*, February 1943, 29.

49 *Glasgow Post Office Directory*, 1898/99.

50 National Records of Scotland: CS240/B/17/2, Court records Henry Burrell v Stewart, Govan & Company.

51 *Edinburgh Gazette*, 26 June 1896.

52 Martin Bellamy, 'Sibling rivalry, shipping innovation and litigation: Henry Burrell and the "Straightback Steamship"', *International Journal of Maritime History*, 31:1 (2019), 98–119.

53 *Glasgow Herald*, 24 November 1896.

54 *The Scotsman*, 5 February 1897.

55 International Society of Sculptors, Painters and Gravers, *Illustrated Souvenir Catalogue of the Exhibition of International Art* (London, 1898).

56 *Glasgow Herald*, 5 February 1898; *Alloa Advertiser*, 8 February 1896; *Glasgow Herald*, 18 February 1898; *The Scotsman*, 4 February 1899.

57 *Glasgow Herald*, 9 August 1899.

58 Glasgow Museums Archive, GMA.2013.1.2.1.264, Burrell to Honeyman, 30 December 1945.

59 *Glasgow School of Art Annual Report*, 1898/99, 10.

60 National Library of Scotland, Acc. 6925/II N – Burrell, A. J. McNeill Reid Papers.

61 Fowle, 'Alexander Reid in Context', 273.

62 Burrell to McNeill Reid, 14th January 1946.

63 Edinburgh University Library Special Collections, MS 2484.3, Sir Robert Lorimer Papers, Coll-27, Lorimer to Dods, 12 February 1902 and 18 August 1902.

64 Edinburgh University Library Special Collections, MS 2484.3, Sir Robert Lorimer Papers, Coll-27, Robert Lorimer to Robin Dods, 17 September 1898.

65 Lorimer to Dods, 17 September 1898.

66 Quoted in Marks, *Portrait of a Collector*, 77.

67 Edinburgh University Library Special Collections, MS 2484.5, Sir

Robert Lorimer Papers, Coll-27, Robert Lorimer to Robin Dods, July 1900. Emphasis original to Lorimer's letter.

68 Lorimer to Dods, 12 February 1902.

69 Edinburgh University Library Special Collections, MS 2484.4, Sir Robert Lorimer Papers, Coll-27, Robert Lorimer to Robin Dods, 29 October 1899.

70 Edinburgh University Library Special Collections, MS 2484.5, Sir Robert Lorimer Papers, Coll-27, Robert Lorimer to Robin Dods, July 1990.

71 Lorimer to Dods, 29 October 1899.

72 Isobel MacDonald, 'Sir William Burrell (1861–1958): The man and the collector', unpublished PhD thesis (University of Glasgow, 2018), 107–14.

73 Edinburgh University Library Special Collections, MS 2484.3, Sir Robert Lorimer Papers, Coll-27, Robert Lorimer to Robin Dods, 12 February 1898.

74 Lorimer to Dods, 29 October 1899.

75 Clive Aslet, *The Last Country Houses* (New Haven and London, 1982), 183.

76 MacDonald, 'Sir William Burrell', 175–87.

77 *Glasgow Herald*, 13 March 1896.

78 *Neues Wiener Tagblatt*, 18 July 1900.

79 Edinburgh University Library Special Collections, MS 2484.6, Sir Robert Lorimer Papers, Coll-27, Robert Lorimer to Robin Dods, 3 January 1902.

80 *The Economist*, 3 January 1891.

81 Cage, *A Tramp Shipping Dynasty*, 30–1.

Chapter 3: Collector and Conservative

1 *Glasgow Herald*, 22 June 1885. The authors are indebted to Dr Anthony Lewis for his input on Burrell's Conservatism.

2 *Glasgow Herald*, 1 December 1894.

3 This analysis of Burrell as a councillor was adapted from Isobel MacDonald, '1896–1906: Burrell the councillor, his election and responsibilities', in (unpublished) MacDonald, 'Sir William Burrell (1861–1958): The man and the collector', PhD thesis (University of Glasgow, 2018), 51–6; *Glasgow Herald*, 2 November 1899.

4 *Glasgow Herald*, 1 November 1899.

5 Irene Maver, *Glasgow* (Edinburgh, 2000), 89–92, 153–61.

6 *Glasgow Herald*, 8 November 1899.

7 *Glasgow Herald*, 2 November 1899; the following discussions on Burrell's stance on the Free Libraries Act has been adapted from Isobel MacDonald, 'Burrell the Councillor: The Free Libraries Act, 1899', in MacDonald, 'Sir William Burrell', 57–60.

8 Albert Shaw, *Municipal Government in Great Britain* (New York, 1895), 137.

9 In 1888 ratepayers in Glasgow were people who owned or occupied property.

10 Shaw, *Municipal Government*, 137.

11 *Glasgow Herald*, 12 December 1899.

12 Glasgow City Archives, GCF 352 GLA, Glasgow Corporation (Tramways, Libraries, &c.) Act 1899, Part III: Libraries.

13 *Glasgow Herald*, 12 December 1899.

14 *Glasgow Herald*, 12 December 1899.

15 *Glasgow Herald*, 12 December 1899.

16 National Library of Scotland, Acc. 10424/23, Glasgow Conservative Archive, 'Thirty-First Annual Report', Glasgow Conservative Association, 22 January 1900.

17 National Library of Scotland, Acc. 10424/23, Glasgow Conservative Archive, 'First Annual Report of the Glasgow Working Men's Conservative Association', 1870.

18 *Glasgow Herald*, 23 January 1900.

19 The following discussion of Burrell's involvement in the 1901 Glasgow International Exhibition is adapted from Isobel MacDonald, 'Burrell and the 1901 Glasgow International Exhibition', in MacDonald, 'Sir William Burrell', 69–100.

20 Glasgow Museums Archive, GMA.2013.1.2.10.10, William Burrell to James Paton, 21 October 1898.

21 Glasgow City Archives, D-TC11/4 (Box 1), James Paton, 'Report by the General Committee on the Fine Art and Scottish History Section', Minutes of the Glasgow International Exhibition Association, No. 28.

22 *Edinburgh Evening News*, 24 April 1901.

23 *Old Masters at the Glasgow International Exhibition, 1901* (Glasgow, 1902).

24 A substantial number of these works have since been dispersed, but some are still housed at Pollok House.

25 *North British Daily Mail*, 26 April 1901.

26 *Wiener Zeitung*, 23 October 1901.

27 *Illustrirtes Wiener Extrablatt*, 16 January 1900.

28 *The Scotsman*, 10 December 1901.

29 International Engineering Congress, *Report of the Proceedings and Abstracts of the Papers Read* (Glasgow, 1902).

30 Glasgow Museums Archive, GMA.2013.1.2.10.1, William Burrell to James Paton, 1 May 1902. Emphasis original to Burrell's letter.

31 Glasgow Museums Archive, no ref. no., William Burrell to Bailie Shearer, 1 May 1902.

32 *Catalogue of the well-known collection of works of art . . . formed by Sir Thomas Gibson-Carmichael, Bart. Of Castle Craig, N. B.*, 12/13 May 1902 (London, 1902).

33 Edinburgh University Library Special Collections, MS 2484.7, Sir Robert Lorimer Papers, Coll-27, Robert Lorimer to Robin Dods, 3 June 1902.

34 S. M. O. Stephen, *Collector's Daughter: The Untold Burrell Story* (Glasgow, 2015), 40.

35 *Glasgow Herald*, 23 December 1882.

36 The analysis of 8 Great Western Terrace is taken from MacDonald, 'Sir William Burrell', 188–227.

37 Edinburgh University Library Special Collections, MS 2484.5, Sir Robert Lorimer Papers, Coll-27, Robert Lorimer to Robin Dods, 29 July 1901.

38 Rocío Ruiz-Neito, 'The Burrell Fireplace Unit: a late-medieval Valencian predella', unpublished MA thesis (University of Glasgow, 2000).

39 Annette Carruthers, *The Arts and Crafts Movement in Scotland: A History* (New Haven and London, 2013), 17.

40 Charles Norton Elvin, *A Dictionary of Heraldry: With upwards of 2,500 illustrations* (London, 1889).

41 Edinburgh University Library Special Collections, MS 2484.6, Sir Robert Lorimer Papers, Coll-27, Robert Lorimer to Robin Dods, 3 January 1902.

42 Walter Shaw Sparrow (ed.), *The British Home of Today: A Book of Modern Domestic Architecture and the Applied Arts* (New York, 1914).

43 Carruthers, *The Arts and Crafts Movement in Scotland*, 6.

44 Burrell's library is a key resource as it gives us an invaluable insight into the mind of the collector. Glasgow Museums Archive, GMA.2013.1.2.6., Miles Kerr-Peterson, 'The Personal Library of Sir William and Lady Constance Mary Lockhart Burrell', Report for Glasgow Life, April 2016.

45 Lorimer to Dods, 3 June 1902.

46 Lawrence Weaver (ed.), *The House and its Equipment* (London, 1911), 48–9.

47 Harriet Richardson, 'Lorimer's Castle Restorations', *Architectural Heritage*, 3:1 (November 1992), 71.

48 This contemporary approach to simplicity in design and white interior decoration was something that Lorimer shared with Charles Rennie Mackintosh.

49 Stephen, *Collector's Daughter*, 42–48.

50 Richard Marks, *Burrell: Portrait of a Collector* (Glasgow, 1983), 86.

51 *The Bystander*, 16 December 1903.

52 A. G. Temple, *Catalogue of the exhibition of a selection of works by French and English painters of the eighteenth century* (London, 1902); A. G. Temple, *Catalogue of the exhibition of a selection of works of early and modern painters of the Dutch School* (London, 1903).

53 *London Daily News*, 2 April 1904.

54 *The Scotsman*, 30 March 1903; Copley Society of Boston, *Loan Collection [of] Oil Paintings, Water Colors, Pastels & Drawings* (Boston, 1904); International Society of Sculptors, Painters and Gravers, *Memorial Exhibition of the Works of the Late J. McNeill Whistler* (London, 1905).

55 *The Bailie*, 5 November 1902.

56 *Dundee Evening Post*, 7 September 1901.

57 *The Bailie*, 5 November 1902.

58 Shaw, *Municipal Government*, 78.

59 Glasgow City Archives, CI 3.32, 51, 'Minutes of the Corporation of Glasgow November 1904–April 1905', 4 November 1904; the following discussions on Burrell and the slum crisis in Glasgow are adapted from MacDonald, 'Sir William Burrell', 61–8.

60 *Glasgow Herald*, 31 March 1958.

61 'Minutes of the Corporation of Glasgow November 1904–April 1905', 4 November 1904, 185.

62 Public Health (Scotland) Act, 1897, Part III, Section 74, 97.

63 Public Health (Scotland) Act, 1897, 98.

64 'Minutes of the Corporation of Glasgow November 1904–April 1905', 4 November 1904, CI 3.32, 36.

65 *Glasgow Herald*, 7 December 1906.

66 The Glasgow School of Art's Archives and Collections, GSAA/ GOV/2/5, 189, 'Minutes of the Annual Ordinary General Meeting held in the School 167 Renfrew Street on Tuesday 13 September 1904 at 12.30 o'clock pm'.

67 The Glasgow School of Art's Archives and Collections, GSAA/GOV 2/5, 190, 'Minutes of the Annual Ordinary General Meeting'.

68 The Glasgow School of Art's Archives and Collections, GSAA/GOV 1/2, Annual Report, 1879–80 to 1905–6.

69 The Glasgow School of Art's Archives and Collections, GSAA/ GOV/5/1/3, 1, 'Minutes of Meeting of the Glasgow School of Art Extension Committee held in the School 167 Renfrew Street on Tuesday 2 October 1906 at 2.30 o'clock pm'.

70 *The Scotsman*, 18 March 1905.

71 *Daily Record*, 25 March 1905.

72 *Glasgow Herald*, 6 and 8 November 1905.

73 *Glasgow Herald*, 19 January 1906.

74 *Glasgow Herald*, Monday, 31 March 1958.

Chapter 4: Shipping Magnate

1 Glasgow Museums Archive, no ref. no., Certificate of appointment, 31 January 1900.

2 *The Economist*, 6 August 1904.

3 *Lloyd's List*, 28 February 1905.

4 *Greenock Telegraph and Clyde Shipping Gazette*, 20 October 1905; David Burrell, 'Burrell's Straths', *Sea Breezes*, 49 (1975), 329–38; R. A. Cage, *A Tramp Shipping Dynasty: Burrell & Son of Glasgow (1850–1939): A History of Ownership, Finance and Profit* (Westport, CT and London, 1997).

5 Meaning a business rumour on the stock exchange.

6 *Lloyd's List*, 28 September 1905.

7 Cage, *A Tramp Shipping Dynasty*, 31.

8 *Greenock Telegraph and Clyde Shipping Gazette*, 20 October 1905.

9 *Belfast News-Letter*, 26 October 1912.

10 Leonidas Argyros, 'Burrell & Son of Glasgow: A Tramp Shipping Firm, 1861–1930', unpublished PhD thesis (Memorial University of Newfoundland, 2011), 327.

11 *The Daily Telegraph* (Sydney, NSW), 28 June 1916.

12 *New York Times*, 17 July 1908.

13 Tyne & Wear Archives, 1622/4, Newcastle Protections and Indemnity Society Minute Book, 1915.

14 *Southland Times*, 5 June 1910.

15 *Daily Record*, 2 July 1914.

16 'Treasurer's Statement and List of Office-Bearers and Members', *Transactions of the Glasgow Archaeological Society*, 5:1 (1905), 11–27.

17 'List of Members', *Proceedings of the Philosophical Society of Glasgow*, 1918, 231.

18 The Paintings of James McNeill Whistler: A Catalogue Raisonné, YMSM 181, *Arrangement in Black and Brown: The Fur Jacket*, https://www.whistlerpaintings.gla.ac.uk/catalogue/display/?mid=y181&xml=his (accessed 7 September 2021).

19 He did not initially record paintings in the purchase books.

20 William Wells, 'Sir William Burrell's Purchase Books (1911–1957)', *Scottish Art Review*, 9 (1963), 19–22.

21 This is a theme that is explored in greater detail in Isobel MacDonald, 'Sir William Burrell (1861–1958): The man and the collector', unpublished PhD thesis (University of Glasgow, 2018).

22 Nick Pearce, 'From Collector to Connoisseur: Sir William Burrell and Chinese Art, 1911–57', CARP, https://carp.arts.gla.ac.uk/essay1.php?enum=1097070125 (accessed 7 September 2021).

23 Object no. 8.67; Glasgow Museums Archive, 52.1, Sir William Burrell, Purchase Book, 16 May 1912.

24 *Curliste Karlsbad*, 4 August 1910. Karlsbad is now known as Karlovy Vary in the Czech Republic.

25 *Falkirk Herald*, 22 June 1912; Burrell wrote that his Glasgow house was 'practically closed for the summer', Netherlands Institute for Art History, The Hague, W. J. G. van Meurs archive, Burrell to W. van Meuss, 27 May 1912.

26 S. M. O. Stephen, *Collector's Daughter: The Untold Burrell Story* (Glasgow, 2015), 51–63.

27 National Records of Scotland, CS46/1913/12/4, Court papers Henry Burrell v George Burrell & others.

28 *The Scotsman*, 31 October 1913.

29 National Records of Scotland, CS46/1913/12/4, Court papers Henry Burrell v George Burrell & others; National Records of Scotland, CS252/310, Court papers George Burrell & others v Henry Burrell.

30 George and the trustees were awarded £183 12s 8d and William, who had ceased to be a trustee, was awarded £157 5s 4d. Following the appeal they were awarded a further £45 2s 10d and £59 16s 1d respectively. National Records of Scotland, CS252/580 and 581, Court papers Henry Burrell v George Burrell & others.

31 National Records of Scotland, CS46/1915/4/5, Court papers Henry Burrell v George Burrell & others.

32 *Rules of the Newcastle War Risks Indemnity Association Limited* (Newcastle upon Tyne, 1913).

33 *Neues Wiener Journal*, 22 February 1914.

34 *The Scotsman*, 8 July 1914.

35 *Curliste Karlsbad*, 26 July 1914.

36 Martin Fryer, *A Newcastle Century: One Hundred Years of the Newcastle P&I Association* (Newcastle, 1987), 31–2, 140.

37 *Daily Record*, 21 November 1914.

38 *Glasgow Chamber of Commerce and Manufactures Year Book 1915* (Glasgow, 1915).

39 *The Mercury* (Hobart, Tas.), 30 September 1919.

40 *Dundee Courier*, 22 January 1916.

41 *Justice*, 13 January 1916.

42 MSS supplied to Richard Marks by Frank Herman, Glasgow Museums Archive. A version of this story appeared in Frank Herman and Michael Allan, *Traveller's Tales* (London, 1999), 198–205. This may in fact be a work of fiction by Herman but it is useful for illustrative purposes.

43 Michael Davies, *Belief in the Sea: State Encouragement of British Merchant Shipping and Shipbuilding* (London, 1992), 95–105.

44 *Daily Commercial News and Shipping List* (Sydney, NSW), 27 July 1916.

45 O. de R. Foenander, 'The Shipping Enterprise of the Australian Commonwealth Government, 1916–1928', *The American Economic Review*, 19:4 (1929), 605–18.

46 *The Daily Telegraph* (Sydney, NSW), 28 June 1916.

47 Frank Brennan, *The Australian Commonwealth Shipping Line* (Canberra, 1978), 18–26.

48 *Examiner* (Launceston, Tas.), 3 August 1916.

49 *Daily Commercial News and Shipping List* (Sydney, NSW), 1 August 1916.

50 Cage, *A Tramp Shipping Dynasty*, 34.

51 *The Scotsman*, 24 February 1917.

52 *Catalogue of a loan collection of antique furniture, mediaeval tapestries, and allied domestic arts, also of lace and drawings*, 27 February–22 March 1917, Edinburgh, New Gallery, 29.

53 The Glasgow School of Art's Archives and Collections, GSAA/ EPH/9/1/3/4, Fra. Newbury to Her Royal Highness Princess Louise, Duchess of Argyll.

54 The Glasgow School of Art's Archives and Collections, GSAA/ EPH/9/1/2, 'Minutes of Meeting of Needlework Exhibition Committee held on Monday October 18th 1915, at 3pm'.

55 The Glasgow School of Art's Archives and Collections, GSAA/ EPH/9/2/1/3, *Catalogue of the Exhibition of Ancient and Modern Embroidery and Needlecraft*, 1916.

56 'Minutes of Meeting of Needlework Exhibition Committee', 1915.

57 The Glasgow School of Art's Archives and Collections, GSAA/ EPH/9/1/3/4, William Burrell to The Secretary, GSA, 16 February 1916.

58 This is an argument that is examined further in MacDonald, 'Sir William Burrell'.

Chapter 5: Knight and Trustee

1 'Table of Sir William Burrell's acquisitions between 1911 and 1957', in William Wells, *Treasures from the Burrell Collection* (London, 1975).

2 The following analysis of Hutton Castle is adapted from Isobel MacDonald, 'Hutton Castle, Berwick-upon-Tweed', in MacDonald 'Sir William Burrell (1861–1958): The man and the collector', unpublished PhD thesis (University of Glasgow, 2018), 228–58.

3 *Berwickshire News and General Advertiser*, 4 April, 1916.

4 Glasgow Museums Archive, GMA.2013.1.3.4., Richard Marks Notes, Notice of Sale of Hutton Castle'; *The Times*, 16 September 1915.

5 Glasgow Museums Archive, 52.56.118, Sir William Burrell to Wilfred Drake, 27 July 1936.

6 The authors are indebted to Dr Anthony Lewis for his input on Burrell's Conservatism.

7 Eric Hobsbawm and Terence Ranger, *The Invention of Tradition* (Cambridge, 1983), 1.

8 Clive Aslet, *The Last Country Houses* (New Haven and London, 1982), 183.

9 *Newcastle Journal*, 27 July 1916.

10 Richard Marks, *Burrell: Portrait of a Collector* (Glasgow, 1983), 95–6.

11 Edinburgh University Library Special Collections, Gen.1963/6/274a, Sir Robert Lorimer Papers, Coll-27, Burrell to Lorimer, 7 May 1916.

12 Burrell to Lorimer, 7 May 1916.

13 Edinburgh University Library Special Collections, Gen.1963/6/271, Sir Robert Lorimer Papers, Coll-27, William Burrell to Sir Robert Lorimer, 20 May 1916.

14 Edinburgh University Library Special Collections, Gen.1963/6/287b, Sir Robert Lorimer Papers, Coll-27, Burrell to Lorimer, 24 July 1916.

15 Edinburgh University Library Special Collections, Gen.1963/6/298, Sir Robert Lorimer Papers, Coll-27, Burrell to Lorimer, 15 August 1916; Edinburgh University Library Special Collections, Gen.1963/6/294, Sir Robert Lorimer Papers, Coll-27, Burrell to Lorimer, 1 September 1916.

16 Edinburgh University Library Special Collections, Gen.1963/6/270a, Sir Robert Lorimer Papers, Coll-27, Sir Robert Lorimer to William Burrell, 6 November 1916.

17 David Goold, '(Sir) Robert Stodart Lorimer', *Dictionary of Scottish Architects*, www.scottisharchitects.org.uk/architect_full.php?id=200052 (accessed 23 June 2021).

18 Sir Robert Lorimer to William Burrell, 6 November 1916.

19 Edinburgh University Library Special Collections, Gen.1963/6/276, Sir Robert Lorimer Papers, Coll-27, William Burrell to Sir Robert Lorimer, 9 August 1917.

20 Edinburgh University Library Special Collections, Gen.1963/6/278, Sir Robert Lorimer Papers, Coll-27, William Burrell to Sir Robert Lorimer, 26 September 1917.

21 Edinburgh University Library Special Collections, Gen.1963/6/281a,

Sir Robert Lorimer Papers, Coll-27, William Burrell to Robert Lorimer, 25 October 1917.

22 Burrell to Lorimer, 25 October 1917.

23 Edinburgh University Library Special Collections, Gen.1963/6/282, Sir Robert Lorimer Papers, Coll-27, Burrell to Lorimer, 29 October 1917.

24 *Berwickshire News and General Advertiser*, 5 March 1929; *The Scottish Law Review and Sheriff Court Reports*, 45 (1929), 193.

25 Glasgow Museums Archive, GMA.2013.1.2.22, Sir William Burrell to T. J. Honeyman, 3 September 1947.

26 *The Connoisseur*, August 1933, 72. The tapestry actually depicts Charity overcoming Envy.

27 For a more detailed analysis of what was found in the rooms at Hutton Castle see Elizabeth Hancock, 'William Burrell's Tapestries: Collecting and Display' in Elizabeth Cleland and Lorraine Karafel (eds), *Tapestries from the Burrell Collection* (London, 2017), 21; For a description of the stained glass found in the castle see Marie-Helene Groll, 'Thomas & Drake, and the Transatlantic Trade in Stained Glass 1900–1950', unpublished PhD thesis (University of York, 2016).

28 Murray Adams-Acton, *Domestic Architecture and Old Furniture*, 43 and 100–11.

29 Tate Archive, TG 4/8/3/4, Burrell to Manson, 8 and 17 February 1935.

30 Glasgow Museums Archive, no ref. no., 'Inventory & Valuation of Certain Articles of Old Silver which belonged to the late Sir Wm Burrell taken at Hutton Castle, Berwickshire for Government Duty Purposes, 8th May 1958'.

31 *The Scotsman*, 18 March 1920.

32 *The Scotsman*, 18 March 1920.

33 National Galleries of Scotland 13th Annual Report, 1920.

34 *The Scotsman*, 18 March 1920.

35 *The Scotsman*, 18 March 1920.

36 *The Scotsman*, 13 August 1921 and 21 August 1922.

37 *The Edinburgh Gazette*, 20 February 1923.

38 National Galleries of Scotland archives and special collections, 'The Board of Trustees for the National Galleries of Scotland', National Gallery, Edinburgh, 28th March 1923, Minutes vol. iii, p. 178. The

last meeting that Burrell's name is mentioned in the Board of Trustee minutes is 31 March 1947. He was listed as absent. 'The Board of Trustees for The National Galleries of Scotland', 31 March 1947, Minutes vol. viii, 96.

39 National Library of Scotland, Acc. 9787/83, 3/19/67, Tom Honeyman Files, Stanley Cursiter to T. J. Honeyman, 31 March 1958.

40 *Aberdeen Press and Journal*, 23 February 1924.

41 Glasgow Museums Archive, GMAC227, 1, National Gallery, Millbank, 'Loan Exhibition of the Burrell Collection', 1924.

42 *Lancashire Evening Post*, 15 March 1924.

43 *The Sphere*, 22 March 1924.

44 *The Times*, 21 March 1924.

45 Tate Archive, Board Meeting Minutes, TAM 72/7, 103; For more on Burrell's loan practice to London institutions see Isobel MacDonald, 'The importance of access: (Sir) William Burrell's (1861–1958) "private" collection on "public" display', in Andrea Galdy, Susan Bracken and Adriana Turpin (eds), *Collecting and Access* (Cambridge Scholars Publishing, forthcoming).

46 *Sheffield Daily Telegraph*, 22 March 1924.

47 Edwin Fagg, 'Modern masters in the Burrell Collection: On loan at the Tate Gallery', *Apollo*, 1:1 (1925), 22–6.

48 *Southport Visiter*, 5 and 19 April 1924.

49 *Truth*, 9 April 1924.

50 *Westminster Gazette*, 17 September 1927.

51 *Glasgow Herald*, 4 June 1925.

52 *Glasgow Herald*, 4 June 1925.

53 *The Bailie*, 17 June 1925.

54 *The Scotsman*, 4 March 1925.

55 Glasgow Museums Annual Report, 1938; 'Table of Sir William Burrell's acquisitions between 1911 and 1957', in Wells, *Treasures from the Burrell Collection*.

56 Tate Archive, TG 92/15/2, List of Mr Burrell's Pictures, 5 September 1925.

57 For example, Burrell presented an English alabaster to them in 1927. *The Scotsman*, 26 February 1927.

58 V&A Archive, MA/1/B3568, Sir William Burrell Part 1, 1920–33/34, 20/519, William Burrell to Eric Maclagan, 22 November 1924.

59 Tate Archive, TG 92/15/2, Burrell to Mr Aitken, 9 May 1925.

60 *The Scotsman*, 2 February 1922; *Fife Free Press, & Kirkcaldy Guardian*, 13 June 1925; *The Berwick Advertiser*, 21 April 1927.

61 For more information on these tapestries see Cleland and Karafel, *Tapestries from the Burrell Collection*.

62 *The Times*, 3 June 1927.

63 *Berwickshire News and General Advertiser*, 7 June 1927.

64 C. E. C. Tattersall, 'Sir William Burrell's Gothic Tapestries', *Old Furniture: A Magazine of Domestic Ornament*, July 1927, 116.

65 Tattersall, 'Sir William Burrell's Gothic Tapestries', 116.

66 S. M. O. Stephen, *Collector's Daughter: The Untold Burrell Story* (Glasgow, 2015), 86.

67 Stephen, *Collector's Daughter*, 95.

68 Stephen, *Collector's Daughter*, 96–107.

69 National Records of Scotland, 1924 Burrell, Henry (Statutory registers, Deaths 252/24).

70 *The London Gazette*, 23 May 1924.

71 *Daily Mirror*, 19 January 1924.

72 *The Berwick Advertiser*, 12 June 1924.

73 *Freeman's Journal*, 12 September 1924; *Belfast News-Letter*, 11 December 1924.

74 *The Gentlewoman*, 7 March 1925.

75 Tate Archive, TG 92/15/2, list of pictures returned from 40 Grosvenor Square, 14 July 1925.

76 Stephen, *Collector's Daughter*, 116–24.

77 *Belfast News-Letter*, 24 May 1926.

78 *Sheffield Independent*, 27 April 1927.

79 The Constitutional Club was a gentlemen's club established in 1886 and closely aligned with the Conservative party.

80 *Dundee Courier*, 3 June 1927; *The Times*, 23 June 1927.

81 *The Times*, 23 June 1927.

82 Glasgow Museums Archives, no ref. no., The Bank Line Ltd, Time Chartered Vessels, Closed Voyages, Year ended 31 December 1927.

83 *Larne Times*, 17 September 1927; *The Scotsman*, 20 August 1925.

84 *The Scotsman*, 15 May 1922.

85 Tate Archive, Board Meeting Minutes, TAM 72/8, September 1926–November 1928, 216; Andrea Geddes Poole, *Stewards of the Nation's Art: Contested Cultural Authority 1890–1939* (Toronto, 2010).

86 *The Times*, 9 January 1928.
87 Tate Archive, TG 4/8/3/2, Burrell to Director, Tate Gallery, 11 January 1928.

Chapter 6: Living as a Laird

1 *Berwickshire News and General Advertiser*, 12 August 1919 and 10 August 1926; *The Berwick Advertiser*, 16 August 1928; *Berwickshire News and General Advertiser*, 6 May 1930.
2 Burrell Collection Lending Order, Statement of Mrs Ethel Todd Shiel, 28 July 1997.
3 Thanks to Neil Johnson-Symington for details of the Hutton Castle staff.
4 *Berwickshire News and General Advertiser*, 2 March 1920 and 7 February 1928.
5 *The Berwick Advertiser*, 11 September 1930.
6 *Berwickshire News and General Advertiser*, 15 September 1931.
7 *Berwickshire News and General Advertiser*, 20 February 1940.
8 *The Scotsman*, 29 November 1928.
9 *British Medical Journal*, 21 June 1930.
10 *Berwickshire News and General Advertiser*, 26 May 1931.
11 *The Scotsman*, 22 May 1931.
12 *The Berwick Advertiser*, 3 January 1935.
13 *Berwickshire News and General Advertiser*, 4 January 1927.
14 *Berwickshire News and General Advertiser*, 13 August 1929; *The Berwick Advertiser*, 27 June 1929.
15 These were purchased through the dealer William B. Paterson. Vivien Hamilton, *Joseph Crawhall 1861–1913: One of the Glasgow Boys* (London, 1990), 85; Vivien Hamilton, *Millet to Matisse: Nineteenth- and Twentieth-Century French Painting from Kelvingrove Art Gallery, Glasgow* (New Haven and London, 2003), 38.
16 Tate Archive, TGA 2000211., Reid & Lefevre Archive, Sir William Burrell to Alexander Reid & Lefevre, 15 March 1935.
17 National Library of Scotland, Acc. 6925/II N, A. J. McNeill Reid Papers, Burrell to McNeill Reid, 14 January 1946.
18 *Berwickshire News and General Advertiser*, 20 November 1928.
19 *Berwickshire News and General Advertiser*, 2 April 1929.
20 *Berwickshire News and General Advertiser*, 8 January 1929.

21 *Berwickshire News and General Advertiser*, 27 October 1931; *Berwickshire Advertiser*, 29 October 1931.

22 *Berwickshire News and General Advertiser*, 9 May 1933.

23 *Berwickshire News and General Advertiser*, 2 October 1928.

24 *Southern Reporter*, 26 February 1931.

25 *The Scotsman*, 11 October 1934.

26 Now known as *The Story of Troy: Diomedes and Ulysses at King Priam's Court*; *The Scotsman*, 11 October 1934.

27 *The Scotsman*, 11 October 1934.

28 S. M. O. Stephen, *Collector's Daughter: The Untold Burrell Story* (Glasgow, 2015), 115.

29 *Berwickshire News and General Advertiser*, 26 August 1930.

30 *Berwickshire News and General Advertiser*, 23 October 1934.

31 *The Sphere*, 19 August 1933.

32 *The Scotsman*, 13 August 1935.

33 *Who's Who* (London, 1935).

34 *The Scotsman*, 5 January 1927.

35 *Berwickshire News and General Advertiser*, 19 September 1933.

36 *Berwickshire News and General Advertiser*, 10 October 1933.

37 *Berwickshire News and General Advertiser*, 24 April 1934.

38 *The Scotsman*, 19 January 1937.

39 *Berwickshire News and General Advertiser*, 4 May 1929.

40 *The Scotsman*, 2 July 1929.

41 Stephen, *Collector's Daughter*, 148.

42 *Berwickshire News and General Advertiser*, 17 February 1931.

43 *The Scotsman,* 5 March 1931.

44 Stephen, *Collector's Daughter*, 153.

45 Stephen, *Collector's Daughter*, 153.

46 For a detailed retelling of Marion's engagements and the breakdown of her relationship with her parents see, Stephen, *Collector's Daughter*, 128–182.

47 Glasgow Museums Archive, 52.56.63–52.56.70.1, Correspondence between Burrell and Wilfred Drake.

48 *Berwickshire News and General Advertiser*, 29 December 1931; *The Berwick Advertiser*, 30 June 1932.

49 *The Times*, 5 September 1930.

50 *Western Daily Press*, 10 June 1927.

51 Royal Archive, RA QM/PRIV/QMD/1930, Diary of Queen Mary,

4 September 1930. With the permission of Her Majesty Queen Elizabeth II.

52 Harold Clifford Smith, *Catalogue of English Furniture & Woodwork*, vols 1 and 2 (London, 1930).

53 V&A Archive, MA/1/B3568, Sir William Burrell Part 1, 1920–33/34, 'Mr Clifford' Minute paper 31/3384, 1 May 1931.

54 Tate Archive, TG 4/8/3/3, Burrell to Mr Aitken, 29 January 1930.

55 Tate Archive, TG 4/8/3/3, Burrell to Mr Manson, 4 November 1933.

56 Tate Archive, TG 4/6/3/4, Burrell to Manson, 9 November 1933.

57 At the time the portrait of Pitt was attributed to Dupont's more famous uncle Thomas Gainsborough.

58 *The Times*, 30 January 1932.

59 *Staffordshire Advertiser*, 22 February 1936.

60 *Haagsche Courant*, 14 December 1935; 'Maris tentoonstelling: van 22 december 1935 tot 2 februari 1936', Gemeentemuseum, 1936.

61 *Northern Whig*, 2 June 1936; *Dundee Courier*, 15 October 1936; *Daily Mirror*, 20 October 1936; *Illustrated London News*, 24 October 1936.

62 *The Scotsman*, 13 October 1937 and 23 September 1938; *Dundee Evening Telegraph*, 17 May 1938.

63 *Dundee Evening Telegraph*, 14 April 1938, 5 September 1938 and 6 February 1939.

64 Glasgow Museums Archive, GMA.2013.1.2.20, Burrell correspondence re loans; *Western Daily Press*, 19 October 1938; *The Scotsman*, 23 September 1938.

65 Tate Archive, TGA 2000211, Reid & Lefevre Archive, Burrell to MacDonald, 7 October 1937.

66 Tate Archive, TGA 2000211, Reid & Lefevre Archive, Burrell to J. McNeill Reid, 30 September 1937.

67 *Yorkshire Post and Leeds Intelligencer*, 6 May 1938.

68 *The Scotsman*, 2 November 1933 and 6 September 1934.

69 Glasgow Museums Archive, GMA.2013.1.2.5.122, Eggleton to Burrell, 6 October 1938.

70 Glasgow Museums Archive, GMA.2013.1.2.5.52–7, correspondence between Eggleton and Burrell March and April 1936; James Eggleton, 'A New Branch Museum for Glasgow: Aikenhead Museum, King's Park', *Museums Journal*, 36 (1936), 130–4.

71 *Leeds Mercury*, 23 July 1938; *Yorkshire Evening Post*, 27 July 1938.

72 *Birmingham Daily Post*, 21 July 1939.

73 Glasgow Museums Archive, 52.12, 35–6, Sir William Burrell, Purchase Book, 4 August 1939.

74 *The Berwick Advertiser*, 3 August 1939.

75 *The Times*, 26 May 1933.

76 'Table of Sir William Burrell's acquisitions between 1911 and 1957', in William Wells, *Treasures from the Burrell Collection: An Exhibition at the Hayward Gallery, 18th March–4th May 1975* (London, 1975).

77 Glasgow Museums Archive, GMA.2013.1.2.2.116, Sir William Burrell to Andrew Hannah, 16 April 1953.

78 Glasgow Museums Archive, GMA.2013.1.2.5.121, Burrell to Eggleton, 5 October 1938.

79 Glasgow Museums Archive, GMA.2013.1.2.20.392, Partridge to Burrell, 8 October 1942.

80 *Berwickshire News and General Advertiser*, 16 December 1930.

81 Glasgow Museums Archive, 52.56.104, Sir William Burrell to Wilfred Drake, 14 July 1933.

82 Glasgow Museums Archive, 52.56.383, Wilfred Drake to Sir William Burrell, 17 February 1941.

83 Brian O'Connell, *John Hunt: The Man, the Medievalist, the Connoisseur* (Dublin, 2013), 44; Richard Marks, *Burrell: Portrait of a Collector* (Glasgow, 1983), 132.

84 Recent research on the bed-back questions whether the object was actually used by Henry VIII and his fourth wife. Because of the uncertainties surrounding its use, it should be referred to as 'Tudor' rather than specifically 'Henry VIII's' bed head.

85 Glasgow Museums Archive, 52.13, 69–70, Sir William Burrell, Purchase Book, 25 November 1938.

86 Glasgow Museums Archive, 52.13, 73, Sir William Burrell, Purchase Book, 25 November 1938.

87 O'Connell, *John Hunt*, 267–92; Lynn Nicholas, *Final Report to the Royal Irish Academy by the Hunt Museum Evaluation Group, 2006*, https://www.lootedart.com/web_images/pdf/huntreport%20june%202006.pdf (accessed 24 June 2021).

88 Glasgow Museums Archive, GMA.2013.1.2.8.82, Hannah to Gertrude Hunt, 23 June 1955.

89 Glasgow Museums Archive, GMA.2013.1.2.8.87, Gertrude Hunt to Hannah, 3 July 1955.

90 Glasgow Museums Archive, 52.13, 42, Sir William Burrell, Purchase Book, 25 November 1938.

91 HC776, Report of the Spoliation Advisory Panel in Respect of a Tapestry Fragment in the Possession of Glasgow City Council as part of The Burrell Collection, 24 November 2014; Elizabeth Cleland and Lorraine Karafel (eds), *Tapestries from the Burrell Collection* (London, 2017), 115–6.

92 National Gallery Archive, Burrell to Kenneth Clark, 17 September 1936; Aus dem Besitz der Firma A. S. Drey, München (Berlin, 1936); Georges Wildenstein, *Chardin* (Paris, 1933).

93 Glasgow Museums Archive, 52.8, Sir William Burrell, Purchase Book, 1930.

94 Department for Digital, Culture, Media & Sport, HC 155 2004–05, Report of the Spoliation Advisory Panel in respect of a painting now in the possession of Glasgow City Council, 24 November 2004.

95 Glasgow Museums Archive, 52.56.40, Burrell to Drake, 10 February 1929.

96 Marks, *Portrait of a Collector*, 120; Cleland and Karafel, *Tapestries from the Burrell Collection*, 668–9.

97 *The Scotsman*, 8 September 1938.

98 Cleland and Karafel, *Tapestries from the Burrell Collection*, 164–7, 303–4, 342–4, 528.

99 *Proceedings of The Society of Antiquaries of Scotland*, 63 (1928–1929), 11.

100 *Glasgow Herald*, 1 May 1924.

101 Elizabeth Hancock, 'Collecting and Display in Museums: Vernacular Furniture in Glasgow, 1900–1950', *Vernacular Building*, 30 (2006), pp. 113–30.

102 *Glasgow Herald*, 5 February 1927.

103 *The Scotsman*, 3 June 1932.

104 Mitchell Library, Special Collections, GC CDf941.443 PRO, Provand's Lordship Club Minute Book No. 3.

105 *Berwickshire News and General Advertiser*, 2 July 1929.

106 *The Scotsman*, 4 November 1931; *Glasgow Herald*, 4 November 1931.

107 *Glasgow Herald*, 16 January 1932.

108 *The Scotsman*, 3 June 1932.

109 Mitchell Library, Special Collections, GC CDf941.443 PRO, Provand's Lordship Club Minute Book No. 3.

110 Malcolm Gillies, *Bartók in Britain* (London, 1989), 32, 101.

111 *The Scotsman*, 23 November 1932.

112 The Scotsman, 20 October 1934. The authors are indebted to the archivist of the National Trust for Scotland for details of Burrell's council membership.

113 V&A Archive, MA/1/B3568, Sir William Burrell Part 1, 1920–1933/34, William Burrell to A. J. B. Wace, 7 July 1931.

114 Glasgow Museums Archive, 52.56.103, Burrell to Drake, 4 July 1933.

115 Glasgow Museums Archive, GMA.2013.1.2.8.51, Burrell to Gertrude Hunt, 21 July 1955.

116 *Kingston Gleaner*, 22 February 1937.

117 Glasgow Museums Archive, GMA.2013.1.2.5.79, Burrell to Eggleton, 9 December 1937.

118 K. Clark, 'Sir William Burrell – A Personal Reminiscence', *The Scottish Review*, 2:6 (Spring 1977) 15–16.

119 *Arbroath Herald*, 3 March 1939.

Chapter 7: Giving Away the Collection

1 *Berwickshire News and General Advertiser*, 10 July 1945.

2 *The Herald*, 20 February 2012.

3 Glasgow Museums Archive, GMA.2013.1.2.4.182, Burrell to Hannah, 31 July 1948.

4 S. M. O. Stephen, *Collector's Daughter: The Untold Burrell Story* (Glasgow, 2015), 175.

5 Glasgow Museums Archive, GMA.2013.1.2.21, Burrell correspondence with galleries.

6 Burrell Collection Lending Order, Statement of Mrs Ethel Todd Shiel, 28 July 1997.

7 Glasgow Museums Archive, 52.56.445, Burrell to Drake, 6 February 1942.

8 *Berwickshire News and General Advertiser*, 5 and 19 May 1942; 27 October 1942.

9 Glasgow Museums Archive, 52.56.370, Burrell to Drake, 11 November 1940.

10 Glasgow Museums Archive, GMA.2013.1.2.2.62, Burrell to Hannah, 24 February 1953.

11 Glasgow Museums Archive, GMA.2013.1.2.16.245 and 257, Burrell to Honeyman, 25 September 1949 and 10 January 1950.

12 *Southern Reporter*, 2 November 1939; *The Berwick Advertiser*, 8 February 1940; *The Scotsman*, 25 March 1941.

13 Glasgow Museums Archive, 52.56.429, Burrell to Drake, 8 December 1941.

14 Glasgow Museums Archive, GMA.2013.1.2.21.47, Ipswich to Burrell, 7 September 1939; GMA.2013.1.2.20.336, Torquay to Burrell, 1 August 1940.

15 Information in email correspondence between Isobel MacDonald and Val Boa, Curator at McLean Museum, Greenock, 9 August 2018. Painting accession numbers: (Vincelet) 1977.1178, (Hervier) 1977.886, (Italian School) 1977.228, (Murhman) 1977.1022.

16 *The Scotsman*, 16 December 1940.

17 Glasgow Museums Archive, GMA.2013.1.2.5.195–223, Correspondence between Burrell and Honeyman, October and November 1940.

18 Information in email correspondence between Isobel Caroline MacDonald and Val Boa, curator at McLean Museum, Greenock, 9 August 2018. Accession numbers for objects still in the McLean Museum collection: C19th asset 1981.1526, C19th two-handed bowl 1981.1530, C18th hanging brass ornament 1981.339.

19 Information in email correspondence between Isobel MacDonald and Rhona Rodger, senior officer, collections management, Perth Museum and Art Gallery, 13 August 2018.

20 Glasgow Museums Archive, GMA.2013.1.2.20.421, Dundee to Burrell, 23 June 1944.

21 Glasgow Museums Archive, GMA.2013.1.2.5.256, Burrell to Honeyman, 21 November 1942.

22 Glasgow Museums Archive, GMA.2013.1.2.1.70, Burrell to Honeyman, 21 June 1944.

23 National Library of Scotland, Acc. 9787/44, 3/19/80, T.J. Honeyman to Kenneth Clark, 21 June 1947.

24 V&A Archive, MA/1/B3568, Sir William Burrell Part 1, 1920–1933/34, Sir William Burrell to Mr Wace, Victoria & Albert Museum, London, 14 March 1931.

25 Malcolm Baker and Brenda Richardson, *A Grand Design: The Art of the Victoria and Albert Museum* (London, 1997), 65; Elizabeth Hancock, 'William Burrell's Tapestries: Collecting and Display',

in Elizabeth Cleland and Lorraine Karafel (eds), *Tapestries from the Burrell Collection* (London, 2017), 22.

26 Hancock, 'William Burrell's Tapestries', 22.

27 Hancock, 'William Burrell's Tapestries', 23.

28 V&A Archive, MA/1/B3568, Sir William Burrell Part 1, 1920–1933/34, 32/4914, Director of the Victoria & Albert Museum, London, 3 June 1932.

29 V&A Archive, MA/1/B3568, Sir William Burrell Part 1, 1920–1933/34, 31/3384, Clifford Smith report on Hutton Castle, Victoria & Albert Museum, London, 3 June 1932.

30 Clifford Smith report on Hutton Castle.

31 Clifford Smith report on Hutton Castle.

32 It is important to note here that Sir William Burrell never made an official offer of gift to the V&A. V&A Archive, MA/1/B3568, Sir William Burrell Part 1, 1920–33/34, 31/3384, Director of the Victoria & Albert Museum, London, 4 May 1931.

33 harmonyrowbc, 'Sir William Burrell's Nearly Gift to London', Glasgow Benefactors, https://glasgowbenefactors.com/2017/10/25/sir-william-burrells-nearly-gift-to-london/ (accessed 7 September 2021).

34 Tate Archive, TG 2/6/1/45, Sir John Rothenstein to Sir William Burrell, 12 March 1940.

35 Tate Archive, TG 2/6/1/45, Sir John Rothenstein to William Burrell, 26 May 1939.

36 Isobel MacDonald, 'Sir William Burrell (1861–1958): The man and the collector', unpublished PhD thesis (University of Glasgow, 2018), 263.

37 Burrell Collection Lending Order, Statement of Mrs Ethel Todd Shiel, 28 July 1997.

38 The National Archives, Kew, T273/52, Sir William Burrell: bequest of art collection and Hutton Castle; harmonyrowbc, 'Sir William Burrell's Nearly Gift to London'.

39 Tate Archive, TGA 8812.1.3.546, Sir William Burrell to Sir Kenneth Clark, 16 November 1942.

40 Tate Archive, Board Meeting Minutes, TAM 72/11, January 1933–December 1935, 479.

41 The National Archives, Kew, IR 62/2054, Proposed gift of art collection to the London County Council; harmonyrowbc, 'Sir William Burrell's Nearly Gift to London'.

42 Tate Archive, TGA 8812.1.3.554, Sir William Burrell to Kenneth Clark, 8 November 1942.

43 This was not included in his will so the painting remains in the Burrell Collection in Glasgow.

44 Tate Archive, TGA 8812.1.3.563/2, 'Memorandum by Sir William Burrell of Hutton Castle, Berwick-on-Tweed, of terms and conditions on which he proposes to offer his Collection of pictures, tapestries, furniture, porcelain, carpets, silver, stained glass &c., to the London County Council', 1942, Bannatyne, Kirkwood, France & Co.

45 Burrell was not in direct correspondence with the London County Council, all matters regarding his proposed gift were sent through Kenneth Clark. Tate Archive, TGA 8812.1.3.548, London County Council to Sir Kenneth Clark, 17 December 1942.

46 Tate Archive, TGA 8812.1.3.551, Sir Kenneth Clark to Sir William Burrell, 11 February 1943.

47 Clark to Burrell, 11 February 1943.

48 Tate Archive, TGA 8812.1.3.552, Sir Kenneth Clark to London County Council, 12 March 1943.

49 Tate Archive, TGA 8812.1.3.55, Sir Kenneth Clark to Sir William Burrell, 1 December 1943.

50 Tate Archive, TGA 8812.1.3.558, Sir Kenneth Clark to Sir William Burrell, 22 December 1943.

51 T. J. Honeyman, *Art and Audacity* (London, 1971), 14.

52 Glasgow Museums Archive, GMA.2013.1.2.5.199, Burrell to Honeyman, 30 October 1940.

53 Glasgow Museums Archive, GMA.2013.1.2.5.200, Honeyman to Burrell, 1 November 1940.

54 Tate Archive, TGA 8812.1.3.546, Sir William Burrell to Sir Kenneth Clark, 16 November 1942.

55 Honeyman, *Art and Audacity*, 135; It is important to note that Honeyman's recollection of Burrell's donation of £450,000 as well as the Collection in December 1943 is not entirely correct, however, in light of the source being a memoir published almost three decades after the fact, his blurring of facts is understandable. In the 1944 memorandum of agreement there is no evidence of an amount of money being given to the Corporation as part of the gift. Burrell did eventually give £450,000 to the Glasgow Corporation, however, this came later and in two instalments: the first a sum of

£250,000 in August 1946 and the second a sum of £200,000 in June 1948. At the time of his offer to Glasgow the conditions were, on the whole, parallel to those he had laid out to the London County Council.

56 National Library of Scotland, Acc. 9787/83, 3/19/70, Tom Honeyman Files, Sir William Burrell to Baillie Burnett, Glasgow Corporation, 12 May 1946.

57 National Library of Scotland, Acc. 9787/83, 3/19/75, Tom Honeyman Files, Lewis Clapperton to Dr Tom Honeyman, 22 May 1946.

58 *Glasgow Herald*, 27 May 1944.

59 *The Scotsman*, 27 May 1944.

60 *Glasgow Herald*, 27 May 1944.

61 *The Scotsman*, 27 May 1944.

62 MacDonald, 'Sir William Burrell', 266–7.

63 Honeyman, *Art and Audacity*, 141.

64 Glasgow Museums Archive, Eighth Condition, Memorandum of Agreement between Sir William Burrell and Lady Constance Mary Lockhart Burrell, his wife, of Hutton Castle, Berwick-on-Tweed and the Corporation of the City of Glasgow, 1944, 6.

65 Eighth Condition, Memorandum, 1944, 8.

66 Eighth Condition, Memorandum, 1944, 6.

67 Eighth Condition, Memorandum, 1944, 2; MacDonald, 'Sir William Burrell', 281–300.

68 National Records of Scotland, 'Record of Wills, no. 14', SC60/47/14, 453, 'Extract Registered Trust Disposition and Settlement and Codicils of the late Sir William Burrell'.

69 Tate Archive, TG 2/7/1/45, John Rothenstein to Sir William Burrell, 25 January 1944.

70 Tate Archive, TG 2/7/1/45, Sir William Burrell to John Rothenstein, 14 February 1944.

71 Glasgow Museums Archive, GMA.2013.1.2.1.245, Burrell to Honeyman, 16 September 1945.

72 Burrell to Honeyman, 16 September 1945.

73 National Library of Scotland, Acc. 9787/83, 3/19/113, Tom Honeyman Files, Sir William Burrell to T. J. Honeyman, 19 January 1950.

74 Glasgow Museums Archive, GMA.2013.1.2.2.125, Burrell to Honeyman, 31 October 1944.

75 Glasgow Museums Archive, GMA.2013.1.2.1.78, Burrell to Honeyman, 24 June 1944.

76 Glasgow Museums Archive, GMA.2013.1.2.10.45b, Burrell to The Curator, Bowes Museum, 7 July 1944.

77 Glasgow Museums Archive, GMA.2013.1.2.1.79, Burrell to Honeyman, 27 June 1944.

78 Glasgow Museums Archive, GMA.2013.1.2.1.170, Burrell to Honeyman, 23 March 1945.

79 Glasgow Museums Archive, GMA.2013.1.2.4.253, Burrell to Hannah, 13 October 1948.

80 *The Scotsman*, 18 May 1946; *Glasgow Herald*, 18 May 1946.

81 *The Scotsman*, 22 November 1946; *Glasgow Herald*, 22 November 1946.

82 Glasgow Museums Archive, GMA.2013.1.4.33, Burrell to Hannah, 9 February 1948.

83 *The Scotsman*, 11 June 1949.

84 *Glasgow Herald*, 10 June 1949.

85 *Berwickshire News and General Advertiser*, 6 August 1946.

86 *Berwickshire News and General Advertiser*, 2 April 1940; Berwick Town Council Minutes, 30 April 1940.

87 *Berwickshire News and General Advertiser*, 10 September 1946.

88 Glasgow Museums Archive, GMA.2013.1.2.16.173, Burrell to Honeyman, 27 September 1947.

89 *The Berwick Advertiser*, 23 and 30 October 1947.

90 *The Berwick Advertiser*, 29 April 1948.

91 *The Berwick Advertiser*, 27 May 1948.

92 *Berwickshire News and General Advertiser*, 1 June 1948.

93 Glasgow Museums Archive, GMA.2013.1.2.6.76, Burrell to Hannah, 28 February 1949.

94 Glasgow Museums Archive, GMA.2013.1.2.6.79–96, correspondence between Burrell and Hannah, March 1949; National Library of Scotland, Acc. 9787/83, 3/19/91, Sir William Burrell to T. J. Honeyman, 9 March 1949.

95 Berwick-upon-Tweed Record Office, BRO 794/81/5, Mayor's address, 5 May 1949.

96 *Berwick Advertiser*, 12 May 1949.

97 Berwick-upon-Tweed Record Office, BRO 794/81/5, List of pictures gifted to Berwick Museum by Sir William Burrell in 1949.

98 Richard Marks, *Burrell: Portrait of a Collector* (Glasgow, 1983), 166.

99 Glasgow Museums Archive, GMA.2013.1.2.6.174, Burrell to Hannah, 14 July 1949.

100 Glasgow Museums Archive, GMA.2013.1.2.2.138, Burrell to Hannah, 13 May 1953.

101 Nick Pearce, 'Archaeology and Lunacy: N. S. Brown's Chinese Neolithic Collection', in Nick Pearce and Jane Milosch (eds), *Collecting and Provenance: A Multidisciplinary Approach* (London, 2019), 127–41.

102 Alex Gordon and Peter Cannon-Brookes, 'Housing the Burrell Collection – a Forty-Year Saga', *The International Journal of Museum Management and Curatorship* (1984), 3, 19–59, 33.

103 Giles Robertson, 'The Burrell Collection at Glasgow', *The Burlington Magazine*, 91:559 (1949), 289.

104 Glasgow Museums Archive, GMA.2013.1.2.23.3, Dr Betty Kurth to Burrell, 16 February 1944.

105 Glasgow City Archive, C1/3/110, 945, Glasgow Corporation Minutes, April 1944–November 1944, 'Burrell Collection – Report by special sub-committee approved', 16 May 1944.

106 Glasgow Museums Archive, GMA.2013.1.2.1.7, Burrell to Honeyman, 26 February 1944.

107 Glasgow Museums Archive, GMA.2013.1.2.1.56, Burrell to Honeyman, 27 April 1944.

108 Drafts of her over ninety completed entries survive in the Burrell archive. In 2018 a tapestry catalogue was finally published by Elizabeth Cleland and Lorraine Karefel, see Cleland and Karafel, *Tapestries from the Burrell Collection*.

109 Glasgow Museums Archive, GMA.2013.1.2.4.31, Burrell to Hannah, 7 February 1948. Yetts was not well and it appears the book was never completed.

110 Glasgow Museums Archive, GMA.2013.1.2.2.261 and 268, Burrell to Hannah, 13 and 26 November 1953.

111 Glasgow Museums Archive, GMA.2013.1.2.1.256 and 264, Honeyman to Burrell, 3 December 1945 and Burrell to Honeyman, 30 December 1945.

112 Tate Archive, TGA 2000211, Reid & Lefevre Archive, McNeill Reid to Burrell, 30 November 1953.

113 Glasgow Museums Archive, GMA.2013.1.2.2.277, Burrell to Hannah, 5 December 1953.

114 Glasgow Museums Archive, GMA.2013.1.2.28.325, Hannah to Adams-Acton, 26 November 1953.

115 Glasgow Museums Archive, GMA.2013.1.2.8.335, Adams-Acton to Hannah, 8 July 1953.

116 *Glasgow Herald*, 27 May 1944.

117 Marks, *Portrait of a Collector*, 159–66.

118 Glasgow Museums Archive, GMA.2013.1.2.22.74, Burrell to Honeyman, 6 August 1947.

119 Glasgow Museums Archive, GMA. 2013.1.2.22, Burrell to Honeyman, 3 September 1947. Emphasis original to Burrell.

120 Glasgow Museums Archive, GMA.2013.1.2.22.103, Surgey to Hannah, 23 April 1948.

121 Anthony Lewis, 'John Glassford's Art Collection', https://glasgow-museumsslavery.co.uk/2019/03/01/john-glassfords-art-collection/ (accessed 7 September 2021).

122 Glasgow Museums Archive, GMA.2013.1.2.8.338, Adams-Acton to Hannah, n.d., received 27 July 1954.

123 Glasgow Museums Archive, GMA.2013.1.2.8.341, Adams-Acton to Hannah, 29 August 1954.

124 Glasgow Museums Archive, GMA.2013.1.2.8.342, Hannah to Adams-Acton, 1 September 1954.

125 Glasgow Museums Archive, GMA.2013.1.2.14.88, Burrell to Wells, 2 July 1956.

126 Glasgow Museums Archive, GMA.2013.1.2.14.18, Burrell to Hannah, 21 February 1956.

127 Glasgow Museums Archive, GMA.2013.1.2.8.392, Hannah to Adams-Acton, 17 March 1956.

128 Glasgow Museums Archive, GMA.2013.1.2.8.379, Hannah to Adams-Acton, 11 January 1955.

129 William Wells, *Temple Newsam House* (Leeds, 1951).

130 Glasgow Museums Archive, GMA.2013.1.2.14.18, Burrell to Hannah, 21 February 1956.

131 Glasgow Museums Archive, GMA.2013.1.2.14.47, Burrell to Wells, 11 April 1956.

132 *The Berwick Advertiser*, 23 January 1958.

133 *The Berwick Advertiser*, 20 May 1954.

134 National Records of Scotland, 1958 Burrell, William (Statutory registers, Deaths 745/4).

135 National Library of Scotland, Acc. 9787/83, 3/19/67, Tom Honeyman Files, Stanley Cursiter to T. J. Honeyman, 31 March 1958.

136 *Glasgow Herald*, 31 March 1958.

Chapter 8: Legacy

1 *The Berwick Advertiser*, 26 June 1958.

2 'Extract Registered Trust Disposition and Settlement and Codicils of the late Sir William Burrell', National Records of Scotland, 'Record of Wills, no. 14', SCO60/47/14, 453.

3 *The Edinburgh Gazette*, 17 December 1957 and 9 June 1959.

4 Glasgow Museums Archive, GMA.2013.1.2.19.3–5, correspondence between Hannah and Logan, May 1958.

5 Glasgow Museums Archive, GMA.2013.1.2.21, Logan to Hannah, 12 February 1959.

6 National Records of Scotland, 'Burrell, Constance Mary', 1961, (Statutory registers, Deaths 745/3); R. A. Cage, *A Tramp Shipping Dynasty: Burrell & Son of Glasgow (1850–1939): A History of Ownership, Finance and Profit* (Westport, CT and London, 1997), 204.

7 Glasgow Museums Archive, GMA.2013.1.2.18.51, Lady Burrell to Wells, 24 March 1959.

8 *The Berwick Journal & Northumberland News*, 17 August 1961.

9 Netherlands Institute for Art History, The Hague, W. J. G. van Meurs archive, Burrell to van Meurs, 5 December 1912.

10 Glasgow Museums Archive, GMA.2013.1.2.18.63, Marion Burrell to Wells, 8 June 1961.

11 Quoted in Alex Gordon and Peter Cannon-Brookes, 'Housing the Burrell Collection – a Forty-Year Saga', *The International Journal of Museum Management and Curatorship* (1984), 3, 19–59, 33.

12 *Daily Express*, 20 March 1963, quoted in Richard Marks, *Burrell: Portrait of a Collector* (Glasgow, 1983), 191.

13 Glasgow Museums Archive, GMA.2013.1.2.4.67, Burrell to Hannah, 18 March 1948.

14 Scotland (Burrell Art Collection), *Hansard*, Volume 728, debated on Wednesday 11 May 1966.

15 Glasgow Museums Archive, DC 371/7/7, Architectural Competition Pack.

16 Glasgow Museums Archive, Burrell Architects Correspondence, Barry Gasson to Trevor Walden, 8 August 1972.

17 *Glasgow Herald*, 4 May 1978.

18 Barry Gasson, 'Notes on the building for the Burrell Collection, Pollok Park, Glasgow', in William Wells, *Treasures from the Burrell Collection* (London, 1975), 117–20.

19 *Glasgow Herald*, 22 October 1983.

20 Glasgow University Archive, DC371/7/3, Lord Muirshiel Papers, Silvia Burrell to Lord Muirshiel, 24 October 1983.

21 Glasgow University Archive, DC371/7/3, Lord Muirshiel Papers, Civic Trust to Lord Muirshiel, 17 November 1983.

22 *Aberdeen Press and Journal*, 12 November 1983.

23 *Financial Times*, 31 October 1983.

24 Glasgow Museums Archive, GMA.2013.1.2.16.239, Burrell to Honeyman, 10 September 1949.

25 *New York Times*, 6 November 1983; *Globe and Mail*, 5 November 1983; *Wall Street Journal*, 14 September 1984.

26 Maria Gómez. 'Reflective Images: The Case of Urban Regeneration in Glasgow and Bilbao', *International Journal of Urban and Regional Research*, 22:1 (1998), 106–21.

27 'The Millionaire Magpie', BBC Two England, 27 July 1976.

28 Kenneth Clark, 'Sir William Burrell – A Personal Reminiscence', *The Scottish Review*, 2:6 (Spring 1977), 15–16.

29 Alan Jenkins, *The Rich Rich: The Story of the Big Spenders* (New York, 1978), 155.

30 Marks, *Portrait of a Collector*, 20.

31 Eva Schaper, 'Burrell: Portrait of a Collector', *The British Journal of Aesthetics*, 26:1 (1986), 84–7.

32 [William Wells], 'The Burrell Collection', *Leeds Art Calendar*, 4:13 (1950), 7.

33 Clark, 'Sir William Burrell – A Personal Reminiscence', 15–16.

34 T. J. Honeyman, *Art and Audacity* (London, 1971), 140.

35 Glasgow Museums Archive, GMA.2013.1.2.8.51, Hannah to Mathieson Gallery, 5 November 1956.

36 [Wells], 'The Burrell Collection', 7.

37 Glasgow Museums Archive, GMA.2013.1.2.16.211, Burrell to Honeyman, 9 July 1949.

38 Glasgow Museums Archive, GMA.2013.1.2.16.100, Burrell to Honeyman, 10 January 1947.

39 Mark Fisher, *Britain's Best Museums and Galleries: From the Greatest Collections to the Smallest Curiosities* (London, 2004), 472.

40 Edinburgh University Library Special Collections, MS 2484.5, Sir Robert Lorimer Papers, Coll-27, Robert Lorimer to Robin Dods, July 1900. Emphasis original to letter.

41 Glasgow Museums Archive, GMA.2013.1.2.2.185, Burrell to Hannah, 27 July 1953.

42 William Wells, 'Sir William Burrell', *Dictionary of National Biography* (1971).

43 There is one studio photograph and two sketches that were published alongside his profiles in *The Bailie*. Other than that, there are only family snapshots.

44 National Library of Scotland, Acc. 9787/83, 3/19/7, Tom Honeyman Files, Sir William Burrell to T. J. Honeyman, 26 January 1944.

45 Glasgow Museums Archive, GMA.2013.1.2.16.45, Burrell to Honeyman, 25 May 1946.

46 Honeyman, *Art and Audacity*, 141; Clark, 'Sir William Burrell – A Personal Reminiscence', 15–16.

47 *Berwickshire News and General Advertiser*, 6 August 1946.

48 *Berwickshire News and General Advertiser*, 24 June 1947.

49 *The Berwick Advertiser*, 12 May 1949.

50 *Berwickshire News and General Advertiser*, 6 August 1946.

51 Charles Kingsley, *Politics for the People* (London, 1848), 5–6.

52 *The Berwick Advertiser*, 12 May 1949.

53 This argument is adapted from Anne Higonnet, *A Museum of One's Own: Private Collecting, Public Gift* (Pittsburgh, 2009), 96.

54 Information from Elizabeth Hancock's notes on drawing room, December 2016 and used in MacDonald, 'Sir William Burrell', 238.

55 This idea of collections reflecting the collector is argued by Jean Baudrillard in 'The System of Collecting', in John Elsner and Roger Cardinal (eds), *The Cultures of Collecting* (London, 1994), 7–24.

56 Other examples are the Isabella Stewart Gardener Museum in Boston, the Frick Collection in New York, Charles Lang Freer's Collection in Washington DC, the Lady Lever Art Gallery outside Liverpool, and the Wallace Collection in London.

Select Bibliography

Argyros, Leonidas, 'Burrell & Son of Glasgow: A Tramp Shipping Firm, 1861–1930', unpublished PhD thesis (Memorial University of Newfoundland, 2011)

Bellamy, Martin, 'Art and Industry: The role of the maritime industries in Glasgow's cultural revolution', in D. J. Starkey and H. Murphy (eds), *Beyond Shipping and Shipbuilding*, (Hull, 2007)

Bellamy, Martin, 'Sibling rivalry, shipping innovation and litigation: Henry Burrell and the "Straightback Steamship"', *International Journal of Maritime History*, 31:1 (2019), 98–119

Brennan, Frank, *The Australian Commonwealth Shipping Line* (Canberra, 1978)

'The Burrell Collection', *The Burlington Magazine*, 125:969 (1983), 725–7

Burrell, David, 'Burrell's "Straths"', *Sea Breezes*, 49 (1975), 213–22, 271–80, 329–38 and 388–96

Cage, R. A., *A Tramp Shipping Dynasty: Burrell & Son of Glasgow 1850–1939: A History of Ownership, Finance and Profit* (Westport, CT and London, 1997)

Cage, R. A., 'The Structure and Profitability of Tramp Shipping, 1850–1920: Some Evidence from Four Glasgow-Based Firms', *The Great Circle*, 17:1 (1995), 1–21

Calder, Barnabas, 'Castles, Cows and Glasshouses: The Burrell Collection Architectural Competition', *Twentieth Century Architecture*, 10 (2012), 36–49

Cannon, Linda, *Stained Glass in the Burrell Collection* (Edinburgh, 1991)

Carruthers, Annette, *The Arts and Crafts Movement in Scotland: A History* (New Haven and London, 2013)

Chamot, M., 'The Burrell Collection', *Country Life*, 23 May 1925, 849–51

Clark, Kenneth, 'Sir William Burrell – A Personal Reminiscence', *The Scottish Review*, 2:6 (Spring 1977), 15–16

'The Crawhalls of Mr. William Burrell's Collection', *The Studio*, 83, 1922, 176–86

Davis, Frank, 'Emerging into Public View – The Burrell Collection', *Country Life*, 21 April 1977, 1043–4

Demarco, Richard, et al., 'The Burrell Collection', *The Architect's Journal*, 42:178 (1983), 56–102

Fagg, Edwin, 'Modern masters in the Burrell Collection: On loan at the Tate Gallery', *Apollo*, 1:1 (1925), 22–6

Foenander, O. de R., 'The Shipping Enterprise of the Australian Commonwealth Government, 1916–1928', *The American Economic Review*, 19:4 (1929), 605–18

Fowle, Frances, *Van Gogh's Twin: The Scottish Art Dealer Alexander Reid, 1854–1928* (Edinburgh, 2010)

Fowle, Frances, 'Alexander Reid in Context: Collecting and dealing in Scotland in the late 19th and early 20th centuries', unpublished PhD thesis, (Edinburgh University, 1993)

Fryer, Martin, *A Newcastle Century: One Hundred Years of the Newcastle P&I Association* (Newcastle, 1987), 31–5

Gasson, Barry, 'Notes on the building for the Burrell Collection, Pollok Park, Glasgow', in William Wells, *Treasures from the Burrell Collection* (London, 1975), 117–20

Gordon, Alex and Peter Cannon-Brookes, 'Housing the Burrell Collection – a Forty-Year Saga', *The International Journal of Museum Management and Curatorship*, 3 (1984), 19–59

Gray, Muriel, *Kelvingrove Museum and Art Gallery: Glasgow's Portal to the World* (Glasgow, 2006)

Groll, Marie, 'Thomas Drake and the Transatlantic Trade in Stained Glass 1900–1950', unpublished PhD thesis (University of York, 2016).

Hamilton, Vivien, *Joseph Crawhall 1861–1913: One of the Glasgow Boys* (London, 1990)

Hamilton, Vivien, *Millet to Matisse: Nineteenth- and Twentieth-Century French Painting from Kelvingrove Art Gallery, Glasgow* (New Haven and London, 2003)

Hamilton, Vivien, *Drawn in Colour: Degas from the Burrell Collection* (London, 2018)

Hamilton, Vivien, 'William Burrell and Impressionism', in Frances Fowle (ed.), *Impressionism & Scotland* (Edinburgh, 2008), 20–32

Hancock, Elizabeth, 'Collecting and Display in Museums: Vernacular Furniture in Glasgow, 1900–1950', *Vernacular Building*, 30 (2006), 113–30

Hancock, Elizabeth, 'William Burrell's Tapestries: Collecting and Display', in Elizabeth Cleland and Lorraine Karafel (eds), *Tapestries from the Burrell Collection* (London, 2017)

harmonyrowbc, 'Sir William Burrell's Nearly Gift to London', Glasgow Benefactors website: https://glasgowbenefactors.com/2017/10/25/sir-william-burrells-nearly-gift-to-london/ (accessed 7 September 2021)

Herrmann, Frank (ed.), *The English as Collectors* (London, 1972)

Higonnet, Anne, *A Museum of One's Own: Private Collecting, Public Gift* (Pittsburgh, 2009)

Honeyman, T. J., *Art and Audacity* (London, 1971)

Kendrick, A. F., 'Gothic Tapestries for Hutton Castle', *Country Life*, 28 May 1927

Leslie, David, 'Urban regeneration and Glasgow's galleries with particular reference to the Burrell Collection', in G. Richards (ed.), *Cultural Attractions and European Tourism* (Wallingford, 2001), 111–33

MacDonald, Isobel Caroline, 'Sir William Burrell (1861–1958): The man and the collector', unpublished PhD thesis (University of Glasgow, 2018)

Manzor, George, 'Sir William Burrell Glasgow Corporation Councillor 1899-1906', *Scottish Local History*, 91 (Spring–Summer 2015), 38–41

Manzor, George, 'Sir William Burrell Glasgow Corporation Councilor 1899–1906', Glasgow Benefactors, 28 August 2017, https://glasgow benefactors.com/2017/08/28/sir-william-burrell-glasgow-corpora tion-councillor-1899-1906/ (accessed 7 September 2021)

Marks, Richard, *Burrell: Portrait of a Collector* (Glasgow, 1983)

Marks, Richard, *The Souvenir Guide to the Burrell Collection* (Glasgow, 1985)

Marks, Richard, et al., *The Burrell Collection: with an introduction by John Julius Norwich* (London and Glasgow, 1984)

Marks, Richard, et al., 'The Burrell Collection', *Scottish Arts Review*, 16:1 (1983)

Matis, Herbert, and Dieter Stiefel, *The Schenker Dynasty: The History of International Freight Forwarding from 1872 to 1931* (Vienna, 1995)

Middlemiss, Norman L., *Travels of the Tramps: Twenty Tramp Fleets* (Newcastle upon Tyne, 1989)

O'Connell, Brian, *John Hunt: The Man, the Medievalist, the Connoisseur* (Dublin, 2013)

Pearce, Nick, 'From Collector to Connoisseur: Sir William Burrell and Chinese Art, 1911–57', CARP, https://carp.arts.gla.ac.uk/essay1. php?enum=1097070125 (accessed 7 September 2021)

Richardson, Harriet, 'Lorimer's Castle Restorations', *Architectural Heritage*, 3:1 (November 1992), 71

Robertson, Giles, 'The Burrell Collection at Glasgow', *The Burlington Magazine*, 91:559 (1949), 287–9

Savage, Peter, *Lorimer and the Edinburgh Craft Designers* (Edinburgh, 1980)

Savage, Peter, 'Through the Eyes of a Friend – William Burrell, Collector', *Country Life*, 27 January 1977

Savage, Peter, 'The Ship Owner Settles Down – William Burrell, Collector', *Country Life*, 3 February 1977

Seligman, G., *Merchants of Art* (New York, 1961)

Stephen, S. M. O., *Collector's Daughter: The Untold Burrell Story* (Glasgow, 2015)

Tattersall, C. E. C., 'Sir William Burrell's Gothic Tapestries', *Old Furniture: A Magazine of Domestic Ornament*, July 1927, 116

Wells, William, 'Sir William Burrell's Purchase Books (1911–1957)', *Scottish Art Review*, 9 (1963), 19–22

Wells, William, 'Sir William Burrell's Purchase Books (1911–1957)', in Frank Herrmann (ed.), *The English as Collectors* (London, 1972)

Wells, William, 'Sir William Burrell and his Collection', *Museums Journal*, 72:3 (1972), 101–3

Wells, William, 'Sir William Burrell', in Wells, *Treasures from the Burrell Collection* (London, 1975), 6–11

Index